ICONS *of* STYLE

First published in Great Britain in 2024 by Laurence King, an imprint of The Orion Publishing Group Ltd, Carmelite House, 50 Victoria Embankment, London EC4Y 0DZ

An Hachette UK Company

10 9 8 7 6 5 4 3 2 1

A CIP catalogue record for this book is available from the British Library.

ISBN (Export Trade Paperback) 978 1 399623766
ISBN (eBook) 978 1 399623773

Design by Dan Jackson
Project editing by Zoe Antoniou
Picture research by Emily Taylor

Origination by F1 Colour Ltd, UK
Printed in China by C&C Offset Printing Co. Ltd

MIX
Paper | Supporting
responsible forestry
FSC® C104740

www.laurenceking.com
www.orionbooks.co.uk

ICONS *of* STYLE

IN *100* GARMENTS

Josh Sims

LAURENCE KING

Contents

Introduction

Fashion moves in cycles of revolution and consolidation, but its primary remit is constant change – that is what drives consumption in what is, after all, an industry. If fashion never changed, perhaps we would only need new clothes when our old ones wore out. But actually there is an element of fashion which, in fact, doesn't change. It's the bedrock on which everything else is built, the fundamental elements through which experimentation occurs.

Sometimes they're referred to as 'classics' or as 'wardrobe staples' – these are the garments that, should someone from the late nineteenth century jump forward through time to more recent years, would, some details aside, likely still be recognisable to them. Likewise, they would be recognisable to us if we were to jump back.

This isn't to say their meanings would necessarily be the same: the joke in *Back to the Future Part II*, when Marty McFly is desperate to fit into the 1950s and so puts on a black leather biker jacket, is that it was totemic then of the trouble-maker, even if today it's totemic of a rather more ersatz rebellion.

That these classics have survived largely unchanged for as long as they have – often a century or more, and most are at least many decades old – is remarkable in a business that so thrives on newness. They speak perhaps to an era when clothes were more highly valued; when people had fewer clothes and so

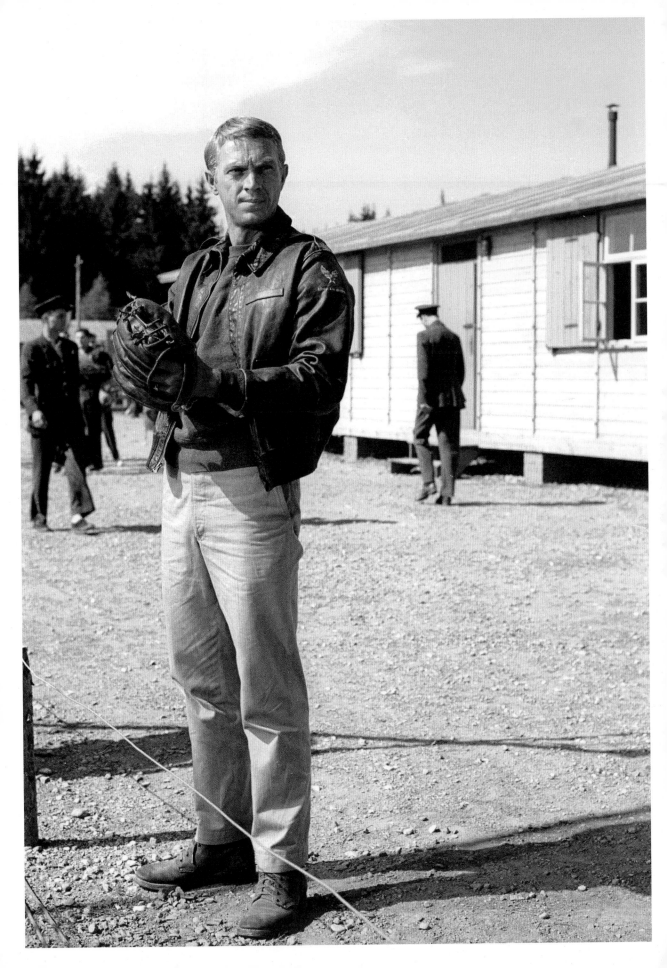

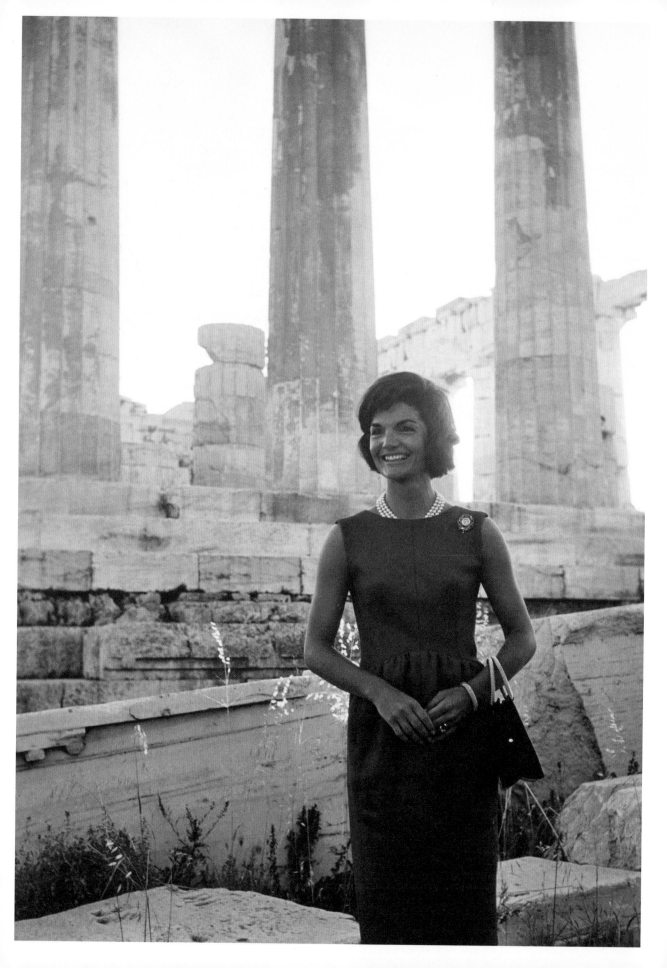

looked after them; when, really, fashion was more just for the frivolous and the well-off; when fashion was slow and not fast.

Yet the longer they have survived, the longer they have provided the blueprint for their category of clothing – for what a man's shirt, or a woman's shift dress, or whatever, should look like; the more they have become the foundational archetypes that fashion endlessly imitates, but also plays with, builds on and subverts. Underneath this playfulness and subversion, they are nonetheless still there – if they weren't, arguably the playfulness and subversion would fail.

Indeed, the longevity of their appeal isn't just because they offer value in their ability to somehow be above fashion, which makes them sound terribly safe. Their appeal is also in constantly taking clothing back to reassuring first principals of proportion, fit, silhouette and the human body. This is the clothing canon. It's not fixed and immutable – it is always growing, albeit that each new entry must prove itself over time to be accredited, and no doubt some of the old ones will eventually fall aside. Ruffs were in fashion for a century too.

In the meantime, we keep going back to them, if for no other reason than this: they still look really good.

Previous page: The sweatshirt, the jacket, the khakis – adding up to make Steve McQueen in *The Great Escape* (1963) one of the all-time great benchmarks for men's casual style.
Opposite: Jacqueline Kennedy Onassis, twentieth-century style icon and First Lady, visiting the Acropolis in Athens in 1961.

Trench Coat
Denim Jacket
Leather Jacket
Cape
Blouson
Waxed Jacket
Overcoat
Duffle Coat
Chore Jacket
Flight Jacket
Mac
Biker Jacket
Field Jacket
Pea Coat
Fishtail Parka
Bomber Jacket

1.
Outerwear

The Trench Coat

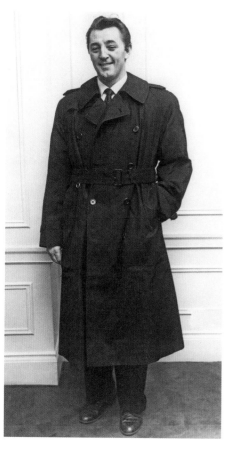

When the trench coat became an optional item of clothing in the British army during the First World War only officers were allowed to wear it. Such class associations have long been lost and the coat, and its variations, is an everyman alternative to the classic macintosh, even if distinctive details of its military heritage remain: the epaulettes that secured rank insignia or anything on a strap; the D-ring, at the front and rear, on to which ammunition pouches and other supplies were hooked; and the storm flap at the shoulder, now an extra means of funnelling rain away from the body, and originally devised to provide cushioning against the kick of a rifle butt. Other details add up to make the trench one of the most weatherproof coats ever devised: the throat latch, wrist straps and the rain shield, which works like the storm flap but across the back.

The trench coat may have come to be the uniform of Chandler-esque private eyes of the 1940s – think Robert Mitchum in *Out of the Past* (1947) or *Foreign Intrigue* (1956) – and is famously associated with Humphrey Bogart's Rick Blaine in *Casablanca* (1942). But by then the trench coat's very mannishness was being toyed with: women had worn the style before, notably during the early 1920s, as much as a statement of emancipation as of fashion. Again, it was stars of the screen portraying the strong woman archetype who wore the trench: Greto Garbo on the set of *A Woman of Affairs* (1928), Gloria Swanson in *Queen Kelly* (1929) and Bette Davis in *Of Human Bondage* (1934). The trench coat continued to be used to signal a sassy mannishness – Katharine Hepburn wore an outsized trench coat in *The Iron Petticoat* (1956), for example – right up until Audrey Hepburn's feminization of the garment.

The image of Hepburn's Holly Golightly in *Breakfast at Tiffany's* (1961), wearing what until then had been perceived as a predominantly male garment, also created a stir. Sales of the coat to women rocketed, establishing it as a fashion classic, soon after given added kudos when Jacqueline Kennedy

Above: The actor Robert Mitchum wearing an Aquascutum trench coat.
Opposite: A trench coat by Burberry, one of the company's that pioneered the design.

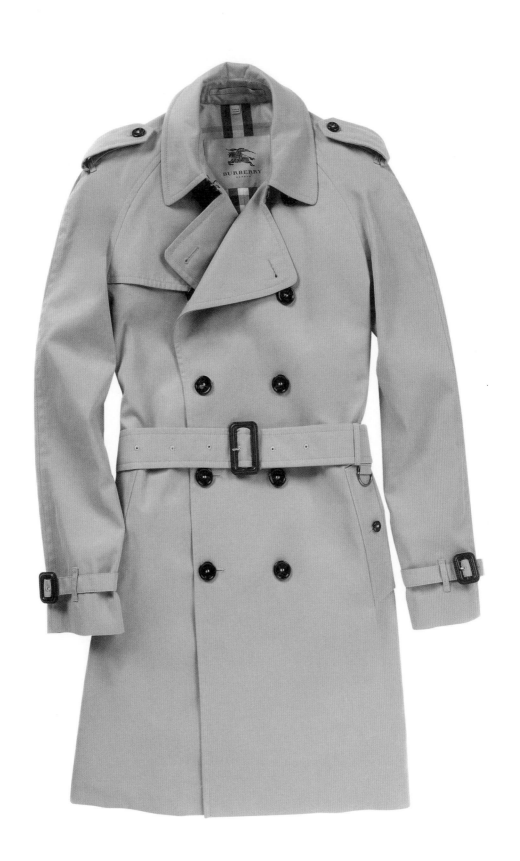

Onassis, Joanne Woodward and Brigitte Bardot (in *Une ravissante idiote*, 1964) were all spotted wearing the trench. Charlotte Rampling, Catherine Deneuve and Charlotte Gainsbourg each made the trench coat part of their style, as well as ensuring the garment remains central to the idea of French chic.

But the trench coat's story begins in nineteenth-century England with two pioneers in fabric innovation: John Emery and Thomas Burberry. The former owned a menswear shop on London's Regent Street and in 1853 developed the first waterproof wool, which he patented and launched under the brand name Aquascutum (Latin for water shield). He supplied capes, field coats and a forerunner of the trench coat to troops of all ranks during the Crimean War (1853–56). Later his company cornered the market for supplying the movie industry: stars wore the Aquascutum Kingsway trench coat on screen and off.

Thomas Burberry owned an outfitter's shop in Basingstoke, southern England, which was popular with local hunters, fishermen, horse riders and cyclists. He created gabardine, made from chemically coated, long staple cotton yarns woven so tightly into a distinctive diagonal twill that, while air could pass through it, the fabric stood up to rough treatment and fended off rain. It was consequently colloquially known as duck. It was not initially used for clothing. Its first test came when explorer Roald Amundsen bought tents made of gabardine for his 1911 race to the South Pole. He gave the fabric what amounted to a hero's endorsement: 'Burberry gabardine is extraordinarily light and strong and keeps the wind out completely.' Ernest Shackleton was entirely kitted out in Burberry gabardine for his 1914–16 Antarctic expedition. The company's first raincoat – before the trench – became the standard, named the Burberry when it proved impossible to trademark its initial name, the Slip-On.

The clearest move towards the definitive trench-coat style came in 1899 with the Boer War in South Africa, when many British officers unofficially adopted Burberry weatherproofs; the company became one of the official outfitters to the British army in 1901. Its first military-specification coat was the Tielocken, so called because it tied at the front with a strap and buckle so securely the wearer was locked into it; this belt became a distinguishing characteristic of the trench coat. Some half a million Tielocken were supplied during the First World War. Aquascutum's version reached even more officers through its Aquascutum Service Kit – a box that contained everything the well-dressed man needed to take to war, bar the weaponry.

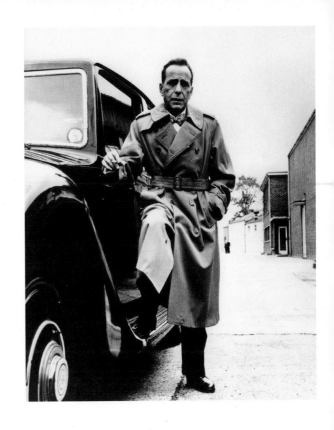

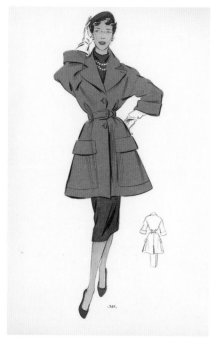

Initially anonymous, the Burberry trench-style garment was nicknamed the trenchwarm by officers who valued its cosy properties, especially the detachable sheepskin liner. It was so successful the *New York Times* of 29 August 1917 reported 'Trench Coats in Demand …' and added: 'It is expected that a coat very similar to this, if not this particular coat, will be included in the men's regular equipment when the American forces finally arrive at the front'. Not just the officers' equipment, it might be noted. It was only a small step for the trenchwarm to be officially named the trench coat. Few officers were ready to give up their coats when the war ended – and the style entered civilian life and sartorial history.

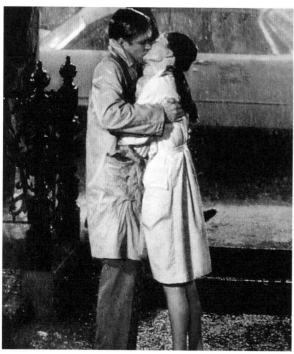

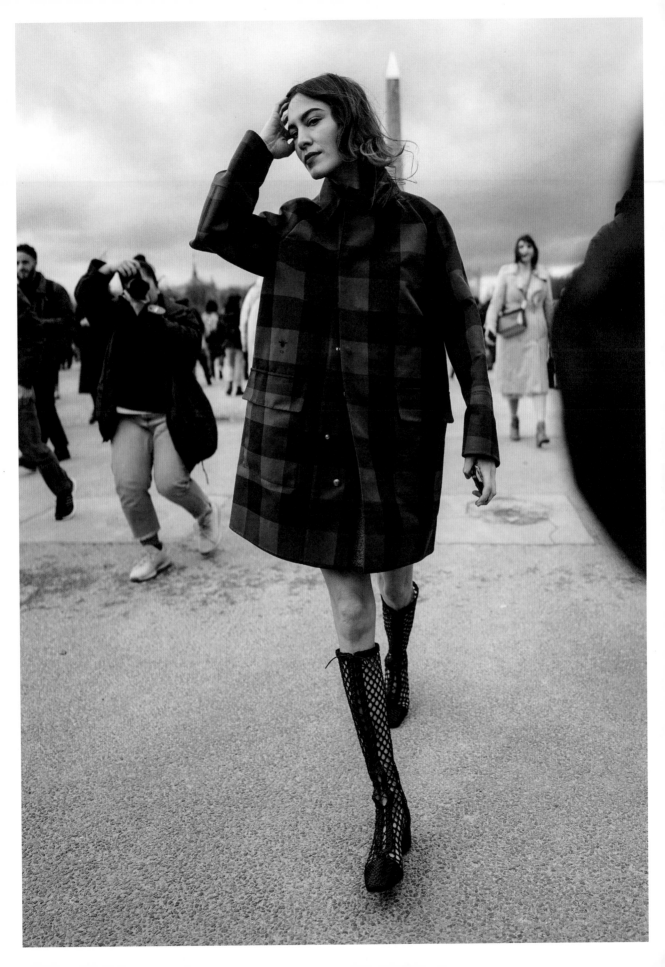

The Denim Jacket

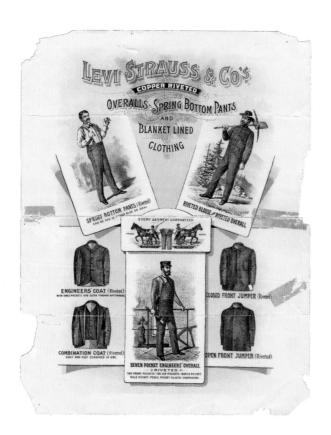

Above: There were many variants on the idea of the denim jacket in Levi Strauss & Co.'s early days, as this late nineteenth-century advert shows.
Opposite: Then as now, western style has an all-American flavour, embraced here by Bing Crosby and his four sons, photographed in 1948.

When Bing Crosby was refused entry into an upmarket hotel during the 1950s because he was wearing a denim jacket and jeans, Levi Strauss & Co. made him a tuxedo – in the same fabric. It was a neat riposte. The jacket had been a staple of the working world for some seventy years, which is why its appearance at a swanky venue might have been unexpected, but this is why its many variations, most of them a take on a simple, waisted, breast-pocket style, have appealed to the outdoorsmen and pioneer workers for whom they were originally created, and to ranch hands and beat intellectuals, heavy metal rockers and artists.

The first denim jacket probably dates to the 1870s and followed hard on the heels of the first denim jeans. Long-defunct names, such as Boss of the Road, Stronghold and Heynemann (which launched in 1851 with its catchily named Can't Bust 'Em brand), made various kinds of work clothes in denim. However, Levi Strauss & Co. introduced the first riveted denim jacket, around 1873; after all, it owned the patent on the device.

The company made other jackets: sack styles from the 1890s (looser fitting and designed to be worn over bib overalls); blanket-lined (a trend that came and went until it became fashionable again in the 1950s); jackets made of duck, a heavy canvas fabric. But the first to sketch out the archetypal style was the lot 506 'pleat front blouse' of 1905, with stitched pleats that could be unstitched to provide more room for warm layers, a chest pocket and a buckle-back that pulled the jacket into a fitted form. It was so popular that a budget version, the 213, had to be introduced.

With each generation Levi's evolved the style. The 506 may have become a favourite of rocker Eddie Cochran but it had also inspired imitations, like H.D. Lee's 401 jacket of 1925. Levi's 507 jacket, the so-called type 2, introduced in 1953, added an extra pocket but did away with the buckle-back in favour of side-adjusters, deemed at the time to present a cleaner, more modern look. This style also had its imitators, such as Wrangler's first jacket,

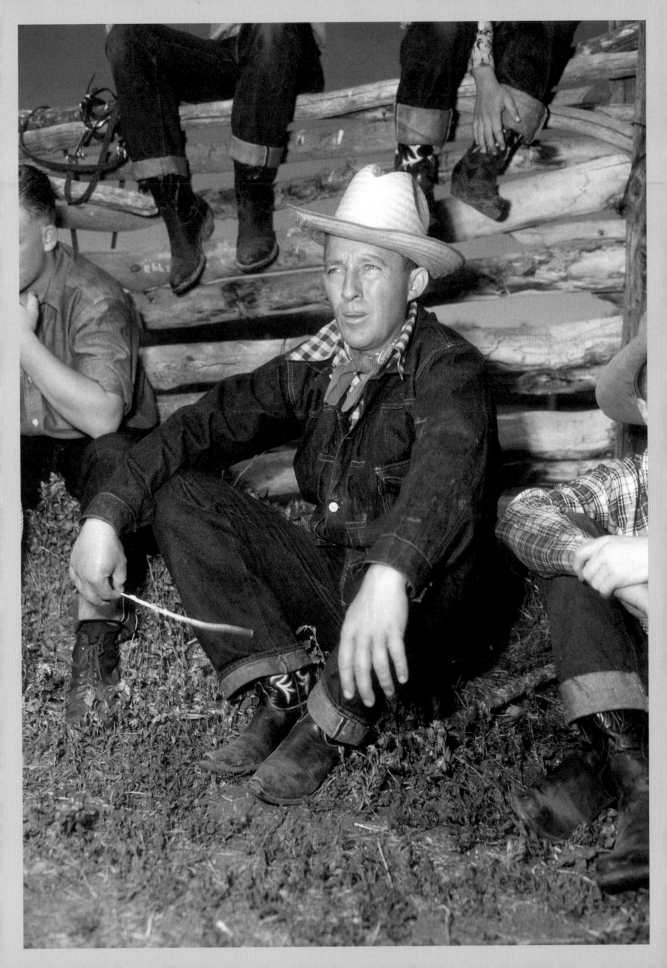

Below: The denim jacket has become almost signature for men such as the pop artist Peter Blake.
Opposite: The Lee Storm Rider jacket, with blanket lining and corduroy collar, first launched in the 1930s.

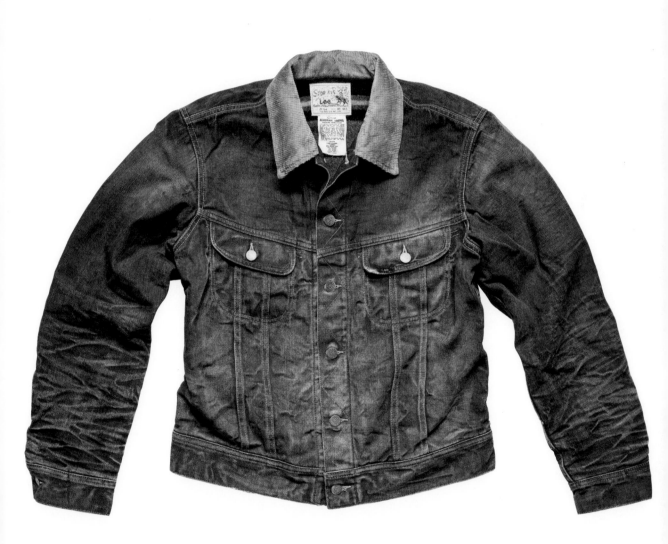

the 11MJ; early examples of this incorporated vents to allow additional freedom of movement.

In 1961 Levi's introduced its preshrunk 557XX. With its two flapped pockets placed higher on the chest and distinctive V-shape seams running from pockets to waistband, it was widely considered to be the classic 'trucker' style (a name conferred on it by fans rather than the company). It was, indeed, favoured by long-distance haulage drivers, even though Levi's targeted the jacket at ranch workers – much as it had its definitive sawtooth Western shirt of 1938. Perhaps the 557 came too late for this market. Even in the 1930s the line of Dude Ranch clothing, of which it was a part, had been aimed at city dwellers and hinted that the cowboy lifestyle was dying out and moving into the realm of myth. Instead the 557 was picked up by riders of metal steeds and came to symbolize the Easy Rider counterculture.

If Levi's defined the jacket used for industrial and general purposes, the Western market had other favourites. In 1933 H.D. Lee introduced its slimline 101J jacket – the companion to its 101 jeans and its first original piece of cowboy clothing. The same year saw the launch of the Storm Rider jacket, essentially a 101J with blanket lining and a corduroy-lined collar, which became the cowboy standard for the next three decades, in fiction as in real life: Kirk Douglas sported one in *Lonely Are the Brave* (1962), as did Paul Newman in *Hud* (1963) and, perhaps most influentially of all – even for men – Marilyn Monroe in *The Misfits* (1961). Indeed, by the 1980s the denim jacket had become a more unisex garment, worn oversized and, come the 1990s, fitted and cropped. It was always, invariably, a long way from any ranch.

Opposite: Not the sort of practical garment truckers or cowhands would likely choose, this oversized denim jacket nonetheless looks the part on Rita Ora in 2023.
Above: Like its leather equivalent, the denim jacket has long maintained rock 'n' roll credentials – it's worn here by Richard Ashcroft of the Verve in 2008.

The Leather Jacket

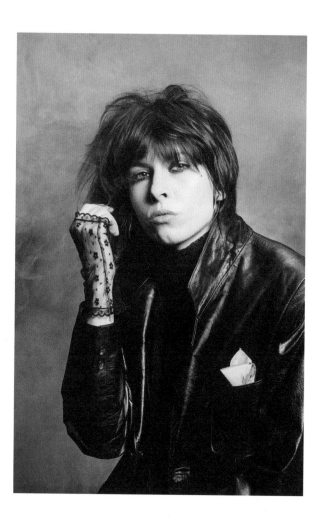

The leather jacket is the most masculine of garments. Notwithstanding the leather itself – typically tough, shiny and shell-like – the connotations are those of historically male enclaves, from biker gangs to the military, to gay subcultures. So perhaps it would require a subculture as combative as punk to bring the leather jacket into the woman's wardrobe. For punk, the garment's hints of the fetishistic – notably biker jackets with their zips, belts and stiff leather – only added to its rebellion against societal norms, be that commercialism, conservatism or gender-specific dress. The heavily customized black leather jacket was as much an anti-establishment symbol for Jordan, the famously haughty manager of punk pioneers Vivienne Westwood and Malcolm McLaren's London shop Sex, or for Siouxsie Sioux, as it was for the Sex Pistol's Sid Vicious. Another subculture – grunge – would underscore the biker jacket's unisexuality in the 1990s: the poster for *Singles* (1992), one of the period movies about grungy twenty-somethings, featured Bridget Fonda and Matt Dillon, both in biker jackets.

This was all despite the fact that the classic biker jacket, the Perfecto, was made famous by one of the most male characters in movie history: Marlon Brando's Johnny, nihilistic leader of a biker gang in *The Wild One* (1953). The Perfecto, designed and made by Irving Schott of Schott Bros, initially for a Long Island Harley Davidson dealership, was the first jacket to be fastened by a zip. With its epaulettes, studs, collar snaps and horsehide, not to mention its popularity among hardcore bikers, from rockers to greasers, it screamed macho, if not trouble.

A similar story might be told of the other key pieces of leather jacket design, the templates for so many copies, from the sheepskin-collared, dark brown Irvin jacket issued to bomber crews of the RAF during the Second World War to the russet A2 pilot's jacket created for the US Army Air Corp. The latter was designed in 1930 and remained standard issue to American military pilots until 1943, but then, flouting regulations, was retained by many

Above: The rock 'n' roll aesthetic of the black leather jacket worked for women every bit as much as it did for men, as here, on Chrissie Hynde in 1979.
Opposite: The Boss, Bruce Springsteen, perfecting his image as a blue-collar troubadour in denim and leather.

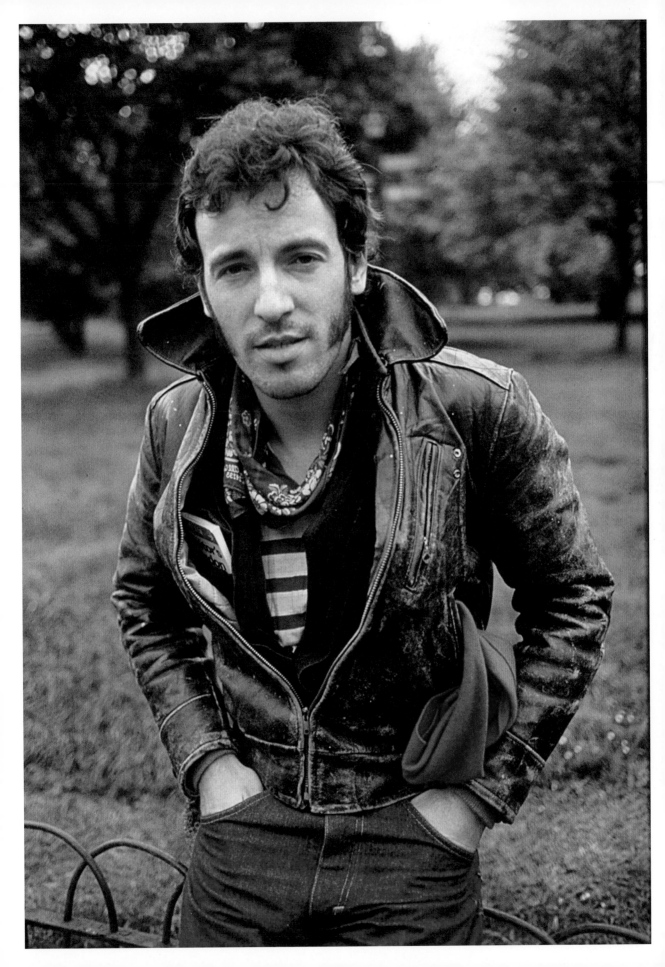

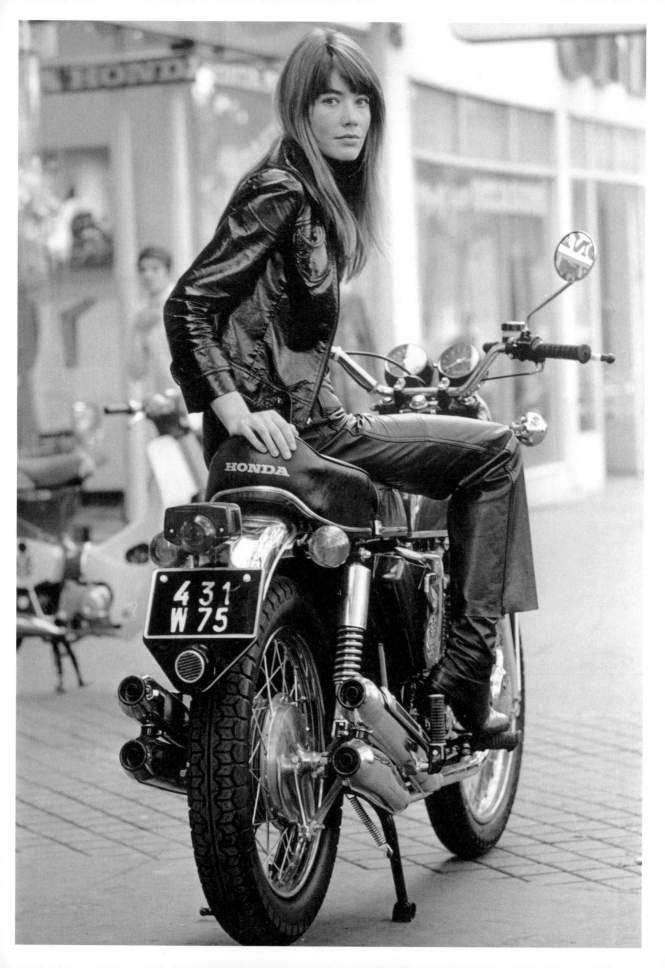

who had become so attached to the jackets that they were still being worn on active service during the Korean War, which ended a decade later in 1955.

If punk co-opted the biker style for wear by women, then it was the more military influence of designer fashion during the 1980s that kept it in vogue. Cropped versions appeared, as did those with shoulder pads, or a slimmed-down look. Leather was softer, more luxurious and sometimes much more colourful for women to wear. Yves Saint Laurent had been two decades ahead of his time by showing a black leather jacket as part of his 'Beat' collection in the 1960s. But it would take designers Giorgio Armani, Gianni Versace, Azzedine Alaïa, Thierry Mugler and Chanel to successfully tweak the leather jacket to give it more feminine appeal, without entirely losing the suggestion of outsider edginess.

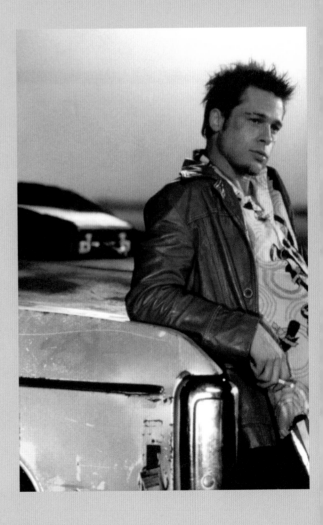

Opposite: Why stop at just the leather jacket? French singer Françoise Hardy adds matching black leather trousers and boots for a kind of 'biker chic' in 1969. **Below:** Brad Pitt wearing one of the most famous leather jackets in cinema, as Tyler Durden in *Fight Club* (1999).

The Cape

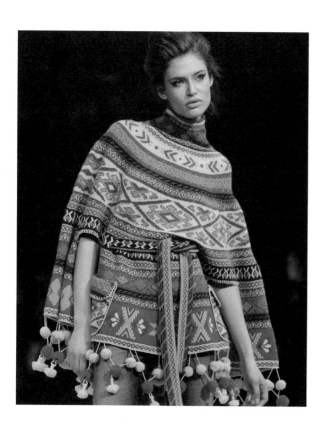

Above: A knitted poncho by Alexander McQueen, from his autumn/winter 2005 collection.
Opposite (above): Christian Dior explored the idea of the cape as part of a suit, as with this 1960s ensemble.
Opposite (below): The Man With No Name, but with, at least, arguably the most famous poncho – in *A Fistful of Dollars* (1964).

In its most basic form, requiring little more than a section of woollen fabric thrown over the shoulders, the cape or cloak and variations on it – the mantle or dolman, for example, or, in lighter form, a stole from the 1960s or a pashmina from the 1990s – have featured in the way we dress for millennia. The Romans wore them ('cloak' comes from the Latin *cloca*), although it was not until the Renaissance that they became a more fitted garment, tailored around the shoulders, akin to an opera cloak. The cape offered immediate practicality – a warm, encompassing cover – which was the main reason any woman would have worn a floor-length hooded cloak during the sixteenth and seventeenth centuries, and why the cloak featured as part of the uniform of servicewomen and nurses until well into the twentieth century. But it has also suggested mystery, the stuff of spies, superheroes, wizards and witches, and romance, of princes and princesses.

Variations in length, textile and trimming gave capes a certain kind a stylishness in their time; Victorian women might have worn a cloak because it covered their wide skirts or to disguise pregnancy, but come the big freeze that hit England in 1861, for example, a sealskin or velvet pile cloak became the look for women of means. But such was its firm place in the history of so many societies, it was not until 1911 that the cape underwent its first true consideration as a fashion item, just when it was going out of everyday wear thanks to the introduction of oriental-style cocoon coats that provided the same top-to-toe protection. This was when Parisian couturier Paul Poiret created a velvet, fur-collared and cuffed batik cape with a swirl pattern. He returned to the style in 1919, when he created the 'Tanger', an ethnic-inspired cape.

That, of course, looked to another cloak-like form of covering – the poncho. Traditionally a rectangular piece of heavy material with a hole through which the head passed, rather than going around the shoulders, it was sometimes defined as the 'South American cloak'.

Ponchos were originally handwoven in bold, broad-weave stripes by the continent's ancient civilizations, the Incas and Aztecs, and it was through the Spanish conquistadores that the style made its way to Europe, although fashionable Spaniards of the time preferred to wear theirs in plain fabrics. Come the mid-1960s, while Clint Eastwood in Sergio Leone's spaghetti westerns did much to revive interest in it, just as important was the hippy movement that embraced the poncho for its authenticity, as an expression of admiration for native peoples or as a souvenir of exotic travels. As Frank Zappa would ask in the song 'Camarillo Brillo': 'Is that a real poncho, I mean is that a Mexican poncho or is that a Sears poncho?'

Fashion designers inevitably picked up on the look for its graphic appeal and suggestion of bohemianism; through the 1960s and 1970s, Pucci, Bill Gibb and Missoni produced various versions, with fringing, crochet, leather trimming and beading, as part of a potpourri of references that encompassed Andean, Indian and Native American arts. Diehards wore only an original, a 'rancid poncho' perhaps, as Zappa sang in the same song. Fashion soon moved on, but revisited the poncho in the early twenty-first century, when Dolce & Gabbana, Mark Montano, Alexander McQueen and Hermès again tapped the boho aesthetic.

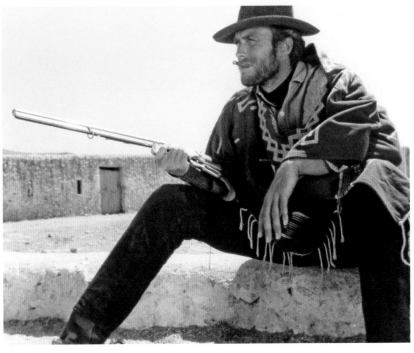

The Blouson

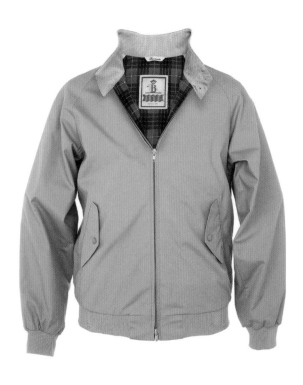

Not content with being a thorn in the side of the West during the late 2000s, president of Iran Mahmoud Ahmadinejad became an unlikely style leader. The reason was his signature fawn cotton blouson, known to foreign correspondents as the Ahmadine-jacket, which was sufficiently inspirational for Iranian entrepreneurs to order container-loads of copies from Chinese manufacturers for the president's more loyal followers to wear in the bazaars.

Ahmadinejad may not be too keen on the fact that the blouson – neat, simple, casual, comfortable, smarter than a denim jacket, not as loaded with stereotype as a leather one – has also been the choice of powerful men in the West. United States president John F. Kennedy was a fan, though only while sailing; Bill Clinton was snapped in a blouson so often it almost became his trademark garment; George W. Bush liked wearing one to make announcements on the decks of aircraft carriers.

Indeed, the blouson – also known as the windbreaker, golf jacket or Harrington – is almost official attire for US presidents. The United States Air Force supplies one embroidered with the presidential seal to each holder of the office, for wearing on Air Force One. In contrast, there is an everyman quality to the blouson, born of it being the public service utility garment of postal workers and firefighters, police officers, delivery men and parking wardens.

Clearly the blouson's functionality is a large part of its appeal: it is lightweight but showerproof, and easy for all ages to wear. But the jacket became a menswear staple in the second half of the twentieth century through pop culture. It was adopted as part of the 1950s teenage uniform that prefigured preppy style and, twenty years later, by the skinhead and mod movements in the United Kingdom. This was largely thanks to the pioneering London retailer John Simons and his store Ivy Shop, which saw queues to buy blousons; the Clash were fans of the jacket for their Times Square concerts in 1981.

Opposite: James Dean as the definitive troubled youth – and style icon – Jim Stark, in 1955's *Rebel Without A Cause*.

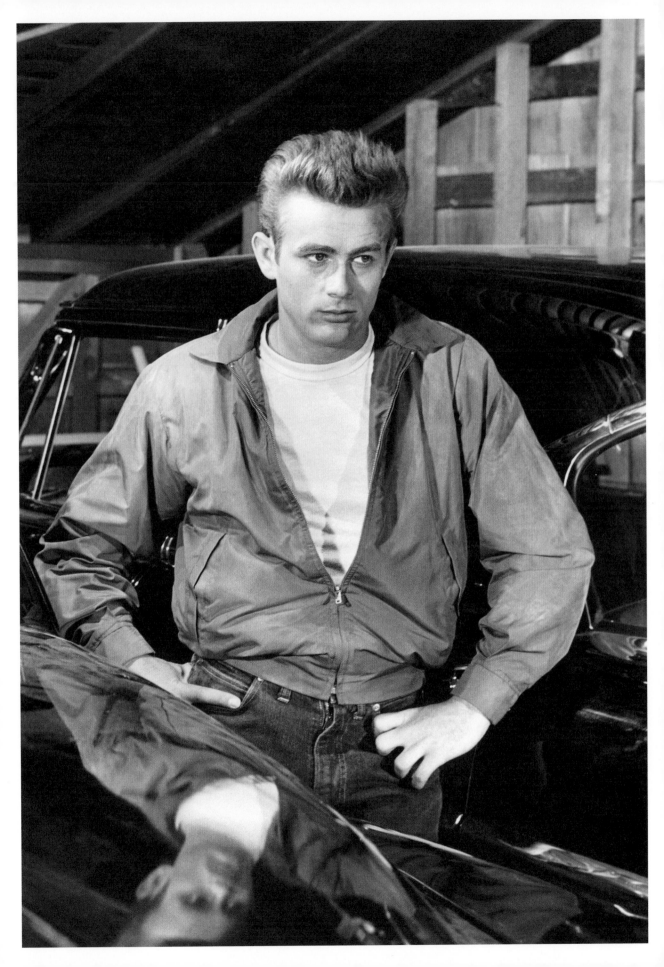

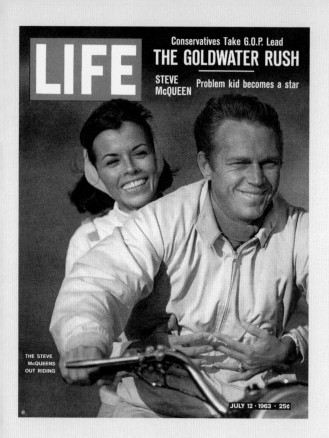

The style itself dates back to 1937 when John and Isaac Miller, garment factory owners in Manchester in northern England, first started making their G9 blouson under the Baracuta brand name. Like most of its many imitators, it was an unfussy cotton jacket with a stand-up collar, knitted cuffs, raglan sleeves and slanted flap pockets. The G9 came with a distinctive Fraser clan red, green and black tartan lining, the use of which was permitted by Simon Fraser, 15th Lord Lovat. The company also made rainwear (it supplied the macs for the 'demob' outfits for British troops in 1945 and for England's World Cup-winning squad in 1966). But by 1950, when Baracuta began to export to the United States, the G9 was stealing all the limelight. When Elvis Presley wore the style in *King Creole* in 1954, and James Dean wore a similar jacket in *Rebel Without a Cause* the following year, its status as a staple was assured.

Steve McQueen became an adherent, and wore a G9 when he was photographed riding one of his many motorcycles for the cover of *Life* magazine in 1963. And the following year Ryan O'Neal wore the G9 in the smash-hit television series *Peyton Place*. His character's name? Rodney Harrington – hence the jacket's informal moniker. In 1966, even Frank Sinatra wore one, in *Assault on a Queen*. However, it was not a style to be contained by the world of cool. The roomy, showerproof blouson was also practical on the golf course: when Arnold Palmer launched his first golfwear collection in 1970 he collaborated with Baracuta on the jackets.

Above: Steve McQueen in a Baracuta blouson, with his wife Neile Adams in 1963. **Opposite:** Ryan Gosling, in the white satin bomber jacket – with scorpion embroidered on the back – designed by Erin Benach for *Drive* (2011).

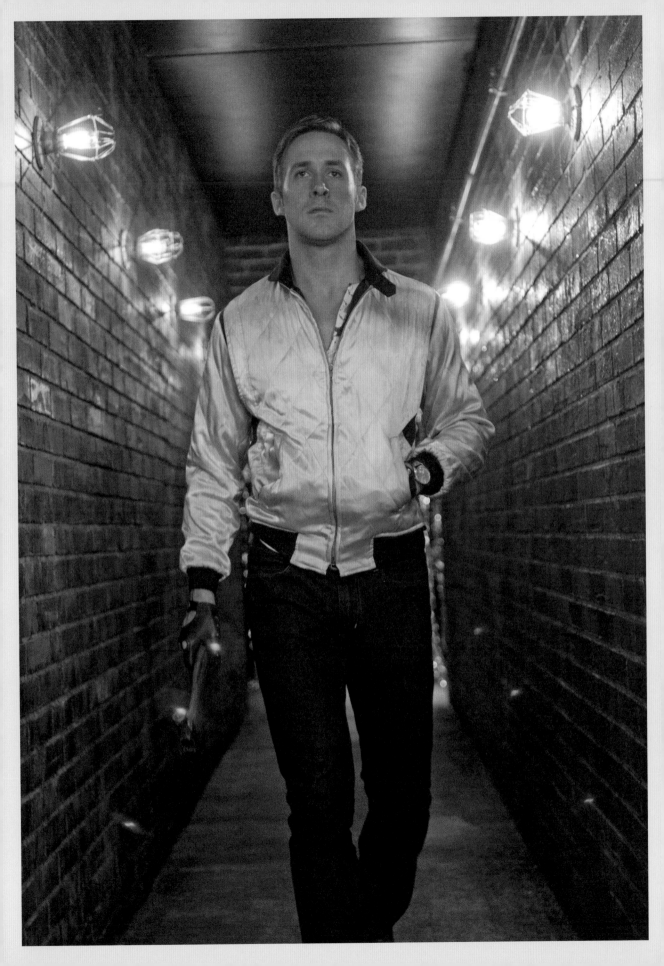

The Waxed Jacket

BARBOUR'S BEACON

SPECIAL LIGHT-WEIGHT COAT.

We sell the SYLKOIL Beacon Coat in large quantities, it is only 3½ lbs. weight and is made of fine texture cambric, silk finished, non-sticky, double all through, bound with leather, button holes stayed with leather, velvet collar, one inside and two outside pockets. A popular coat for many years with officers of the merchant service, and an ideal coat for

YACHTING

FISHING

DRIVING

BOATING

WALKING

SHOOTING

Post paid
21/-

Never in the way, it stows into a very small space when not in use. Wears well, looks well, and is absolutely weatherproof. Stocked in black only, (yellow in 14 days, 1/- extra).

Above: Barbour's heritage lies in making industrial clothing for fishermen and workers in other all-weather trades.
Opposite: Patched and re-patched, the waxed jacket of King Charles III – shown here in 2001 while Prince of Wales – has proven an old favourite.

The cover is dated 1908 and reads 'John Barbour & Sons – Oilskin Clothing, Factors & Warehousemen – Market Place, South Shields'. It was for the first catalogue produced by the purveyor of tough, all-weather clothing for use chiefly by seamen and dock workers some fourteen years after John Barbour, a Scotsman born in 1849, started his dry goods retail business. But it was not until 1980, some seventy years later, that Barbour, still a family company, came to be known internationally and its jackets attained iconic status.

This was the result of a photograph selected for the 1980 catalogue. It showed a good-looking young couple, in the English country uniform of green wellington boots, flat caps and Barbour jackets, walking their Jack Russell terrier across the fields. Although one of John Barbour's sons, Malcolm, had extended the company's sales targets in 1906 to include farmers, the image was still a long way from the brand's grimy, hard-working beginnings. Indeed, it epitomized a new breed of urbanite with pretensions to country living: the country of manor houses and Range Rovers rather than of dawn starts and mucking out. So definitive was the type, named the Sloane Ranger by cultural commentator Peter York, that it both divided opinion – the Sloane was a figure equally of aspiration and approbation – and, in part, defined the decade.

The image also seemed to be in defiance of what until then had been the utility and specialization of Barbour's garments and the signature waxed-cotton fabric from which they were made. Although it was no longer in the biking market, the company had provided some of the first motorcycle clothing in 1911 and launched the acclaimed International jacket, also for bikers, in 1936. It had created the Ursula foul-weather suit for British submariners in the Second World War, named after the U-class submarine of the same name. And it would later be known for its Cowan Commando style worn during the Falkland Islands conflict of 1982. Yet in its 1980 catalogue the jacket was being co-opted for a new country fashion.

Two styles captured the public imagination, and cemented Barbour's shift from being a maker of 'industrial' clothing to one of 'countrywear'. The Bedale, launched in 1980, was a short, lightweight, thornproof style designed by company chairman Dame Margaret Barbour as an equestrian jacket. It had many of what have become trademarks of a Barbour jacket: big, bellows pockets, corduroy collar and brass, ring-pull, two-way zip fastening. The Beaufort was developed two years later as a shooting jacket, based on styles Margaret Barbour had seen on visits to France (hence its Frenchified name), where shooting clothing was driven more by the needs of functionality than the sport's sartorial codes.

The Beaufort was originally available only in sage, which has effectively become a house colour for the Barbour brand. It added to the company's trademark two hand-warmer pockets, and a full-width, rear pocket for game, lined with nylon so the blood could easily be washed away. Not that its many city-dwelling fans saw much of this. They were more impressed by the fact that the jacket was worn by members of Britain's royal family when they were at Balmoral in Scotland. Queen Ellizabeth II gave her Royal Warrant to Barbour in 1982, and Charles, Prince of Wales, gave his in 1987.

Inevitably, cheaper copies of Barbours have flooded the market – a backhanded acknowledgment of their classic status – and the popularity of the jackets has moved through cycles that have distanced them from their Sloane beginnings. Today they are respected as much for function as for country fashion.

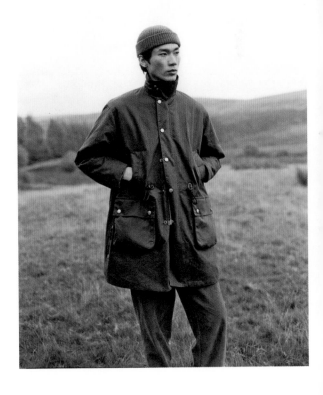

The Overcoat

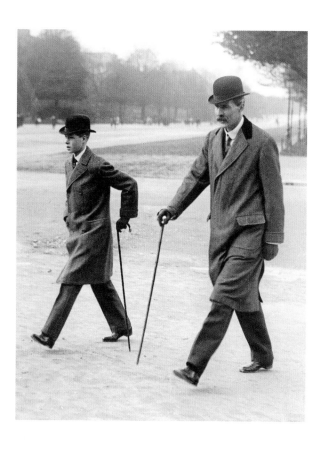

A coat created by a Scottish family business that dates back to 1772 may be an unlikely style totem for Teddy boys, mods and skinheads. But in its various guises the Crombie, as it was affectionately called, became as much part of their considered and particular uniforms as certain polo shirts or shoes.

The coat was part of the menswear canon long before the 1950s and 1960s. John Crombie was born into the family weaving business and in 1805 established a woollen mill in Aberdeen with the original idea of selling quality cloths not only to merchants but also direct to tailors. This meant there was something of an association with sartorial exactitude long before Crombie first made coats under its own name, in the 1880s. Early in the company's history one breakthrough model was nicknamed the 'Russian coat', largely because it was designed to protect the wearer from what was imagined to be the kind of cold experienced during the harshest Siberian winter.

Another coat, created specifically for the Russian royal family to wear in the country, was the Covert – from the French *couvert*, a shady place or thicket – which had a contrast velvet collar, ticket pocket, poacher's inside pocket and distinctive bands of reinforcing stitching at the cuff and hem, and was made in a smooth, thornproof, fawn or charcoal fabric. It became the template for the classic Crombie overcoat, although Crombie and another British company, Cordings, established in 1839, have disagreed about which of them pioneered the style; Cordings claims that its founder, John Cording, created it as a riding coat as far back as 1877.

The Cordings coat was later selected for the permanent fashion collection in London's Victoria & Albert Museum. But Crombie's business success in the late nineteenth century, notably through exports across Europe, and to the United States and Russia (where the overcoats became widely popular with the aristocracy), meant that its name was sometimes used incorrectly to describe a certain simple style: a coat made from thick, dense, dark

Above: On the left, a young Prince of Wales – the future Edward VII and hugely influential menswear experimenter – out for a stroll in 1912.
Opposite: An example of the classic Covert-style coat, with its characteristic ticket pocket.

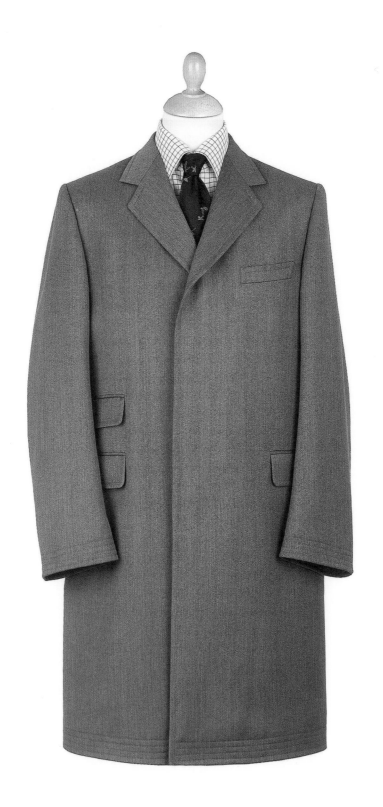

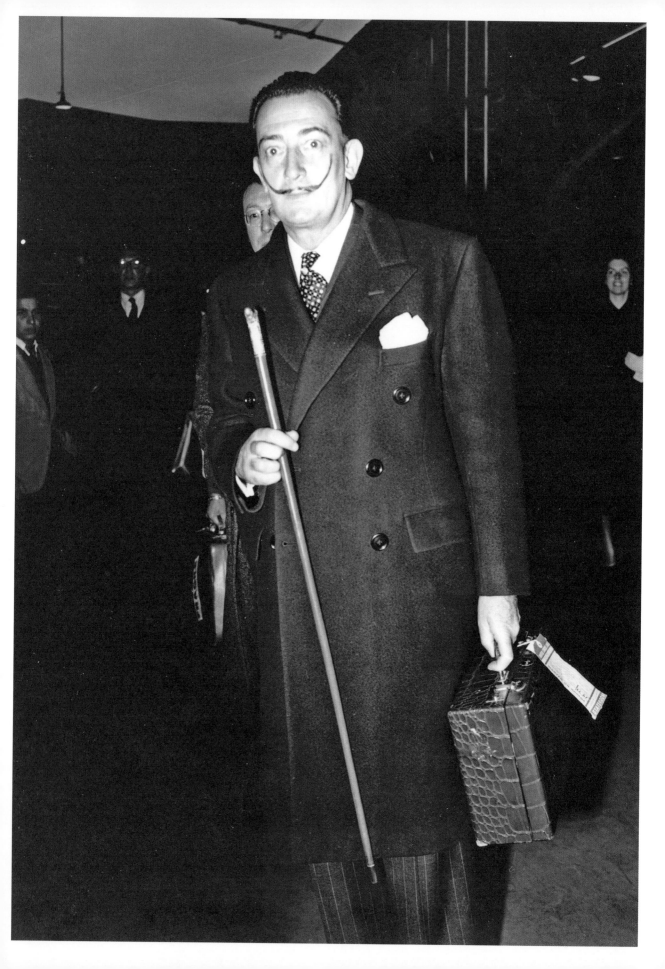

wool, single-breasted (sometimes with a fly front), with narrow lapels and straight cut to just above the knee. Its reputation has lasted: when the Russian premier Mikhail Gorbachev visited the West to pursue his policy of glasnost he wore a Crombie.

The Crombie's reputation for fending off the big freeze also won it military contracts – a sure stamp of approval. The first was with the Confederate army during the American Civil War (1861–65), when the colour of the cloth from which the coats were made became known as rebel grey. Coats were supplied to the French when Paris was besieged by the Prussian army in 1871; anecdotally at least, one customer ordered a Crombie via a hot-air balloon. The so-called British Warm – double-breasted, with peak lapels and epaulettes, and sometimes belted – was worn by British officers during the First World War.

By the 1930s, however, heated interiors and travel by car meant very heavy fabrics were no longer needed, and lighter-weight versions of the Crombie were developed. The coat became an undisputed part of the male wardrobe, to some extent because it was favoured by Edward, Prince of Wales, as well as Winston Churchill, Frank Sinatra and United States presidents Dwight D. Eisenhower and John F. Kennedy. Certainly, the fact that it was considered the stuff of officers, gentry and power brokers only reinforced the perception that a Crombie was a coat for the upper classes. This was a perception that style movements from the 1950s onwards subverted by making the coat their own – the Crombie has been the coat of statesman and gangster alike.

Opposite: A conventional double-breasted, peak-lapelled overcoat, despite its wearer, the surrealist artist – and unconventionally moustachioed – Salvador Dalí. **Below:** The BBC series *Peaky Blinders* (2013–22) did much to popularise a revival of Edwardian men's fashion – the haircuts, the caps and the coats.

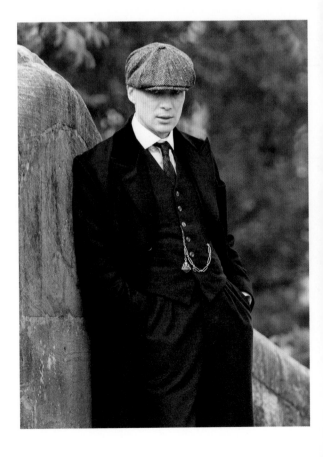

The Duffle Coat

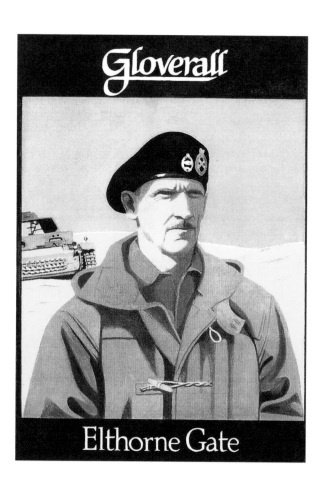

Gloverall

Elthorne Gate

Above: It was Field Marshal Montgomery who popularized a coat that was originally designed for seafarers, and was considered rather shabby and shapeless by the officer classes.
Opposite: The unlikely vision of an alien in a duffle coat – David Bowie in *The Man Who Fell to Earth* (1976).

It is ironic that the commander of Britain's Eighth Army during the Second World War, who led his Desert Rat troops to victory over Rommel in the sweltering heat of El Alamein in North Africa, should be so closely associated with a heavy, hooded coat designed to tackle the cold of the North Atlantic. Field Marshal Bernard Montgomery's image was defined in part by his distinctive and sometimes shabby wartime dress – his grey, knitted sweater and, most famously, his beret – but was perhaps best captured by his preference for a duffle coat.

For a military design the duffle coat has a somewhat cosy reputation, as the choice of Peruvian bear (and children's storybook character) Paddington, and the uniform of the British nuclear disarmament movement of the late 1950s. But the basis of the style predates the Second World War considerably: 'duffle' comes from the Belgian town of Duffel (now part of Antwerp), where a heavy woollen cloth with a high lanolin content that makes it naturally water-repellent has been woven since the Middle Ages. It was used to make coats for Royal Navy personnel during the First World War, but not in the duffle style.

The duffle coat's characteristic fastenings – large wooden toggles slotted through rope loops – could easily be manipulated with cold hands and were thought to have originated with Belgian peasants who used whatever basic materials were available to them. The coat retained its humble nature. During the Second World War, when what might now be recognized as the duffle coat was manufactured to Britain's Ministry of War specifications as a Royal Navy general issue item, coats were rarely assigned to any one serviceman. Rather, one was picked up and worn by whoever needed it, officer and rating alike. The style's loose fit made it workable for just about every size and shape. Few classic movies of naval warfare – *The Cruel Sea* (1953) for instance – are free of the duffle coat. David Bowie later wore one in *The Man Who Fell to Earth* (1976).

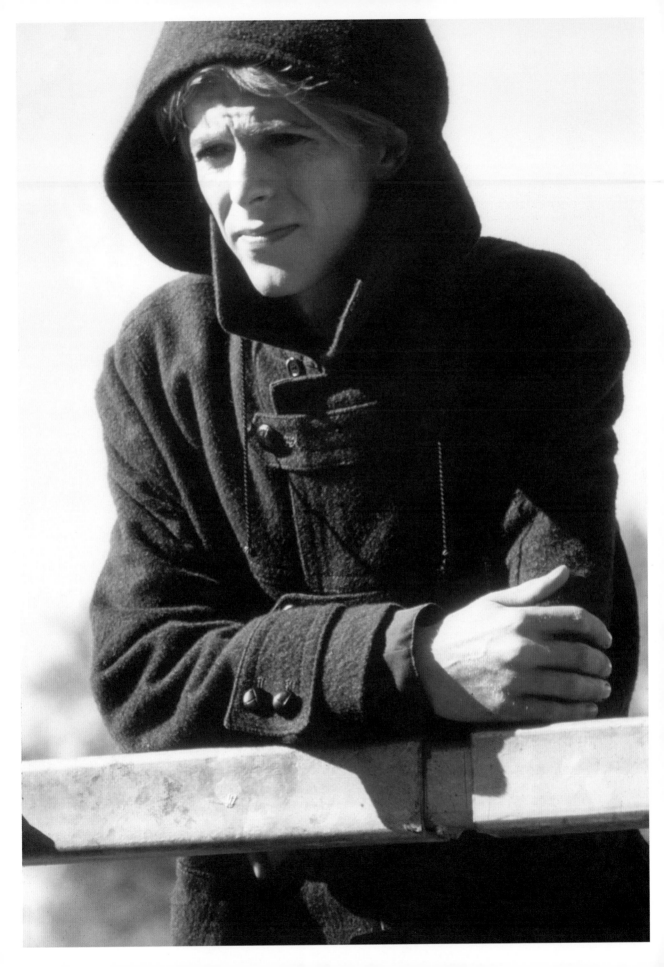

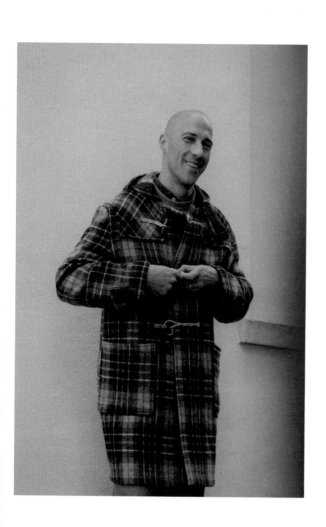

The duffle's transition to civilian wear came about only because so many coats were surplus to requirement after the war. The Ministry of Defence contacted M. & F. Morris Industrial Clothing, a specialist supplier of overalls and chainmail gloves, for assistance in getting them to market. To make the coats more appealing to a public tired of war and anything associated with it, in 1951 the company's head, Harold Morris, conceived a brand name: Gloverall.

Demand for Gloverall coats – affordable, durable and very warm – was such that when the surplus supplied ran out the company began to manufacture them, albeit in a more streamlined, fashion-friendly version styled by Morris's father, a master tailor. The bucket hood was scaled down, flap pockets were added, a new double-faced woollen cloth in navy and tan was used (rather than the Royal Navy's undyed dun colour), the wooden toggles were replaced with horn ones and the rope loops with leather. The benchmark style was called the 512 and by 1955 it was being exported. The French film-maker Jean Cocteau, playing on the coat's everyman, democratic leanings, was photographed wearing one, not just among café society but also on grand occasions. Actor James Stewart was a fan. John F. Kennedy wore a 512 for sailing during winter.

For all its new glamour – albeit of a homely kind – the duffle coat never lost sight of its hardy roots. In 1979 the members of the British Transglobe Expedition wore them, as did members of the British Winter Olympic Team in 1980 as part of their official uniform. Belgian though its origins may be, the duffle coat has now come to be regarded as quintessentially British.

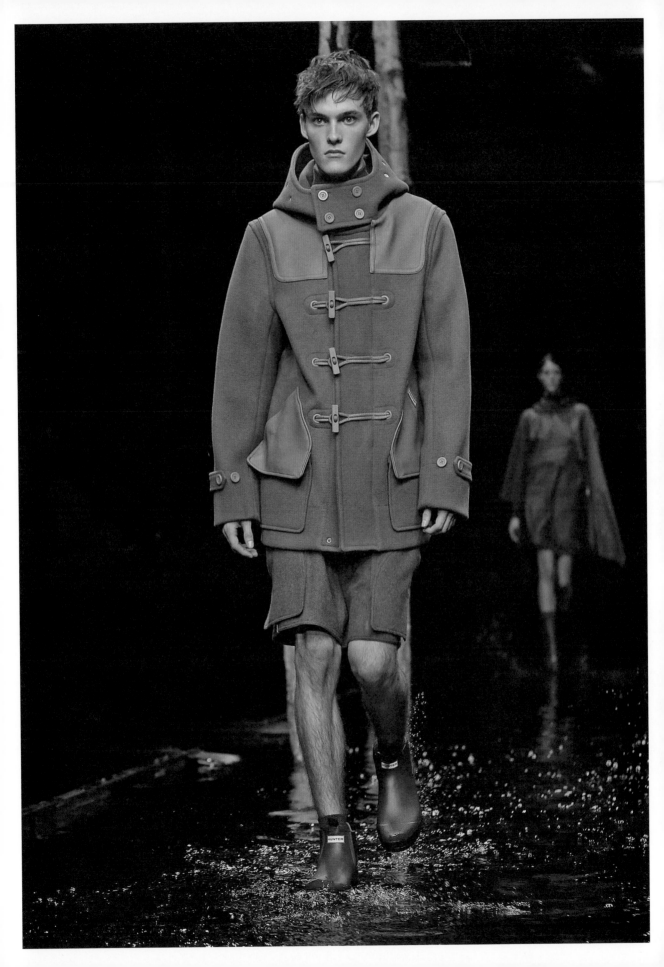

The Chore Jacket

........................
........................

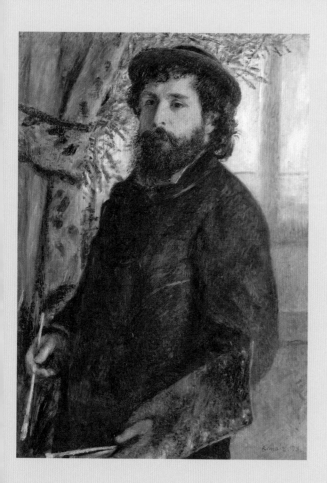

Above: An 1875 portrait of Claude Monet, who favoured a blue de travail to paint in, by Pierre-August Renoir.
Opposite: Paul Newman, as the eponymous *Cool Hand Luke* (1967). In the US chore jackets and trousers were worn by chain gangs to work the land.

Before specialist garments were designed for various forms of manual work, with the right pockets in the right places, 'hi-vis' layers and protective fabric – be that for road repair or factory assembly lines – physical labour might have been conducted in a more generic but also more stylish garment.

The chore jacket – just one of the many forms of workwear that have had an influence on fashion – originated in the late nineteenth century as a simple, tailored but loose-fitting, typically unlined, single-breasted button-fastening item with shirt collar and several large patch pockets for both tools and personal effects. It was made in hardy fabrics – rough twill, sail cloth drill, moleskin, canvas duck, corduroy – that could withstand the battering of work and which, since they lent themselves to ageing beautifully, would later appeal to more fashion-minded collectors.

In an era in which the distinction between wearing work and leisurewear had yet to be established, chore jackets became an important means for street sweepers and railway workers, builders and farmers, to protect their own clothes beneath; prisoners too, for that matter, as Paul Newman demonstrated in 1967's *Cool Hand Luke*.

Different nations have had their own styles of chore jacket with differing degrees of functional design detail. From the United States, what was sometimes called a 'sack coat', by Levi's, Carhartt, Red Kap, Dickies or OshKosh B'gosh, might come in denim or, later, brown duck, with corduroy collar and cuffs, shoulders double-lined in a rubberized cloth, a double-pleated back and a drop seat to sit on, and with pockets described as 'blood-proof', ideal for outdoor pursuits like hunting.

Some chore jackets had more intentional use in mind: an engineer's jacket – as worn by the drivers and stokers of steam trains from the 1920s – might be cropped and collarless to suit the cabin environment; the watch pocket – for one's pocket-watch – was abandoned as wristwatches came in. The UK's tan or navy drill cotton shopcoat-

style jackets, commonplace in grocers' shops and on factory floors up until the 1960s, might come with removable buttons for easier laundering.

But arguably the king of chore jackets hails from France. A regular sight in France from the 1880s, right through to the 1970s, 'bleu de travail' – roughly translating as 'work blues' – included trousers and overalls but is now best known for its boxy chore jackets, characterised by a distinctive deep purple shade of blue (with rarer styles made in black, and ones in green, designed for gardeners, also produced). This vibrant blue colour ably hid the dirt of the day and, in line with manual workers also wearing blue in the form of chambray or denim fabrics too, helped give rise to the term 'blue collar worker'.

Cut very squarely, this allowed the arms to be fully raised if necessary without undoing the buttons – useful perhaps too for artists such as Claude Monet, who is said to have favoured the jacket to paint in. And since the French fashion industry was so dominant over much of this period, the quality surpassed anything similar made, for example, in post-war East Germany.

A number of these jackets' historic French manufacturers – such as Adolphe Lafont, Le Mont St Michel, Vetra, Le Laboureur, founded between the late nineteenth century and the mid twentieth century – remain in business at the time of writing, or have been acquired and revived following an upsurge in interest in chore jackets, and workwear more generally, as unisex clothing over the early twenty-first century.

This has perhaps been the case of some puzzlement in France itself, where 'bleu de travail' is resolutely shunned for its association with lower class occupations. That never put off the pioneering, bicycling New York street-style photographer Bill Cunningham, who wore a blue de travail daily as the most practical choice.

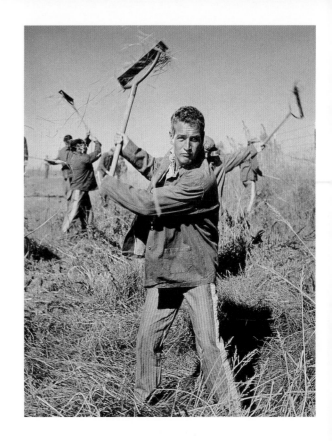

The Flight Jacket

· ·
· ·

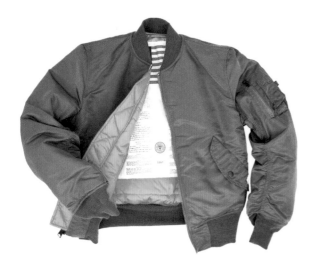

The jackets created specifically for the United States military in the years after the Second World War were paragons of functionality and so, perhaps inevitably, have also found a life in civilian service. Foremost among these is the MA-1, a jacket that, for its comfort, ease of use and distinctive style, from the 1970s came to be beloved not only by skinheads but also by nightclub bouncers and other security staff, before it also took on the role of a promotional gift, complete with embroidery celebrating a corporate event or band tour on its back.

A nylon flight jacket, the MA-1 was issued to all United States Air Force and United States Navy pilots in around 1950, as a replacement for the B-15. Introduced in the late 1940s this was similar in style to the MA-1 except for its mouton fur collar. Indeed, each jacket evolved from its predecessor in response to the changing needs of servicemen or the introduction of new equipment: the B-15's collar interfered with new helmets issued for use in jet aircraft. The light, windproof nylon B-15 was similarly a development of the B-10, a thick, cotton version introduced in 1943, and itself a replacement for the classic leather flying jackets favoured by United States pilots.

Certain characteristics of the original MA-1 are visible in the B-15 it replaced: sleeve pocket; chest tabs, used to secure radio wires between cockpit and helmet; and chest webbing – a clip for the oxygen mask while taxiing. But by 1960 the B version of the MA-1 had seen the removal of both tabs and webbing – radio and oxygen supply were by then integrated into the helmet. Further revisions were introduced in 1963: for flight crews, the sage-green lining was replaced with one in bright orange – known as Indian or rescue orange – and the jacket was reversible. Downed pilots wore their jackets bright side out to be more visible to search and rescue parties. This is arguably the most iconic of all versions of the MA-1.

Over the years of its development, other sibling jackets for the US Air Force (and, before 1948, its predecessor, the US Army Air Force) were widely

appreciated by civilians. The L-2B, an MA-1 lookalike in summer-weight nylon, introduced soon after the end of the war, was the first jacket to have an orange lining and, until the mid-1960s, also had epaulettes. The N-2B flight jacket, issued in the late 1950s, was a sage-coloured version of the navy-blue N-2A and effectively a cold-weather MA-1, complete with fur-lined hood.

King of the nylon jacket manufacturers was clothing entrepreneur Samuel Gelber's Alpha Industries, which is still in business thanks to its foresight in developing a civilian market – for example, by issuing the MA-1 in colours other than the standard air force sage green or army olive green. Jackets made for the civilian market are also identified by three lines on the labelling. This was before many of Alpha's fellow manufacturers were forced to close down by a combination of international competition and a decline in government contracts, which diminished sharply after the boom times of the Korean and Vietnam wars.

By then, however, the MA-1 was well on its way to becoming a classic. Certainly style sub-cultures would be early adopters among the non-military: in the UK of the 1970s, Skinhead made the MA-1 a crucial part of its uniform – along with Ben Sherman button-down shirts, Levi's 501s, and highly polished Dr. Martens cherry red boots. And then in 1988 came stylist Ray Petri's Buffalo style movement, with its magpie approach to mixing and matching high and low cultural references, and for which the MA-1 – as worn by singer Neneh 'Buffalo Stance' Cherry – became a key piece.

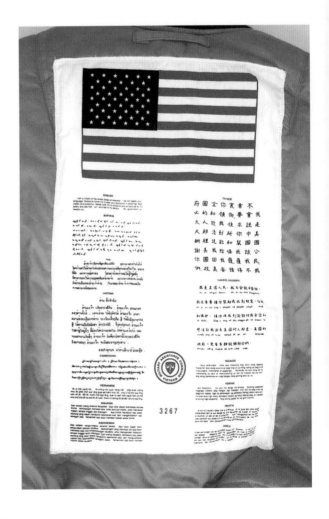

The Mac

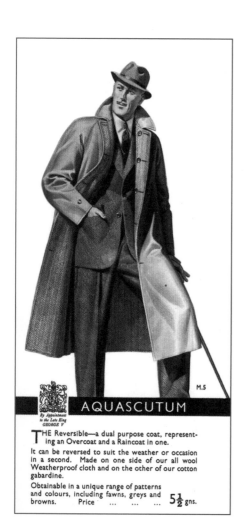

Above: Original ad for the Reversible waterproof mac by Aquascutum.
Opposite: The film director Claude Sautet out with actor Romy Schneider in the early 1970s – both in variations of the mac and ready for the rain.

That the generic term for the raincoat is mac – an Americanism spread through post-Second World War Hollywood, and arguably now superseded in general parlance by the computers from Apple – is a testament to the originality of the idea pursued by one Charles Macintosh.

A chemist born in Glasgow in 1766, the son of a textile dye manufacturer, and a man with a fondness for experimentation, Macintosh inherited the family business on his father's death in 1823. Soon afterwards he discovered that coal-tar naphtha could dissolve India rubber, then an expensive novelty material with limited industrial use that included tubing for medical devices. The world's first waterproof fabric was created when he realized this rubber solution could be shaped into sheets that could be laminated on to cloth. The early fabric was not ideal. Macintosh first used wool to create a material that was both warm and waterproof, but the resulting coat proved almost unbearably heavy to wear, and natural oils in the wool rapidly degraded the rubber. Other combinations tended to turn brittle over time, or the rubber coating melted in hot weather. The first truly successful mac was some years away.

The breakthrough came in 1843, thirteen years after Macintosh had amalgamated his business with a Manchester one run by Thomas Hancock, when Hancock patented a rubber treatment process he named vulcanization, after Vulcan, the Roman god of fire. This created a lighter, more hard-wearing and chemical-resistant substance that could be combined with fabric to make a lighter, more flexible and more comfortable garment without sacrificing the coat's all-important waterproof qualities. It also made the resulting material easier to dye and work with, which led to the close-fitting, narrow-shouldered styles for which it was first used, and the later looser, raglan-sleeve style for which the mac is better known. A further construction process – smearing the seams with the rubber solution and taping them – meant water could not penetrate the outer shell of the coat.

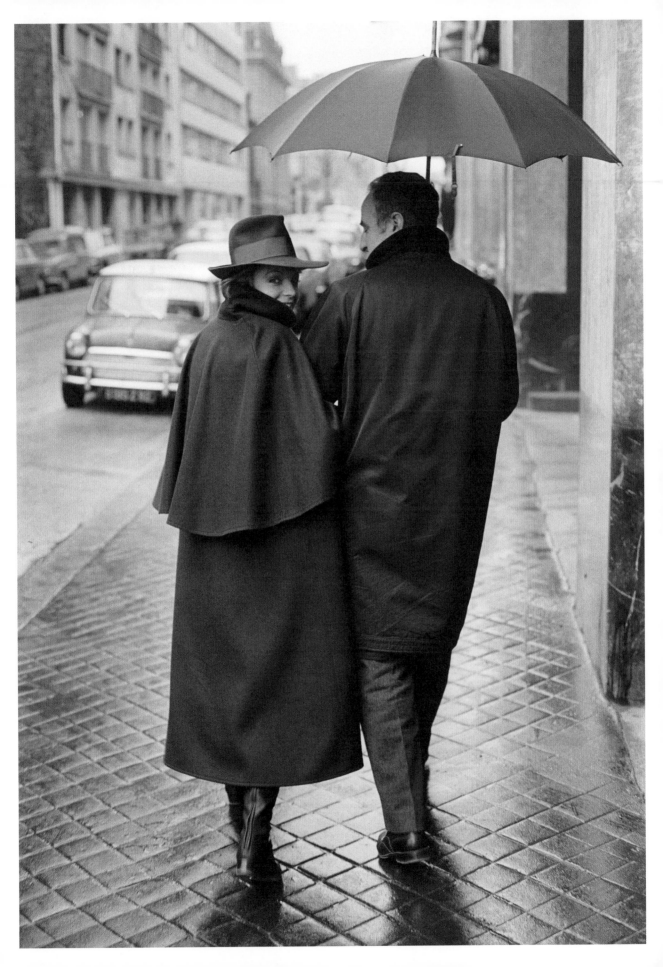

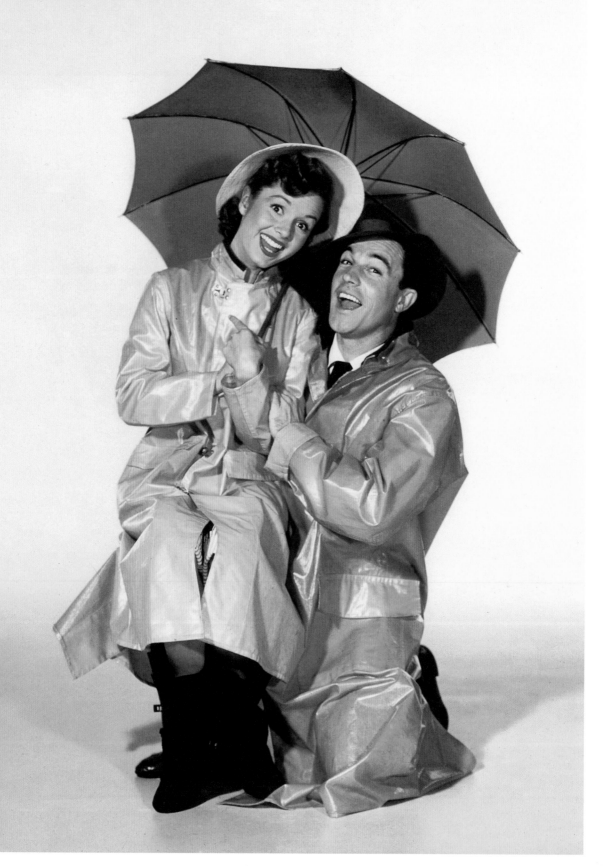

Older macs tended to develop a characteristic smell that, in time, was masked by adding perfumes to the rubber. It would take science another 150 years or so to develop fabrics that overcame the mac's last remaining problem: without ventilation (and even with strategically placed breathing holes) it could become stiflingly hot to wear; some doctors spoke of wearers blighted by 'rubber sickness'.

Nevertheless, the mac soon became an established part of the male wardrobe – although dress codes of the late nineteenth and early twentieth centuries meant it was rarely seen in the city. Together with tweed jackets, it was worn only in a rural setting, a dress etiquette that reflected the fact that it was regarded as being purely functional rather than fashionable.

Macintosh and Hancock found themselves with a ready market among more prosperous workers. And the mac's utility was soon recognized by those who travelled by horse, be they coachmen or more well-to-do horse riders. In fact, the Charles Macintosh India Rubber Company, as it was known, suffered its first and only major downturn in business with the advent of the railways and public transport systems that everyone could afford.

Perhaps this made the mac a romantic as much as a practical item – a totem of the British climate and the sartorial struggle of living stylishly with it. 'There is a wild garment that still carries nobly the name of a wild Highland clan,' G.K. Chesterton, writer and creator of the *Father Brown* detective series, wrote. 'I like to think of all the Macintoshes, in their macintoshes, descending on some doomed Lowland village, their wet waterproofs flashing in the sun or moon ...'

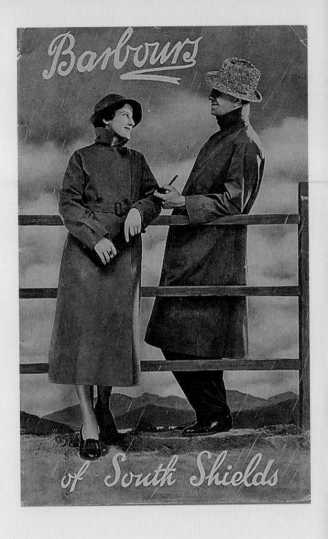

Opposite: Gene Kelly and Debbie Reynolds in matching macs for *Singin' in the Rain* (1952).
Above: Though known for its waxed jackets, Barbour, originating from South Shields in north-eastern England, also made macs.

The Biker Jacket

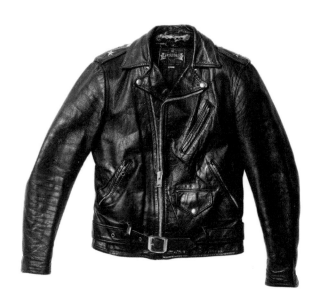

Few movie characters have created an icon from their clothing with quite the lasting impact of Johnny in *The Wild One* (1953). Played by Marlon Brando, he is the disaffected youth who, when asked what he is rebelling against, bluntly replies: 'What have you got?' He is also the leader of a biker gang, at a time when such gangs epitomized the outsider threat to society to the extent that many high schools banned their jacket style. This is the point of the joke in *Back to the Future Part II* (1989), in which Marty time-travels to 1955 and, asked to dress to be less conspicuous, buys, like Johnny, a Perfecto jacket.

The Perfecto more than any other garment suggested a kind of anarchy, a reputation rock stars have capitalized on ever since. James Dean, the archetypal role model for living fast and dying young, was rarely without his. But then Johnny Ramone, leader of the Ramones, enforced wearing one as part of the New York band's image. Likewise Joan Jett, the godmother of women rockers (even if she preferred the Twin Track Bronx from British maker Lewis Leathers).

Irving Schott, the son of Russian immigrants, founded Schott Bros in 1913 to make coats, and was a pioneer from the outset – he is believed to be the first garment-maker to put a zip (manufactured by Talon) in a casual jacket. But his major contribution to menswear was made in 1928, when a Long Island Harley-Davidson distributor called Beck Industries contacted him and asked him to create a tough, zip-up leather jacket to protect motorcyclists against the weather and unfortunate falls. Beck got what they asked for. It retailed for $5.50 and was called the Perfecto, after Irving's chosen brand of signature cigar.

The original style was distinctive. Made of horse hide, it had a belted front, zip-up sleeve cuffs, hidden collar snaps, several pockets (a D-pocket with a vertical rather than horizontal opening, a change pocket, and a side pocket strategically positioned to make access easier during riding) and epaulettes with studs. But it was two later styles, of the 1940s and 1950s – both slimmer with two side pockets,

Above: The 613 or One Star version of the Perfecto, dropped in 1963 when retailers complained that the stars were always being stolen.
Opposite: The biker jacket – along with sunglasses and his signature wigs – was a long-standing favourite of the pop artist Andy Warhol, seen here in 1968.

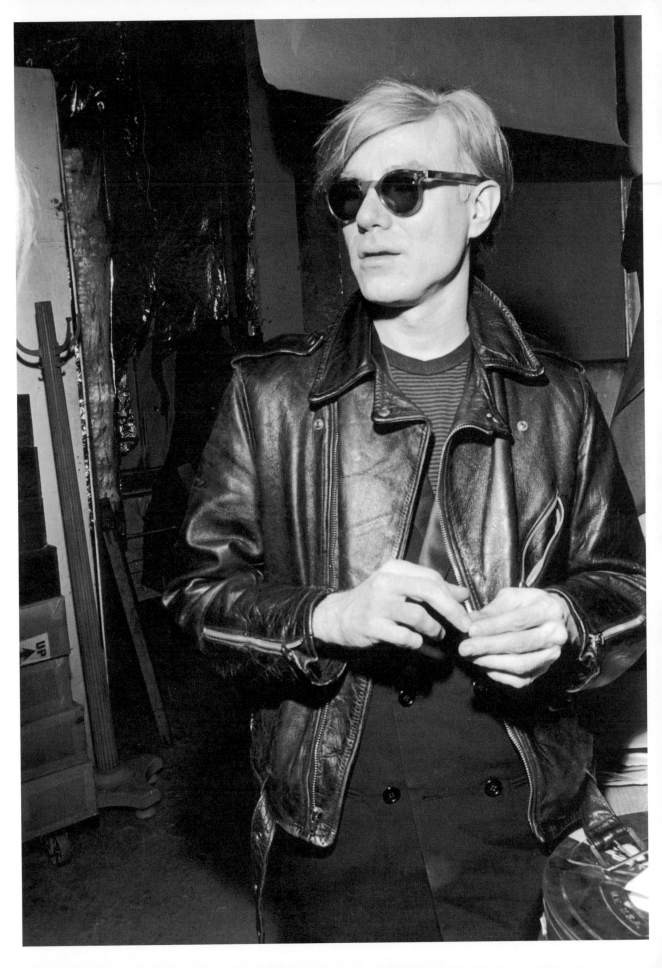

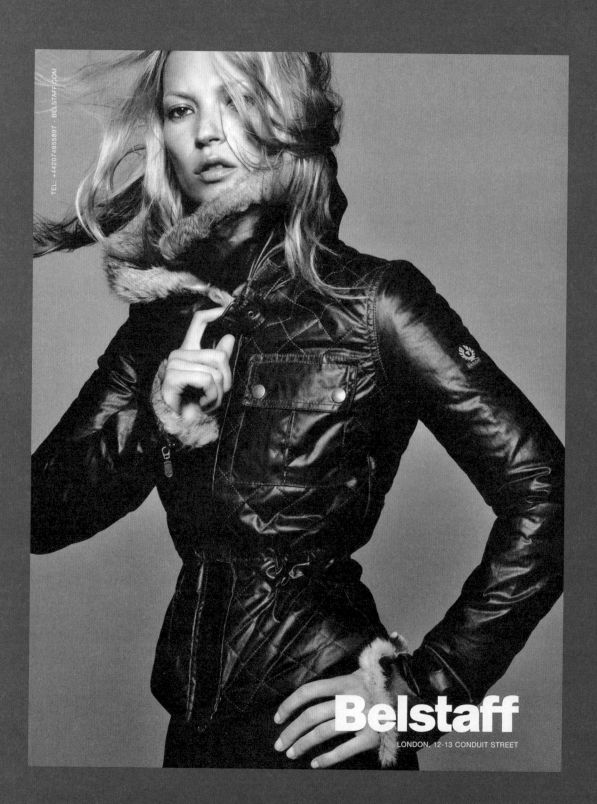

Belstaff

LONDON, 12-13 CONDUIT STREET

no D-pocket, an angled breast pocket and a stud to allow a fur collar to be attached – that would capture the public imagination. And slightly scare it.

They were the 618 and, as worn by Brando's Johnny, the 613 or One Star, named after the star emblem on each epaulette which distinguished it from other biker jackets including ones from Trojan, Buco and, by now, those of Harley-Davidson itself. The stars were dropped in the late 1960s when retailers complained that customers kept stealing them. There have been a few further cosmetic changes. The mitre belt (so called because of its mitred corners) has gone, the lower back panel has changed shape, the zips are two-way and the jackets are only occasionally made from horse hide. Otherwise, the Perfecto is much the same as it was over half a century ago. And just as tough.

The Field Jacket

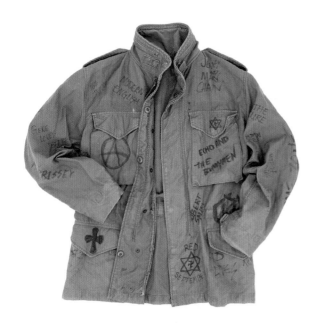

It is difficult to know whether protesters against the Vietnam War dressed in the M-1965 (M-65) field jacket out of a sense of irony because to do so was to reappropriate a symbol of militarism as one of peace, or because army surplus stores made the jacket affordable, or, indeed, because many of the protestors were ex-servicemen.

What perhaps united all wearers of the M-65, both in and outside the army, was its highly practical style, which makes it arguably the most widely copied military garment and certainly the one that has been most worn in civilian/commercial life. Like the motorcycle jacket, the M-65 has a certain outsider status. Small wonder it has been repeatedly chosen by costume designers – most famously for Robert De Niro in *Taxi Driver* (1976) – or, for that matter, by Osama bin Laden.

The M-65 was a jacket stripped down to its most functional elements: long enough to offer protection, short enough to allow for movement; a nylon/cotton sateen fabric that was wind resistant and almost indestructible; four large flap pockets; a hood hidden in the collar; a nylon quilted liner; tighteners at waist and cuffs to keep in body heat; and, ominously, a triangular attachment inside each of the cuffs to which could be attached gloves designed to further protect the jacket's wearer on a nuclear battlefield.

Reaching this apotheosis of design – subtle variations of which are worn by many armed forces today – took more than two decades. Its first incarnation came in 1943, when the M-1943 (M-43) field jacket was introduced to replace the 1941 standard issue one, then designated not the M-1941 but the Parson's Jacket, after its designer Major General J.K. Parsons. This was a neat, waist-length, almost sporty, zip-up cotton jacket with a button-up fly, flannel lining and a couple of slash pockets (later given buttons). Based on a civilian jacket, it had style but lacked many of the practical benefits of the M-43; notably, it was either too warm or too light, depending on conditions, it lacked

pocket space and the light, dun colour was deemed to make its wearers rather too conspicuous for comfort.

In 1942 the Office of the Quartermaster General (the United States Army department that was concerned with the design and supply of equipment) began tackling this issue by developing its first products according to the uniform ensemble layering principle (which was applied most successfully with the parka): various garments could be combined to provide suitable attire for differing combat conditions.

The final design of the M-43 saw the jacket as an olive drab, cotton-lined sateen shell with four characteristic pockets, a button-up fly front and button-on hood, worn with a pile faux-fur liner in winter or over a cropped M-1944 Ike jacket in more temperate locations. The M-43 was tested in severe conditions: it was worn in January 1944 by the US Army 3rd Division in action around Anzio, Italy, where one of the bloodiest battles of the Second World War took place. It passed the tests, although delays and priority manufacturing of other uniform parts meant it did not see widespread distribution until the end of the year. In 1948, when the United States Air Force was established, it created its own version of the M-43, without epaulettes and with a large, crescent-shaped collar.

Further tweaks to the design after the war moved it closer to the M-65: the M-1950 brought a button-in liner; the M-1951, which did not actually come into service until late 1953, introduced snaps for the pockets and a zip to replace the button closure, so that wearers could crawl on their fronts without their jackets snagging on obstructions. Finally, after more than ten years of service, the field jacket was again updated as the M-65. The chief advance was the use of a tougher mixed fabric and, for some forces, camouflage prints. These may have given the garment a more military bearing; without them it remains a classic example of fuss-free functionality.

Opposite: Field jackets were worn not only by veterans after the Vietnam War – through which the style entered the clothing mainstream – but also, as a result of army surplus, by protesters against the conflict. Scrawled with graffiti, the jackets became sites of personal expression. **Below:** Robert DeNiro as Travis Bickle in *Taxi Driver* in 1976. The Vietnam War had ended the previous year and many well-stocked army surplus stores were still in operation across the United States. Bickle also takes his haircut from the military.

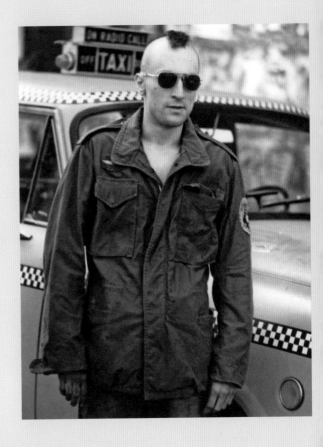

The Pea Coat

With its thick, 900 gram (32 ounce) Kersey wool, double-breasted fastening, extra-tall collar with throat latch, broad lapels and warming, tan corduroy-lined pockets, few coats are as cosseting as the pea coat. Smart though it may be, it is also an ideal garment for fending off the bitter cold at sea – which is why it has been a standard part of the United States Navy uniform since about 1881.

The definitive Naval Clothing Factory pea coat was not introduced until the late 1940s, when it lost the longer line and flap pockets of models issued before the First World War, and gained wider, flatter lapels and one of its most distinctive characteristics today: six large, black, shiny, Bakelite buttons with a fouled anchor stamp (an anchor wrapped in rope), rather than the crest of thirteen stars featured on earlier versions. Although the stars represented the thirteen states of America that signed the country's Declaration of Independence in 1776, the pea coat originated in the British Royal Navy. It is derived from the double-breasted, heavy wool reefer jacket worn by midshipmen (also known as reefers), whose duties included climbing the rigging and unfurling the sails – a process known as reefing.

The reefer jacket's essential style may have come to be regarded as typically naval over time, but it was one of the first pieces of standard-issue clothing issued to all services. It was introduced as part of the Royal Navy's 1857 overhaul of dress regulations for all crew members; until then they provided their own clothing (often known as slop) and no consistency was imposed. The officer class had been expected to abide by regulations laid down a century previously. (In the 1940s the heavy pea coat ceased to be standard issue for US Navy officers – who adopted either a more formal version with epaulettes and brass buttons, or a bridge coat – and was provided only for ratings.)

Like the pea coat that evolved from it, the reefer jacket was highly functional: it was double-breasted to provide additional warmth against cold and wind, and to protect the body against the rubbing of the rigging

Above: Robert Redford in his character's pea coat, filming the classic conspiracy thriller *Three Days of the Condor* in 1975.
Opposite: A classic pea coat from Alpha Industries, contract manufacturers of many military clothing items including the MA-1 flight jacket.

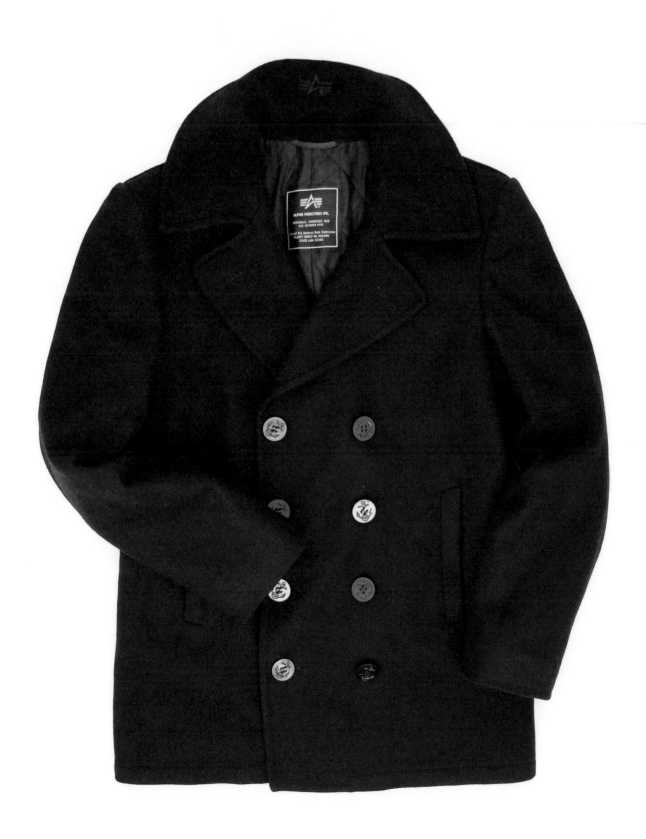

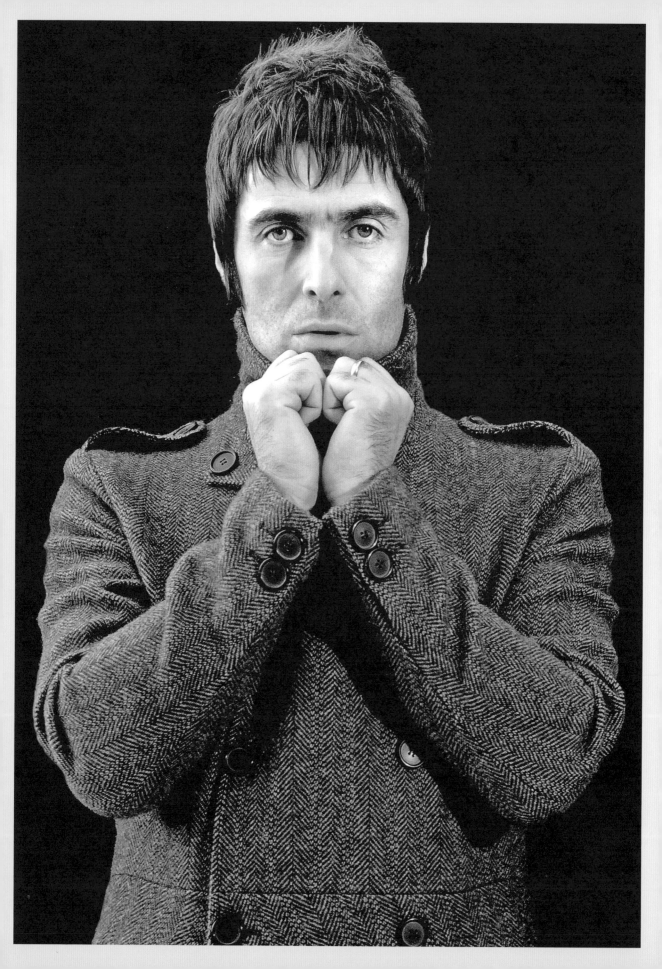

ropes. The buttons were set to one side (even though one row became decorative as a result), which made it less likely that they would get caught on the ropes. The jacket was cut short to allow ease of movement. It was coloured indigo navy, to hide dirt and also because at a time when there were no colourfast dyes it was the shade most resistant to being faded by sunlight and repeated drenchings by rain and by seawater.

The US Navy pea coats were issued in what was known as midnight or dark navy blue – barely a shade from black. From 1980, black Melton wool was used. This was just one of the changes that diminished the Navy-issue pea coat's quality during the post-war decades, as pressure on military budgets mounted. Others included the elimination of the corduroy pocket lining and cuff-stitching detail in 1967, and replacing the Bakelite buttons with pewter ones in the mid-1970s.

The cloth historically used for pea coats is believed by some to have given the style, variations of which became standardized throughout European navies, its familiar name: pea may well be a corruption of *pij*, a coarse wool cloth woven in the Netherlands during the eighteenth century and used for a typical worker's jacket called a *pijjakker*. Alternatively, the name is simply a misspelling of P-jacket, from pilot's jacket, named for the mariner who guides a ship through congested or dangerous waters.

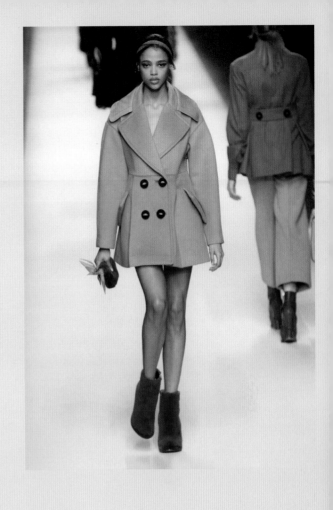

Opposite: Key characteristics of the pea coat – the high collar, when upturned, the double-breasted fastening – have been translated many times, as with this style from Liam Gallagher's Pretty Green label. **Above:** Fashion has long considered the pea coat a staple, playing with fabrication and proportions, as with this example from Fendi's autumn/winter 2015 collection.

The Fishtail Parka

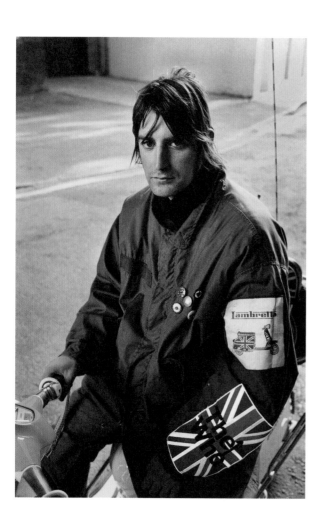

Above: Long after the heyday of the mods, the subculture continued to have resonance, and its ardent fans still finding the fishtail parka the ideal outerwear for scooter-riding.
Opposite: The film that launched a thousand fans of the fishtail parka, *Quadrophenia* (1979), with Phil Daniels (centre) as the mod-ish scooter boy Jimmy.

The 1950s fishtail parka might be considered one of the first 'flexible clothing' systems. With various elements that built up into an increasingly cosseting garment it could be worn in all weathers and conditions. To a loose and light, sturdy cotton outer shell could be added a thick, alpaca-wool pile, button-in liner, then a fur-trimmed hood. Each 'fin' of the fishtail was designed to be tied around the legs to create a more fully insulated, closed environment – and safer, more efficient aerodynamics for paratroopers.

The United States Army had tried to develop such a system during the Second World War, for general cold-weather issue. The OD-7 was a hooded coat plus a liner, made from pile at the start of 1945 and fibreglass in 1947. But neither was successful and after the details had been finessed the M-48 or M-1948 (after the year of its introduction) was issued. This was essentially a top-spec version of the initial concept, complete with a pocket on the arm – an idea borrowed from the MA-1 flight jacket (see p.48).

But it was the M-51, or M-1951, introduced in June 1951 during the Korean War (1950–53), that saw the parka style more widely distributed. The first winter campaign had been disastrous in part because of the lack of cold weather clothing, and this had provided the incentive both to keep costs down and to supply more troops with parkas. The M-51 was mass-produced and cheaper than its predecessors: the pile lining and extras like the sleeve pocket were removed and the fur trim was replaced by a synthetic one. If the liner was removed the shell gave some protection during Korea's monsoon summers.

The M-51 initially came with epaulettes and an attached lightweight, fold-down hood, with button fixtures that allowed a heavier hood to be worn over it. There was also an attempt to retain the feel of the M-48 by using similar heavy fabrics. But these were slow to dry. A second generation of the M-51 was created in lighter, faster-drying materials, with a cotton and wool lining, that gave added mobility without too much loss of warmth. It also came in

olive green rather than olive drab, the standard army shade during and since the Second World War.

The M-51 was produced in the United States for only five years, and then in Allied-occupied Germany, where it was made by German companies for another three. Aside from contract orders for foreign militaries, notably those of Canada and the United Kingdom, the style was dormant until 1965 when its next evolution, the M-1965 or ECW (Extreme Cold Weather) parka, was designed. Its shell was made of a cotton/nylon blend, treated for additional waterproofing, and it had a single detachable hood. It remained in service until 1987 when it began to be phased out.

But it was the M-51 that gave the parka its moment in fashion. In the United Kingdom during the late 1950s and 1960s the mod movement and cheap army surplus supplies of the now redundant garment came together and the M-51 was deemed ideal for keeping rain and dirt off a sharp tonic suit while riding a Vespa scooter. Indeed, that the parka is as much part of mod iconography as the movement's preferred mode of transport was assured in 1973 when the Who featured it on the cover of their concept album 'Quadrophenia' – this was realized as a film of the same name in 1979 and sparked a second, more populist fashion life for the parka, complete with pin badges and patches.

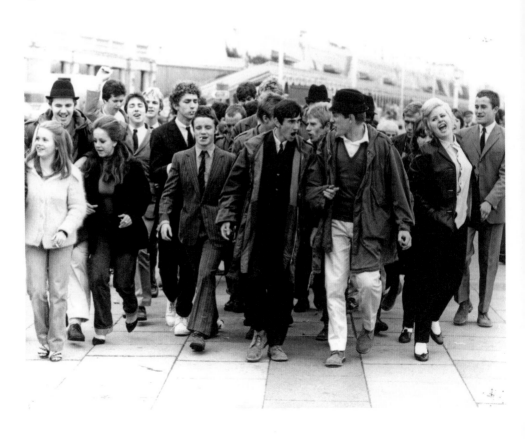

Below: The M-51, arguably the definitive version of the parka. Introduced as a less expensive version of its predecessor, it was rushed into production to supply US troops fighting through Korea's extremely cold winters. The official design spec cited 'a parka designed to be worn over other clothing at mean monthly temperatures below +14˚Fahrenheit (-10˚Celsius)'.
Opposite: Green was obviously not good camouflage for snow-covered territory, so the military provided versions of its parka in white.

The Bomber Jacket

Above: The A2 was so popular with pilots that when it was discontinued in 1943 a number of small manufacturers sprang up to supply servicemen who could no longer get one. The jackets were held in such high regard that, while they were officially only ever available to airmen, generals Patton and MacArthur also wore them. Wartime publicity shots of James Stewart and Glenn Miller – who both saw active service – often showed them wearing A2s.
Opposite: Frank Sinatra wore a Second World War era bomber jacket for his role as Colonel Ryan in *Von Ryan's Express* (1965).

When Frank Sinatra sought to give his character in *Von Ryan's Express* (1965) a tough-guy image, and Bob Crane required a distinctive piece of military clothing for his role as Colonel Hogan in the United States television series *Hogan's Heroes* (1965–71), their costume departments turned to the A2 pilot's jacket, and sparked a renewed appreciation of it in the process. The same would happen after the release of the film *Pearl Harbor* (2001).

Such is the appeal of this leather zip-up style (known as the bomber jacket even though its use was not restricted to bomber crews) that its pattern, or subtle variations thereof, has come to represent the archetypal flyer's jacket. This is some achievement for a garment designed in 1930, and introduced the following year for the United States Army Air Corps as a replacement for the button-up, knitted-collar A1 model that had been in service for just four years. The A2 was standard issue until 1943, after which it was gradually replaced by cloth jackets.

As with many military clothing contracts, the variety of manufacturers, civilian and specialist, that produced the A2 – among them Cooper Sportswear, the Poughkeepsie Leather Coat Co., Aero Leather, Spiewak & Sons and the Cable Raincoat Co. – saw the introduction of subtle variations in the design. These were of a kind that now excites avid collectors drawn to vintage pieces, not only for the jackets themselves but also for the blank canvas that their one-piece backs provided for budding flyer-artists. If the front of a bomber was the place for nose art – illustrations that blended sex and death, the crew's successful raids counted next to Alberto Vargas-style images of a leggy pin-up after whom the aircraft might be named – the rear of a flyer's jacket was an ideal spot for recording his tours of duty.

Three squadrons – the so-called Flying Tigers of the 1st American Volunteer Group, US pilots who controversially fought with the Chinese air force against the Japanese from 1941 to 1942 – painted a blood chit or escape flag in the space. This contained

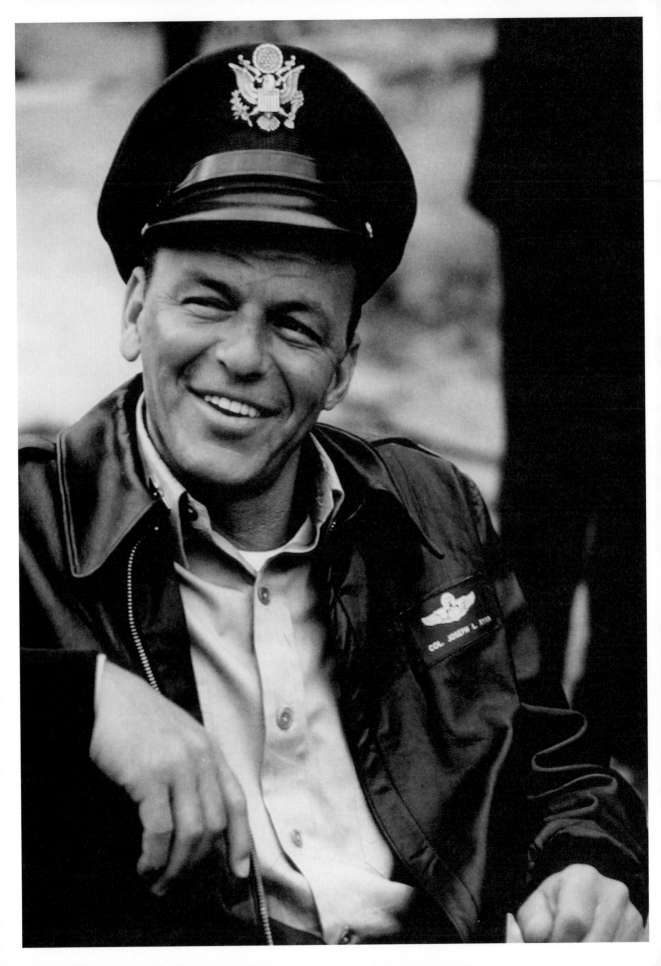

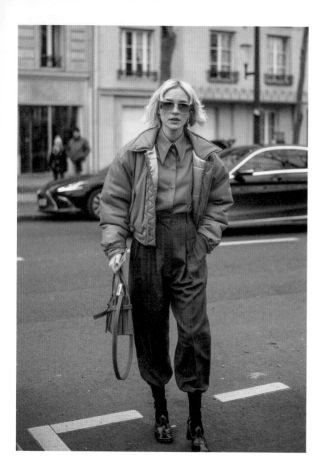

instructions in Chinese that any downed airman should be afforded assistance and protection. It became a distinctive characteristic of the costumes worn by John Wayne and others in *Flying Tigers* (1942), which was passingly based on the squadrons' exploits.

The left sleeve of an A2 typically bore the emblem of the US Army Air Force, while the right was a site for proudly worn squadron patches that were added and removed as a pilot moved between bases (or – a quirk of Navy pilots – simply added, one next to another).

Materials varied from issue to issue. Tanned horse hide was the norm, but goatskin and steer hide were also used, with the colour varying between seal (dark brown) and russet (medium brown). But the bare, essential design created a leather jacket that was durable and practical – worn fitted, as it was, it provided essential warmth for aircrews, at least during all but winter operations – and also smart. As on a button-down shirt, the collar was fastened to the body of the jacket with snaps; unlike the A1, the A2 had epaulettes; and, behind the front flap pockets, hand-warmer pockets were popular designs for the civilian market but considered unmilitary as wearers might walk with their hands in them. Until 1939, when cost prohibited it, the jacket came with a silk lining. This was replaced with a cotton lining – for all flyers except the fighter aces of the 56th and 479th Fighter Groups, who, when their fifth kill was confirmed, were entitled to a red satin lining.

In 1988 the US Air Force reissued a goatskin version of the A2 (complete with hand-warmer pockets). Unlike the original A2, it was not available to all airmen who had passed through basic training, but only to those who had completed mission qualifications. Consequently it was all the more prized. Sadly, regulations did not permit recipients to paint the backs of their jackets.

Above: Viky Rader wears a quilted leather bomber jacket in 2021.
Opposite: British ska-inflected band Madness, with several members of the band wearing bomber jackets, 1979.

Miniskirt
Pencil Skirt
Skirt Suit
Circle Skirt

2.
Skirts

The Miniskirt

~~~~~

**Above:** Mary Quant, pioneer of the miniskirt, shows off the style that helped make her name as a quintessential fashion designer of the 1960s and 1970s.
**Opposite:** In 1966 the tongue-in-cheek British Society for the Protection of Mini Skirts picketed the House of Dior for its alleged 'unfair' treatment of the style – that is, by its championing longer skirt lengths, supposedly in an affront to 'women's lib'.

Quite who came up with the idea of the miniskirt remains open to debate. Was it British designer Mary Quant, whose design of 1965 was inspired by her childhood love of ballet attire and named after Alex Issigonis's groundbreaking Mini car? She daringly took hemlines well above the knee, tapping into the street style of 'Swinging London' and the women who visited her influential King's Road shop Bazaar, while also, more controversially, channelling the school uniform style of big-eyed, gamine girls.

Or was it French designer André Courrèges, whose futuristic, space-age short skirt was shown to haute-couture customers in 1964? Was it John Bates, British founder of the Jean Varon label, costumier for Diana Rigg in the 1960s television series *The Avengers* and designer of even shorter skirts before either Courrèges or Quant? Or perhaps it was the ancient Egyptians, whose female performers wore something mid-thigh and very similar?

Regardless, the miniskirt was a sartorial summation of the 1960s: the growing gap – in attitude and in dress – between youth and the parental generation; an increased (sexual) liberation for women; and a readiness to challenge ossified rules of propriety. Witness the storm created when British model Jean Shrimpton attended the Melbourne Cup Carnival in Australia in 1965 without hat or gloves and, more radically, bare-legged in a white Colin Rolfe minidress. Or when Brigitte Bardot arrived in London by jet wearing a plaid miniskirt in the same year, also bare-legged. It has been argued that the miniskirt was only socially feasible because of the advent of tights, and Quant's coloured and patterned tights, in particular, which made the wearing of stockings and garter belts unnecessary. Imagine the fuss when, in 1966, as part of his 'Body Jewellery' collection, Paco Rabanne introduced new versions of the miniskirt, including a semi-transparent one in plastic chain mail, another made from wire-linked metal discs and even a 'throw-away' minidress.

Like the hot pants that followed, the miniskirt suited fashion's feminine ideal of the time – tall, slender, boyish, leggy, even gawky – and Christian Dior and Yves Saint Laurent would also later lend their credibility to the design. For all that, it was certainly too much, or rather too little, for some. The miniskirt worn in the more puritanical United States was always longer than its European equivalent. 'Swinging London' was outrageous to visiting tourists, so much so that a 1967 television documentary from the US ABC network was called *The Miniskirt Rebellion*. In some countries, the skirt even prompted reported instances of violence against supposedly inappropriately dressed women.

Quant was disconcerted by these reactions. 'We thought we were designing clothes for our friends around Chelsea. It wasn't anticipated that it would have any effect. I didn't set out to shock [with the miniskirt]. I wanted to move and run, go to work then go on in the evening somewhere I could dance.'

For many, the miniskirt reflected an upbeat sense of new possibilities during the mid-1960s; it was a barometer of changing public mood. Indeed, it was a test of the theory that hemlines rise in economic boom times, disproven perhaps by the miniskirt's later, ironic adoption by punk during the 1970s, when it appeared in leather and PVC, with slashed tights or fishnet stockings. Yet, by the 1980s it again substantiated this theory by its inclusion in corporate female power dressing. As with any hemline, fashion was destined to periodically make the length unfashionable: by the end of the 1960s, for example, the mini was being upstaged by the calf-length midi-skirt. This was, in part, because the mini, now the micro-mini or pelmet, could not get any shorter without, as the joke had it, becoming a belt.

Opposite: Raquel Welch – here in 1968 – was often shot in a miniskirt, serving to add to her standing as 'the world's next sex missile', as she was dubbed on her cinematic debut.
**Above:** Ever one to play with the possibilities of extremes, designer Vivienne Westwood took the miniskirt even more mini – as with this style from her autumn/winter 1994 collection.

# The Pencil Skirt

Few garments in the woman's wardrobe scream the 1940s and 1950s as much as the pencil skirt. Cut straight from hip to hem just below the knee, creating a tube- or pencil-like garment, the skirt – designed by Christian Dior in the 1940s – may have been introduced as a consequence of rationing. If, for modesty's sake, the full skirts of the period could not be made shorter, then they could be made narrower, using less fabric in the process. Worn high on the waist and hugging the body (all the more so thanks to the consequent popularity of the corset), the pencil skirt became a definition of femininity. It emphasized the hourglass figure that was not only a welcome counter to the mannish factory clothes of wartime, but which also came to define glamour for the next two decades.

Dior's H-line skirt, as he called it (in contrast to the fuller A-line style of his post-war New Look), and similar skirts by Pierre Balmain and Jacques Fath were seen on women from office workers and secretarial staff to Hollywood stars Lauren Bacall, Grace Kelly and Elizabeth Taylor. The pencil skirt's sharp tailoring, especially when worn with a short jacket, fitted blouse or sweater, may have been superficially reserved, even prim, but deep down was strongly sexual. As Jack Lemmon's character Daphne was to approvingly sum up, the sassy, short-stepped movement of Marilyn Monroe in a pencil skirt in Billy Wilder's 1959 movie *Some Like It Hot*, was 'like Jell-O on springs'.

Fashion had, however, been here before: in the early years of the twentieth century, the hobble skirt, its name inspired by the restriction it imposed on taking long strides when walking, had become high style thanks to the birth of flight. When, in 1908, Wilbur and Orville Wright made their first flight with a passenger, they so impressed the wife of one of their associates, a Mrs Berg, that she asked for a ride. To protect her modesty, her long dress was tied to her legs above the ankles. The result was an image disseminated globally by the press that proved to be an inspiration to designers, most notably Paul Poiret who created a similar dress in 1910, closely fitted at

**Above:** Catherine, Princess of Wales, wearing a pencil skirt in 2023.
**Opposite:** Perhaps few other women embodied the hip-hugging sassiness of the pencil skirt as well as Marilyn Monroe, here in a publicity still for *Niagara* in 1953.

HATHAWAY-A678
MARILYN MONROE
AS "ROSE"

TO BE SPOTTED
#2

5/21/52
DES-JEAKINS

the ankles. 'I have freed the bust from prison but I have put chains on the legs,' Poiret famously said.

It was a change in hemline length that brought the pencil skirt's most triumphant years to an end. The advent of Mary Quant's miniskirt in 1965 suddenly made the traditional pencil skirt look stiff and all too respectable. Indeed, it would not be until the 1980s that the pencil skirt would make a return, in part because of the retro-futurism of Ridley Scott's sci-fi movie *Blade Runner* (1982), but primarily as a component of a business suit. A corporate, 'power-shouldered', tightly waisted suit echoed the explosion in banking and financial services in that decade, for which the respectability of the pencil skirt was just right. Of course, the style could still be suggestive when required, especially in black leather.

**Right:** Sienna Miller, stylish in a pencil skirt.
**Opposite:** The French fashion designer Pierre Balmain presented his take on the pencil skirt with his 'tubular line' of knitted womenswear garments in 1958.

# The Skirt Suit

Women have worn skirts with tailored jackets since the late nineteenth century when they began to live more active lifestyles and it became more widespread to wear what were then perceived as practical, streamlined garments. But it was not until the 1930s and 1940s that the skirt suit – jacket and skirt matching with a rule-bound formality that had previously been the preserve of menswear – found popularity.

Two forces were at play, each powering the skirt suit into fashion or practical use throughout the decades. One was Hollywood, which saw a degree of experimentation in the cutting of women's skirt suits, resulting in striking designs such as that worn by Joan Crawford in *No More Ladies* (1935), designed by Adrian Adolf Greenberg, complete with mid-calf skirt and a fitted jacket with outlandishly outsize lapels. Or the dramatically cut, almost futuristic jackets with sculptural V-line skirts, also by Greenberg, who was better known for show-stopping evening gowns.

Huge puff sleeves, butterfly collars, square shoulders with very fitted sleeves, asymmetric fastenings and distorted proportions were all at play. Ironically, such tailored outfits were considered ideal for travel – the 1930s saw the first boom in international tourism – albeit travel of a luxurious kind in which dressing up was still considered de rigeur. Christian Dior's influential pencil-skirt design of 1940 was introduced as part of a woman's suit ensemble.

If Hollywood lent the skirt suit a kind of glamour, and – as it could not follow fashion because of the risk of looking dated by the time a movie was released – also a sense of boldness, the other driving force was the much more mundane change in working patterns during the 1940s. Wartime led to more women entering the office space, initially as secretarial staff, and wartime rationing meant that most skirt suits were simple and practical, with skirts cut just around the knee, although a striking V-shaped silhouette remained typical until the 1950s.

The 1950s saw a considerable softening of the suit as it made a return as a fashion garment rather than

**Above:** Grace Kelly – often regarded as the epitome of elegance during the 1950s – relaxes in a skirt suit for a scene in *Rear Window* (1954).
**Opposite:** Arguably no designer other than Coco Chanel was responsible for making the skirt suit – especially one in tweed – fashionable for women. Here she poses outsider her Paris home.

a workaday one. Gabrielle 'Coco' Chanel introduced one of her most famed garments, the woollen cardigan suit, a knee-length skirt with a version of the semi-structured cardigan jacket she had created in 1925, which found favour with Audrey Hepburn and Grace Kelly. Continually updated, the Chanel suit – often in tweed or wool jersey – with a slim skirt and collarless boxy jacket, trimmed in braid, with patch pockets and gold buttons, and with an internal chain that helped it hang properly from the shoulders, became one of the designer's biggest hits, helping her business make a return when it was relaunched in 1953 (having closed at the outbreak of the Second World War).

Throughout the 1960s it, and its many imitations, proved the archetype of the skirt suit, which was still being worn by an older generation of women or on more formal occasions by those whose role dictated it, for example, Jacqueline Kennedy. But such ladylike dressing – of a kind that had been exemplified by Hitchcock's leading ladies, Grace Kelly in *Rear Window* (1954) and Kim Novak in *Vertigo* (1958), for instance – was increasingly coming into conflict with a much looser, hippie-inspired style.

The skirt suit would not make a comeback until the 1980s and 1990s, again thanks to working women taking up executive positions within companies. Dubbed 'power suits', with their shoulder pads reminiscent of 1940s style, these semi-conformist creations had the benefit of drawing attention to the wearer's seriousness without expecting her to ape male dress. Books such as John Molloy's *Dress for Success* (1975) and *The Woman's Dress for Success Book* (1977), with its navy-suited, briefcase-carrying woman on the cover, championed the concept of dressing your way up the corporate ladder, and became part of the plot of the 1988 movie *Working Girl*.

Opposite: Diana, Princess of Wales, gives the skirt suit the royal seal of approval while naming a cruise liner in 1984. **Above:** Model Claudia Schiffer attends Chanel's 2009 spring/summer fashion show wearing, naturally, a classic Chanel skirt suit.

# The Circle Skirt

Novelty might not be the best starting place for a wardrobe classic, but it worked for the circle skirt. In 1947, American actress, soprano singer and designer Juli Lynne Charlot decided to make a skirt inspired by the nipped-in waists and full-volume skirts of Christian Dior's New Look, the lifting of wartime rationing on fabric and the fact that her husband had just lost his job. Her idea was to make a skirt that comprised a plainly draped single circle of fabric, contrary to the trends for lightly gathered dirndl-like and fully pleated skirts. As such it was easy to make, with just one seam to arrange and no darts, pleats or gathers. This was essential to Charlot since, although she had designed all of her stage costumes, including those in which she performed as the straight woman to the Marx brothers, she could not sew.

Charlot decided to add interest to her design in the form of appliquéd shapes in felt, of which she had a limitless supply as her mother owned a factory that used felt. Such was the fun in the style, all the more so perhaps with the Second World War still a fresh memory, that a local Beverly Hills store bought and quickly sold all she had. It also suggested what she might put on her next batch: dog shapes. Charlot agreed, producing a run featuring three dachshunds performing a small story of canine flirtation and entwined leads – the designer liking the idea that her skirts would be conversation starters.

The next run featured poodles. It was this design that captured the public imagination and the 'poodle skirt' entered the fashion vernacular. The influential Bullocks Wilshire department store placed orders and even offered Charlot the store windows to show off her designs. Neiman Marcus and Bergdorf Goodman soon followed suit and bought her circle skirts in large enough quantities to allow her to set up her own factory.

The style was soon copied, less by other designers and more by women who easily made their own inexpensive versions, which meant, appealingly, that no two skirts were the same. This did not, however, prevent most of the major sewing-pattern companies

publishing patterns for circle skirts, nor circle-skirt kits entering the market. Available from dime stores, these kits were cardboard tubes filled with the skirt fabric, printed with outlines for the felt pieces, which were also provided, along with the needle and thread with which to attach them. As such, by the early years of the 1950s the circle skirt was ubiquitous in the United States, especially among teenage girls; the skirt style, heavily advertised in such magazines as *Seventeen*, proved the ideal, swirling garment in which to move to the new jitterbug dance craze.

Other popular designs that appeared on the skirt were playing cards, vinyl records, cats, flowers, desert scenes (Charlot was particularly inspired by the Mexican landscape) and motifs from circus and cowboy lore, though some also added more sophisticated embroidery, sequins and beading. Adult women were more inclined to wear plain styles – the circle skirt may have been one of the first fashions with an age limit.

The circle skirt helped to define the 1950s in the United States, fitting in with its image as a decade of new, pastel-coloured domestic appliances, kitsch design, the positivity of a consumer boom and the birth of the housewife. This has ensured that whenever fashion revisits the 1950s, it invariably revisits the circle skirt, although the poodles are usually kept on a leash.

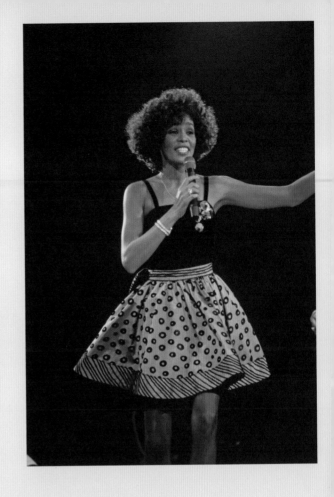

**Opposite:** Long associated with the 1950s, the circle skirt and its excess of fabric presented a golden opportunity for decoration – as with this skirt's parade of cairn terriers, in 1954.
**Above:** Whitney Houston wearing a circle skirt on stage, 1990s.
**Next page:** 'Tell me more, tell me more' – Olivia Newton-John as Sandra in *Grease* (1978), with its nostalgic take on 1950s style.

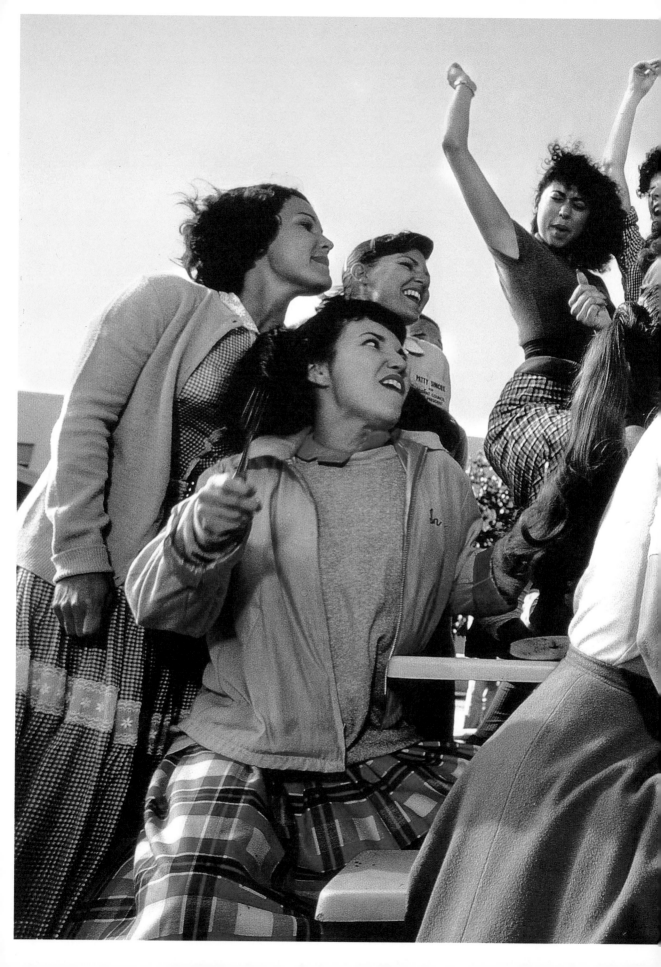

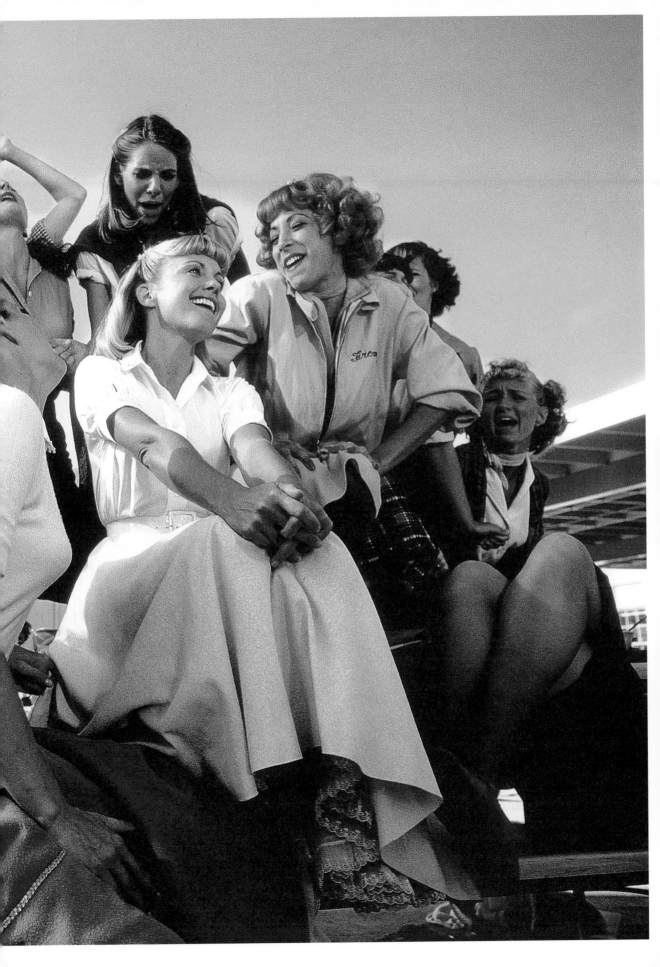

A-line Dress
Little Black Dress
Prairie Dress
Empire-Line Dress
Shift Dress
Wrap Dress
Halterneck Dress
Shirt Dress
Kaftan
Pleated Dress

# 3.
# Dresses

# The A-line Dress

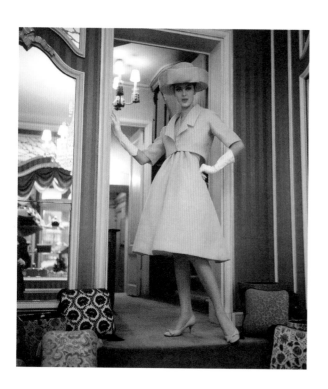

**Above:** Dior was not the only designer to propose a 'triangular' shaped skirt – here a model shows off a design by Lanvin-Costillo in 1962.
**Opposite (above):** Stripped down but maintaining the same simple geometric shape, the A-line also found relevance citing the 'pop' years of the 1960s and 1970s, as with these dresses by Hanae Mori and Charles Cooper.
**Opposite (below):** Part of André Courrèges's spring/summer collection of 1968, in which the A-line meets the miniskirt.

Hemlines may rise and fall and certain styles have their moment, but few silhouettes can have been so influential in the late twentieth century as what came to be known as the A-line. The shape, triangular from the shoulders or hips, has historical precedent: sixteenth-century Elizabethan fashion insisted on the flattening of the bust and a full skirt, producing a proto-A-line shape; the hoops of underskirts in the seventeenth century created similar lines; and women's fashion during the Edwardian era, with its emphasis on such new physical pursuits as bicycle riding, teamed a blouse with an ankle-length flared skirt to also achieve an A-line effect. Even in the mid-twentieth century, designer Jacques Fath's swing coat of the late 1940s hinted at the A-line. But it was Christian Dior, who christened the style 'A-line' in his spring collection of 1955.

Dior's was an exaggerated version: the key look was an unfussy, flared jacket over an even more flared pleated skirt, a true capital A, in keeping with the letter shapes that inspired his collections (he also produced styles based on H and Y). In fact, the A-line was devised in part to mark a distinct break with the nipped-in waist of his 'Corolle' line, introduced as part of the New Look in 1947, and influential for many years after. The A-line was, as *Vogue* quipped, 'the prettiest triangle since Pythagoras', and, although not immediately successful, it did inspire copies and sewing patterns.

It was in 1958, with Yves Saint Laurent's first collection at Christian Dior, that the A-line established itself as a truly modern shape with wide appeal, not least because it was distinctly flattering, narrowing the waist and hiding hips and thighs. Saint Laurent's 'Trapeze' collection offered knee-length coats and dresses that flared from the body more softly and less dramatically than Dior's designs, although more extreme takes were soon created by other designers.

In spite of its long history, the A-line, with its emphasis on comfort without sacrificing structure, came to be viewed as a futuristic shape, especially

during the space age of the 1960s. The playfulness of the A-line, Mary Quant-inspired minidress seemed especially suited to the boom in youth fashion over the decade. It was a graphic, wearable shape to which bold colours, patch pockets and various necklines could be applied. The A-line of the 1960s explored new fashion materials such as paper, PVC and other plastics; the fact that they could retain a stiffness made them ideal for the A-line, as French designers Pierre Cardin, Emanuel Ungaro and André Courrèges each investigated, the latter's 1964 'Moon Girl' collection including A-line minidresses in silver plastic inspired by astronaut suits. But the A-line remained a fashion staple precisely because it worked regardless of length: come the 1970s, the A-line was appearing in longer styles, worn in denim with knee-high boots.

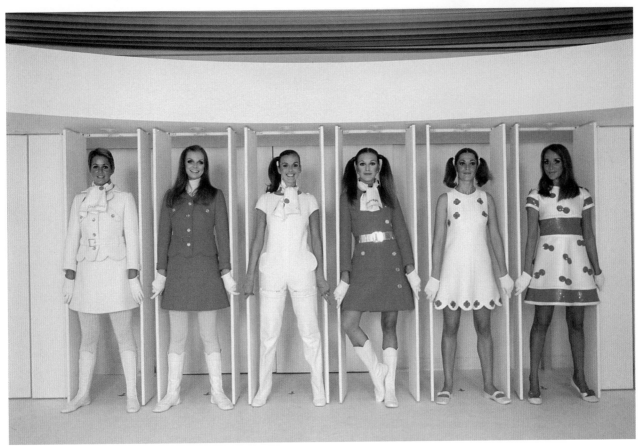

# The Little Black Dress

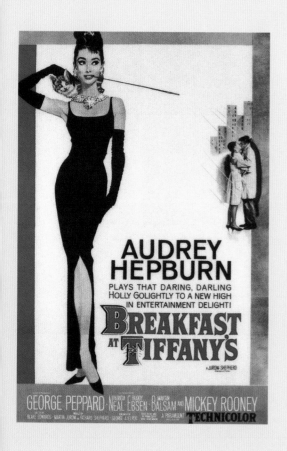

**Above:** Arguably the quintessential Little Black Dress was that worn by Audrey Hepburn in *Breakfast at Tiffany's*, the film that brought the look to the mainstream.
**Opposite:** Elizabeth Hurley – wearing the safety-pinned dress by Versace that caused a global sensation – at a film premiere with then boyfriend Hugh Grant.

It may not sound like much of a compliment, but when American *Vogue* compared a dress illustrated on its pages with the Ford Model T car, it undoubtedly was. Both were revolutionary in their back-to-basics simplicity, and both were, as *Vogue* termed them, 'attainable'. The dress stripped back ornamentation and reinstated black as the colour not of mourning but of sophisticated, elegant fashion (since dye was so expensive, black had actually been worn by Spanish aristocracy as early as the sixteenth century), while the car democratized personal transport.

The comparison was made in 1926, some eighteen years after the launch of the car but nonetheless apt: it was the year that Gabrielle 'Coco' Chanel debuted her version of the dress that, arguably, proved to be her greatest contribution to fashion. Although the simple black dress had been experimented with before Chanel – by British couturier Edward Molyneux, for example – Chanel's was a striking, minimalistic, figure-hugging, knee-length jersey version with high neckline and long sleeves. It was Chanel herself who dubbed it her 'little black dress' (although 'little black frock' was a phrase used before in Henry James's *The Wings of the Dove* in 1902), with a familiarity and fondness that helped define it as the default style for almost any occasion, dressed up or down as required.

The design was ahead of its time, although it played a fitting part in the radical changes that womenswear underwent during the flapper era of the 1920s and beyond. Starlets, performers and royalty from Joan Bennett to Josephine Baker and Wallis Simpson, the Duchess of Windsor, wore some variation on the LBD, as the style came to be abbreviated, from those with peacock feathers to those with asymmetric necklines and diamanté embellishment. Over the following decades, black became an everyday part of women's wardrobes both for reasons of practicality, especially the rationing in many countries during the Second World War, and for its growing reputation as the colour of sexiness – see Rita Hayworth in *Gilda* (1946).

But the LBD was not to have its greatest, most defining moment until 1961, when Audrey Hepburn wore the style as Holly Golightly in *Breakfast at Tiffany's* (Blake Edwards). Only then did the little black dress undergo a transformation from wardrobe novelty to universal staple. And this despite the fact that the little black dress worn by Golightly in the opening credits, designed by long-time Hepburn collaborator Hubert de Givenchy, was not that little, being floor-length and worn with evening gloves. Elsewhere, Catherine Deneuve's dress in *Belle de Jour* (1967) would seal the dress's reputation for French chic. Synthetic fibres made the style available and affordable, and sheer fabrics such as tulle and netting began to be incorporated into the design.

In time, the LBD came to be a term applied to almost any black dress, the graphic directness and blank canvas of the shade, whether in silk, spandex or leather, proving more important than any particular cut. This was something that Jacqueline Kennedy Onassis recognized, seeing the dress as a means of expressing her love of accessories, notably her signature pillbox hat and outsize sunglasses. There would, however, be exceptions, most famously the Gianni Versace dress – very low cut, split down the side of the torso and fastened by giant gold safety pins – that actress Elizabeth Hurley wore to a movie premiere in 1994.

**Opposite:** Marlene Dietrich's most iconic image sees her in the black and white of mannish bow tie and tails. In this publicity still it's a black dress that offsets platinum hair.
**Below:** Yves Saint Laurent's take on the little black dress came sleeveless, belted at the hip and decorated with studs, here modelled by Catherine Deneuve.

# The Prairie Dress

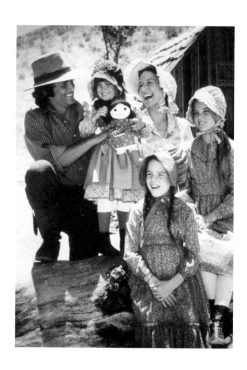

**Above:** The long-running US TV series *Little House on the Prairie* – all 204 episodes – did much to romanticize the 'western' style of the late 1890s.
**Opposite (above):** In the UK the designer Laura Ashley came to be known for her collections' romantic, Edwardian period style throughout the 1980s.
**Opposite (below):** Prairie style – complete with vintage Ford pick-up truck, as seen through the vision of a *Vogue* shoot in 2001.

In 1967, everything changed for a company well established in Wales for making printed aprons and gardening smocks: Bernard and Laura Ashley produced their first dresses. These could not have been more different to the shapeless shift and short minidresses that then dominated the flesh-revealing fashion. Far from being modernistic, they obviously referenced the past; and they were demure rather than sexy. As Laura explained: 'I had to do something that was completely different because I knew in my heart that [the dominant fashion style of the 1960s] was not what most people wanted. I sensed that most people wanted to raise families, have gardens and live life as nicely as they can. They don't want to go out to nightclubs every night and get absolutely blotto.'

The Laura Ashley style hinted at a simpler, more innocent life, pretty rather than sassy. The dresses were a twist on Edwardian and Victorian patterns, characterized by a high neck with perhaps a stand-up or Peter Pan collar, pleated full-length skirt with maybe a flounce, long sleeves, puffs at the shoulder, button cuffs, sometimes button-fronted like a shirt, sometimes with a pin-tuck bodice. They were most appreciated for their distinctive, subtle prints, often floral or nature-inspired, but also with heraldic or medieval imagery. They were, in short, blends of all forms of historic romanticism, with later dresses exploring empireline Regency style too.

The appeal of these blends of styles had much longevity. Sewing patterns for the look proliferated in a period when dressmaking was still a commonplace hobby; and when, as late as 1981, Lady Diana Spencer was first photographed as the girlfriend of Prince Charles, she was wearing a Laura Ashley dress. Although the glossier, power dressing of the 1980s would come to replace this soft-focus style, the Ashleys successfully implemented the nostalgic look of their dresses in homewares and interiors, becoming one of the first lifestyle brands.

The early success of Laura Ashley dresses in the UK reflected a wider cultural interest in the past:

hugely successful television programmes of the time included *Upstairs Downstairs* and *The Forsyte Saga* (both set in the early 1900s). A similar nostalgia fuelled designers abroad: in 1974, the American television series *Little House on the Prairie* began its nine-year run, while the mid-1970s saw the advent of similarly romantic, homespun and home-made styles based on the history of the American Midwest pioneer.

Prairie, folk or granny dresses by such designers as Oscar de la Renta explored similar territory to those of Laura Ashley: ruffled and floor length, with pie-crust collars, feminine but covered up. By the late 1960s and early 1970s, the granny look was in, along with shawls, workman-like ankle boots and lace-trimmed petticoats. A number of designers, from Biba's Barbara Hulanicki to Bill Gibb and from Angela Gore to a more western-inspired Ralph Lauren were rifling through costume history books to offer their interpretation.

# The Empire-line Dress

In the twentieth century, the empire-line dress has most commonly been associated with saucy lingerie thanks to a 1956 movie called *Baby Doll*, in which the main character appears in a short, busty nightgown. A decade later, the style would return in the form of a dress, no less short than the miniskirts and minidresses of the time dictated, but drawing no less attention to the décolletage either. In more streamlined, schoolgirlish versions, it had a certain modish appeal too – the boyish supermodel of the period, Twiggy, wore the style – but its sexual undertones were not forgotten come the 1990s, when Hole's Courtney Love led something of a grunge revival of it. These undertones, however, cannot be further from the line's origins.

A fashionable interest in history can spark a style. The Georgian period of the 1790s through to the 1820s saw women not only wear less and less clothing – compared with the modesty-saving layers that went before – but also enjoy a fascination, in the arts and architecture as well as in fashion, for all things Roman and Grecian.

Drawing on both these things, fashion took the popular chemise shift and combined it with what it perceived as being the style of the ancient civilizations to create a full, free-flowing form of dress, akin to a nightgown, with short puff sleeves, a low neckline and a high waist. The skirt eventually draped from just below the bust, no longer making it necessary to emphasize the waspish waist through tight corsetry. The dresses 'à la grecque', as the French called them, were often worn in white or pale pastel muslin or batiste, both of which required frequent and expensive laundering, making the dress an expression of wealth and status.

In keeping with the territorial ambitions of another icon of the times, the cut came to be referred to as the empire waist, or empire line, inspired by the empire building of France's Napoleon Bonaparte. He was a man well known for his efforts to promote the French fashion industry – almost destroyed during the French Revolution – not least through his wife Josephine, an ardent fan of French couturier Leroy. Bonaparte had fireplaces blocked and insisted no dress

could be worn twice at court, all in a bid to make women buy more clothes: to protect their modesty a chemisette (a kind of half blouse) was worn during the day to cover the low neckline of empire-line dresses; a pelisse (a knee- or full-length, open-fronted lightweight coat, also empire line) might be worn over the dress too.

Following notions of Greek classicism, empire-line dresses kept ornamentation to a minimum. Geometric borders were the most favoured options, but other influences had their day. Following Napoleon's campaign in Egypt (1798–1801), for example, otherwise plain empire-line dresses took on ancient Egyptian motifs (first seen on Josephine's dresses). Over the coming years these became increasingly elaborate – and decreasingly classical – as women tired of the unchanging minimalism of the empire-line shape. Gothic, medieval and Elizabethan influences were among the new developments.

During the first two decades of the nineteenth century, the empire line really was a predominantly French phenomenon. While French women found new embellishments to reinvigorate the style, English women soon abandoned it altogether, seeing their dress waistlines drop considerably. This, in part, stemmed from the unsuitability of the flimsy style to the British climate. One commentator, Lady Morgan, reported that, contrary to the empire line's seeming lightness and simplicity, she found it 'the most uncomfortable style of dress – so scanty that it was difficult to walk in them and to make them tighter still, invisible petticoats are worn'.

Indeed, prolonged war between what were then the two centres of European fashion – the UK and France – often affected their respective directions in matters of style. When peace was finally achieved in 1814, they began to share ideas on fashion – chiefly for the French to ridicule those of the English, and for the English to again start copying those of the French. Even French women soon began to give up on the high waistline however, with it reportedly dropping an inch a year until, by around 1825, the waistline was at the natural waist.

The empire line lived on; it was a key look among women in the United States during the 1890s, for example, and has been periodically revisited by such fashion houses as Yves Saint Laurent, partly due to how flattering it is on most body shapes. Perhaps it is most frequently seen on wedding dresses, with brides aiming to capture the classical elegance of Regency ladies, and on maternity dresses. Not for nothing did a piece of comic verse during the Regency period note that women 'all look as if they were got with child'.

**Opposite:** The empire-line dress came in with the Georgian fascination for all things classically Greek – as with this late-eighteenth century Delecroix portrait of Madame Raymond de Verniac.
**Above:** Barbara Streisand wearing a vintage empire-line dress in the mid-1960s, as is suggested by her hairdo if not her clothing.

# The Shift Dress

**Above:** Mia Farrow became a touchstone of 1960s and 1970s style for her gamine hair and easy, uncomplicated dress sense, seen here in 1967.
**Opposite:** The simplest of dresses nonetheless held an appeal for even the wealthiest of clients. Shown here is heiress and socialite Wendy Vanderbilty (right), wearing a graphic style by Lilly Pulitzer.

The story of the origins of the shift dress – a style that hangs straight from the shoulder without hugging the body's curves or cinching at the waist – is an entertaining one. Twenty-one-year-old New York socialite Lilly McKim eloped with Peter Pulitzer and they moved to his Palm Beach home, where he also owned fruit groves. She decided to make fruit juices and sell them at the roadside, but asked her dressmaker to create a simple, inexpensive dress that she could happily get stained by the juice, and in a sufficiently bold pattern that it would hide it well anyway. The result was a sleeveless, knee-length, front-darted but otherwise minimalistically cut dress in loud patterns. The so-called 'Lilly' dress was not dissimilar to the straight-cut, low-waisted, embellished dresses worn by the rebellious, bob-haired and bust-flattening garçonnes or flappers from the mid to late 1920s. For them, as for the wearers of the 'Lilly' dress some twenty-five years on, such a silhouette suggested a progressive emancipation from fuss and clutter in dressmaking.

However, the dress's transition from roadside to fashion staple required friends in high places. The story has it that customers were as impressed by her dresses as her juices, so Pulitzer began to sell them too. But it took fashion barometer and schoolfriend of Lilly Pulitzer, Jacqueline Kennedy – at the time the president's wife – to wear one on the cover of *Life* magazine, for the style to go mainstream. 'Jackie wore one of my dresses – it was made from kitchen curtain material – and people went crazy,' Pulitzer once recalled. 'Everybody loved them, and I went into the dress business.'

But leading fashion designers would only be associated with the style from 1961, when Hubert de Givenchy created the costumes for Audrey Hepburn in *Breakfast at Tiffany's*, including a shift style based loosely on the waistless sack dresses he and others had introduced four years earlier. Hepburn's screen version came in black, but its sleek lines also represented modernity. And it certainly helped that Kennedy was also a customer of Givenchy.

In 1965, Yves Saint Laurent created one of the most widely recognized versions of the style with his wool jersey Mondrian dress, using the blank canvas of the shift dress to show geometric panels of strong colour, after Dutch artist Piet Mondrian's paintings. In the dress, Saint Laurent demonstrated a masterclass in dressmaking, setting in each block of jersey to create the semblance of Mondrian order and to accommodate the body imperceptibly, hiding all the shaping in the grid of the seams. In 1966, British designer Mary Quant created her minidress by shortening the shift dress in line with her miniskirts. Leslie Hornby, aka Twiggy, took her first step to becoming the first internationally known model when she was hired to model the dress.

The uncomplicated nature and general ease of this understated dress ensured its reputation as a classic. A young Mia Farrow would make it something of a signature look, along with her boyish hairstyles also echoing the 1920s, although its appeal would peak after periods of more ostentatious fashion. Calvin Klein, for example, won praise for his shift dresses in the early 1990s after the excesses of the previous decade. Since a good fit was essential to the shift dress's appeal as it lacked distracting ornamentation, designer versions tended to be more complexly cut than outward appearances suggested: well-placed darts at the bust and a narrow A-line shape created a more flattering style.

**Above:** Paco Rabanne's shift dress of 1968, channelling the Dutch painter Piet Mondrian for inspiration.
**Opposite:** Jacqueline Kennedy – soon to be Mrs Onassis – in a simple black shift dress, walking in New York in 1968.

# The Wrap Dress

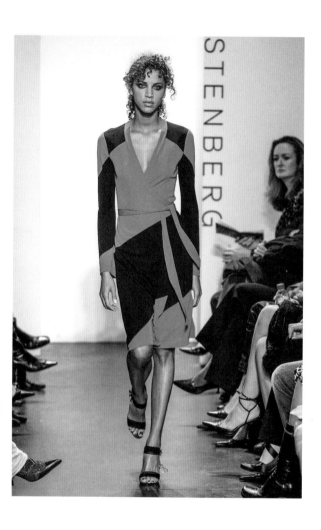

**Above:** A wrap dress on the catwalk for von Fürstenberg's autumn/winter 2002 collection
**Opposite:** Diane von Fürstenberg, in 1973, wearing the kind of wrap dress that made her name.

Belgian-born Diane von Fürstenberg revived the idea of practicality and comfort in women's dressing without dispensing with femininity in the 1970s, much as American designer Claire McCardell had during the 1940s with her popover dress. 'Feel like a woman, wear a dress,' as von Fürstenberg put it in a 1973 advertisement. But not any dress. Her solution was a style of dress whose basic template was borrowed from those quintessentially comfortable garments the dressing gown and domestic housecoat, although the designer likened it more to such traditional forms of clothing as the kimono, toga or other garments without buttons or zips.

Von Fürstenberg's wrap dress did just what it said: it wrapped closely around the body, the fabric overlapping at the waist to fasten in a tie on the hip. Like Chanel's little black dress before it, the wrap dress worked for all occasions, formal and casual, smart and alluring. It was, as von Fürstenberg put it, a 'very down-to-earth product, which was really a uniform. It felt very good. [It suited] all sorts of women ... young and old, fat and thin, poor and rich.'

The style was inspired less by von Fürstenberg's heroes Bill Blass and Diana Vreeland, than by seeing Julie Nixon Eisenhower, daughter of former US president Richard Nixon, on television wearing a wrap top with a wrap skirt. Von Fürstenberg's idea was to take the simplicity of the outfit a step further by making it a single, bright, boldly patterned cotton-jersey garment: a wrap dress. The style was launched in 1974. By 1975, von Fürstenberg was reported to be making 15,000 a week to keep up with demand; by the end of the following year, she had sold some four million of what had become a staple for both the Studio 54 high-glamour party-goers and the well-to-do set of Park Avenue, New York, and beyond.

As von Fürstenberg noted, it became 'an interesting cultural phenomenon. It's more than just a dress; it's a spirit.' In fact, the ethos of the dress – easy yet sassy – came to embody women's liberation in the 1970s, especially as more and more women entered

the workplace and looked for an uncomplicated yet professional garment to wear. Von Fürstenberg was consequently cited in Dolly Parton's single 'Working Girl', while the wrap dress made women feel what they wanted to feel like: free and sexy, as the designer noted. Free was certainly one aspect; more personally for von Fürstenberg, the design of the dress came at the end of her marriage to Prince Egon of Fürstenberg, with the need to make an independent career for herself and have a hit to underpin it.

Certainly the press recognized that von Fürstenberg's one garment had made her 'the most marketable woman since Coco Chanel', as *Newsweek* put it in 1976. The wrap dress would have a second life during the 1990s, when its revival encouraged von Fürstenberg to relaunch the style in 1997.

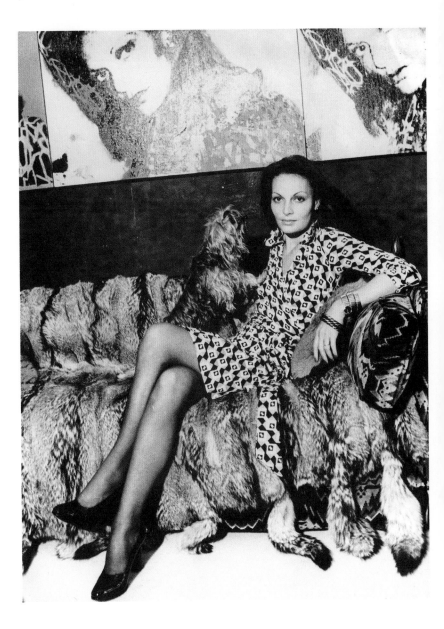

# The Halterneck Dress

There was a very good reason why Joe DiMaggio, Marilyn Monroe's husband at the time, was said to have hated the cocktail dress she wore in Billy Wilder's 1955 movie *The Seven Year Itch* for the famed scene when she stands on a subway grate and her dress billows up. It was daringly revealing, to DiMaggio's chagrin: a halterneck style, it not only enhanced the curvature of Monroe's breasts, but also left her shoulders and back bare. Designed by Oscar-winning costumier William Travilla, that dress became – thanks to the scene – an icon in its own right, later owned by actress Debbie Reynolds, and eventually sold at auction in 2011 for £2.8 million.

The halterneck was created to tantalize, despite the term being derived from the halter placed around an animal's neck to effect better control of it. Dating from between 1914 and 1919, the neckline is credited to French designer Madeleine Vionnet – pioneer, too, of the bias-cut, handkerchief dress and draped, Grecian-style dress. It is also said that she intentionally realized it in sensuous, streamlined, form-following fabrics such as crêpe de Chine and satin. Vionnet was arguably responsible for abandoning the constraints and silhouette imposed on women through the use of corsets; her halterneck exposed the back but also varying degrees of cleavage. Her dresses expressed the natural female form. 'It was a pity to go against nature,' noted Vionnet, who went on to design a double halterneck, with the front of the dress or swimsuit supported by two sets of straps fastened at the back of the neck.

During the boom years of the 1920s, the halterneck dress became the sophisticated eveningwear of choice – and a risqué one, linking the style to notions of hedonism. While the neckline would later appear on swimsuits and casual tops, the halterneck was, perhaps, the first 'come-hither' dress in an age in which any public sexual impropriety was social suicide. At first, only the superstars of the period – the likes of actress Clara Bow, who wore one for official studio portraits – could pull it off.

Marlene Dietrich, Greta Garbo, Jean Harlow, Ginger Rogers and Katharine Hepburn all supported the style; Hepburn is even said to have inspired the halterneck top that Levi's included in its 1938 'Tropical Togs' line of coloured denim. Furthermore, the halterneck dress became the style of choice for a Hollywood facing the pre-war censorship of the Hays Code, which limited the amount of cleavage shown on screen; the back provided an alternative erogenous zone to reveal.

Synonymous with seductiveness and glamour during Hollywood's Golden Age, the halterneck dress also became the signature style of another period that revelled in decadence: the 1970s. Sleek gowns by Roy Halston Frowick (better known simply as Halston) were particularly favoured during the disco era. The celebrity crowd, Bianca Jagger and Liza Minnelli, for example, made the Halston halterneck a regular feature at New York's legendary bacchanalian Studio 54 nightclub.

# The Shirt Dress

The shirt dress, or shirtwaister, was the definitive style of the 1940s, less so for its fashionability than its easy utility. As the Woman's Institute of Domestic Arts and Sciences in the United States noted, the shirt dress was 'a simple, practical dress' that 'because of its trim simplicity and graceful dignity' was ideal for both classroom and in business. This was the button-down dress that helped adolescent girls feel more adult, and adult women feel ready to go anywhere. The style was worn as much for sport, golf especially, as for eveningwear. In its versatility it was, in some respects, the less glamorous forerunner of the little black dress.

So uncomplicated was the style that it took interest from Christian Dior in 1947, with his seminal New Look breaking through post-war rationing and dowdiness, to make it fashionable. One dress, the 'Chérie', is said to epitomize the look: a soft silhouette with sloped shoulder, raised bustline, narrowed waist and full, lightly under-padded skirt – in Chérie's case, also heavily pleated. Such was Dior's affection for the shirt dress, it reappeared in collections for 1948 and 1949.

The shirt dress was now, as *Harper's Bazaar* called it, 'the essence of femininity'. As practical lifestyle magazine *Good Housekeeping* pointed out, at a time when magazines were notably powerful in influencing millions of women's clothing choices, Dior's prices were prohibitively high, but the template of narrow waist and full skirt that he had provided had great potential, especially if all those pleats were done away with and a more affordable, streamlined and easier-to-make look was created.

Small wonder then that the shirt dress became the signature style of stateside domesticity and motherhood, the uniform of that post-war invention of the American advertising industry: the housewife. Some – in large part due to influential US television shows of the period, most notably *Leave It to Beaver* – have even suggested that it helped define the woman's place as being in the home. Furthermore, some companies marketed the shirt dress as a 'house dress'. After all, 1957 saw the

**Above:** Keira Knightley in a shirt dress by Philip Lim, shot in Kenya in 2007.
**Opposite (above):** A Laura Ashley shirt dress from the autumn/winter 1986 collection.
**Opposite (below):** This image, from the summer of 1955, highlights the essential practicality, simplicity and, for the times, modernity of the shirt dress.

publication of Anne Fogarty's *Wife Dressing: The Fine Art of Being a Well-Dressed Wife (With Provocative Notes for the Patient Husband Who Pays the Bills)*.

The shirt dress had, however, taken a long journey to this point of ubiquity. Shirtwaisters had been worn in the early 1900s, and a book published in 1917 entitled *Patterns for Blouses and Dresses* talked of the 'mannish shirtwaist' as being 'a garment so designed to follow practically the same lines as those of a man's négligée shirt'. By the 1920s, its practicality saw it adopted for various uniforms, those of nurses and teachers, for example. Come the 1940s, the widespread rationing of textiles in the Second World War saw the UK bring in a range of government-approved Utility Clothing, for which the unembellished form of the shirt dress, with square shoulders and a straight skirt, became a staple. Throughout the 1950s, the shirt dress persisted and was regularly updated by the fabric choice; in 1955, for example, it was, as *Harper's Bazaar* suggested, all about 'the shirtwaist in flower, its natural up-to-the-minute aptness made suddenly more so by one of this spring's miraculous botanical prints – sharp acid greens and yellow and tart vermillion pinks that blaze.'

A long history may have ensured that the shirt dress became a style to which womenswear would repeatedly return, but the mid-1960s saw its first downturn in popularity, before, of course, it bounced back the next decade in sexier form thanks to Roy Halston Frowick and Ralph Lauren. Rudi Gernreich was one of the designers to help kill off the style; his 1967 show caused gasps when he surprised the audience of fashion buyers with a model wearing a belted shirt dress covering her knees, complete with nylon stockings, matching bag, shoes and gloves. Then out came another model in a thigh-revealing minidress in the same print as the shirtwaister. Gernreich called them 'Mrs Square and Miss Hip'. And, there was no doubt which was which.

# The Kaftan

**Above:** The kaftan is often conceived of as a poolside dress, easy to slip on of off over a swimsuit, as Jennifer Lopez demonstrates. **Opposite:** Grace Kelly in 1972 wearing a kaftan at a swimming competition at Palm Beach, Monte Carlo, Monaco, the principality of which she had been princess since 1956.

Call it what you will – from 'boubou' to 'takchita' and 'dashiki' as various cultures through history have – it is hard to conceive of a simpler or more ancient garment than the kaftan. Whether plain and unadorned, or boldly coloured, heavily decorated and panelled, as royalty and the well-off favoured, sometimes giving them as gifts to visiting dignitaries, the basic garment is essentially a fuss-free, loose, long-sleeved, three-quarter or ankle-length, over-the-head tunic. As such it preserved its wearer's dignity while keeping him or her cool.

The kaftan was historically a unisex garment (and still is in North Africa, for example), originating in the Middle East and Asia and popular with the Ottomans, who made them from velvet, silk brocade and metallic threads in indigo, red, violet and yellow. *Kaftan* is a Persian word, with the first garments believed to have originated around 600 BC in Mesopotamia – Syria, Kuwait, Iran, Iraq and Turkey (where, in Istanbul, the Topkapi Palace houses a collection of rare, historic and lavish kaftans).

Inevitably then, its take up as a fashion item was fuelled by a recurring interest in all things Eastern, exotic and mysterious. The kaftan appealed to the hippie movement of the 1960s, demonstrating an affinity with non-Western values. Elsewhere, fashion trendsetters such as *Vogue* editor Diana Vreeland – whose visit to Morocco had inspired a number of Eastern fashion editorials – quickly picked up on the style, too, as did major womenswear designers Pierre Cardin, Emilio Pucci, Krizia, Valentino and Oscar de la Renta, as well as such less well known names as Germana Marucelli, Dorothée Bis and Thea Porter. Celebrities from Grace Kelly to Elizabeth Taylor wore the look.

For the designer, the kaftan, typically in wool, silk, cashmere or cotton, was as an ideal canvas for impressive displays of print and embellishment, an idea that remained into the 1970s. A departure from the basic kaftans picked up by the hippies for pennies in Eastern bazaars, more luxurious 'evening' versions, designed by Roy Halston Frowick, graced the

celebrity set of New York's Studio 54 nightlife scene. Yves Saint Laurent – who had a home in Morocco, where he often found inspiration for his designs – was similarly enthused about the traditional garb's freedom, elegance and suggestion of bohemianism.

Yet this was not the first time the kaftan was in vogue: the marriage of Queen Victoria's granddaughter Princess Alix to Nicholas II of Russia at the end of the nineteenth century inspired a fleeting fashionability for the garment as she was photographed in a kaftan, a style then also worn by Russians. But this look to the East really came to a head in the 1910s, when Serge Diaghilev's Ballets Russes performed *Scheherazade*, with Eastern-inspired costumes by Léon Bakst. In turn, couturier Paul Poiret adopted the aesthetic of drapery, using his wife Denise as his model. Under his influence, the fitted, tightly waisted clothing typical of the period enjoyed a spell of the free and easy that reminded wearers of pre-Raphaelite painters and their muses, and was perfect for casual at-home entertaining. Indeed, it was this uncomplicated, flowing quality that ensured the kaftan would become a mainstay of summer dressing, in particular, at festivals, or as a more glamorous alternative to the sarong as beach or poolside attire.

# The Pleated Dress

**Above:** French dancer Regine Flory in a Delphos gown – made of pleated silk weighed down by glass beads – by polymath and couturier Mariano Fortuny in 1910.
**Opposite (above):** Japanese designer Issey Miyake would explore the architectural potential in intricate pleating for his 'Pleats Please' line, these, incorporating wired hoops, from a 1994 collection.
**Opposite (below):** Marilyn Monroe in a pleated halterneck dress – and subsequently one of the most valuable pieces of movie memorabilia – for *The Seven Year Itch* (1955).

The problem, from fashion's point of view, with the pleated skirt has been its long association with frumpiness. The pleated skirt bookends life either as a girl's kilt-like school uniform or the uniform of old age – the skirt of grandmotherly, dowdy Miss Marple figures, and the late Queen Elizabeth II when on less formal duties. The function of the pleats, allowing the cloth to attain an elasticity that encourages it to the cling to the body without the use of panels or darts, while also allowing ease of movement when required, has also made it unappealing to the less than svelte.

However, perhaps not so the pleated dress, which has moved beyond the utilitarian nature of the pleat to tap into what some have claimed is its youthful nature. In 1938, the *Montreal Gazette*, reporting on fashion out of New York, noted how 'no one can fail to be impressed with the way pleats have carried on – pleats for daytime and pleats for evening, pleated prints and pleated solid colors ... These pleated fashions have a young air that is irresistible.' In fact, curvy Marilyn Monroe provided one of the most famous moments in pleated dress history, when hers – designed by Hollywood costumier William Travilla – was lifted above her head in *The Seven Year Itch* (1955).

Skirts and dresses alike with various kinds of pleating – among them knife, plissé, accordion, cartridge, box and Fortuny – have a long history going back to ancient Egypt and the Vikings. They were a common feature on the clothes of the wealthy (because pleating, of course, requires more fabric) during the medieval and Renaissance eras and well into the eighteenth century. They have also prompted innovative design history: the Fortuny pleat is named after Spanish designer Mariano Fortuny, whose secret pleat-setting process, developed for fine silks in 1907 and patented in 1909, allowed the creation of then revolutionary form-fitting dresses, including his floor-length, ancient- Greece-inspired 'Delphos', as worn by Lillian Gish and other movie stars of the silent screen.

French sculptor-turned-designer Germains Krebs, better known as Madame Alix Grès, also won

acclaim for her Grecian dresses during the late 1940s and 1950s, each dress comprising hand-stitched pleats of no more than 1mm width and taking some 300 hours to intricately assemble. Pioneering American designer of casual wear Claire McCardell saw the accordion pleat's potential for less dressy clothing at about the same time, while in 1947 Christian Dior applied pleats to his 'Bar' suit with a skirt made from wool crêpe.

Pleats have invited a certain inventiveness: in the 1950s, Irish designer Sybil Connolly developed a process over eight months that allowed horizontal pleats to be permanently pressed into linen, aiming to make a feature of its tendency to crease anyway. 'Crumple it into a suitcase and it will emerge, uncrushed, uncrushable, to sweep grandly through a season of gaiety,' as *Vogue* noted in 1957. Some 8.2 metres (9 yards) of linen were required to make one pleated dress. And, in 1993, Japanese designer Issey Miyake launched his 'Pleats Please' line, using traditional tight pleating but in polyester fabrics to create lightweight and easy-to-wear modern garments, some of which also introduced zigzag pleating.

Throughout the twentieth century the pleated dress has drawn the attention of more progressive fashion designers, including Elsa Schiaparelli, Jean Dessès and Yohji Yamamoto. But it is Miyake again, this time in the twenty-first century, who has arguably provided the most unexpected confluence of modern methodology with this ancient dressmaking technique: he used ultrasonic waves that emitted heat vibrations to create pleats of an intricacy not seen before for his 2004 'Fête' collection, particularly his 'Colombe' dress.

Leather Trousers
Cargo Pants
Khakis
Palazzo Pants
Leggings
Culottes
Jeans
Sweatpants
Bermuda Shorts
Hot Pants
Fatigue Pants
Capri Pants
Pyjama Pants

# 4.
# Trousers

# Leather Trousers

×  ×  ×  ×  ×  ×  ×  ×
×  ×  ×  ×  ×  ×  ×  ×

**Above:** Suffering for fashion? Model Heidi Klum wears double leather despite the heat of Los Angeles.
**Opposite:** Few garments are more redolent of rock 'n' roll than leather trousers, as worn here by the Pretenders' Chrissie Hynde.

With their skintight fit, leather trousers are animalistic and sexually highly charged. That, of course, was not their original intention; a form of leather trousers has been worn as a protective leg covering since prehistoric times by, among others, the ancient Greeks, the Inuits and other peoples from extreme cold climates and the knights of medieval Europe who wore them as a layer between skin and armour, much as motorcyclists have worn them since the early twentieth century.

It was for much the same reason that, in the nineteenth century, they came to be associated with the ranchers of the American west, even if technically chaps – from the Spanish *chaperajos*, meaning 'leg of iron' – were seat-less and worn over the top of jeans to protect clothes while in the saddle. It was this aspect of leather trouser lore that inspired Jim Morrison of the Doors. He took his cue from *The Fugitive Kind* (1960), in which Marlon Brando plays a modern-day cowboy. Morrison persuaded a Beverly Hills tailor – a German immigrant trained in making traditional lederhosen – to make his not out of sturdy cow leather, but super-soft glove leather, which allowed the fit to be much more figure-hugging. This is how leather trousers attained their most famous association: as part of the uniform – typically in black or red – of the rock god, from Eddie Cochran to Gene Vincent and from the Beatles in their Hamburg residency years to the glam rock of Aerosmith, Mötley Crüe, Guns N' Roses and Kiss.

This more theatrical form of rock from the mid-1970s through to the mid-1980s, heightened the suggestiveness of leather trousers as signifiers of outsider cultures, rebelliousness and sex, rather than protection, and was embraced as much by women as by men. Early female rockers of the period – Suzi Quatro, Joan Jett, Chrissie Hynde, Tina Turner and Lita Ford in particular – led the way, perhaps seeing in leather trousers a way to be perceived as equal to their male contemporaries, and certainly distancing themselves from any stereotypical notions of soft-edged, pink femininity. Strutting rock god turned sassy rock chick.

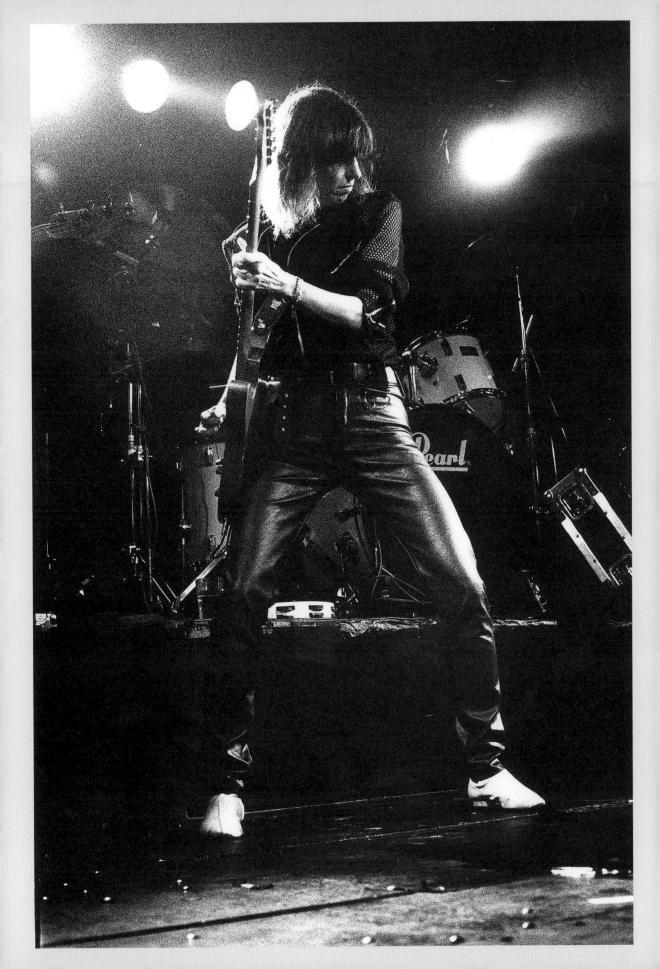

**Below:** Suzi Quatro's association with leather trousers runs deep – she played a leather-clad character by the name of Leather Tuscadero in the US sitcom *Happy Days*.
**Opposite:** If leather trousers are not a garment readily associated with hip hop, Run DMC, seen here in 1983, nonetheless made the style work with chains and sneakers.

It was not until designer versions of leather trousers emerged in parallel over the same period that the garment lost some of its grit in favour of glamour, in large part due to a reinstatement of femininity; the pants were teamed with contrasting stiletto heels or loose silk blouses. Leather has a natural give to it, but is also able to provide structure and definition, making it suitable for most women's body shapes. Out went the association with the louche, in came one with luxuriousness with an edgy coolness.

Claude Montana, the French designer who often referenced the fetishistic and macho, made leather trousers a key part of his first collection in 1977. Around the same time, Thierry Mugler also made them part of his signature style, in patent leather and stretch leathers for an even closer fit. Over the next fifteen years or so the catwalk would see leather trousers undergo multiple variations: as hot pants, rhinestone-covered, in every colour from the neon (Versace) to the neutral (Calvin Klein) and, later, even as leggings. Thanks to designers such as Isabel Marant and Balmain, leather trousers became a popular alternative to skinny jeans.

# Cargo Pants

x x x x x x x x x
x x x x x x x x x

People first carried small pouches tied to their waists in the medieval period, and interior pockets in clothing were introduced in the late eighteenth century. But it was another two centuries, the last of which saw the steady build-up of professional armies, before the utility of putting extra pockets on the trousers of service personnel on active duty was recognized. Before combat or cargo pants, today as much a standard in fashion as in fighting, image was more important than usefulness – the overspill of an ethos that saw military dress as being all bold colours and brass buttons: pomp and pageantry rather than practicality.

Jump forward to the 1930s and the European programmes of rearmament. These included the growing mechanization of armies, most notably in ammunition-hungry machine guns and anti-tank rifles. It soon became apparent to the British War Office that a distinction needed to be made between battledress worn in action and service dress, worn off duty and less particular in its requirements beyond the need for smart presentation.

Trials of a new battledress – initially known as Field Service Dress (FSD) – took place in the early part of the decade. Safari-style jackets were considered but their length hindered movement. The final design, arrived at in 1937 and tested on a small scale throughout that year, was little different to the service dress adopted in 1902, except that it had dark buttons that did not require polishing and bag-type pockets.

The FSD was introduced in 1938 – the eve of the Second World War – at first in denim, which was found to be too light and insufficiently warm, and then in heavy khaki serge. Trousers were cut in a looser shape that used fabric more economically (a major concern for a potential war economy) and took its cue from contemporary designs for skiers, which allowed better ease of movement.

Not everyone approved of the new rational design. But at the time it was arguably the most advanced in the world. Every detail of the new look had been considered, down to what should

be carried in each of the new pockets: one to the rear, for personal effects; one pleated pocket front right, for field dressing; and one large flap pocket (with hidden button) on the left thigh, in which to store maps. Tabs at the ankles made gathering the material easier before adding gaiters, which themselves replaced expensive high leather boots.

With the exception of minor revisions from late 1942 – to save money the P40 austerity design saw belt loops and ankle tabs removed, and a simple button-through map-pocket flap added – the 1937 battledress (BD) design became the standard for British infantry from the outbreak of the war until 1960. The first combat trousers had been created; other Commonwealth nations introduced their versions of the design throughout the war, as did the United States with what it called its European Theatre of Operations (ETO) uniform. The design was so successful that when the German forces captured large stockpiles after the fall of France in 1940 the trousers were issued to U-boat crews.

Yet more pockets were added to the trousers in 1942; a specialist uniform for US paratroopers saw another large 'cargo' pocket on their lightweight cotton twill trousers. Even then, it seems that US Department of Defense designers and soldiers in the field were somewhat at odds: paratroopers often added a further cargo pocket themselves, the only servicemen who were generally allowed to make personal modifications to their uniforms.

Certainly men and women alike have appreciated their utility, durability, looser cut and perhaps tough street image in civilian life too: cargo pants were a mainstay style of skaters, hip-hop artists – Tupac Shakur helped drive their popularity – and, through the 1990s, girl bands, from TLC to All Saints and Gwen Stefani.

**Opposite:** The multi-pocketed cargo pants were designed to allow US paratroopers of the Second World War – like these in 1943 – to carry as much equipment as possible hands- and bag-free.
**Above:** High fashion has long reinterpreted military garments, as with this Givenchy take on cargo pants for its spring/summer 2019 collection.

# Khakis

*New*

*Campus*

*Classic!*

**LEVI'S**

**CINCHBACKS**

SANFORIZED

NO PLEATS
NATURAL SLIM LINES

**Above:** Khakis were one item in the military uniform that US veterans of the Second World War wanted to wear in civilian life, and soon became a staple of any young man's preppy wardrobe.
**Opposite:** Khaki pants originate in the US military dress uniform, here modelled by Phil Silvers as Sergeant Bilko in *The Phil Silvers Show* of the late 1950s.

Traditionally, flat-fronted khaki trousers, or, more simply, khakis, are a standard casual alternative to jeans, and their strongest associations are with the United States Army during the Second World War and with the preppy style of the 1950s. Their roots, however, can be traced back a further century.

The story begins in 1845, in India. In one version, in an early attempt at camouflage, British soldiers deliberately discoloured their white uniforms, which made them conspicuous targets, with mud, the distinctive local dust, coffee and even curry; *khaki* means dust-coloured in Urdu. In another, Sir Harry Lumsden, commander of the forces in the Punjab, replaced his regulation trousers with lighter, looser pyjama bottoms to cope with the heat. He had them dyed with tea leaves and later realized that they were also useful as camouflage.

In 1848 the British army recognized the military advantages of a colour that blended into the environment and officially adopted khaki for the warm-weather uniforms worn by its troops in India and in subsequent late nineteenth-century campaigns in South Africa, Sudan and Afghanistan. These were originally made in China, ostensibly to save on transport costs, but demand was such that by the 1850s khaki fabric was woven within the British Empire; John Haller, a weaver from Europe, introduced the first hand looms to the Indian region of Mangalore and the invention of khaki dye is usually attributed to him. As a consequence, khaki became a standard colour for the uniforms of armed forces in many countries.

It was not until 1898, during the Spanish-American War, that US troops adopted uniforms of a similar cut and colour. Chino, which has come to describe a more generic casual cotton trouser (khakis, by definition, are chinos in a specific dun colour), is a corruption of the Spanish word for Chinese. The style's general utilitarian use was soon pursued commercially: Levi's, for example, launched its first khakis in 1906 under the Sunset label.

Khakis were officially adopted by the United States Navy in 1912 as part of the uniform worn by naval aviators. They were worn by submarine crews from 1931. Ten years later, in 1941, during the Second World War, khaki trousers made from a tough, twill cloth called Cramerton, created by weavers Galey & Lord, were approved as part of senior officers' uniforms during on-station duties; at the end of the same year permission to wear them during spells of 'liberty' was granted. Two further regulation styles were issued in 1942 and 1945. The khakis worn by British servicemen were a darker shade (known as British khaki) than the US versions, and GIs referred to them as suntans.

After the war, assisted by the huge quantities of cheap army surplus clothing that were available, khakis soon found a role in civilian life. They aged well, were functional, comfortable and hard-wearing, and their style and neutral colour allowed them to cross over. In a big way. They were symbolic of adventure – pioneering aviator Charles Lindbergh and action-man novelist Ernest Hemingway favoured the style – but it was nevertheless their adoption by Hollywood that ensured khakis became a menswear staple. Men's men James Stewart, Humphrey Bogart, Gary Cooper, Clark Gable and James Cagney, and later John F. Kennedy, Steve McQueen and bohemian literary types such as Gore Vidal, were all snapped wearing them.

**Opposite:** A khaki-clad Clark Gable, ready for safari with Grace Kelly, in *Mogambo* (1953). **Below:** Original US Army khaki trousers were made from a hardy twill called Cramerton, also used by Levi's for its version.

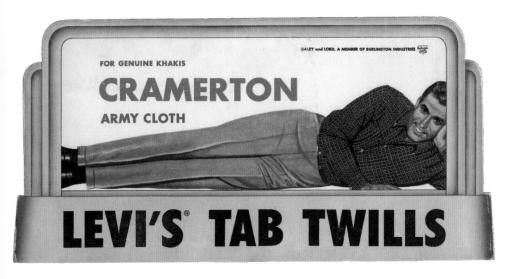

GALEY and LORD, A MEMBER OF BURLINGTON INDUSTRIES

FOR GENUINE KHAKIS

**CRAMERTON**

ARMY CLOTH

**LEVI'S® TAB TWILLS**

# Palazzo Pants

x x x x x x x x x
x x x x x x x x x

**Above:** Palazzo pants in heavy silk – worn with a bodice in the same material – designed by Emilio Pucci.
**Opposite:** Palazzo pants as part of a casual suit, from Stella McCartney's spring/summer 2023 collection.

With their light fabric (often silk crêpe or jersey) and voluminous proportions, palazzo pants are long trousers with a loose and very wide leg that flares from the hip. It is perhaps little wonder that the grandly named palazzo pants – after the Italian for 'palace' – were originally known more prosaically as 'beach trousers'. After all, they allowed air to circulate against the skin without actually revealing any skin; they were skirt-like but would protect the wearer's modesty in case of a coastal breeze. This made the style ideal for the chic resorts defined and populated by the wealthy in the early decades of the twentieth century, as womenswear was freed by changing social values to embrace elements of the male wardrobe, such as trousers.

The trouser had obvious appeal: it was elegant, narrowed the waist and was comfortable. Sometimes it was worn with a loose matching top to create a more dramatic version of the look, obviously inspired by pyjamas. Examples of this style were produced in the 1920s by Parisian couturiers Edward Molyneux and Paul Poiret (who also made harem pants fashionable). Furthermore, their comfort made palazzo pants a popular choice for lounging around the house – as such, they may represent the origins of leisurewear.

Coco Chanel was a fan, sporting them herself on vacation, but also taking them out of their usual summertime context by producing them in jersey wool for her shop in Deauville, Normandy. Chanel also liberated the Breton top from the traditional garb of fishermen (see p.190) and palazzo pants may owe some debt to the wide-legged trousers worn by gondoliers in Venice.

Chanel was not the only woman who favoured palazzo pants: they were popular in similar forms with such actresses of Hollywood's Golden Age as Veronica Lake and Carole Lombard; the latter caught the headlines by wearing the style to play golf with her husband Clark Gable at Los Angeles's upmarket Riviera Country Club. Actress and progressive stylist Katharine Hepburn wore a similar style — more trouser-like and with a turn-up — a decade

later, which she termed 'lounge pants'; and many women during the 1960s found them a means of wearing trousers without doing so in an obvious way that would offend a society that still believed trousers should only form part of the male wardrobe.

This was in no small part down to the palazzo collection produced in 1960 by influential aristocratic Russian-Georgian designer Irene Galitzine, whose silky, wide-legged trousers helped the palazzo style become a fixture of more avant-garde eveningwear dress at society events. It was *Vogue* editor Diana Vreeland who dubbed them 'palazzo pants', a nod to the expensive Mediterranean resorts for which they seemed ideal.

Palazzo pants were not for wallflowers. Their expanse of fabric soon became a site for experimentation in embroidery and bold prints. For example, Italian air-force-flyer-turned-designer and 'prince of prints' Emilio Pucci produced silk jersey pants with geometric, op-art-style, almost psychedelic, patterns during the 1960s. The trousers also lent themselves to the lightness of chiffon jersey, which Pucci invented in 1968.

Women had largely been liberated from strictures of dress by the 1970s when Bianca Jagger made palazzo pants her trademark and was widely emulated. Making a fashion comeback, the style was seen on Ingrid Bergman in 1975 when she attended the Oscars, and was considered elegant yet edgy at a time when the dress code dictated traditional black tie or evening dress. Palazzo pants may have been historically associated with leisure and even sportswear, but their floaty silhouette and their suitability for fine-gauge fabrics make them ideal for eveningwear, and appealing to the sensibilities of designers from Céline to Marc Jacobs.

# Leggings

××××××××
××××××××

When Olivia Newton-John appeared in the video for the song 'Physical' in 1981, she was aptly dressed for the song and for the decade's fascination with work-out routines: headband, cotton top knotted at the waist, leotard and leggings. During the decade she was not alone in borrowing this latter piece of dancer's attire: Madonna, Cindi Lauper and girl group Bananarama all sported them, wearing them often as a form of undergarment beneath a short skirt and sometimes with leg warmers.

Leggings may have been one of the styles that defined the late 1970s and 1980s but, like their historic relation tights, their appeal was also in great part down to their comfort and ease of wear. The same thinking lay behind their sartorial antecedent, too. Despite bewilderment during the 2010s at the idea of men wearing 'meggings' (men's leggings), from the feudal 1300s on, leggings were worn by men as a protective layer. This initially comprised a two-piece garment – one sleeve for each leg – made of wool or leather and worn under chain mail by knights or a smock by those serfs who worked the land. Outdoorsmen of all kinds appreciated the protective leather-stocking layer such a garment afforded, and, ultimately, it was from it that long johns for men developed, and the likes of bloomers for women.

Audrey Hepburn made a form of leggings – worn in black, with ballet pumps and a white shirt or black polo neck – something of a signature look after appearing in them in *Funny Face* (1957), a musical film with a plot in part about the search for the next big fashion trend by a photographer character loosely based on Richard Avedon. But it was not until two years later that a true second-skin, trouser-like garment was developed for women, when, for the first time, advances in textile technology made stretch materials that held their shape and elasticity a possibility.

Chemical company DuPont invented the first versions of Lycra in 1959, with claims that its spandex fibres could stretch up to 500 per cent while retaining shape. This led to the creation of super-skinny, fabric-

belted trousers akin to the Capri pants popular at the time (see p.154), while the world of dance soon picked up on similar styles, both for their flexibility and their means of keeping the leg muscles warm during rehearsal.

It was just a short leap from professional to amateur use, with the late 1970s seeing leggings become a regular at roller discos. They were a staple during the dance and aerobics boom of the 1980s – driven by Jane Fonda's *Workout Book* (1982) and *Flashdance* (1983) – at the same time as designers embraced them as fashionable. Perhaps the most important among these was New York designer Norma Kamali, whose sweats collection first took workout gear from the studio to the street, with London designers David Holah and Stevie Stewart's Bodymap label, launched in 1982, doing much to give leggings a stylistic edge.

**Opposite:** Leggings aren't just for workouts – here a boldly patterned style is part of Maya Hansen's spring/summer 2013 collection.
**Below:** Jane Fonda, the woman who made aerobics a global phenomenon, shown clad in leggings and ready to start.

# Culottes

When Italian designer Elsa Schiaparelli wore what appeared to be a divided skirt in London on a trip to buy tweeds in spring of 1931, it caused a sensation. While trousers on all but the most progressive (or famous) of women were considered disrespectful, women had worn what amounted to a hybrid shorts/trousers/skirt garment since the mid-1920s, ostensibly to enable them to take part more easily in the various sports and physical activities that were becoming fashionable.

However, this hybrid had always been hidden under some semblance of a wrap-around skirt, if only to keep up appearances of standard feminine dress. The garment induced a form of mass self-delusion: as long as the shorts-trousers could pass for a skirt, society would turn a blind eye to the breach of form. Schiaparelli did away with that, and was condemned by the British press. Tennis player Lilí de Álvarez, who wore Schiaparelli's 'divided skirt' for the Wimbledon tournament in the same year, was also criticized.

One theory has it that the culotte was out of favour following the obscenity trial of British author Radclyffe Hall for her 1928 novel *The Well of Loneliness* about a 'sexual invert'. Before the trial, women who chose to wear trousers were, in the UK at least, considered merely affected oddballs, but afterwards they were associated with lesbianism. The heat was less intense among the fashion followers of France, for whom the style was historically familiar. There, something like the Schiaparelli garment had been worn by aristocratic gentlemen since the 1500s. Culottes, in fact, came to be better known because of the opposition to them: during the 1790s and the French Revolution, those against the rigidly hierarchical system dubbed themselves the 'sans-culottes' (and their anti-elitist philosophy 'sans-culottism') or 'without breeches', and distinguished themselves by dressing in full-length trousers.

Culottes slowly achieved acceptance, in part for their novelty. In 1939 the *Deseret News* reported that 'Schiaparelli's flair for leading off with something entirely new and fun to wear must be

**Above:** Designer Elsa Schiaparelli (right) in Hyde Park in 1931, wearing the 'trousers skirt' that caused a sensation.
**Opposite:** Leather culottes from the Chloé autumn/winter 2016 collection.

responsible for her terrific popularity. Witness the tailleur, for example, with its divided skirt – or "jupe culotte", bloused like old-fashioned "gym" bloomers – in place of the regulation skirt.' Yet, the peak in interest for culottes did not come until the 1950s.

The brief popularity of gauchos, a trouser modelled on those worn by the South American cowboys of the same name, was partly to thank for this peak. Worn to mid-calf length, and definitely a form of trouser, they were a gentler reintroduction to the similar but shorter culottes, by then typically worn to the knee or, daringly, the mid-thigh. While culottes would make occasional returns to fashion over the following decades – such designers as Stella McCartney, Marc Jacobs and Bottega Veneta proposed them again in 2011, for example – they more often than not divide opinion, appropriately enough, their very halfway-house status limiting their appeal.

# Jeans

x x x x x x x x x
x x x x x x x x x

**Above:** Levi's jeans were first worn by miners. In 1920 Levi's received a letter of complaint from a miner called Homer Campbell stating that the jeans he had worn for six days a week for three years had not held up as well as the previous pair he had worn for 30 years. On closer examination the jeans were fine. Only the patches he had added were shredded.
**Opposite:** The first riveted denim pant, or modern blue jeans, by Levi's.

Jeans were built to last. From 1886 pairs from Levi's featured the brand's famed two-horse logo, which depicted the animals trying, and failing, to pull a pair of Levi's jeans apart – a handy depiction of the product's durability for anyone who couldn't speak English. The style – described as 'patent riveted waist overalls' – would come to be better known as 501s, after the lot number introduced in 1890 to help track inventory. The 501 would, arguably, go on to become the most iconic garment in modern clothing history.

Jeans were the brainchild of Jacob Davis, a Latvian immigrant and tailor who serviced workers on the fledgling American railroad. He was asked to make working trousers that would not fall apart, and hit upon the idea of riveting the stress points on what was then a jeans-style garment made of white cotton duck. He needed a partner to realize his ambitions, and in 1873 he and Levi Strauss, a Bavarian immigrant and successful dry-goods wholesaler, patented the rivet using Strauss's money. The result was the first pair of jeans – then better known as waist overalls – made of 255 gram (9 ounce) denim from the Amoskeag Mill in Manchester, New Hampshire, and sewn in San Francisco.

Jeans proved to be the ideal, superstrong garment for miners and cowboys, railwaymen and lumbermen; and some seventy years later 501 jeans were symbolic, somehow simultaneously, of generational unity and individual rebellion. Jeans were the garment not only of workers, but also of bikers, rockers and peaceniks and, ultimately, every man and woman.

Reaching this stage was an evolutionary process of details. The original 501 jeans had only one rear pocket, on the right, featuring the Arcuate – an arc of stitching (machine-sewn by eye until 1947). This was perhaps originally used to hold a pocket lining in place, but worked more effectively as an early form of branding that was sufficiently successful to be copied by Levi's competition. In 1901 a second rear pocket – referred to as the fifth pocket (a small one for watches was among the other four) – was

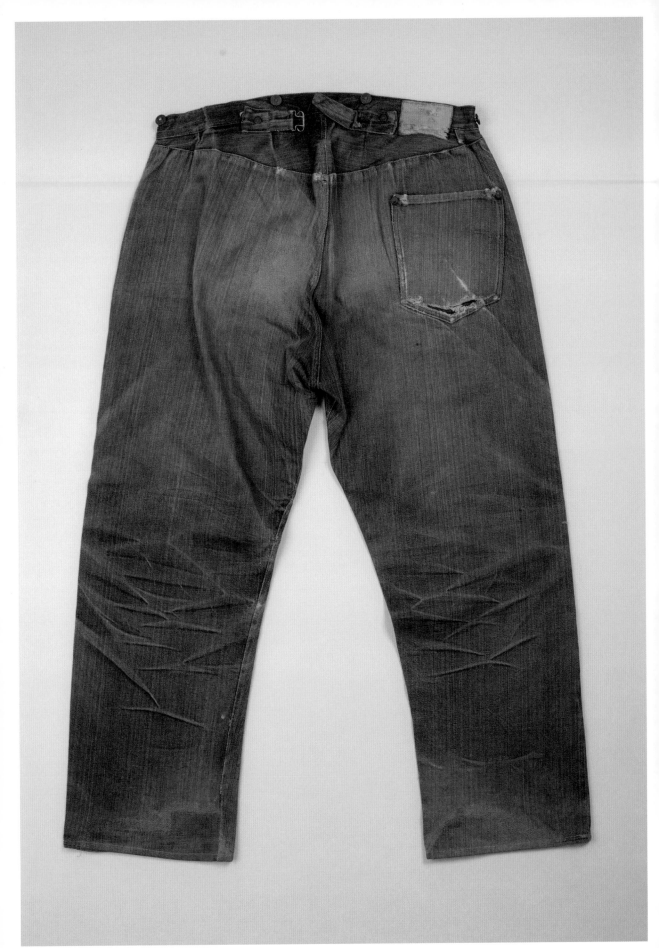

Get the real thing!

LEVI'S®

AMERICA'S FINEST JEANS • Since 1850

added. Belt loops came in 1922, probably because braces were falling out of fashion. By the 1920s the denim was supplied by Cone Mills in Greensboro, North Carolina, which, by the end of the decade, had developed a 225 gram (9 ounce) red-selvage denim called O1 that was used exclusively for the 501.

In 1936 a red tab devised solely to distinguish the style from copyists was sewn into the back pocket edge; the capitalized lettering went lower case in 1971. And in 1937, after cowboys complained that the rear-pocket rivets scratched their saddles and housewives that it ruined the furniture, the pockets were sewn over the rivets. This was also the year when buttons for braces died out (although Levi Strauss continued to provide 'press on' buttons for those who wanted to avoid newfangled belts).

The Second World War brought the last key changes, and the style has remained largely the same since then. Because of a shortage of raw materials, the Arcuate was temporarily replaced with a painted version and the crotch rivet was removed. (The rear-pocket rivets went in 1966 when technology allowed equally tough stitching.) Come 1947 the slim-line, streamlined 501 style recognizable today was born. And was finally ready to go national – until then the jeans had been available only through retailers in western states.

The practicality both of denim and of jeans would not be lost on womenswear of course. In the 1940s, groundbreaking American ready-to-wear designer Claire McCardell – creator of the 'popover' dress that wrapped around the body and the shirtwaister – was one of the first to apply the durability of denim to womenswear, with a view to dressing a new, active, fast-living post-war woman with her collection of casual, sporty, functional clothes. This gave denim its first cachet among East Coast white-collar professionals, and gave the first hint that jeans could be more than the uniform of the teenager and be worn by sophisticated adults not going to a country-and-western hoedown.

However, when Marilyn Monroe wore 501s in *The Misfits* (1961) it was in contrast to her obviously feminine glamour. The countercultural American West Coast hippies of the mid to late 1960s, together with campaigners for peace and equal rights, wore them for practicality – they were cheap, plentiful and comfortable – as a statement of equality, to show community and blue-collar 'everyman' solidarity, but also, crucially, to undercut gender stereotypes. That changed when Calvin Klein became the first fashion designer to show jeans on

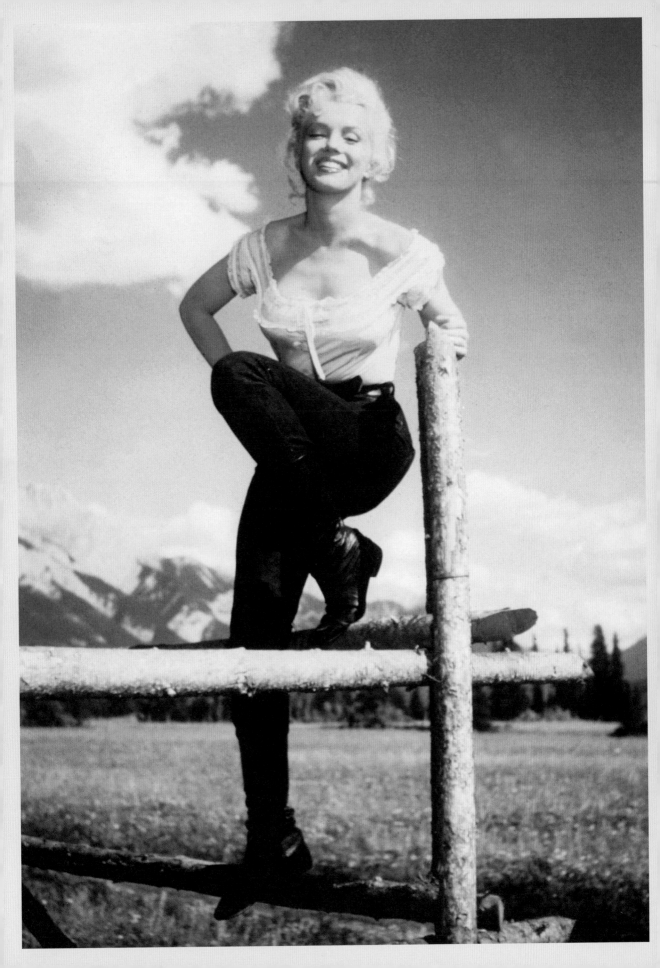

the catwalk, in 1976, although it was not until 1981 that Levi's launched 501s specifically for women.

A myriad of styles came on the market, from boot-cut jeans (devised as the 'cowboy cut' by Wrangler back in 1947) to the 'designer jeans' of Calvin Klein, the straight, baggy, 'boyfriend- cut' jeans (an echo of the fact that if a woman wanted to wear jeans prior to fashion's interest in the garment, she would have to borrow her boyfriend's) and the low-rise jeans that followed designer Alexander McQueen's 1993 'bumsters'.

# Sweatpants

× × × × × × × ×
× × × × × × × ×

The comedian Jerry Seinfeld once joked that wearing sweatpants was a sign that the individual had given up on life. 'Again with the sweatpants?' Seinfeld asks his friend George. 'You know the message you're sending out to the world with those sweatpants? It's "I can't compete in normal society. I'm miserable. So I might as well be comfortable."' 'Sweatpants are a sign of defeat,' as Karl Lagerfeld would later add.

The explosion in what was called athleisure over the 2010s saw sweatpants – or jogging bottoms – repurposed from their sporting origins as a casual alternative to jeans. More tailored styles, some in luxury fabrics, saw the philosophy of ease, mobility and coziness even enter more formal settings, all the more so as workplace dress codes loosened. A Harvard Business School study even argued that the wearing of sweatpants had become a clever display of reverse psychology: it signalled great wealth by suggesting the lack of need to signal at all, as one might through the wearing of obviously designer clothing, for example.

But, arguably, it was the Covid pandemic – and the resulting experiment with home/remote working – that helped sweatpants become a mass-market wardrobe staple, prized for their convenience and, often, their cheapness. For the same reason sweatpants have formed part of the standard issue uniform for prison populations around the world, even for astronauts in training.

Of course, sweatpants originated in sport; with the sweatshirt already established as a practical and, given that it introduced heavyweight jersey knit cottons, eminently washable way to keep warm after practice, the same in trouser form was an obvious logical extension. It was Emile Camuset, the founder of the French sports brand Le Coq Sportif, who introduced the idea in 1920. By the Berlin Olympics of 1936 sweatpants – tie-waisted and with elasticated or zipped cuffs, so they could be pulled over running spikes – were worn by most male and female athletes between competition and on the medal podium.

In 1939 Camuset went on to refine his sweatpants, introducing a more streamlined fit and teaming them with a matching zip-up jacket. And so the track-suit was born, initially dubbed 'the Sunday suit' as considered something to be worn for exercising at or around your home. It was, however, the German sportswear giant Adidas that would popularise the track-suit from the late 1960s.

At this time, track and sweatpants remained strictly for wear in the sporting context. Indeed, even when the wearing of athletic clothes become more socially acceptable as fashion from the mid 1970s and into the 1980s – shaped by the repurposing of synthetic materials to create more form-fitting styles and driven by the boom in aerobics and exercise videos – sweatpants remained the more serious choice. And, given that the classic colour way was grey marl, certainly the less glamorous one. They were ideal then for the sweat-soaked training montages in *Rocky* (1976).

Nonetheless sweatpants were starting to be embraced by style subcultures like the burgeoning hip-hop scene in the United States – a more slouchy, urban option against the track pants favoured by b-boys breakdancing and popularized by bands such as Run DMC. Their 'My Adidas' (1986) and subsequent endorsement deal with that company would kick-start a lasting business relationship between sportswear and hip hop.

Established as a 'street' look, sweatpants would find resonance in later style subcultures such as Roadman, coming out of the UK's grime music scene. Again, the practicality, accessibility, durability and, since Roadman grew out of low income housing estates, affordability of sweatpants all added to their appeal – as did their relative anonymity in the context of CCTV surveillance, especially when worn with matching hoodie. Arguably the anonymity of this attire – see the cover of Dizzie Rascal's 'Boy in Da Corner' album (2203) – also placed extra emphasis on one's trainers: this was where kudos, income and social rank were displayed.

**Opposite (above):** Olympics greats Helen Stephens and Jesse Owens wearing sweatpants in Berlin, 1936.
**Opposite (below):** Grey marl sweatpants and hoodie, beloved of both Roadman and the catwalks.
**Above:** Sweatpants would be rivalled by synthetic – and more colourful – track pants, such as these worn by British rapper Stomzy on stage in 2017.

# Bermuda Shorts

× × × × × × × × ×
× × × × × × × × ×

**PRESENTING OUR EXCLUSIVE KILT JACKET...**
**DESIGNED TO BE WORN WITH BERMUDA SHORTS**

With the tremendous and ever growing popularity of Bermuda shorts there has arisen the need for a shorter sport jacket to wear with them. Our answer to this problem is an interesting, good-looking modification of the authentic Highland day jacket which is worn with kilts. It offers trim lines, casual styling and just the right balance of length to complement Bermuda shorts.

We believe it will be one of the most attractive, practical and widely accepted style innovations that we have ever introduced.

**550** Two-button model Kilt jacket with back vent and fine detailing... in a natural color Brooksweave, finished to look like linen. Brooks sizes 39 to 46 and 48, regulars, longs **$45**

**551** Our well-tailored pleated or plain front Bermuda shorts of a lightweight, comfortable medium or oxford grey flannel. In even sizes, 30 to 42 ............... **$18.50**

**Above:** Tailors were inspired to design jackets to be worn with Bermuda shorts.
**Opposite:** Awkward as it may look, wearing a shirt, jacket and tie with long socks and shorts became the distinctive national dress of Bermuda.

Shorts may not rank highly in the menswear-style stakes. They are all too suggestive of the uniforms of Scouts and private schoolboys, and it's all the better to keep knee holes, those signs of an adventurous life, to a minimum. Arguably, in an age before childrenswear comprised scaled-down versions of 'adultwear', they helped children to think and behave like children. They were acceptable for grown men only on the sports field – plus fours were worn for golf from the 1890s, while the first tennis shorts were not seen until 1932 (on Bunny Austin in the United States men's championships in New York).

Except, that is, for men who lived on the island and British Overseas Territory of Bermuda, from whence come Bermuda shorts, the progenitor of smart shorts. They have been worn here since the 1930s to a strict dress code – pleated and 7.5 centimetres (3 inches) above the knee, together with blazer, regimental tie, tasselled brown or black loafers and knee-length 'Bermuda hose' – as work and even evening attire. 'The short-pant is a terrible fashion choice,' as Winston Churchill had it. 'Unless it is from Bermuda.'

Bermudas are the grandfather of shorts worn today for summer weekends, on vacation and even, in some cultures, to the office. They were part of the Bermudan national dress until 2007, when their association with the island's colonial past and the British armed forces saw their status downgraded. Indeed, the shorts originated with these same armed forces. Bermuda became a military outpost for the Royal Navy in 1816, when the island became its North Atlantic headquarters. Anecdotally, one Nathaniel Coxon ran a tea shop that became a hot spot for the navy. In its crowded interior the heat, always unbearable on the island, grew until the staff complained that their uniform of blazer and khaki trousers was uncomfortable. Coxon's cooling, money-saving solution? Each pair of trousers was cut off just above the knee. All it took then was for Rear-Admiral Mason Berridge, a tea-shop regular, to see the style – he is said to have judged

it to be 'a bit of old Oxford and a bit of the Khyber Pass' – and adopt it for his officers. He added the knee-length socks to smarten up the overall look.

The shorts spread throughout the British armed forces, worn by troops serving in tropical climates who had long shortened their standard-issue trousers when permitted to do so. Which came first – Coxon's practicality or that of the British squaddie – remains unclear. What is clear is that in Bermuda the Royal Navy uniform reflected back on island life; Bermudans found their own distinctive style. Ironically perhaps, men typically wear shorts in every hue except khaki, which is worn only by schoolboys.

In making long, smart shorts an acceptable part of the male wardrobe – sufficiently masculine for Ernest Hemingway to become a big fan – Bermudans harked back to menswear history. By the early nineteenth century men had been wearing what were better known as breeches for over two centuries; made of wool for winter and cotton or linen for summer, they fitted the thighs and were buckled or buttoned just below the knee. For the Elizabethan man the selection was wide: trunk hose (very short breeches), slops (baggy breeches) or galligaskin (very baggy breeches), not to mention French, Venetian and plunderhosen styles. Gentlemen slashed their breeches to reveal a brightly coloured underlayer. On some, additional strips of different-coloured fabric fully covered this lining; with a nod to the name-calling that might result were a man to wear such shorts today, the breeches were said to be 'pansied'. It was not until around 1825 that trousers came into favour, and breeches were subsequently worn only on very formal occasions.

# Hot Pants

**Above:** 'Sex sells seats' as Southwest Airlines of Texas put it in the early 1970s – stewardesses were expected to be able to look their best in hot pants.
**Opposite:** The shorts equivalent of the miniskirt perhaps, and just as daring, Christian Dior's spring/summer 2000 collection sees a pair worn with thigh-high boots.

Very brief and usually tight-fitting, hot pants are aptly named, both for their sexual connotations and for the intensity with which their moment in fashion flared up and then subsided. Few other womenswear garments were such an expression of their time, specifically 1971, a period of women's increased sexual liberation (and a concomitant conservative disapproval), of the rise of disco and even of the need to find a more practical, less revealing alternative to Mary Quant's revolutionary miniskirt (see p.74). Their invention, in fact, is also attributed to Quant, their name to *Women's Wear Daily*. By the end of 1971, *Life* magazine summed up the year sartorially, declaring: 'Hot pants: a short but happy career.'

Hot pants epitomized the decade's growing daring in women's fashion. They were a shorter version of the fitted, beach-party shorts popular during the 1940s and 1950s, notably on Betty Grable, Marilyn Monroe, Esther Williams and on the illustrated pin-ups by George Petty and Alberto Vargas. They also questioned how that daring might cross a culturally acceptable line about propriety and how much flesh a woman could or should reveal.

One minute hot pants were high fashion, introduced on the catwalks of France and Italy for the autumn/winter 1970 collection, the next they were a mass-market item worn to parties, weddings and offices. Most famously, the airline stewardesses of Southwest Airlines in the United States wore orange hot pants and go-go boots as part of their uniform. Another reason why 1971 was a boom time for hot pants was due to an advance in fabric technology: the creation of polyester, which allowed the shorts to be stretchy and close fitting. The style inspired endless sewing patterns, new tequila and schnapps cocktails and songs from Vicki Anderson, Soul Brothers Inc., Bobby Byrd and James Brown. In 'Hot Pants' (1971), Brown sang: 'Hot pants make you sure of yourself / Good Lord – you walk like you got the only loving left', which also identified the style as ideal to dance in.

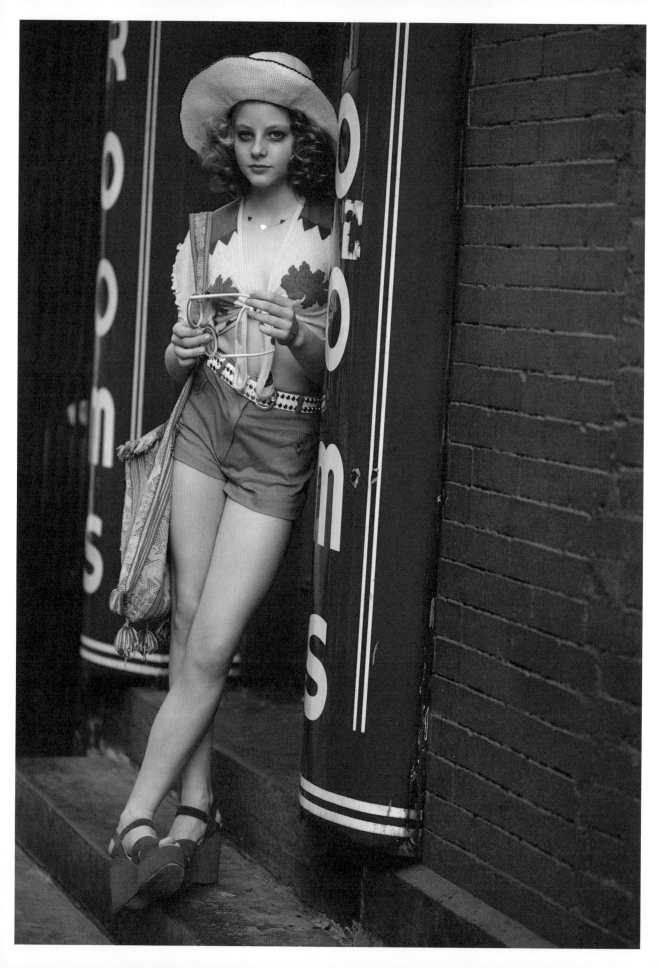

There were those who condemned hot pants as symbolic of sexual availability and the uniform of dubious cocktail waitresses, strippers and prostitutes. These were exactly the kind of cultural export non-Western countries did not want, not even in satin or crushed velvet, let alone in the flesh tones that, from a distance, suggested the wearer was semi-naked. Hot pants were denounced by Daniel Moi, vice-president of Kenya, as an 'undesirable and unbecoming kind of grotesque dress'. Even the West recognized the double life of hot pants: when the costume department for the movie *Taxi Driver* (1976) wanted to express the lost innocence of Jodie Foster's Iris when she turned child prostitute, it was said with hot pants.

This – and the rapid shift in fashion towards longer skirt styles – was the kind of association that tolled the knell for such short shorts. Think of the denim cut-offs worn by Daisy Duke in *The Dukes of Hazzard* (a long-running US television series beginning in 1979) or the fur and suede pair in the Fashion Institute of Technology collection in New York for a sense of how the style – although periodically resurrected by designers Katharine Hamnett, Azzedine Alaïa and Dolce & Gabbana, and performers such as Kylie Minogue in her gold lamé hot pants and Beyoncé in black leather ones – belongs to the 1970s, along with platform boots and flares.

# Fatigue Pants

×  ×  ×  ×  ×  ×  ×  ×
×  ×  ×  ×  ×  ×  ×  ×

When it comes to military garments that have found a place in civilian life, many people will think first of cargo pants, or the M-65 field jacket or the peacoat. Their details speak of life in the services. But it's a far more understated garment that arguably has had greater influence and reach: the OG-107 fatigue trouser, a straight cut, loose-fitting style with two flapped button-fastening back pockets and, most distinctively, two large rectangular patch pockets, from side seam to mid thigh.

The OG-107 trouser was part of the US Armed Forces' standard issue 'utility uniform' from 1952 through to the end of the 1980s – making it one of its longest serving designs and helping to define the army's look through the Vietnam War and Cold War. As such the style was mass-produced in countless millions of pairs, many examples of which made their way into surplus stores – sometimes to be worn by those protesting against the United States' involvement in Vietnam, but also by climbers, hikers, skaters, decorators and anyone else who appreciated the hard-wearing, practical and cheap design.

It also provided the template for countless interpretations by fashion brands too, then often being referred to as as utility or baker pants – thanks, apocryphally at least, to the style being worn by bakers in Japan, home to many an ardent collector of vintage US militaria; maybe because it allowed the young Japanese men who embraced it early to somewhat distance it from memories of US occupation; maybe because the style's patch pockets look a little like the shape of a slice of bread. Nobody knows for sure. What's clear is that the very basic nature of OG-107s has, like chinos, or five pocket western jeans, made them a wardrobe standard, worn with almost anything.

Although officially called OG-107, the trousers were dubbed 'fatigues' by those soldiers who wore them, and maybe slightly resentfully, as this was what they would be kitted out in when 'on fatigue', that is when being kept busy with training and menial chores in times of peace. US servicemen at least also had

dress and combat uniforms to wear, unlike their one-uniform-for-all-purposes poorer British counterparts of the time. So basic was the style that initially it was issued only in small, medium and large, with waist tabs to make any necessary adjustments. A full range of measured sizes was only introduced in 1964.

But the ubiquity, universality and simplicity of the design – especially in contrast to the detail-rich and functional trousers designed for combat – still somewhat belies the energy and consideration that went into its creation. Indeed, it was the product of a post-Second World War effort by the Army Uniform Board to overhaul the look of the US Army soldier for the modern, to project a blend of smartness – fatigues might still be starched and pressed – and readiness in a new age of superpower rivalry.

The desire to signal a break with the past was one reason why the board was keen on having its new trousers – worn with a matching jacket-like shirt – in a different colour. Indeed, the OG-107 was named for the particular darker, deeper shade of cloth it was made from: OG stands for 'olive green'. This was hard-wearing sateen, developed during the Korean War (1950–53) as a replacement for the herringbone twill (HBT) common throughout the Second World War, though by the 1970s this had been replaced by a polyester blend version, the OG-507. This incarnation lasted only a few years before the OG fatigues passed out of service and into style.

# Capri Pants

× × × × × × × × ×
× × × × × × × × ×

**Above:** If the Chanel suit is normally a combination of cropped jacket and skirt, in autumn/winter 2022 the couture collection tried it with Capri pants instead.
**Opposite:** Swedish actor Anita Ekberg wearing Capri pants in her convertible in 1955.

Capri may have been an unlikely inspiration for a fashion designer whose first studio and store, Salon Sonja, opened in the grim surroundings of Munich in 1945 in the immediate aftermath of the Second World War. But it was there that Prussian designer Sonja de Lennart devised the two key pieces of what she would call her 'Capri' collection, named simply after her favourite holiday destination: a wide skirt with matching wide belt and a blouse with three-quarter-length sleeves. Three years later when women, or at least those women who wore trousers, were still sporting wide, straight-legged styles, she added to the collection with a trouser that was slim cut and cropped just above the ankle (or shorter for her summer version), with a small split along the seam. Naturally enough, she named them Capri pants.

'I was just hot,' de Lennart once told *Bild* newspaper to explain the idea. 'I was with my parents on Capri, cut my long trousers and strode through the water. That was wonderful. I found that these pants should be able to work anywhere.'

They seemed decidedly modern – streamlined, svelte and fitted – at a time when people wanted especially to look forward. German actress Mady Rahl took up the style, which helped to create local demand, but it was Hollywood, where more influential leading ladies embraced Capri pants, that they became a signature style of the 1950s. This was the time when de Lennart also combined her designs to show the trousers worn under a button-through Capri skirt. Audrey Hepburn, under costumier Edith Head's direction, wore de Lennart's Capri skirt, belt and blouse in *Roman Holiday* (1953), and she wore the pants, teamed with kitten heels (see p.314), and remade by Hubert de Givenchy from de Lennart's pattern, in both *Sabrina* (1954) and *Funny Face* (1957), making them a key component of her own style.

Following Hepburn, other stars wore the style too, appropriately enough, given that Capri had become a holiday destination for the rich and famous. The style seemed to ably bridge the gap between those

whose image was one of seductiveness – Jane Russell, Ava Gardner, Sophia Loren, Brigitte Bardot, Marilyn Monroe and Elizabeth Taylor – and those whose image was more family-friendly and comedic – Doris Day and Mary Tyler Moore, for example. That said, in her role as Laura Petrie in the hit early 1960s US television series *The Dick Van Dyke Show*, Moore often wore tight Capri pants, which caused some controversy. Most housewives of the era wore dresses, at least on television. Moore countered that most housewives she knew wore trousers, and insisted that she did.

Other designers soon produced their own versions, cropped mid-calf, for example, or cuffed just below the knee as so-called 'pedal pushers' or 'clamdiggers', or even longer, as 'cigarette trousers'. Customers had come to appreciate the style's versatility, looking just as good with heels as with ballet pumps.

# Pyjama Pants

× × × × × × × ×
× × × × × × × ×

There was, in underwear becoming outerwear in the 1980s and 1990s, a certain decadence. But fashion had been there before, with nightwear becoming daywear. The palazzo pants Coco Chanel designed in the 1930s were similar to pyjama bottoms. And the loose trousers Katharine Hepburn would wear the following decade – seductively referred to as 'lounge pants' – also owed a debt to pyjamas. Indeed, 'pyjama pants' was another term commonly used to describe such wide-leg trousers, whether they were plain and silky smooth, or boldly patterned in almost psychedelic swirls (although later the term would be applied to more fitted, typically high-sheen and patterned trousers, sometimes worn with matching shirt).

Loose-fitting trousers had obvious appeal for women – they were elegant, narrowed the waist and, as men had discovered long before, they had the advantage of comfort. Whereas the original pyjama – which can be traced back to the Persian *payjama*, meaning 'leg garment' in Hindustani – would not have been considered a night-time garment, British men in seventeenth-century India wore them whenever they were relaxing. It was later in the nineteenth-century colonial period of the British in India that pyjamas became fashionable with men back in the West as a garment to be worn in bed, sometimes with matching jacket. Although pyjamas were typically worn with bare feet, tailors sometimes made them for their customers with a kind of sock in the same fabric sewn on. By the post-war twentieth century period, pyjamas had become nightwear for women too, as demonstrated by Lucille Ball in the US television series *I Love Lucy* and the Pink Ladies in *Grease* (1978, but set in the 1950s), who enjoyed gathering for pyjama parties.

But the comfort of pyjamas was too appealing to leave to one's sleep and as people began to adopt them before bedtime, pyjama trousers moved towards style alone. While ground-breaking couturiers such as Paul Poiret and Edward Molyneaux had, earlier in the century, been the first to dress up the pyjama trouser in more luxe fabrics and trimmings to

introduce them as suitable for eveningwear, only those in circles for whom such loose, freeing styles on women were acceptable, could wear them then. Later designers such as Yves Saint Laurent, Halston and Celine, who all appreciated the style's silky allure, would take up the idea and give it greater appeal. Then, come the 2010s, designers including Diane von Fürstenberg, Louis Vuitton, Ferragamo and Tommy Hilfiger revived pyjamas once more as both day and eveningwear – but this time both matching top and bottom were worn, the trousers often more akin to printed silky cigarette pants than the loose versions that had gone before. Designer Stella McCartney perhaps took the style to its logical dressed-up conclusion: the three-piece pyjama suit.

**Opposite:** Russian fashion designer Ulyana Sergeenko wears pyjama pants – with matching pyjama shirt – in 2018.
**Above:** Kate Moss wearing pyjama pants at the Dior catwalk show in 2018.

Bespoke Suit
Dinner Suit
Sack Suit
Blazer
Ready-to-wear Suit
Tweed Jacket
Trouser Suit

# 5.
# Tailoring

# The Bespoke Suit

**Above:** Bespoke tailoring by Anderson & Sheppard, 2024.
**Opposite:** Movie stars of the era before the Second World War – such as, here, Clark Gable, in 1932 – saw the wide-shouldered suit as a means of emphasizing their masculinity and so their screen appeal.

Perhaps no other garment typifies the apogee of men's style more than the bespoke suit – made by hand, and from scratch, for the individual; designed with a tailor's eye to hide the wearer's physical weaknesses and make the most of his attributes; magnifying masculinity; its sombre shades the epitome of formality. Unlike other icons of the male wardrobe, it did not originate with one company, nor was it designed to suit a particular need. The suit, as the heart of menswear, is a garment of evolution.

The English king Charles II took to wearing a long jacket, waistcoat and breeches – the basis of the modern suit – in the late seventeenth century, at a time when war with Holland had left the national coffers at rock bottom and a new frugality was in order. The garments were made from dark, matching fabrics and as a result Charles's courtiers were forced to stop wearing the rich materials and flamboyant finery that characterized the dress of any man with enough money to buy new clothing. This change was more radical than it may seem today: not only did the aristocracy define fashion but also clothes were an expression of status and wealth. To dress darkly was to dress like the masses and was, arguably, the first step towards the democratization of the suit. A further step, by the eighteenth century, was to adapt clothing to make riding more comfortable by shortening the jacket, cutting it away from the front, making the whole ensemble closer fitting and tailoring it in warm wool; unbuttoning, and turning back, the top button prefigured jacket lapels.

The English gentleman-about-town George 'Beau' Brummell, and his fanatical attention to how his clothes fitted (more tightly than ever before), brought the suit even closer to the kind that is worn today. Such was Brummell's command over perceptions of correct dress in early nineteenth-century fashionable society – not to mention the influence he wielded, thanks to his on–off companionship with his 'fat friend' the Prince Regent, later George IV – that by 1824 Beethoven was bemoaning his lack of a

black coat to wear for the premiere of his Ninth Symphony in Vienna. Brummell's influence during the nineteenth century's first two decades also saw suits that were 'bespoken' for an individual: they were made for him, in terms of both his form and his fancy. Influenced by country sports and the needs of military men, the suit as it is known today was effectively established by the twentieth century.

Although bespoke tailoring is not quintessentially British, and it probably originated in medieval France – 'tailor' is derived from *tailler* (to cut) – it was London's Savile Row area that came to be recognized as its spiritual home: the Japanese take their word for a suit, *sabburu*, from the street name. It was where the great and good had their suits made. The making of the first one was a rite of passage, with its dozen or more personal measurements, the discussion of cloth, cut and details, the making up of a pattern, and the several fittings required to perfect the final garment. Anderson & Sheppard, Gieves & Hawkes, Henry Poole and Huntsman & Sons are among the oldest and most esteemed names – with, latterly, more directional ones such as Tommy Nutter, Hardy Amies and Douglas Hayward.

Historically, the old guard have been the most protective of tradition. For instance, two developments in the 1930s – belted trousers and the trouser zip – were widely considered too radical. Traditionalists thought belts spoilt the manner in which trousers hang. And only Lord Louis Mountbatten favouring the zip saw the contraption reluctantly adopted.

The periods before and after the Second World War saw the first high-quality ready-to-wear suits available on a truly mass scale, with bespoke tailoring increasingly for the elite. By the turn of the twenty-first century, however, Savile Row had taken a more commercial, customer-friendly approach. Several new companies that were as au fait with marketing as they were with cutting and sewing opened shop and gave bespoke tailoring a new, more fashionable and accessible lease of life, especially in the face of the increased casualness of men's dress.

# The Dinner Suit

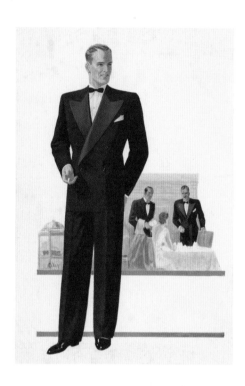

**Above:** The peak-lapelled dinner suit of the 1930s and 1940s was arguably the best of all variations.
**Opposite:** Thanks to the James Bond films' iconic opening credits, evening dress – the dinner suit – is forever associated with agent 007. Sean Connery, here, first wore the attire in *Dr. No* (1962).

The dinner suit is a curio in the male wardrobe: a specialist item, yet designed more for effect than function; expensive, yet rarely worn; supremely elegant and beloved by Lotharios and James Bond, yet giving little opportunity for self-expression. While it has evolved by small degrees since its arrival in the mid-nineteenth century, the dinner suit today is much as it was then: a fitted jacket with slit pockets, one-button fastening and – its most distinctive feature – a shawl collar covered in silk, velvet or grosgrain or, from the early twentieth century, a jacket with more military peak lapels; matching trousers; white wing-collared shirt; and neat bow tie.

It has been suggested that dressing for dinner came about because upper-class gentlemen whose clothes were grubby from activities on their estates needed to change. Influenced by menswear's love of black – from Beau Brummell's rejection of finery, through to Victorian practicality and Protestant restraint – dinner dress was originally an adaptation of military uniform, rendered in the colour of the night. The white shirt was starched and worn with a matching bow tie and a waistcoat, topped with a cutaway silk-lapelled jacket or tailcoat (as worn for riding) and trousers with a braided seam (as in uniforms of the day). Called 'full dress', the ensemble is worn today on especially formal occasions.

A shorter 'dinner jacket' infiltrated evening events, via the smoking jacket, and finally evolved into a new, more relaxed take on full dress. Queen Victoria's eldest son, the future Edward VII, adopted the look in 1860 and ensured its place in polite society. In 1886 the New York millionaire and coffee broker James Brown Potter, a guest of the prince, emulated him and introduced the style to the members of Tuxedo Park, a private country club for wealthy New Yorkers – from which the dinner suit (aka evening suit or 'black tie') takes its more informal name: the tuxedo.

While elitists prefer the term dinner jacket, tuxedo was commonly used in the United States. In Europe the jacket became known as

the Monte Carlo – perhaps as a consequence of it being worn in Monaco's famed casinos – or, especially in France, *le smoking*, reflecting the style's historical connection to the smoking jacket.

Whatever its name, by the 1920s the dinner suit had democratized eveningwear, inasmuch as tails were rarely worn and the style was suitable for most functions. Its adoption by Prince Edward, international trend-setter and future Duke of Windsor, more or less guaranteed its wide acceptance as the standard in dinner dress. The prince introduced twists of his own, most notably the use of midnight blue, rather than black, fabric, and a backless, white pique waistcoat – a bib held together 'behind the scenes' by two straps.

Later changes to the standard style included the abandonment, in the 1930s, of the waistcoat (the cummerbund, although widely considered gimmicky, sometimes took its place); the adoption of the Marcella, a semi-stiff-fronted or pleat-fronted shirt (with a turn-down collar and cuffs in the waistcoat's piqué); and lighter fabrics. Variations such as double-breasted jackets, white jackets for warmer weather and colour-coordinated accessories have been more fad than properly formal.

Attempts were later made to introduce an element of fashion and, perhaps, individualize the conformity of what was supra-fashion and adherence to dress etiquette. The 1950s and 1960s saw jackets in loud colours, patterns and textured fabrics – silk-faced lapels retained some formality – and experimentation with ties such as the continental crossover, a silk strip that overlapped where the knot had been and was held together with a button. Fashions in the 1970s included dramatic, Edwardian flourishes and cuts, even Nehru jackets. Small wing collars and red accessories appeared in the 1990s, and the 2000s was the era of notch lapels and the 'creative black tie'. However, the style established by the 1930s continues to define the classic and, one might say, the most legitimate 'black tie'.

**Top:** Ryan Reynolds, with wife Blake Lively, subverts dinner dress etiquette for the Met Gala of 2022 by wearing white tie with a lounge suit.
**Above:** Correct dinner dress once meant wearing white tie and tails – here modelled by Cary Grant and Randolph Scott in 1934 – although the influence on fashion of Edward VII effectively saw a dark lounge suit style take over.
**Opposite:** The dinner suit is arguably the most glamorous item in a man's wardrobe, an association from which advertisers have often sought to benefit.

# The Sack Suit

**Above:** Gregory Peck considers his tailoring in *The Man in the Grey Flannel Suit* (1956) – the suit became symbolic of his character's unwilling embrace of corporate America.
**Opposite:** The style of Brooks Brothers' sack suit was a radical departure from the traditional tailoring of the time, indicative of a company that knew even men's suiting had to keep evolving. 'If we were thoroughly conservative, we'd be dead,' a Brooks Brothers executive said in the 1950s.

The turn of the twentieth century saw a radical new development in menswear. Until then, most gentlemen's clothing was custom-made or custom-ordered; the idea that someone could walk into a store with a wallet and walk out with clothing was a bold departure from the norm. Brooks Brothers has attributed much of its early success to its then innovative emphasis on ready-made clothing – it sourced its own fabrics and operated its own workshops, as, for example, Montague Burton did in post-war Britain, providing countless servicemen with their 'de-mob' suits.

Manufacturing ready-made garments meant that the company became the designer, with decisions about dress and style made for the customer rather than by him, and was consequently a definer of style and shaper of society. Perhaps the most profound example of this was the impact on tailoring. Until 1900 men generally had their suits – stiff, hard-wearing and precision-fitting – made for them. But in this year Brooks Brothers introduced its Number One 'sack suit'. Its rather unflattering name was at least accurate: Brooks brought the baggy clothing that had been worn by the average man for some decades to tailoring. The suit had a softer construction, a 'natural', padding-free shoulder, a comfortable, four-button jacket (a three-button was launched in 1918) with a centre vent and a buttonhole in the left lapel, and straight, loose trousers.

It was, in a way, the first case of deconstruction. More casual, comfortable clothing was a fashion choice rather than indicating that someone was indifferent to what they wore. The suit was widely imitated and set the basic style for American menswear, and business dress in particular, for at least the next five decades; the protagonist of *The Man in the Grey Flannel Suit* (1956), in which Gregory Peck's character epitomizes the anonymity of office life and corporate America, wore a style that is a clear descendant of the sack suit. So too is the characteristic Italian fashion suiting of the late 1970s and early 1980s when Giorgio Armani was said to be (re-)releasing men from the strictures of traditional tailoring. Pedestrian as the sack suit

style may look today, when it was introduced it extended boundaries, less as a disposable fashion – something to which Brooks Brothers was opposed – and more as a progressive, functional way of dressing.

When Brooks moved away from the Number One sack suit cut it did so largely out of desperation. During the Great Depression, in a bid to increase sales, it had displayed the suit, complete with price tag, in its store windows as a totem of what later would be called its brand identity; what was then regarded as aggressive marketing scandalized the company's regulars, and the suits were soon removed. Later in the 1930s, in another bid to encourage customers to buy, Brooks introduced the Number Two suit, with a nipped-in waist and broad, padded shoulders. One writer of the time called it 'a ghastly concession to hard times'. Tellingly, when trade picked up, the company quickly modified the style along Number One lines.

As the *New Yorker* put it in 1938, the sack suit is 'the real trademark of Brooks Brothers. Brought up-to-date every year or so, it nevertheless essentially hasn't changed in half a century. The coat has been copied time and time again by other tailors, but the true Brooks fanatic insists upon the natural shoulders, the distinctive roll of the lapels, the straight lines, the general uncompromising sloppiness of the general article.' And the reference to sloppiness was a compliment. The sack suit, as the article went on, 'remains a whole philosophy of dress'.

# The Blazer

//////////////////////////
//////////////////////////

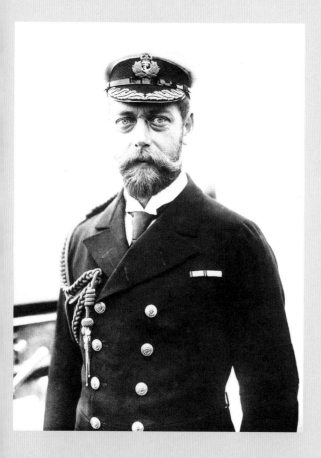

The blazer has long seemed most at home with the old school tie and a certain hauteur. The kind of semiformal tailoring worn on yachts or at polo matches, it is the jacket of respectability donned by David Niven in *Death on the Nile* (1978) or the cinematic James Bond in *The Man with the Golden Gun* (1974), rather than that of practical, shabby seafaring as worn by Humphrey Bogart in *Key Largo* (1948).

While the blazer is typically teamed with chinos and loafers for casual smartness, it finds its origins in the disciplined environment of the Royal Navy. Before the introduction of blue and white dress regulations for all servicemen, it was not unknown for captains to decide on the look of their crews' uniforms. During the mid-nineteenth century this loose arrangement allowed Captain Wilmott of HMS Harlequin to pay for his men to wear harlequin outfits and the captain of HMS Vernon to order his to wear red serge frocks; when stock ran out only the port watch dressed in red and the starboard wore navy. So in 1837, when the captain of HMS Blazer heard that the new queen, Victoria, would inspect his ship, he smartened up his crew by making them wear blue-and-white striped seamen's sweaters and navy-blue jackets in a short, black-buttoned, double-breasted reefer style – 'reefing' the sails reduces the area of sail exposed to the wind.

That is one story, and the double-breasted, side-vented, navy-blue blazer certainly became part of the nautical fashion inspired by Britain's nineteenth century naval power and empire-building. There is a clear lineage to HMS Blazer's jackets: the reefer evolved to become a longer style with six gold buttons, worn as part of an officer's dress uniform. So-called monkey jackets, with eight buttons, worn on active duty are similar, and army regiments adopted the style (often in shades of green) for unofficial wear at civilian events. Another story is that the style originated with the jackets worn by members of the Lady Margaret Boat Club of St John's College, Cambridge – they were an eye-watering red, suggesting their wearers were on fire, and so were called 'blazers'.

The style became known as a boating jacket and, in turn, as one for sports, mainly tennis and cricket, at a time when players' uniforms were less specialized than they are today and more hidebound by sartorial rules. In this context, blazers were as bold as team strips in order to differentiate teammate from opposition: although the traditional double-breasted blazer in block navy is now the standard, on earlier, single-breasted versions bold stripes or distinctive contrast piping for lapels and cuffs were common in the United Kingdom.

This style became part of the British public school uniforms of the Edwardian era, complete with badge or crest on the breast pocket and a matching peaked cap or boater. 'The striped flannel jackets, under the familiar name "blazer", brilliant in colouring, created for the river and the cricket field, are worn on nearly all occasions now by girls and boys,' a commentator in the *Lady's World* journal noted in 1887. Blazers were often awarded as a mark of sporting or academic excellence, or membership of an august institution of higher learning. Perhaps this association with certain elites is why they were appropriated by the mods of the 1960s: members of the Who, the Kinks, the Yardbirds and the Animals, among other key groups of the era, often dressed more as though they were about to attend Henley Regatta than trash the stage.

**Opposite:** The Duke of York, the future King George V, wearing his captain's uniform, including his navy blazer, on his ship HMS Crescent. **Below:** Rock/blues band the Yardbirds – which proved to be the musical launchpad for Eric Clapton, Jeff Beck and Jimmy Page – in the mid-1960s.

# The Ready-to-wear Suit

'To his tailor no man is a hero,' read a newspaper advertisement of the early 1950s, complete with an illustration of a man in a neat two-button, single-breasted, three-piece suit. 'Overall statistics from the records of Montague Burton Ltd, the world's largest tailoring organisation, produce this picture of The Average Man. His height is 5ft 9in and he has a slight tendency towards rounded shoulders. He boasts a 38-inch chest measurement and a 35-inch waist. His arms are 32 inches long and his legs are 30 and three-quarter inches (inside measurement) …'

Montague Burton's company, later known simply as Burton's and still going strong, was among the first to offer the average man the kind of tailoring that had previously been available only to the wealthy. If bespoke tailors cut for the singular man and charged accordingly, Burton made suits that hid most sins and cost considerably less. In effect, he helped to democratize the suit and pave the way for today's ready-to-wear versions.

This had been his mission when in 1903, aged eighteen and with £100 borrowed from a relative, he opened the Cross-Tailoring Company in Chesterfield in England, with the promise that men could replace their cotton or moleskin working clothes or hand-me-downs with a made-to-measure suit offered at an accessible price and in a new style that was equally at home in town or country, for factory or office work.

He fulfilled his promise not least by adopting what were radically humanistic employment policies: fair wages, workers' rights and progressive working conditions, including Europe's first air-conditioned factory and largest canteen. He also divided tailoring labour so that a customer could have a suit made from scratch and delivered in 24 hours, and instituted vertical integration. Then a revolutionary idea, this meant controlling the production process from weaving through to manufacture and sales, and eliminated profits that would otherwise be made by intermediary companies.

**Above:** Pages from Burton's catalogues of the 1940s and 1950s display the broad spread of styles that was possible. Modern tailoring methods, said Burton, mean that men 'are able to afford a greater change and variety of attire, which tends to develop a race of well-dressed men. And the immaculate citizen is an asset to his community and a credit to his country.'
**Opposite:** English goalkeeper Gordon Banks, on the right, with actress and socialite Viviane Ventura in the 1960s.

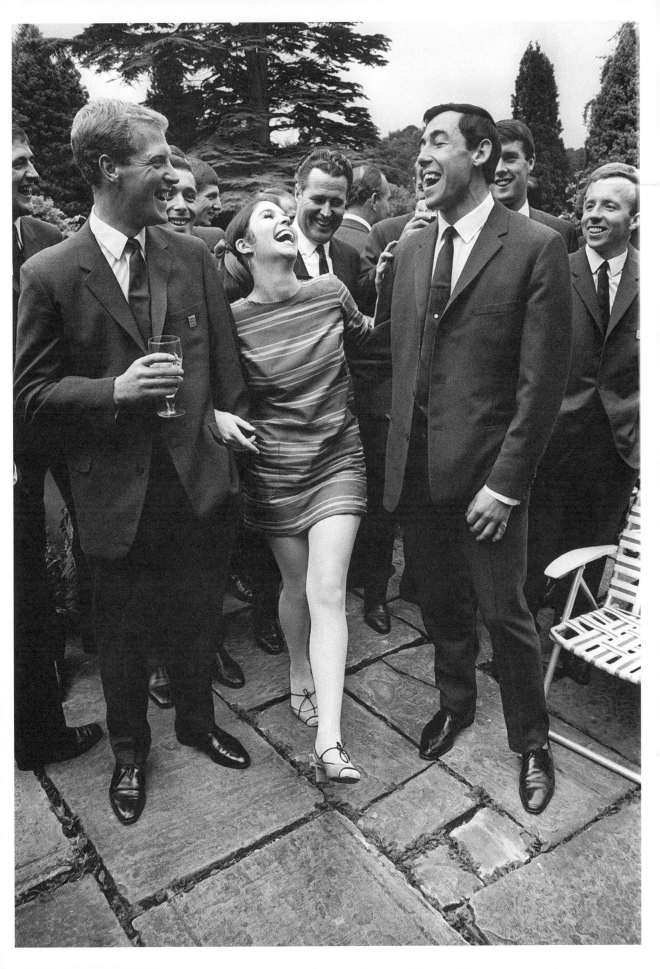

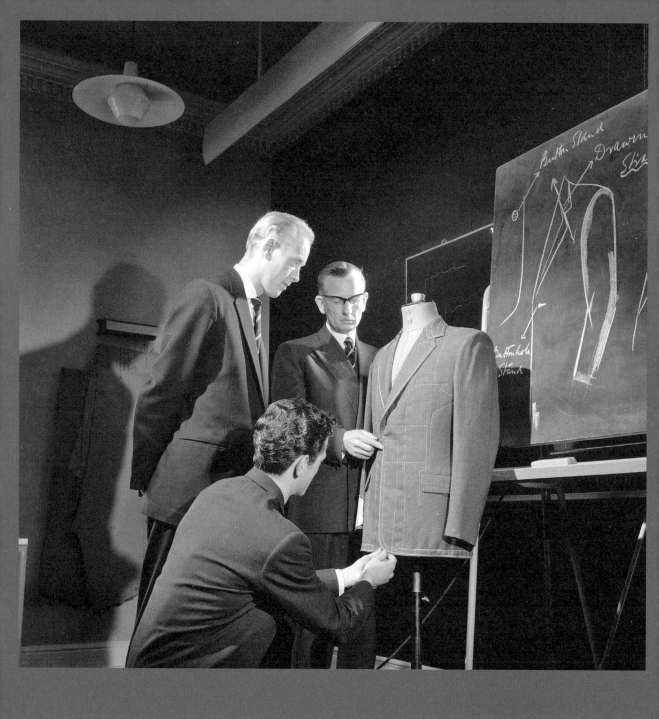

During the First World War some 25 per cent of British soldiers wore uniforms made by Burton's company. This gave it the financial footing to expand massively, so that by 1928 it was operating some 400 shops, factories and mills across the UK and served the entire British Empire. In his book *Ideals in Industry*, published in 1925, Burton opined that the war, along with a general societal overhaul, had been the making of the modern suit: regional and professionally distinct styles of dress 'underwent a swift and radical change'.

In time, Burton suits became part of the social fabric of Britishness, not least because they were long-lasting; each cloth and style underwent rigorous tests, including rubbing, simulated downpours, exposure to sunlight, and soaking the sleeve linings in a solution that was described in *Ideals in Industry* as being 'equivalent to that of the perspiration produced by an average man after standing continuously in a hot atmosphere for 145 minutes'.

When the Second World War ended Burton supplied all servicemen with clothes, including a three-piece suit, for their return to civilian life. This demob (from demobilization) suit was nicknamed 'the full Monty' – what would become slang for 'the whole thing' or 'everything that is wanted or needed'. By 1950 one in five men in the UK wore a Burton suit every day, and in 1966 the company provided England's World Cup football champions with their suits. By then, thanks to Burton's pioneering, ready-to-wear tailoring was a widespread reality.

"Laird" Scotch Tweed Plus-Four Suit possesses a rugged strength in wear and a proved loyalty in service like a trusted friend faithful in all weathers. If you are hard on your clothes, here's your choice . . And you'll wonder that so much beauty of pattern, so much delicacy of style can be combined with rigour of service. As smart as it is sturdy, as delightful as it is durable . . . as popular as its price

5 GUINEA VALUE
PLUS FOUR SUIT
TO MEASURE FOR **55/-**

**Opposite:** Montague Burton, on the left, pioneer of high quality affordable ready-to-wear tailoring in the UK from the 1950s on. **Above:** More from Burton's early catalogues. The company aimed to offer what Burton suggested was 'a five guinea suit for 55 shillings'. This was made possible by complete control of the production process.

# The Tweed Jacket

The single-breasted two-button tweed jacket is a quintessentially British garment – and a contradictory one. Rough to the touch, it is tailored yet often sloppy. It suggests the upper-class country-house set but was adopted by 1950s radicals; it is smart enough to go almost anywhere, yet is sturdy enough to be worn around mud and muck. The tweed jacket is Prince Charles carrying a shotgun – and Woody Allen wearing battered cords.

Tweed itself is the story behind the jacket. It was first made in Scotland, and is the generic name for a flecked woollen fabric that was carded and spun by hand, woven, and then stretched and dried before being cut and sewn. Thornproof and naturally water repellent, its thickest versions can weigh up to 800 grams (28 ounces). It initially came in the subdued shades of the Highlands: browns and pale greens, blues, greys and shades of heather that blended into the terrain like an early form of camouflage. Old tweed even has a characteristic smell created by the lichen dyes, known as crottle, used to create its characteristic flecks.

The original fabric was a twill, known in Scotland as tweel. According to a possibly apocryphal story, it was given the name by which it is now known in about 1830 by a London cloth merchant who misread tweel for tweed in a letter from a Scottish weaving company, and assumed the latter was a brand name taken from the Tweed River, which runs through what was then the heart of the textile manufacturing region in the Scottish Borders. The fabric was consequently promoted as tweed and an industry grew out of the demand south of the border. Production reached its peak in the mid-1960s, when the farmer in the field, the gentleman in his club and young lecturers at the new British universities all wore tweed jackets.

Some aspired to the king of tweeds: Harris tweed or *Clò Mòr* (the big cloth) in Gaelic. A brand name in itself, at one time it encompassed over 8,000 different designs (thanks to the introduction of more advanced looms during the 1920s). It is the catch-all term for tweed made with local wool, which is today spun and dyed by machine but still hand-woven by

islanders in their homes on the Scottish islands of Harris, Uist, Lewis and Barra in the Outer Hebrides.

Harris tweeds were first put on a commercial footing by Lady Catherine Herbert, the widow of Alexander, 6th Earl of Dunmore and owner of the North Harris estate. In 1846 she commissioned skilled Harris weavers to copy a tartan for jackets worn by the estate's gamekeepers. The detail and colour of the fabric impressed her landed gentry friends, and it became fashionable as far away as Queen Victoria's court circle in London. The cloth, and in particular a tweed suit, came to define what a gentleman wore in the country, and was also central to men's semirural wear.

In 1909 genuine Harris tweed was granted a certification mark that defined it as 'a tweed, hand-spun, hand-woven and dyed by the crofters and cottars in the Outer Hebrides'. This gave it the type of appellation contrôlée applied to the likes of champagne and cognac, and was a prescient move: during the 1930s an attempt by weavers on the Scottish mainland to imitate it in order to capitalize on its popularity resulted in a record civil case. Harris tweed won and its provenance was protected. Later legal changes allowed the fabric to be made with wool from anywhere in the world. However, while Harris tweed's fortunes have fluctuated, the old-world appeal of the tweed jacket has not.

**Opposite (above):** Although different estates in Scotland have had distinctive colours and patterns of tweed, the tonal range of the most typical variants is clearly that of the British countryside: moss, heather, bark.
**Opposite (below):** The most acclaimed tweed cloth is made by Harris – handwoven, dyed and spun in the Outer Hebrides of Scotland and enshrined in law by the Harris Tweed Act 1993.
**Below:** James Stewart wearing a checked tweed blazer over a yellow sweater in a publicity shot of 1935.

# The Trouser Suit

It was bold for any woman to play with gender stereotypes through her clothing during the 1920s and 1930s. Exceptions, perhaps, were the Hollywood stars such as Marlene Dietrich, who wore trouser suits by Elsa Schiaparelli, and Josephine Baker, a regular at the Parisian men's bespoke tailor Cifonelli, or later such artists as Frida Kahlo and Lee Miller. Their celebrity and/or avant-garde lifestyle somehow permitted it. But not for others.

Society has long-held deeply cultural prohibitions against women dressing as men, sometimes, as in the late eighteenth and early nineteenth centuries, even proscribing it in law. It was only from the early 1890s through to late in the first decade of the 1900s that women were permitted to wear trousers in public for horse riding and bicycle riding. This was not, however, an issue for most women, and few would have considered wearing what was strongly defined as a man's two-piece suit – it was the choice of some early women's rights campaigners during the 1920s precisely because of its scandalous nature and bohemianism.

This was political dressing, much as, historically, other women saw the power benefits of male dress and adopted these psychological advantages full-time. In the mid-nineteenth century, Josephine Monaghan was forced west in America's frontier land after having an illegitimate child, and survived by dressing as a man, cropping her hair and even scarring her face for full effect. Portuguese general Tito Gomes was jailed for three years in the 1990s after fraudulently collecting a military pension for twenty years. The general, better known to her family as Maria Teresinha Gomes, said that one day she had put on the uniform for a carnival and noticed how 'everyone respected me, while as a women I felt diminished'. Women pirates from the early 1700s Anne Bonny and Mary Read through to jazz musician Billy Tipton in the 1900s all found they were awarded privileges dressed as men that they never gained as women.

In contrast, until the Second World War, most women who did wear trousers did so purely

**Above:** Back when a woman wearing 'male' clothing was still a radical statement, movie star Marlene Dietrich pushed at the boundaries in a very public way, starting with the film *Blue Angel* (1930).
**Opposite:** Bianca Jagger, seen here in 1979 wearing a white suit. She and husband Mick Jagger often wore complementary suiting.

for acceptable reasons of practicality – for ranch or factory work, or because one happened to be an adventurer–aviator like Amelia Earhart. But this was a trend that the war made much more commonplace, so much so that throughout the 1940s it became fashionable for women to wear trousers, again assisted by the endorsement of 'slacks' by Hollywood stars such as Katharine Hepburn (whose characters often played on her supposed mannishness). Trousers were worn for sport and leisure. For most, the tailored suit, however, remained an outsider proposition – the stuff of theatre and androgynous play. It was a perception that would last, as shown by Julie Andrews in *Victor/Victoria* (1982), Annie Lennox of the Eurythmics and Madonna during her *Vogue* era.

What type of suit would become accepted by society and fashion alike? It turned out to be a much softer, more feminine version, popularized by André Courrèges and Yves Saint Laurent in the mid-1960s. Most noteworthy was the latter's 'Le Smoking' of 1966, a velvet and wool dinner suit reinterpreted for the female physique, which helped revolutionize attitudes towards women in trousers and scandalized society in the process. When singer Françoise Hardy wore it to the Paris Opera, 'people screamed and hollered', she recalled. New York socialite Nan Kempner was refused entry to upmarket restaurant La Côte Basque in 1968 wearing a trouser suit, so she removed the trousers and wore the jacket alone as a kind of impromptu minidress (and was admitted). 'For a woman, Le Smoking is an indispensable garment with which she finds herself continually in fashion, because it is about style, not fashion. Fashions come and go but style is forever,' Saint Laurent noted in 2005.

Through the 1970s, the pant suit was taken on by American designers Ralph Lauren, Bill Blass and Calvin Klein. The fabrics used may have been traditionally masculine – flannel and tweed – but the cut was more fitted in the body, looser in the leg and altogether less manly. By the end of the decade, and in no small part thanks to the wardrobe of Diane Keaton in *Annie Hall* (1977), women wearing what a few decades before had been considered masculine clothing was now mainstream. Come the 1980s, and power dressing, the trouser suit complemented the corporate climb of women in the workplace, even somehow symbolizing the idea of playing businessmen at their own game.

**Above:** Diane Keaton arguably helped make the idea of women wearing mannish clothing widely fashionable through her role in *Annie Hall* (1977).
**Opposite:** Cara Delevingne wearing a mid-blue suit from the Christian Dior collection for autumn/winter 2021.

T-shirt
Breton Top
Blouse
Twinset
Crop Top
Tube Top

# 6.
# Tops

# The T-shirt

Top: Sailors aboard a US Navy ship take a break to play cards in the mess hall, during the 1950s – the white T-shirt was by then standard issue uniform.
Above: The Suedeknit T-shirt became one of Hanes' best-selling styles after the Second World War. Indeed, it rapidly became an everyman and everywoman product. 'On their precious vacation dates, Dad and Mom will really relax – in Hanes Suedeknit Sports Shirts,' ran an advertisement in 1948. 'So comfortable – yet you look and feel "well dressed" for any resort occasion.'
Opposite: Screen legend Paul Newman served in the US Navy from 1943 – perhaps this is where his love of a simple white T-shirt came from.

In about 1913 amendments to the uniforms of both the Royal Navy and the United States Navy meant British servicemen wore a vest-type undergarment and American seamen a cropped-sleeve undershirt – an evolution of the square-necked, shoulder-buttoning shirt worn since the 1880s. The changes were ostensibly made to leave men's arms free when they performed deck chores or manned armaments. White (still the T-shirt's most popular colour) was chosen for several reasons: it married well with the colours of navy uniforms, it was cheap to manufacture as it required no dyeing, and since it revealed dirt it helped to instil self-discipline and maintain hygiene. The problem was that the British garment offered little protection and the American one was made of wool flannelette and took a long time to dry.

Two companies in particular led the development of the T-shirt as it is now recognized. Before the First World War a UK manufacturer, Thomas A. Hill and Co. – established in the late nineteenth century and later known as Sunspel – had exported long-sleeved but lightweight cotton underwear to tropical climates, notably to Britain's colonies in the Far East. Meanwhile, a US fabric merchant, Jacob Goldfarb, was selling, under the Fruit of the Loom brand, an evolution of a T-shirt-type garment he had been making since 1910. When British and American soldiers met in the trenches the idea of combining a cotton fabric with short sleeves was born. The other major T-shirt manufacturer, Hanes, creator of the Beefy T, entered the market in about 1930.

The popularity of the simple T-shirt grew in the run-up to the United States' entry into the Second World War: a Sears, Roebuck and Co. advertisement proclaimed, 'You don't need to be a soldier to have your own personal T-shirt', suggesting the item was fast becoming indicative of a certain heroism or machismo. Nevertheless, wearing an uncovered T-shirt did not become socially acceptable until after the war, when public resistance had been worn down by images of soldiers at work and unconcerned with propriety.

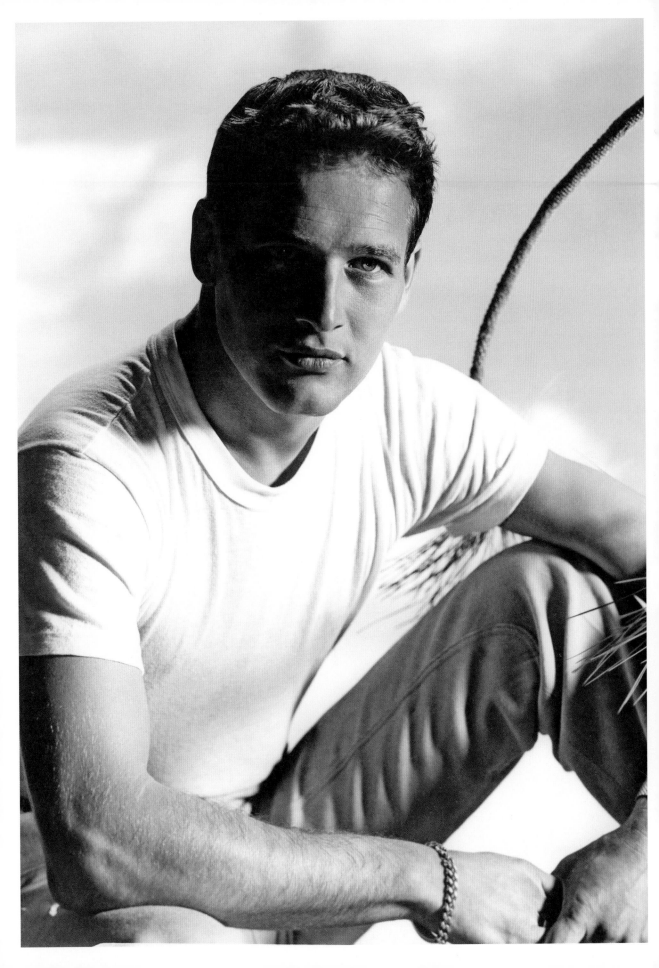

By the mid-1950s the T-shirt had become the symbol of the new teenager and of rock 'n' roll rebellion. It was sported sweat-soaked and sexually magnetic by Marlon Brando in *A Streetcar Named Desire* (1951) and under tough-guy leather in *The Wild One* (1953); and as the cool uniform of James Dean and jazz trumpeter Chet Baker.

But all that white space also afforded an opportunity. It was a black canvas for promotion – of politics, of brand, of affiliation, of event. Hanes may have been the first company to produce T-shirts for promotional purposes – specifically, for the release of *The Wizard of Oz* in 1939. But with the evolution of screen printing during the 1960s and the availability of cheap blank T-shirts it certainly would not be the last.

In 1967, graphic designer Warren Dayton was among the first to use the T-shirt in political and pop-art style, devising bold graphics featuring such things as the Statue of Liberty, comic-book excerpts, the *Life* magazine masthead and images of polluted lungs – all T-shirts worn as much by women of the decade's counterculture as by men. Since then T-shirts have been widely used as a site for opinions (graphic designer Milton Glaser's much-imitated 'I ♥ NY' of 1977), jokes ('My mum went to Vegas and all I got was this lousy T-shirt'), brand logos (notably after the rise of 'designer' fashion in the 1980s) and campaigns (as in the fashion industry's 'Target' programme to raise awareness of breast cancer).

When British fashion designer Katharine Hamnett met the then British prime minister Margaret Thatcher in 1984, she wore a white, oversized T-shirt proudly proclaimed in bold black lettering: '58% Don't Want Pershing', a reference to proposed plans to base American nuclear weapons in the UK. Other Hamnett statement T-shirts included 'Education Not Missiles', 'Worldwide Nuclear Ban Now', 'Use a Condom' and the more obscure 'I Love CSP' (concentrated solar power). As Hamnett would put it: 'The T-shirt presents the chance to get a message on your chest that can be read 35 feet away and give voice to perhaps taboo subjects.'

But arguably it's the band T-shirt that has dominated, with some designs even become classics in their own way, among them Storm Thorgerson's prism design for Pink Floyd, Stanley Mouse's cover art for the Grateful Dead and John Pasche's 'lick' logo for the Rolling Stones.

**Above:** A dancer at New York's Studio 54 club, wearing Milton Glaser's NY promotional design on her T-shirt.
**Opposite:** Using a T-shirt as a billboard was not a new idea, but Katharine Hamnett made it both fashionable and much more politically direct.
**Next page:** Mick Jagger in 1978 with other members of the Rolling Stones, his T-shirt featuring arguably the best known of all band logos.

# The Breton Top

**Above:** John Wayne in 1937 on the set of *Adventure's End,* wearing a suitably seafaring Breton top and captain's cap.
**Opposite:** American actress Jean Seberg, who made her big break in Jean-Luc Godard's 1960 French New Wave film *Breathless.*

A type of clothing can speak of a certain era or suggest a certain person. But few garments still widely worn today encapsulate a particular nation – and, indeed, shape public perception, however stereotyped, of how its inhabitants dress. But just as lederhosen are undeniably German and the bowler hat is English, the Breton top is as French as Camembert, even if it was the signature choice of James Dean, Kurt Cobain, Andy Warhol and, most famously, Pablo Picasso, none of whom was French.

At least two famed Frenchmen, Jean Paul Gaultier and Jean-Paul Sartre, have also favoured it. The former used it to play on the idea of Frenchness for photographers Pierre et Gilles (then made it his signature); the latter helped the Breton top become associated with post-war, countercultural and existential angst as much as it was perceived as a traditional, or nearly national, kind of dress. When costume designer Edith Head envisaged Cary Grant's French Resistance leader turned suave cat burglar in Alfred Hitchcock's *To Catch a Thief* (1955) she dressed him in a Breton top.

Gabrielle 'Coco' Chanel, who appropriated much sportswear and workwear from the male wardrobe, had made the simple blue and white-striped, boatnecked, knitted shirt famous nearly three decades previously as a womenswear item. She is said to have been inspired by seeing fishermen at work while on holiday at Deauville on the French coast; in turn Jean Seberg made the style her own in *Breathless* (À *bout de souffle*, 1960), Jeanne Moreau made it a staple and Brigitte Bardot teamed hers with cropped jeans and ballet pumps to define a signature look. But it was not just actresses in France who took to such a characteristically French garment as the Breton top. Kim Novak regularly wore a Breton, as did Natalie Wood, Edie Sedgwick, Audrey Hepburn – notably in *Funny Face* (1957) – Marilyn Monroe and Jacqueline Kennedy Onassis.

But the shirt, for all its fashion and occasionally fey leanings, could hardly be more masculine.

The *marinière*, as the French call it, was created by an act of the French government on 27 March 1858 as part of the official uniform of the French navy. The Russian navy also adopted the look.

Fishermen in the Brittany region of north-western France had long worn warm, loose-fitting versions of the top, with three-quarter-length sleeves and, according to France's Musée de la Marine, specifically twenty-two blue and white stripes – in part out of regional pride, and in part because the stripes made it easier to see anyone who fell overboard. The Breton top was not the only practical item of naval dress that was eventually assimilated by fashion and adopted as chic rather than, as with much army clothing, subversive: others included the sailor top (a lightweight blue canvas V-neck pullover), bell-bottom trousers (which could easily be rolled up when swabbing the deck), knotted neckerchief, espadrilles and the naval cap.

The shirt's first transformation from working to fashion item was not entirely welcomed. In 1934 *Adam*, a style-watching magazine of the interwar period, noted that the French Riviera was being overrun by bohemian young men wearing a 'fashionable sailor outfit' of Breton top and (that other French clothing icon) beret. 'We urgently ask our friends to see that all grotesque individuals of this type vanish immediately,' its commentator requested. The second wave of appreciation of the shirt, amid the burgeoning youth culture of Paris after the Second World War (and prefiguring beat culture in the United States), made the Breton similar to a French take on the all-American plain white T-shirt. If the white T was the choice of Marlon Brando's Johnny in *The Wild One* (1953), Lee Marvin, playing his fellow rebel biker, wore something akin to a Breton, in blue and yellow.

**Opposite:** The man who made the Breton his style signature: the Spanish artist Pablo Picasso, in 1960. **Above:** Katharine Ross relaxing in a Breton top between shooting scenes for *The Graduate* (1965), with her co-star Dustin Hoffman.

# The Blouse

**Above:** Blouses could be highly embellished, as with the ruffle of fabric fronting this example in a Edwardian fashion plate by the illustrator DeLosques.
**Opposite:** Katharine Hepburn in 1940. An enthusiastic sportswoman, a collared shirt and practical roomy trousers were always her preference.

From poet to peasant and from pussycat bow to folk and Edwardian, the blouse has been a constant fixture of the woman's wardrobe since the 1890s, before which the corset and full-length dress had been dominant for some centuries. The blouse was a product of women's move into the workforce; worn with a plain skirt, it provided the right balance of formality and comfort for the new office class. Indeed, such was their quick ubiquity that they attained a certain fashionability – either heavily embroidered in a way that had previously been the preserve of underwear or tucked and pleated to enhance the female form.

American illustrator Charles Gibson's idea of the modern woman, the 'Gibson Girl', with hair piled high on top of the head and wearing a crisp, white, button-front, fitted blouse, became a new standard of dress for progressive women. While the blouse often showed detailing characteristic of the Edwardian period, for example, a high neckline, lace edging and leg-of-mutton sleeves, it was fairly minimalistic compared with what had gone before. The blouse was ideal for increasingly emancipated, professional and active young woman, especially those who embraced new crazes such as bicycling. It remained, however, resolutely buttoned up.

When a brief vogue for a blouse with a V-neck or semi-transparent yoke at the front or back came in, it was denounced, both as indecorous and as a threat to the wearer's health, being dubbed the 'pneumonia blouse'. One organization in Massachusetts, the Purity Brigade, decided that the style was 'immodest', and appealed to the community at large to abstain from encouraging such 'open work' effects. As the *Evening Post* reported in 1906: 'Strange to say, this movement, which was held up to ridicule at first, has continued for a year ... [But such is the fashionability of the blouse that] it is said that "looking from a skyscraper building today you can see mile upon mile of moving streams of white shirt waists".'

Over the following decades, the blouse became more streamlined, fitted and, as the Purity Brigade

might have found it, revealing. Necklines, sleeve and body lengths rose and fell with the fashion, but popularity remained constant. Worn with trousers, the blouse, sometimes short-sleeved, often more shirt-like, became a staple of 1940s and early 1950s dress, as epitomized by Katharine Hepburn. It would not, however, be until the 1970s that the groundbreaking Edwardian look made a return, in keeping with the nostalgic romanticism that underpinned designs by designers such as Laura Ashley. Together with pearl strings, navy blazers and waxed jackets, it would be a key part of the influential look of the British upper-middle-class conservative style, termed 'Sloane Ranger', by cultural commentator Peter York. Designer versions from Chanel and Valentino followed, either deconstructing or playing up the prim.

It was at this same time that the blouse found new appreciation, for much the same reason it had the first time around: it became a statement of intent for the pioneering female business executives, some of whom (in the United States at least) wore button-down shirts with loosely tied bows, aping male business attire.

'There were not many women role models so you found guys that you admired how they conducted themselves,' as Hewlett Packard CEO Meg Whitman once noted. 'So we'd wear an interpretation of the man's shirt and tie. I look back at those pictures today and think "what were we thinking?" But it was our attempt to be feminine but fit into what was then a male world.'

In time, the neck area would take a more feminine form with Peter Pan collars, lower top fastenings and the revival of a floppy bow at the neck, a style favoured by Britain's first female prime minister Margaret Thatcher. The origin of the term is uncertain, but a 1934 Anne Adams sewing pattern includes a design for 'an intriguingly feminine pussycat bow tied high under your chin'. One theory has it that, since the pussycat bow was designed to be a softer take on the traditional men's tie, the reference was euphemistically towards female genitalia.

# The Twinset

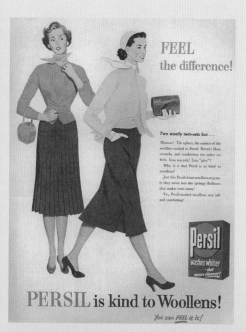

The simple matching of a trim, often sleeveless, tight-fitting wool sweater with an equally neat, short, round-necked cardigan in the same fabric is first attributed to Austrian designer Otto Weisz, who came up with the pairing for knitwear company Pringle of Scotland in 1934. The 'twin set' was a clever idea, not only commercially – necessitating the purchase of two items of knitwear to achieve the look – but also practically: two layers may well have been in demand at a time of no central heating, especially two that could still give an air of smart formality in the dress of young women striding out into the new world of office work.

The twinset fast won a reputation as the uniform of the secretary, the American college girl and the demure, even when, in the late 1940s and 1950s, Marilyn Monroe and, more suitably given her perceived primness, Grace Kelly were regularly seen wearing the ensemble, albeit in cashmere. The twinset soon became associated with conservatism, with the phrase 'twinset and pearls' a slightly damning term used to describe the habitual look of the well-to-do, schoolmarmish, prim and unfashionable. The style proved to be a favourite of Queen Elizabeth II throughout her life.

As a style, the twinset has, however, always been in competition with what is perceived, and, in some instances marketed, as its sexier sister, the sweater, its look achieved by a kind of undressing – simply the removal of the cardigan. Worn in a snug fit and with a nipped-in waist to emphasize the breasts, the form-hugging knitwear was favoured by such Hollywood starlets as Jane Russell, Jayne Mansfield, Sophia Loren and Lana Turner. Thanks to her role in the appropriately titled movie *They Won't Forget* (1937), Turner won them the label 'sweater girls', with all that suggested of their particular charms. Underwear manufacturers Berlei, Triumph and Maidenform rushed to provide the right conically shaped 'bullet' bras to underline this 'bombshell' look, while teenage girls in the United States borrowed their mother's twinset cardigan and wore it back to front, buttoned up at the back.

The sweater-girl look was certainly in stark contrast to that of, for example, Audrey Hepburn in *Funny Face* (1957), whose less fitted black polo neck suggested more beatnik chic than brassy sexuality, harking back to Marlene Dietrich's pioneering subversive style of mannish polo neck and trouser suit. Similarly, the key fashion sweater of the 1960s, the ribbed polo neck, pushed by designers Foale & Tuffin and Mary Quant, suggested more a streamlined, unisex, modernistic look than seductive style.

The twinset comes in a variety of lengths and sleeve styles – set-in or raglan, short- or long-sleeved for both the cardigan and the pullover. It is popular among those looking for a retro style, particularly since the huge success of the TV drama series *Mad Men*.

**Opposite (above):** A fair warning to wash your twinset using Persil if you want your woollens to be soft and not scratchy – an advertisement from 1954.
**Opposite (below):** Queen Elizabeth II in her signature twinset.
**Below:** A model poses in a studio portrait wearing a raglan-sleeved twinset with a white border, 1958.

# The Crop Top

**Above:** Perhaps the original crop top, a belly-dancer wearing traditional attire in the late 1900s.
**Opposite:** More regularly seen in a swimsuit, the Olympian Esther Williams starred in many 'aquamusicals' throughout the 1940s and 1950s. Here she wears a crop top in white lace.

Given the historic religious requirement of Indian women's dress to be modest and respectful, that the sometimes scandalously midriff-baring modern-day crop top should have originated centuries ago on the Indian subcontinent makes for an unexpected story. But the style may well have derived from the *choli*, the fitted short-sleeve bodice worn under saris. Of course, that is not the only precursor to the crop top: belly dancers of the Middle East also wore the bedleh, a heavily beaded version of the style, the beads helping to exaggerate their movement. It is from this that comes the modern romantic notion of crop-topped princesses and genies of the kind to feature in the eighth century tales of Sinbad the Sailor, which in turn shaped the costume of Barbara Eden in the 1960s hit US sitcom *I Dream of Jeannie* (about a housewife-cum-genie).

It was this show that sparked one of the biggest uptakes of the cropped top as a mainstream fashion item. But it was not the first. Garments that exposed the midriff – daringly so for the times – date to the 1920s as parts of swimming costumes designed by Jean Patou or pioneering cut-outs in dresses by Madeleine Vionnet. It was not until the less conservative 1940s, and the advent of leisurewear as a category of clothing in its own right, however, that cropped tops became more widespread. A burgeoning beach culture and the rise of the beach resort holiday, especially on the West Coast of the United States, saw local firms produce boldly patterned, so-called 'play' clothes that, for example, matched a crop top with tantalizingly short, if high-waisted, shorts. It was the popularity of high-waisted clothing – shorts but more particularly skirts and trousers – that allowed crop tops of all sorts to be worn in both a more chic and more socially acceptable manner. Designers such as Tina Leser and Claire McCardell did much to popularize these styles.

The modern concept of the much less reserved crop top – cut high and worn with bottoms cut low – emerged in the 1960s as part of the hippie movement (the midriff perhaps being the female alternative to the male chest, a place on which one could write

one's message of love or protest). It was given a fashion spin in the form of 'ethnic' pyjama suits and loose-flowing loungewear also popular at the time, but more strikingly in pieces from John Bates, one of the key designers in 'Swinging London', for whom a crop top was the perfect combination with miniskirts and go-go boots. It was the 1960s that de-eroticized the midriff by exposing it so widely, paving the way for the trend for navel piercing two or more decades on.

Certainly the unforgiving crop top has, since the 1960s, moved in and out of fashion, in no small part down to celebrity seals of approval. In tune with the new interest in aerobics and gym-going in the 1980s, Madonna wore a black mesh crop top in the video for 'Lucky Star' (1983), going on to make the style a staple of her influential lace and leggings aesthetic for the next two years. Britney Spears revived the look in her video for 'Hit Me Baby One More Time' (1998), and pop star Gwen Stefani also made the crop top her own.

The looser cut-off crop top was very popular throughout the 1980s, while the 1990s saw the introduction of the bustier crop top, a lingerie-style shirt that revealed the midriff and was often worn under a blazer. Later in the same decade, the T-shirt crop top came to prominence, often depicting graphic logos. Varieties are endless, from the polo-neck version to the cropped tank top and from the short athletic vest to the strapless cropped boob tube.

**Opposite:** Madonna performs in a crop top, complete with crucifix – during her extended commentary on Catholicism – in 1985.
**Above:** It's not just T-shirts that can be cropped – actress Zendaya Coleman wears a cropped blouse to attend the Oscars in 2022.

# The Tube Top

The tube top has its origin in a production mistake in a clothing factory, which resulted in a job lot of fabric tubes in an Indian-print elastic gauze. Some of these found their way to 50 West 17th Street and Murray Kleid's S&M Fringing, New York's largest women's accessories store. There they stayed, mostly ignored, until Elie Tahari, Israeli fashion designer and new immigrant to the United States, spotted them – and their potential – at the start of the 1970s. He bought them for $2 and sold them for twice as much. Soon after, he was taking orders for thousands, and he began manufacturing them in 1973, eventually building a $500-million-a-year business.

'It was an East Village happening: "I am not wearing a bra! I am a modern hippie girl!"', is how Tahari explained the tube top's appeal, adding the tube top was 'totally disco'. When covered with sequins and worn with heels and skintight jeans, the tube top was the perfect garment for the crowd at legendary New York nightclub Studio 54, practising their *Saturday Night Fever* moves.

By the 1980s, the tube top was mainstream enough to be considered sufficiently respectable office attire, albeit under a tailored jacket. But it was the film about the disco period – *The Last Days of Disco* (1998) – that induced a major fashion revival for the sparkly style in the late 1990s and early 2000s, one which was quickly picked up on by popstar Britney Spears, who in turn influenced teen fashion, and the Carrie Bradshaw character in the fashion-focused US series *Sex and the City*. Come 2012, the tube top was back again in new, dressier form, thanks to Prada and Versace.

The tube top may have had an unelasticated precursor back in the early 1950s, which *Vogue* editor Diana Vreeland championed as beachwear but, in fact, a similar style can be traced back much further to fourth-century Greece, where women wore it to swim in. Thanks to fabrics woven with elastic, the incarnation in the 1970s was a new idea: simple and comfortable but tight, clingy and revealing. Being strapless, it was sometimes too revealing: a few years

after its launch, the tube top won a kind of infamy thanks to the US game show *The Price is Right*, in which contestants were selected at random from the audience. When her name was called out during the recording, in 1979, one audience member jumped up in excitement, and her tube top came down. 'She came on down,' host Bob Barker told the audience [a reference to the show's 'Come on down!' catchphrase], 'and they came on out.' Small wonder, perhaps, that in the UK the tube top was better known as the boob tube.

The tube top went on to provide the basis for many other garments, from tube-top smocks to tube-top dresses and, applying the same idea further down the body, tube skirts. Their development was assisted by an ever-more-sophisticated variety of fabrics – stretch nylon, spandex products such as Lycra – that allowed the garment to cling, to stay up securely (some makers even applied an adhesive band on the inside to make sure) and to hold its shape.

Shirt
Sweatshirt
Button-down Shirt
Guernsey Sweater
Hawaiian Shirt
Polo Shirt
Lumberjack Shirt
Cardigan

# 7.
# Shirts & Sweaters

# The Shirt

- - - - - - - - - -
- - - - - - - - - -

A stroll down London's Jermyn Street can leave no one in any doubt about the role the classic business shirt plays in the male wardrobe. While other cities, such as Venice, may have a long pedigree in shirtmaking, this single street is the epicentre of the craft. Named after Henry Jermyn (1604–84), 1st Earl of St Albans, who was responsible for much of the development of London's West End as a business and retail mecca, it was a magnet for elite shirtmakers who, over generations, defined the characteristics of the quality shirt: among them the split yoke and multiple pleats where sleeve meets cuff. By the late nineteenth century few other trades were represented on the street.

Although the shirt became a lynchpin of business dress and later, in its many softer forms, also of casual wear, its beginnings were less auspicious. It started life during the Middle Ages as a form of underwear, the first layer against the skin, which is one reason why white shirts came to be so highly prized: they suggested a man had sufficient status and wealth to be able to wear fresh linen every day, which would have been necessary given the limited hygiene of the times. In fact, wearing a pristine shirt was regarded as an acceptable substitute for bodily cleanliness. So prized were shirts, in linen or silk, that they were given as prestige gifts and were part of wedding dowries.

Until the early twentieth century only the well-to-do changed their shirts regularly. Before then, although the first button-through front shirt was registered by London tailors Brown, Davies & Co. in 1871, a shirt was typically donned by pulling it over the head and was cut long enough to double as a nightshirt. The collarless shirt, the 1827 invention of Hannah Montague, a housewife who was tired of scrubbing a tidemark of dirt from her husband's collar, was widely worn until the 1930s; a fresh collar and cuffs could be fixed to it each day, and its hidden main body, often in bold colours and patterns, was worn repeatedly without being washed. A clean white collar indicated the status of the new aspiring class of office-based employees or 'white-collar workers'.

**Above:** The shirt provides a gentleman with the opportunity to revel in stripe and pattern in a way few other clothing types do – something London tailor Gieves played on in its brochures.
**Opposite:** John Lennon wearing a shirt with an outsized and curved collar typical of the late 1960s.

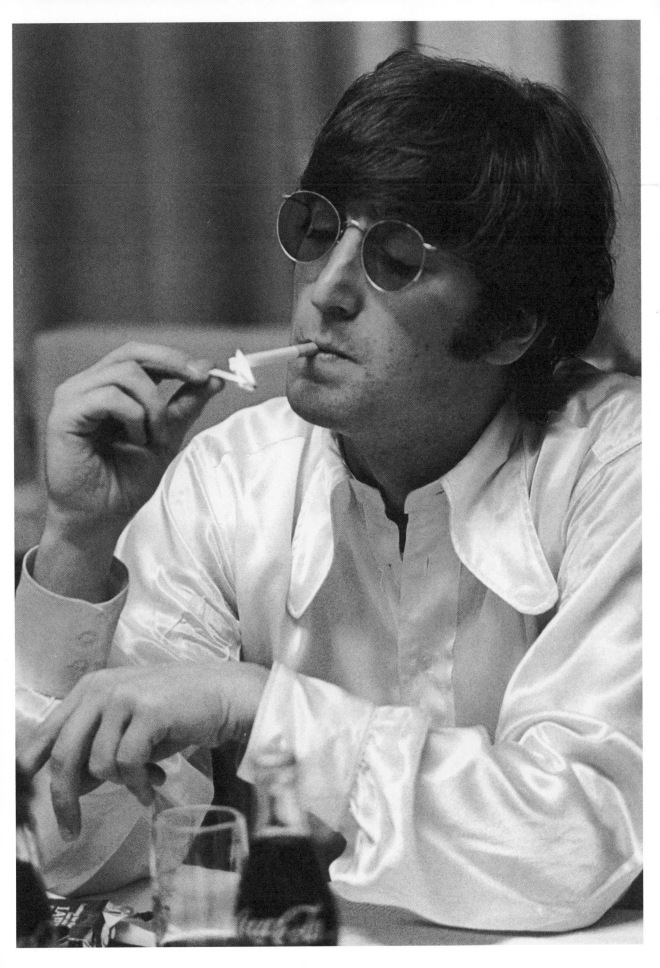

Because the shirt was initially regarded as underwear, emphasis was placed on the collar, the part that was most visible, and its accoutrements, such as cravats and ties. During Europe's Thirty Years' War (1618–48), when shorter hairstyles for men came into vogue, the collar ran the gamut of extremes, from the small flat French style through to what Italian courts of the time referred to as the giorgiera, which was created with an incredible 11 metres (36 feet) of fabric.

Shirts may not have involved such excesses, but they provided opportunities for personal expression well into the twentieth century: shirtmakers such as Cluett, Peabody & Co. in the United States, the company behind the pioneering Arrow brand of shirts, regularly offered the same shirt body with perhaps thirty variations of turn-down collar style – many more than the spread, club, pin, point, cutaway, tab and button-down varieties now available from specialists.

Indeed, by the twentieth century collar styles were increasingly subject to fashion: in 1900 any self-respecting man about town wore a high-band, a 7.5 cm (3 inch) wall of starched rigid linen, capable of bruising the jaw if the wearer turned his head too far. Other changes to the shirt were responses to advances in lifestyle. The first breast pockets, for example, were introduced in the 1960s. When central heating in homes and offices became more widespread the demise of what was then the typical male attire of waistcoat or three-piece suit followed, and a breast pocket became useful. What has lasted is the centrality of the shirt in the modern male wardrobe: stiff-collared, it remains key to received ideas of business attire and smart dress.

**Opposite:** Elizabeth Taylor wearing purple Capri pants and waisted yellow gingham shirt, 1960s.
**Below:** Singer and actor Sammy Davis Jr in an artfully dishevelled shirt for an early studio portrait.

# The Sweatshirt

Today it is one of the most innocuous garments in both the men's and women's wardrobe, mass-manufactured like the T-shirt or jeans, but without the rock 'n' roll credibility of either. It's the perfect thing to throw on for a lazy Sunday and, with its hooded version, the one of the cornerstones of athleisure, the comfort sportswear-driven dress-down look dominant through the 2010s.

Yet when Steve McQueen, as the 'cooler king' in *The Great Escape* (1963), wore one under his A2 flight jacket and, later, during his motorcycle escape attempt, the humble sweatshirt attained a touch of cool. Indeed, although the movie is set during the Second World War, it was around the time of its release that the sweatshirt made its transition from being strictly a sports garment to one worn casually. Before collegiate preppy style adopted it, before Virgil Hilts, and long before the 1980s when designer fashion appropriated it, the sweatshirt was merely a solution to a problem.

During the early 1920s sportspeople wore a knitted woollen sweater, typically grey, in order to keep warm before and after training. Inevitably it needed regular washing but was prone to shrinkage and slow to dry. By the end of the decade this had changed. The first example of what is now regarded as a sweatshirt – a simple, loose, collarless pullover made of soft, thick woven cotton (then still grey) – was produced by Russell, a company founded by Benjamin Russell in Alexander City, Alabama, in 1902 to make women's and children's underwear. Business was solid but a new generation's thinking inspired new products: in about 1922 Benjamin's son Bennie, a keen American football player while he was at the University of Alabama, suggested that the company's women's union-suit top should be modified to create shirts for him and his teammates.

Until this time football uniforms were heavy woollen garments, impractical and, typically worn next to the skin, uncomfortable. The new product – plain, unremarkable but familiar and, like jeans, khakis and leather jackets, better looking with age – was a huge hit, even though an anonymous

Russell employee named it, however accurately, the sweatshirt. Russell shipped the first batch to its Philadelphia distributor, who sent the garments to four local football teams. They sold out immediately. Sales to baseball as well as football players, and to athletes, followed and the sweatshirt became ubiquitous among sportspeople, professional and amateur alike. Within a decade Russell had created a new division, Russell Athletic, solely to handle the new sweatshirt business – which ultimately replaced the underwear lines.

A second development in the creation of the sweatshirt increased its potential. In 1919 brothers Abe and Bill Feinbloom established the Knickerbocker Knitting Company – trading under the name Champion – and shortly after patented a flocking process that enabled raised lettering to be printed on fabric. The weight and thickness of the sweatshirt fabric made it the ideal site for such printing. By the early 1930s the sweatshirt was no longer just a functional item, but one that indicated membership of a high-school team, showed allegiance to it, promoted a company or displayed a slogan.

Champion was quick to see how sweatshirt fabric could be used for other sporting clothing. It was first to create an outsize, zip-up, hooded sweatshirt, originally worn by football players over their uniforms and padding when they were on the sidelines. The company also developed the first reverse-weave sweatshirt; the light ribbing ran horizontally across the body rather than vertically up it, which meant minor shrinkages did not affect its length, no matter how many times the sweaty garment was washed. The machine on which these sweatshirts were made was known as a loopwheel. It was slow and inefficient by modern manufacturing standards, but minimized any tension when the thread was being woven and arguably created a better garment. Loopwheel machines fell out of wide use during the 1950s, but the garments they produced are much sought after by clothing collectors.

# The Button-down Shirt

- - - - - - - - - -

ポロカラーシャツ

一般には〝ボタンダウンシャツ〟の名で親しまれているこのシャツは、1900年、元社長ジョン・ブルックスが、英国で観戦したポロ競技の選手が着ていたシャツにヒントを得て、世界で初めて考案したものである。

**Above:** The button-down shirt reached an international audience. Brooks Brothers found its Oxford cloth at a Scottish manufacturer, D. & J. Anderson, in 1875.
**Opposite:** Wearing the button-down collar in a more individualistic way was part of its appeal – as novelist F. Scott Fitzgerald demonstrates here in the 1925, the year *The Great Gatsby* was published.

Menswear has a habit of taking sartorial ideas out of context and making them work. The button-down shirt is an example of one such transition. It began on an English polo field in 1896, where one of the spectators was John Brooks, grandson of the founder of Brooks Brothers – arguably the most famous and influential name in American men's clothing history. Polo players then adhered to strict rules of propriety in dress and rode in formal shirts, with one important modification: buttons were attached to keep the collar affixed to the shirt's main body and prevent it flapping into the rider's face.

It was a workaday style. And one, Brooks saw, with potential. The Brooks Brothers button-down shirt was initially made from whitish Oxford cloth, soon after in pink and later in many colours and stripes, and came to be a new American symbol of youth and vitality. It was a huge success from the moment it went on sale in about 1900, as 'the original polo shirt', and remains a bestselling item. Its introduction not only brought a more casual element to men's dressing, it also changed the nature of shirts in the United States. Until this time they were collarless and worn with separate, stiff, attachable collars that could be easily detached and washed.

The button-down was more comfortable, more bohemian and almost avant-garde, and by 1915, along with Brooks Brothers Number One sack suit, was part of wealthy collegiate life, especially at America's East Coast educational institutions Harvard and Yale. Winthrop Brooks, president of Brooks Brothers from 1935 to 1946 and an heir to the business, was a member of the Whiffenpoofs, Yale's singing society, which was typically kitted out in head-totoe Brooks Brothers. F. Scott Fitzgerald wore the shirt at a time when it was still considered a daring choice.

By the years just before the Second World War the button-down, along with collegiate sweatshirts, cardigans, loafers and khakis, was an essential part of the smart-but-relaxed preppy uniform of students and men about town. It also suggested something of

the upper crust: in John O'Hara's novels, for example, among them *Appointment in Samarra*, the baddies invariably wore loud clothes and the good guys – typically well-to-do – wore Brooks, including the neat button-down. The shirt also came to represent a certain conservatism: in Mary McCarthy's short story 'The Man in the Brooks Brothers Shirt', clothes symbolize the ambitions of a straitened steel industry executive – in a button-down shirt – and are contrasted with those worn by the more artistic love interest.

What perhaps sealed the shirt's status as a menswear icon was celebrity. Clark Gable, Hollywood superstar, may have killed the vest – after he took his shirt off to reveal a bare chest in *It Happened One Night* (1934), sales of vests plummeted – but he helped make the button-down shirt. With his 112 cm (44 inch) chest and 81 cm (32 inch) waist, he was generally ill-suited to most ready-to-wear-clothing of the time – with the exception of the Brooks Brothers button-down shirt. He became a lifetime fan and a source of promotion that money could not buy. Tyrone Power subsequently wore the shirt in *The Razor's Edge* (1946), Fred Astaire in *Funny Face* (1957) and Cary Grant in *North by Northwest* (1959).

As in the movies, so in industry and art. Fiat supremo Gianni Agnelli popularized the style in Europe and wore his favourite blue, white or ecru button-downs with characteristic style: watch strapped over the cuff and collar buttons undone. Andy Warhol wore the shirt in white only.

# The Guernsey Sweater

**Above and opposite (above):**
Fishermen traditionally had two Guernseys: one for work, which was rarely washed and was embedded with protective oils, the other for church on Sundays. The sweater is knitted flat so that it can be worn either way round, allowing it to be thrown on at a moment's notice and still be comfortable; it can also be turned round if certain areas, such as the elbows, are in need of repair.
**Opposite (below):** A contemporary take on the original design.

The Guernsey sweater may be the oldest unchanged garment in the male wardrobe. It dates back to the sixteenth century and the reign of Elizabeth I when, for the first time, English seafaring was on an oceanic scale and trade grew internationally. The need for seamen to be protected from the elements resulted in a sweater designed specifically for them, which was developed in the cottage industry of Guernsey, one of Britain's Channel Islands, and in other rugged coastal communities. So entrenched was the sweater as part of the seafaring image, and so successful the design, that some two centuries later Horatio Nelson, admiral of the English fleet, ordered that the style be issued to crews serving in the Royal Navy.

The Guernsey sweater is also known as a gansey, a now defunct dialect word for the island, and in Gaelic cultures this name is also used for a home-knitted, workmanlike sweater. But the Guernsey is not just any gansey. It is a distinctive item that is traditionally cut to be long and fitted, to provide maximum warmth; it is tightly knitted with five-ply, heavyweight oiled wool – known colloquially as seaman's iron – to give a degree of protection even against rain. A straight, slightly raised collar, higher than a crew neck, is also characteristic, as are the sleeves, which are slightly short of the wrist to keep them dry during work, and to prevent them being caught in equipment.

The sweater is flat and tubular with no side seams, and the pattern, if any, is identical front and back, so a Guernsey can be worn either way round. Unlike most sweaters, it is knitted from the top down; the stitch allows for the arms or lower body to be unravelled and replaced. Vintage Guernseys may show that several complementary but not identical shades of wool have been used over the years.

Although classic Guernsey sweaters are plain, when patterns are incorporated these have a function, not least of which is providing added insulation. Most of them have seafaring connections, be they references to ropes, ladders, anchors, nets, herring bones, the waves or the elements, and in

the past were badges of belonging to specific fishing communities. Small, personal variations in a pattern, or the subtle incorporation of initials, could be used to identify a specific member of a crew if he fell overboard and drowned and the body was not recovered for some time. There are also symbolic patterns, such as the zigzag 'marriage lines' typical to Filey, on England's north-eastern coast, which are said to reflect the good times and bad in a relationship.

Fishing communities in the United Kingdom are more remote than communities further inland and, despite the gradual industrialization of knitting, a degree of self-sufficiency was inevitable. Guernsey sweaters continued to be widely made domestically well into the twentieth century, as a matter of community pride. Patterns, memorized rather than written down, were passed from mother to daughter, and each generation added its tweaks. Each hand-knitted sweater became a work of local art or craft, and remains a piece of menswear history – and essential gear for any sea dog worth his sea salt.

# The Hawaiian Shirt

The Hawaiian shirt is the clown of the male wardrobe. If men have largely been constrained to straight lines and sober colours since Georgian times, this outlandish garment remains a last bastion of colour, pattern and excess. For brands such as Kahala, which has become the exemplar of the contemporary style, it is a kind of canvas, and the shirts are as appealing framed as worn. The best older pieces are masterworks of detail, from the hand-printing in up to twenty colours, and the matched pockets and longer collars of the earlier styles, to buttons traditionally carved from native coconut (twenty buttons to a nut). The shirts, which date to the 1920s, were also at the forefront of fabric innovation – the most highly prized are 'silkies' made from cool spun rayon or, after 1953, from Dacron, an early version of polyester.

For some people the shirt is a wearable postcard, for others an expression of positivity. For the people of Hawaii they are a point of cultural pride. Few items of men's clothing, with perhaps the exception of the Stetson and the Nehru collar, have come to be so firmly associated with one place: the Hawaiian shirt, sometimes called the Aloha Shirt, is the worldwide symbol of the United States' fiftieth state.

By the 1930s it had become synonymous with vacationing and was worn by every holidaying film star from John Barrymore to Al Jolson, Douglas Fairbanks to Ronald Colman. With hat and pipe, the shirt came to define Bing Crosby's look (especially in the road movies he made with Bob Hope). It was a favourite of rat-packer Peter Lawford, and Montgomery Clift got his come-uppance wearing one in *From Here to Eternity* (1953). Presidents Eisenhower and Truman wore Hawaiian shirts at weekends. Tom Selleck, playing Magnum PI, made it his own throughout the 1980s.

The origins of the shirt remain a mystery. Some say the first one was made by a Japanese tailor in Hawaii from kimono cloth, others that it derives from the so-called tails-out shirts native to the Philippines, yet others that it migrated from Tahiti, where images of hibiscus, breadfruit and other exotica

have long been printed on cloth. The western shirt was introduced to Hawaii by Captain Cook in the late eighteenth century (somewhat parsimoniously, as it was exchanged for a prized royal cloak from King Kalaniopuu). Missionaries subsequently taught the islanders how to sew so that they could cover up their offensive nakedness. And, finally, Chinese and Japanese brought to Hawaii to work on pineapple and sugar plantations introduced not only their own printed silks and traditional fabrics, but also the art of tailoring. In short, history conspired to put a bright turquoise-and-banana-print garment on Elvis's back for *Blue Hawaii* (1961) some 150 years later.

The Hawaiian shirt – a term coined by Ellery J. Chun, a tailor and dry-goods businessman who made it up in 1927 to boost sales, with Aloha Shirt registered nine years later – has enjoyed an uninterrupted pre-eminence in Hawaii's cultural history ever since it first dazzled US naval crews and Hollywood big shots in the 1930s. Such was the shirt's appeal, to both natives and visitors, that within a decade Honolulu had 275 tailors and the great Hawaiian shirt labels had been born: Royal Hawaiian Manufacturing Co., Haw Togs, Holo-Holo, Malihiwi Sportswear and the Kamehemeha Garment Co. among them.

By 1947 employees of Hawaii's city councils were allowed to wear Hawaiian shirts to work and in 1948 Aloha Wednesday, a precursor to dress-down Friday, was introduced across the islands. Duke Kahanamoku – founding father of surfing and Hawaii's most famous son – was brought in to promote Hawaiian shirts. By 1958 their manufacture was the islands' third biggest industry, with many of their inhabitants hard at work making them. They did not take the advice of Duke Kahanamoku, printed in an early 1950s advertisement for the shirt: 'Hoomanau Nui' (Take it Easy).

**Above:** Joan Blackman with Elvis Presley wearing a Hawaiian shirt – of course – for the film *Blue Hawaii* (1961).

# The Polo Shirt

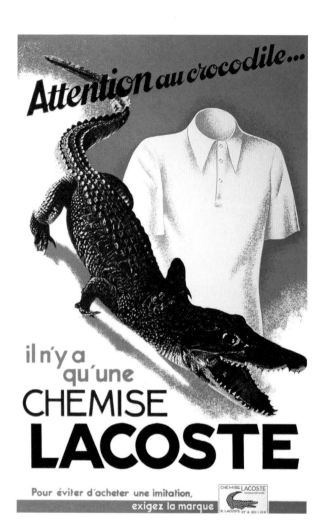

Attention au crocodile...

il n'y a
qu'une
CHEMISE
LACOSTE

Pour éviter d'acheter une imitation,
exigez la marque

CHEMISE LACOSTE
R. LACOSTE ET A. GILLIER

**Above:** Ad for the Lacoste polo shirt,
featuring alligator in full swing. Initially
the style was available only in white,
as befitted – despite its name – its
designed purpose as a shirt for tennis.
**Opposite:** René Lacoste,
co-creator of the polo shirt.

It began with a wager to encourage the captain of the French Davis Cup squad to lead his team to victory – the prize for winning was a set of alligator-skin luggage – and ended with one of the most counterfeited logos in menswear: a small alligator. The logo would overshadow the sporting triumphs of the man behind it, René Lacoste, winner of seven Grand Slam titles. And it would overshadow his contributions to tennis racquet design, including the first steel racquet and the first shock dampener. Indeed, the logo – designed by the artist Robert George after 'the alligator' became a nickname for the tennis ace – has become better known than all it emblazons, with the exception of perhaps one item: the pique polo shirt.

Before Lacoste, professional tennis was a sport of rigorous sartorial rules: women dressed in blouses and full-length skirts; men in flannel trousers and full-sleeved shirts, sleeves rolled. Until, that is, Lacoste wore a short-sleeved shirt in a lightweight, breathable cotton known as jersey petit pique, with an unstarched collar – soft but stiff enough to be turned up to protect the back of the neck from the sun – and three-button placket. Originally, styles had a longer cut at the rear, known as the tennis tail, to prevent the shirt coming out of the trousers into which it was tucked.

The polo shirt – as it came to be more commonly known after it was adopted by polo players, who had also been constrained by heavy shirts – debuted at the 1927 United States men's championship. How much of Lacoste's success on court can be attributed to his ground-breaking clothing is debatable, but the polo shirt's ease of wear off court prompted him to create a business. He joined forces with knitwear manufacturing entrepreneur Andre Gillier in 1933 and the shirt, known as the 12-12, went into commercial production. Initially produced only in white, it is now available in the full spectrum of colours.

As happens with many menswear icons derived from sports clothes, the practicality of the design soon saw the polo shirt being worn away from the tennis court or field of play. Because of its collar, it

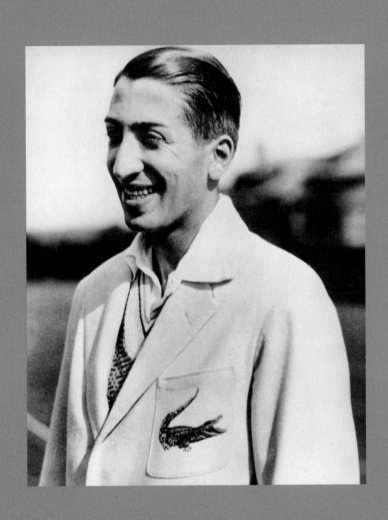

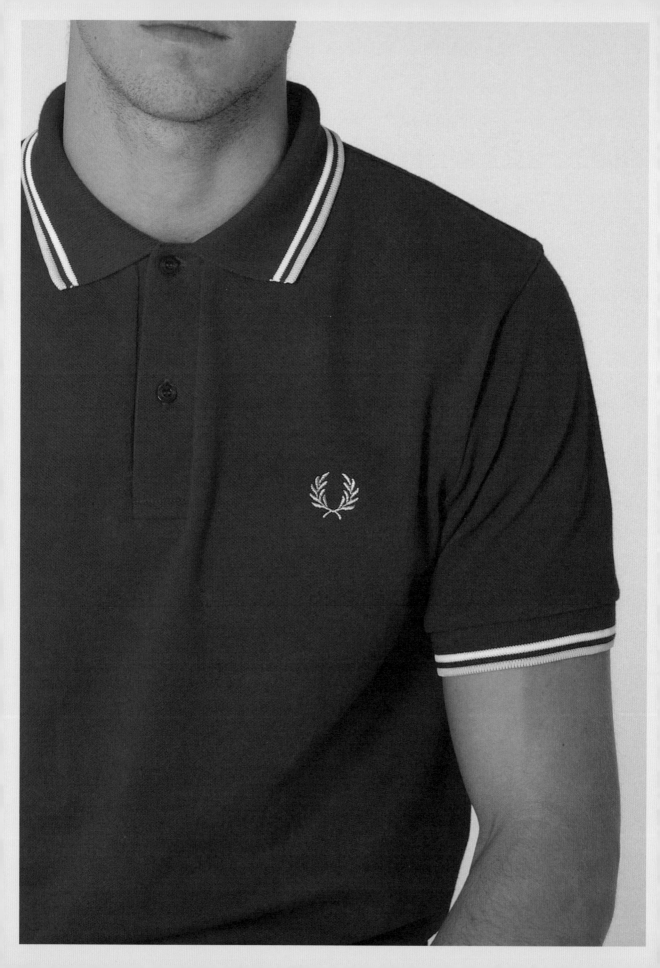

has been deemed a more formal alternative to the T-shirt. It has crossed social boundaries, and over the decades has come to represent distinct social classes, be they Euro hip-hop kids in the banlieue of Paris, British mods, American West Coast skaters or the wealthy preppy set of Long Island, New York.

Other brands followed Lacoste with their own take on the polo shirt and have won loyal followings. British-born Fred Perry hailed from the same sporting background as Lacoste, and was an eight-time winner of Grand Slam titles and the World No. 1 player for five years. After his retirement in the late 1940s he was approached by Austrian footballer-turned-entrepreneur Tibby Wegner, who had an idea for an antiperspirant device to be worn on the wrist; a few modifications by Perry resulted in the sweatband. Wegner also suggested a branded polo shirt with Perry's victory laurel logo, loosely based on an old Wimbledon Championship one. Also initially available only in white, it was launched at Wimbledon in 1952. It was a mod staple by the end of the decade, and later a key element of skinhead and northern soul uniforms.

More recently, Ralph Lauren developed his Polo brand. With its embroidered polo-player logo, it references the rich man's equestrian sport more than tennis and, in doing so, makes the polo shirt totemic of a well-to-do WASPish lifestyle.

# The Lumberjack Shirt

- - - - - - - - - - -
- - - - - - - - - - -

**Above:** Pendleton's early advertising played on the lumberjack shirt's associations with the great outdoors, **Opposite:** An unusually stubbled Rock Hudson wearing a lumberjack shirt in 1952 – such shirts defined his costume when he played the owner of a tree nursery in the 1955 film *All That Heaven Allows*.

In 1963 the Majorettes released 'White Levi's, Tennis Shoes, Surfin' Hat and Big Plaid Pendleton Shirt', which, aside from being a good example of girl group as effective stylists, reflected the extent to which the Pendleton shirt had become ingrained in American culture. The single went to number one.

The early 1960s also saw the Pendletones, whose look – a winter-weight Pendleton worn jacket-style, open over a white T-shirt, with jeans – created a new college campus uniform. In time the group became associated with the Hawaiian shirt and better known as the Beach Boys. There is not much call for woollen shirts in California, but surfers of the period sometimes used a plaid shirt as a quick cover-up when they left the waves, and the garment came to be nicknamed a 'board shirt'.

The Pendleton continued to have resonance for the music industry with the advent of grunge in the 1990s, which, like the shirt, grew out of the American Northwest (notably Seattle). Much the same youth uniform, albeit taking a grubbier, more distressed, anti-fashion, thrift-store form, reflected a darker, countercultural music.

While Pendleton is the benchmark in woollen work shirts, these were established before the brand was launched in the first decade of the twentieth century. But early shirts were functional products, plain and mostly grey. Bold plaid patterns, now associated with the archetypal blue-collar working man – construction worker or, more frontiersman, the lumberjack – were Pendleton's contribution. Worn over a red flannel undershirt, its shirt sets the rugged, manly style for work in the great outdoors, and clothing to relax in come the weekend.

Although the shirt is quintessentially American, the Pendleton company owes its origins to an immigrant, one Thomas Kay from England. In 1863 he travelled to the new American state of Oregon to join its burgeoning wool-milling industry and, in 1889, set up his own mill in Salem, Massachusetts. In 1909,

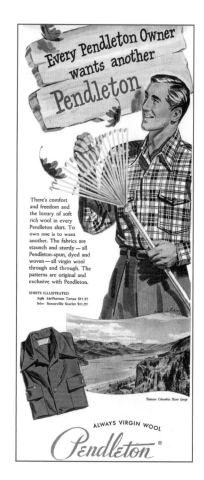
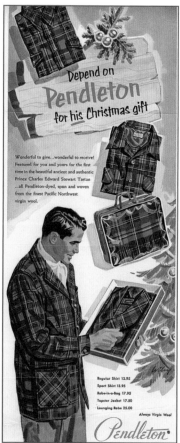
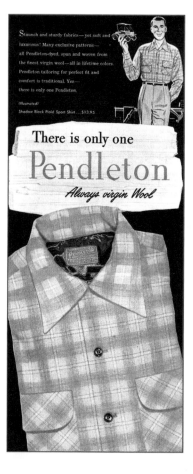
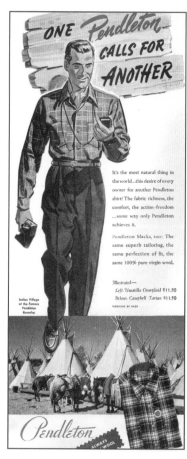

his grandsons Clarence, Chauncey and Roy Bishop acquired a mill in Pendleton, Oregon, that had fallen on hard times when a venture to supply bed blankets for Native Americans failed. The Bishops relaunched the business, and by responding to the local preference for stronger colours and jacquard patterns, rather than the dour plaids and block-colour designs that had been offered, made a success of it. They were soon selling blankets that had ceremonial significance as well as trade value to Native American nations far and wide.

Three years later they took their first step towards the lumberjack shirt when they established a new mill to make softer fabrics, including virgin wool. Their intention was to apply the same design philosophy to warm but drab men's work shirts as they had applied to the blankets. It was some time before the idea was realized, but in 1924 the first Pendleton virgin wool plaid shirt came off the production line; light, warm and colourful, it was soon a big hit, even purely as a fashion. 'Another winter mode that is spreading like wildfire is the lumberjack shirt,' wrote a correspondent for the metropolitan American trade journal *Men's Fashions* in early 1925. 'It is, however, only modelled after lumberjack shirts, as the real ones sold in the north country are extremely heavy.'

Within five years Pendleton was producing a full line of men's sportswear. The woollen shirt became so central to the concept of winter dressing for men that it was 1972 before the company first launched clothing for summer. It remains a family business, with many of its shirts still made by hand in order to ensure the careful matching of their highly patterned components.

**Opposite:** Pendleton was founded in the great outdoors, in Oregon. The conditions there were ideal for sheep rearing and its soft waters were perfect for wool production. **Above:** Sometimes fashion subverts the more macho connotations of the lumberjack shirt – as with this cropped and tied version worn by Sarah Jessica Parker for *Sex and the City* in 2009.

# The Cardigan

- - - - - - - - - -

Many clothing types have won a kind of immortality for individuals who were honoured or celebrated during their lives: the Chesterfield coat, or perhaps the Windsor knotted tie. But the cardigan commemorates a man who is associated with a military disaster. James Thomas Brudenell (1797–1868) was a British army officer who was beset with scandal throughout his life: he was removed from a military post for misconduct and later tried by the House of Lords for fighting a duel. He was serving in the Crimean War in 1854 when, as a result of a series of miscommunications, he was ordered to lead a suicidal cavalry charge against Russian cannon. Many of his men were killed, and their courage was remembered in Alfred, Lord Tennyson's poem 'The Charge of the Light Brigade'.

Brudenell was also the 7th Earl of Cardigan and, in part because the cavalry charge had made him famous, his soft, thick, fur-trimmed and braided button-through sweater – which he is said to have worn because he could slip it on and off without disarranging his hair – became a fashion craze in high society, even though it was derived from traditional fishermen's clothing that dated to the seventeenth century. The cardigan, as it became known, was not the only garment to come out of the Crimean War: the balaclava, a woollen accessory that covered the entire head, was named after the town, now in the Ukraine, near where the Light Brigade's charge took place. But while balaclavas have something of a reputation for being worn by sinister characters, the cardigan's origins in warfare could hardly be further from its more modern associations: fireside cosiness.

During the years after the Second World War the menswear industry slowly began to distinguish between a man's working wardrobe and what he wore for leisure. Cardigans were considered inappropriate for the workplace, and thus became symbolic of relaxation; they were particularly popular in the avant-garde beat scene of the American West Coast and with the intelligentsia of the Parisian Left Bank. Heavy-knit, zip-up and/or shawl-collar styles became popular country sportswear.

**Above:** The shawl-collared cardigan – or cardigan sweater as it's called in the United States – is perhaps the cosiest of all garments – here modelled by Warren Beatty in 1962. **Opposite:** In his role as Starsky in long-running US TV cop show *Starsky and Hutch* (1975–79), Paul Michael Glaser's cardigan was a defining trope, alongside the duo's red-with-white-stripe Ford Gran Torino. **Next page:** Kurt Cobain's battered mohair cardigan – seen here while recording *MTV Unplugged* in 1993– helped make the garment a staple of grunge.

Crosby was not the only singing superstar of the era to don the cardigan. Frank Sinatra and Perry Como were also fans, and their high-rating television shows helped to make the garment fashionable. All three men shared a love of golf, and the cardigan attained a certain swinger credibility through the sport: golf legends Jack Nicklaus, Arnold Palmer and Dan Sanders wore what were known as alpacas – baggy-sleeved, loose-fitting cardigans. Sinatra's annual bill at the store of the Canyon Club in Palm Springs, his local course, was said to run to $30,000 for his knitwear alone. The Voice preferred his cardigans in orange.

The cardigan's appeal also became more youthful during the 1940s and 1950s, thanks to the popularity of the letterman system on American college campuses: students who reached a certain standard in their studies or achieved success in a team sport or performing art were awarded a chenille letter, typically the school's initial. This was generally stitched on to the left breast of a heavy cardigan like those worn by Ritchie Cunningham and Potsie, characters in the 1950s-period television series *Happy Days*; it was also stitched on to a socalled letterman jacket – a crew-neck, baseball-jacket style with a boiled wool body and leather sleeves. Cardigans and jackets alike were prized mementos after graduation.

The cardigan's association with an older generation was perhaps most vividly demonstrated when David Bowie and Bing Crosby teamed up for a Christmas television performance of 'Little Drummer Boy' in 1977. The former wore a sharp jacket, denims and turn-ups, the latter was in an open-neck shirt and grey Slazenger cardigan, albeit without his trademark pipe. In contrast womenswear has managed to evade the same fuddy-duddy association, through a neater cut – as with Coco Chanel's smaller, more fitted styles, born of the fact she disliked having to pull knitwear over her head – or fashion detailing, like the fluffy cuffs of Alicia Silverstone's cardie in *Clueless* (1995).

Only on occasion has the men's cardigan's explored an edgier image; James 'Gene' Tunney, the heavyweight boxing champion of 1926–28 made the shawl-collar version a macho trademark out of the ring, during the early 1990s Nirvana's Kurt Cobain reinvented the mohair cardigan's appeal through grunge, while Jeff Bridges as The Dude in *The Big Lebowski* (1998) brought to the style a louche sexiness.

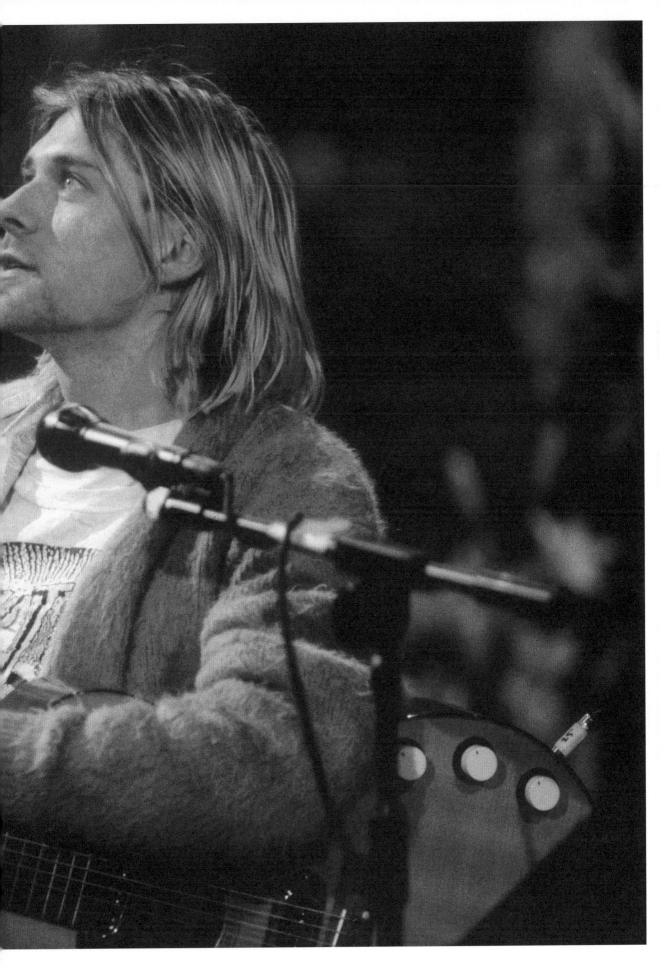

Tights
Bra
Slip
Y-fronts
Boxer Shorts
Corset

# 8.
# Underwear

# Tights

Stockings may have the sensual advantage, but it is in the more humble pair of tights that comfort and practicality are found. Perhaps it is no coincidence that pantyhose, as they are known in the United States, became popular in the 1960s, an era of women's liberation and of more revealing fashion. Indeed, by the time Mary Quant had pioneered the miniskirt in the 1960s, she was already selling branded tights. Tights even managed to attain some sex appeal during this period, in no small part down to Brigitte Bardot, who was photographed otherwise naked in a pair.

The now commonplace item – machine-knitted from often advanced textiles into a one-piece garment – was not how the design started out. Originals were called pantyhose for their simple combination of 'panties' and 'hose', comprising underwear and stockings sewn together as one, with the intention of covering the legs without breezy gaps while also minimizing the need for extra undergarments.

Quite who can claim to have invented the style remains debatable, although, ironically perhaps given their stereotypical love of stockings, it was a man. Allen Grant, of the Californian company Glen Raven Knitting Mills, devised what he called 'Panti-Legs' in 1953, although it took another six years to bring them to market. Meanwhile, in 1956, Ernest Rice filed for patent on his design for 'combination stockings and panty', the design of which became industry standard. Pantyhose were not an instant success: knitting the flat pieces together and creating the rear seam associated with stockings of the period were time-consuming and expensive procedures, at least until the invention of the circular knitting machine, which allowed cheaper, seam-free styles to enter the market in 1958. Their popularity was increased by their necessity after the introduction of the miniskirt.

The garment did retain some allure, at least in linguistic terms; in the United States, pantyhose continued to refer to items of a low denier near transparency. This made them more akin to 'peelable' stockings, which were hugely

popular through the 1940s and 1950s thanks to the invention by DuPont chemist Wallace Carothers of nylon, patented in 1935 and introduced to the world in 1938. Nylon made pantyhose accessible, cheaper and, perhaps most appealingly, form-fitting, unlike their silk predecessors. The term 'tights', in contrast to 'pantyhose', was used to refer to thicker, opaque and often woollen styles worn in winter.

This description of tights was, in fact, closer to stockings or hose, as they were originally conceived in the sixteenth century, when they were made from coloured wool or silk, and worn under breeches by men only (European society did not permit women's clothing to reveal any part of the leg, an idea that would last until the early twentieth century). A 'good leg' was a supposed indication of male virility: 'Remember who commended thy yellow stockings ... And wished to see thee cross-gartered,' as Malvolio says in Shakespeare's *Twelfth Night*.

The term 'cross-gartered' referred to the fashion for decorating hose with overlapping ribbons, and was an insight into the future of tights 400 years later. It was not until the 1970s that tights, until this moment plain, dark and ubiquitous, were considered a site for self-expression thanks to advances in textile technology and the invention of Lycra and spandex. The decade saw the introduction of coloured and patterned versions, with Dior, for example, famously offering 101 alternatives.

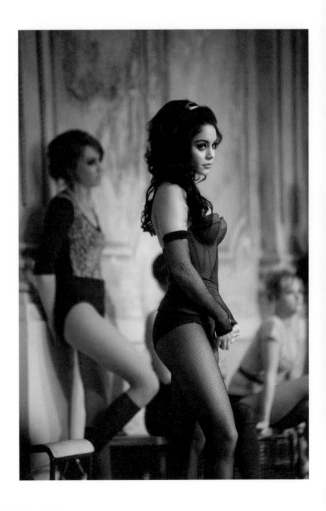

# The Bra

**Above:** A promotional poster for *The Outlaw* (1943) starring Jane Russell – Russell is said to have refused to wear the bra specially designed for the role.
**Opposite:** The design of the bra had to contend with shifts in fashion – when evening dresses exposed the shoulders, strapless bras (as seen being sewn here in 1952) become a necessity.

That the history of the bra incorporates a series of experiments in engineering is perhaps best illustrated by the part played by Howard Hughes, the oil magnate, eccentric innovator and film-maker who believed that Jane Russell's already impressive cleavage was not quite impressive enough. This was in 1941, during the filming of *The Outlaw*, and Hughes set to work using his knowledge of aviation design to create the first cantilevered bra, with steel rods connected to the straps, resulting in a shelf-like bust. The contraption was, however, so uncomfortable that during filming Russell is said to have worn her own bra padded with tissues. The result was much the same, and the Hollywood Production Code Administration ordered 30 seconds of film of Russell's bosom to be removed before it passed the film.

That, at least, is how the story goes, although it could be an urban myth or a publicity stunt devised by Hughes. But it still points to the bra as the place where physics meets fashion, as seen later in *Desperately Seeking Susan* (1985), which introduced the idea of underwear as outerwear, one later developed by Jean Paul Gaultier for Madonna's 'Blond Ambition' tour in 1990. It also highlights the lengths to which underwear designers go to give not only comfort and support, but also added lift, separation and cleavage. Feminists have argued that these traits objectify women, expressing this most poignantly by throwing bras, washing-up liquid and false eyelashes, among other items, into what they termed the 'Freedom Trash Can' at the 1968 Miss America competition in Atlantic City.

The history of the bra, however, goes back much further, to 1866, when the first styles, produced from wire and silk and making no concession to comfort, appeared in the UK and later in the United States. In 1889, a French corset-maker, Herminie Cadolle, developed her *bien-être* ('well-being'), a corset–bra hybrid in which the breasts were supported by cups and shoulder straps. Four years later, Marie Tucek patented her 'breast supporter'. With its shoulder straps and hook-and-eye closure, it was arguably the first recognizably

modern bra. It was also an idea Cadolle worked with; in 1905, she separated her hybrid design into a waist corset and a bra, calling the latter a *soutien-gorge* ('chest support'), as the bra is still known in France.

By the 1920s and aided by the decline of corset-wearing during the First World War due to women taking up factory work and the need to ration materials, bra design had moved on again. Between 1922 and 1928, Ida and William Rosenthal, founders of Maidenform, together with Enid Bissett, laid claim to creating the first bra with distinct cups and the notion of sizing the cups (though it was not until 1935 that the underwear manufacturer Warner introduced the now standard A to D – and beyond – cup-size system).

The evolution of the bra did not stop there, as designs to provide comfort segued into those to offer artificial enhancement of the bust. In 1947, Frederick Mellinger, founder of Frederick's of Hollywood – and, one might note, a man, as he said, shamelessly making garments ultimately for male pleasure – created the first padded bra. A year later, he devised the first push-up bra, sold under the fantastic name of 'The Rising Star'. More amusing still, his cone-shaped bras were called 'Missiles'.

These were not, however, expressions of a new idea. The development of the cone-shaped bra during the 1930s was deliberately intended to accentuate the bust; those women who wore them were nicknamed 'sweater girls', after the original sweater girl, actress Lana Turner, who introduced the look in *They Won't Forget* (1937). Indeed, the first bra-like prototype on record was similarly concerned with aesthetics over support; dating to 1859, it was designed by an American called Henry Lesher and incorporated inflatable pads. Again following fashion, the 'Backless Brassiere', patented by New York socialite Mary Phelps Jacob in 1914, was designed not to enhance the bust but to flatten it.

Decade by decade, the appeal of the enhanced bust would rise and fall but, perhaps inevitably, it would mostly rise. The boyish look gave way to the ultra-curvy, with Canadian designer Louise Poirier creating the Wonderbra in 1964 – a wonder of textile construction, comprising some fifty-four parts, and, in future years, a wonder of billboard advertising, thanks to its 'Hello, Boys' campaign of 1994, featuring a bra-clad Eva Herzigova looking down appreciatively at her cleavage. She was not the only one; several traffic accidents were attributed to it too.

# HELLO BOYS.

# The Slip

Some might believe that the bra was the first instance of underwear becoming outerwear, during the 1980 and 1990s, or perhaps the camisole's gradual transition from lingerie to top. But it had happened before. The slip, devised in the 1920s as a silken undergarment, was essentially an extended camisole that allowed the more close-fitting, boyish clothes of the era to be worn, while smoothing one's outward appearance in the process. However, the period was also one of growing emancipation for women and, consequently, the corseted restrictions of Edwardian fashion were being rejected. The slip – svelte, tactile, gently loose and, with those spaghetti straps, very comfortable – proposed itself as an ideal outer garment. The archetypal, straight-lined, sleek dress favoured by the flappers was, in effect, a slip in more substantial, modesty-saving fabric.

It was an insufficiently liberated time for women to wear an actual slip as a dress, even if the following decade saw slips becoming more sophisticated still. Cut on the bias, after the idea was introduced by Madeleine Vionnet in 1927, they sat more closely to the figure, like a second skin, and had subtle embellishment around the bust. But the world had changed by 1949. One story has it that a New York fashion model called Anna-Lee Danels and Henry Callahan, designer and window-display artist for lingerie company Lord & Taylor, decided to demonstrate that the slips of the time were so minimalistic, and often luxurious, that they could pass for dresses proper. So they went out to all the best places – the famed Stork Club, a masked ball at the Waldorf Astoria, the El Morocco lounge – to test the theory, with a photographer from a magazine in tow. Danels's slip passed without comment, despite its obviously provocative, sexy suggestion of underwear, nightwear and négligées.

It would be almost another ten years before relaxed regulations – most notably in the United States – finally allowed women to appear in their underwear in advertising imagery, in the movies and in magazines, a moment that made the slip the star of the

**Above:** A 1930s advertisement for 'slim-line' slips, meeting the concern that the garment would spoil the line of one's dress. **Opposite:** Elizabeth Taylor in the film version of *Cat on a Hot Tin Roof* (1958), her slip – covering up but also revealing – symbolising her character's thwarted sexuality.

All the sultry, explosive drama of Tennessee Williams' Pulitzer Prize Play is now on the screen!

M·G·M presents

# Cat on a Hot Tin Roof

starring

## ELIZABETH TAYLOR · PAUL NEWMAN
## BURL IVES

This is Maggie the Cat...

## JACK CARSON · JUDITH ANDERSON

Screen Play by
RICHARD BROOKS and JAMES POE

Based on the Play "CAT ON A HOT TIN ROOF" by
TENNESSEE WILLIAMS · in METROCOLOR
AN AVON PRODUCTION

Directed by RICHARD BROOKS · Produced by LAWRENCE WEINGARTEN

new boudoir dressing. Elizabeth Taylor's appearance in a white slip in the 1958 movie *Cat on a Hot Tin Roof* further spread its innocent-cum-sassy appeal – even if Taylor's was fully lined by its designer Helen Rose to ensure no transparency would upset watchful censors.

The slip went through a resurgence of popularity in the 1990s, in no small part down to British designer John Galliano, who further refined the bias-cut version, 'a symbol of what women wore at night', as *Vogue* editor Anna Wintour called it. This time there was no concern about hiding what lay beneath. Models, increasingly regarded as benchmarks of style, were said to favour them because they were easy to take on and off when changing for shoots. But when waif-like Kate Moss wore a see-through silver version by Liza Bruce to her model agency's 'Look of the Year' party in 1993, attention certainly increased. That decade, the slip even shed its obvious femininity, when it was worn over a white T-shirt, with baggy sweater and chunky footwear, in the grunge style of Hole frontwoman Courtney Love. Love did also wear it in more glamorous style on occasion, however.

# Y-fronts

The first commercial for Jockey Y-fronts aired on America's *The Tonight Show* in 1958, a time when chat-show hosts were expected to present promotional slots in person and live. The honour fell to Jack Paar, who fell into fits of laughter as he held up the underwear and read his script from the boards. The client was not pleased. But the planned 30-second commercial lasted two minutes while Paar recovered himself and started again, and the next day there was a run on Jockey briefs across the United States.

Compared with the simplicity of boxer shorts there is something comical about Y-fronts. And this is despite their obvious functional advantages: a snug fit and support. The name Jockey suggested sleek lines and the top-drawer image of equestrianism – and was also a way of hinting at 'jock strap' (the sports device and then the only way for men to find support) without using what was then deemed an offensive term.

It was in 1934 that Arthur Kneibler, an executive of Cooper's Underwear Company (Jockey's predecessor), received a postcard from the French Riviera depicting a man wearing a bikini-style swimsuit. This gave him an idea: to replace loose-fit boxers with a daringly skimpy brief that, as promotional material coyly had it, offered 'comfortable and masculine support'.

During the year it took to get the new design to market, the prototype was refined in consultation with a medical specialist in urinary tracts and underwent considerable testing. On 19 January 1935 the first briefs were unveiled in Chicago's Marshall Field & Co. department store. All 600 sold out in three hours. The following week 12,000 were bought and Jockey had to hire an aircraft, wittily dubbed the 'Masculiner', to speed up national distribution.

At the end of 1935 Jockey introduced an evolution of the brief: the fly opening. This comprised two overlapping flaps, the seams of which created a Y-shape, and not only allowed 'improved masculine access' – a delicate point to get across at the time – but was also a clever piece of engineering. In Jockey's original briefs, seams that ran up the front of each

**Above:** Modelling underwear was once so risqué that the models wore black masks to hide their identities.
**Opposite (above):** Emporio Armani unveils its underwear advertising campaign in San Francisco, 2022.
**Opposite (below):** Likely one of those catwalk ideas that are best left on the catwalk – matching hoodie and Y-fronts at London Fashion Week in 2022.

leg provided the main support. The Y-front, which originally sold for 50 cents, shifted the direction of the truss work and redistributed weight, as one sales bulletin of the time had it, to 'the upright portion of the letter which is attached to the elastic belt of the garment'. In short, the wearer could position the waistband where it was most comfortable and gave the desired level of support. This also allowed Jockey to develop versions of the Y-front with, for example, legs. In 1959 the company launched the first low-rise bikini underwear for men, made of 100 per cent stretch nylon – one of the new synthetic wonder fabrics of the decade

The Y-front's history can be traced to another part of the anatomy: the feet. Samuel T. Cooper was on holiday in Minnesota in 1876 when he met lumberjacks suffering from foot sores, largely due to ill-fitting and poor quality socks. Unable to convince sock manufacturers to improve their product, he launched his own company. At the turn of the twentieth century Cooper's branched out into underwear with its White Cat brand, which was as pioneering as Jockey would be later. In 1909, at a time when men wore 'drop seat' all-in-one union suits, with an inconvenient and uncomfortable panel at the rear, one of its designers, Horace Greely Johnson, was responsible for a style with an overlapping diagonal opening at the front – not dissimilar to that used in the Y-front. The Kenosha Klosed Krotch became the international template for men's underwear, much as the Jockey styles were a generation later.

# Boxer Shorts

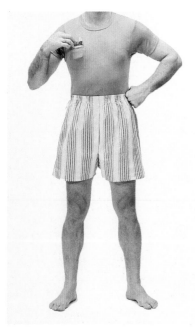

Few sartorial rivalries are as distinct as that between boxer shorts – the male wardrobe's most classic undergarment – and Y-front briefs. The battle has even resulted in scientifically unproven claims that 'masculine support', as Jockey, creator of the Y-front, once put it, was essential to a healthy sperm count, while the opposition had it that boxer shorts' better regulation of the temperature around the genitals had an equally beneficial effect.

Nor has the stand-off been without its ironies. Tastes may change – the preference for Y-fronts during the 1970s suffered an abrupt about-turn in 1984, thanks to Levi's model Nick Kamen being seen in pristine white boxers for one of its 501 jeans cinema campaigns. But surveys have repeatedly found that, at the turn of the twenty-first century at least, something like two men out of three prefer briefs to boxers – the female preference is the inverse.

Woven cotton, knitted or broadcloth boxer shorts were first popular some time after 1926 when Jacob Golomb founded Union Underwear and later the sports brand Everlast. He provided boxers (of the fighting kind) with new, lighter, more comfortable elastic-waisted shorts to replace the leather-belted versions that had been worn until then. By the 1930s the rising demand for comfort saw a fashion craze for versions of the boxers' shorts that could be worn as underwear. Golomb manufactured them under licence with Fruit of the Loom, which dates to 1871 and is one of the United States' oldest brands.

As well as providing relief from the heavy, mostly wool underwear that preceded them, boxer shorts introduced sartorial interest through the variety of patterned or shirting fabrics that were used to make them. Some, such as the 'atomic' prints of the 1950s and the novelty shorts of the late 1980s, were barometers of their times; others, like the brightly coloured silk boxers popular in the United States during the early 1930s, were said to provide men with an escape from the woes of the Great Depression; there was some colour under their otherwise dour exteriors.

**Above:** A 1960s novelty print pair of boxer shorts from Fruit of the Loom.
**Opposite:** The legendary boxer Sugar Ray Robinson, on the left, wearing the sports shorts that would inspire the underwear.

Early boxer shorts were effectively truncated and looser versions of long johns, named after John L. Sullivan, the American boxer popular during the 1880s. More sophisticated models had the added benefit of what was known as a balloon seat – a panel of extra fabric in the rear of the shorts that allowed movement without the boxers pulling against the body. Long johns remained commonplace in the United States until the 1930s, and in the UK until 1947 when John Hill of the British brand Sunspel introduced boxer shorts after a visit to America. Their rapid popularity might be attributed to the GIs who were stationed in Britain (and other countries) during the Second World War: boxer shorts had been standard issue.

During the war, while boxers with elasticated waists and metal snap closures had long been on the market, an old-style tie-side version – the tapes on each hip could be tightened and knotted – with button fastenings was reintroduced to spare rubber and metal for the war effort. This was just one of many devices that ensured a comfortable fit; others included the elastic-free French Back, which featured a series of buttons with a tab that could be tightened. Styles were also devised to protect the wearer's modesty, notably the uppermost layer of the fly was cut at a diagonal to the waistband. But men have always been too conscious of the need for easy access for the fly opening itself to be a new idea. It dates back to the Renaissance, when a button or tie-closing opening was cut into braies – calf-length underwear worn by men since the thirteenth century.

# The Corset

STEBBING, ph    MARGILL                    F.K.

As influential on fashion trends as Madonna has been, when she performed for her 'Blond Ambition' tour in 1990 she sparked demand for a most unexpected garment: the corset. She wore one in dusky pink, with conical cups, a creation of French designer Jean Paul Gaultier, who was responsible for introducing the idea of underwear as outerwear in his 1983 'Dada' collection. He had based it on a design he had first made in paper for his teddy bear as a child. 'It was slightly sadomasochistic for a teddy bear really, and the first transgender teddy-bear at that,' Gaultier noted, 'but it was held together with lots of safety pins, so was quite punk as well.'

Gaultier went on to design corsets for Kylie Minogue too. And, with the rise of influential new lingerie companies such as Joe Corré's Agent Provocateur in 1994, and the revival of burlesque performance towards the end of the decade, the corset underwent a revival that might have astounded many women less than a generation before. In the mid-1970s, Vivienne Westwood (who was, incidently, Corré's mother) was the first designer of the twentieth century to use the corset in its original form since Poiret had rejected it at the start of the century. Although corset dresses by such designers as Dolce & Gabbana and Thierry Mugler came into style during the 1980s, the corset element was actually a softer construction that suggested its supposed sexiness without the restrictions. The corset proper had been for the best part of a century a symbol of the oppression of women. It was worn to meet society's expectations – yes, of fashion, but also of the ideal, hourglass feminine form.

The First World War and the boyish flapper fashion that followed signalled the slow demise of any form of corsetry. But not before it had enjoyed centuries at the heart of women's attire. The corset had, in variously restrictive forms, been worn since the early-to-mid sixteenth century, notably by those well-to-do women who could afford the often complex constructions of lacing and, later, horn or whalebone stiffeners that eroticized by exaggerating curves, lifting

up and unifying the bosom and squeezing in the waist, but which also literally rearranged one's internal organs and threatened one's ability to breathe.

Tellingly, the metal eyelet, now commonly found on shoes, was invented in 1828 to allow the corset to endure greater stress while being laced; 1900 saw the introduction in Paris of a new S-shaped style that held the torso straight but, as fashion dictated, pushed the hips back. It was said to alleviate pressure on the ribs and so was marketed as the 'health corset'.

Women had last worn some form of girdle-like, shape-enforcing foundation garment in the 1960s, before a revolution in fabric technology, in fashion and in gender politics made it look antiquated. Now, here the corset was again, forty years on, this time more knowingly bawdy, and typically in comfortable stretch fabrics – a symbol of empowerment, perhaps, or maybe just of sexual objectification. Indeed, liberated from being hidden as an undergarment, the new corset obviously nodded to fetishwear and lingerie's sexy stereotype of bustier, stockings and suspenders.

**Opposite:** The corset would help to literally define the 'ideal' female form, as the cabaret artist Margill demonstrates in 1900. **Above:** Musician Billie Eilish wears a Gucci corset for the Met Gala in 2022. **Left:** Madonna's Gaultier-designed conical bra corset – here in 1990 – helped reinvent the garment as outerwear, not just underwear.

*Swimming Costume*
*Swimming Trunks*
*Bikini*
*Jumpsuit*
*Leotard*

# 9.
# Leisure & Swimwear

# The Swimming Costume

**THE BELGIAN COAST**

VIA HARWICH-ZEEBRUGGE OR DOVER-OSTEND

Information from Continental Departments, L.N.E.R Liverpool Street Station, London, E.C.2, or Southern Railway, Victoria Station, London, S.W.1, or principal L.N.E.R and S.R. Offices and Agencies

**Above:** The pre-war decades of the twentieth century saw the railways help popularize holidays by the seaside – and with them the appropriate attire.
**Opposite:** The definitive pin-up of the Second World War, Frank Powolny's studio portrait of actress Betty Grable, shot in 1943.

In an age of biomimetic technologies, tan-through fabrics and a skimpiness that makes the swimming costume a bikini in all but name, it is hard to imagine that in the Victorian era, when the development of the railways first allowed ready transport to the coast, and the idea of the seaside holiday and public bathing first developed, women would don bathing dresses made of serge or dark flannel. Their name – bathing dresses – indicates the moral agenda of the day: that women should remain as covered up as possible, regardless of the activity at hand. Even today, the use of the word 'costume' suggests that this is clothing worn for an event regarded as being somehow outside the social norm.

The only concessions to practicality were that on occasion the jacket had short sleeves and that, beneath a knee-length skirt, a pair of trousers was worn. This was the first time that women wearing trousers was tolerated, although wearing trousers as daywear would not tentatively enter fashion until the 1920s. Changes to swimwear were slow, revealing a touch more flesh with each evolution: cap sleeves exposed the upper arm, for example, and then shorter bloomers a flash of calf.

It was not until the twentieth century that anything like a made-for-purpose garment came into fashion, and even then the figure-hugging, sleeveless 'tank suits' of the 1920s, inspired by Portland Knitting Company's 1913 swimsuit design for men, were still made of wool and still had propriety front of mind. A switch to printed cottons and a backless, shorter cut – sometimes inspired by the new fashion for sunbathing, but just as often worn with a mid-thigh-length overskirt dubbed the 'modesty apron' – was introduced in the 1930s, when the all-in-one swimming costume finally became a subject of style.

Hollywood helped to dictate trends in no small part due to a new interest in synchronized swimming or 'water ballet', a sport that developed in the United States over the next ten years and was reflected in a spate of 'aquamusicals' that made stars of Dorothy Lamour and, more notably, Esther Williams,

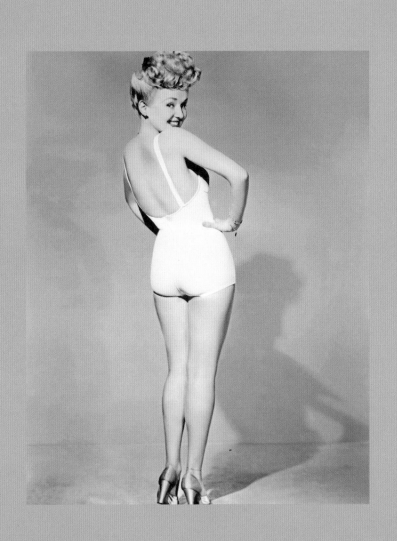

whose first Technicolor film, *Bathing Beauty* (1944), popularized the term. Companies such as Cole of California – which did much to prettify swimsuits with sequins, beads and prints – created the 'Esther Williams' swimsuit ('Like Esther, this swimsuit has everything,' read one advert), and Williams eventually launched her own swimwear line. A readiness for starlets to be snapped poolside helped to spread the more glamorous trends and to increase the profile of Rita Hayworth and Betty Grable (the highest paid Hollywood celebrity of the period, whose famed and oft-exposed legs were insured for $1million).

As self-consciousness grew in the 1940s, no doubt prompted by the fashion for close-fitting, high, straight-cut swimsuits, underwear manufacturers entered the market to offer swimwear stretch 'control panels' – many using Lastex, a latex-based elastic thread developed by Dunlop in the 1930s – and bust support, allowing the first strapless styles to be created. It was the widespread use of Lastex's replacement, Lycra, and of nylon in the 1960s that brought about a more revealing and distinctive style of swimsuit, in part because it was now in competition with the more commonplace bikini. Cut-out sections, perhaps filled in with mesh or plastic rings, and a higher-cut leg were among the developments that, textile science aside, brought the swimming costume into the modern era, with only increased exposure to come.

And sometimes in a big way. In 1964, designer, provocater and nudist Rudi Gernreich introduced the monokini, a topless swimsuit. While it inspired a fad for topless nightclubbing, it did not initially catch on as beachwear; Gernreich actually intended it as a protest against a repressive society rather than as a commercial product. 'Women drop their bikini tops already, so it seemed like the natural next step,' Gernreich said at the time. By the 1980s, however, it did achieve a brief popularity – albeit in opposition to a concurrent trend for more athletic, racer-style swimsuits that echoed the looks of the 1920s. Gernreich's subsequent attempt to launch a 'pubikini' – exposing the pubic area – did not, perhaps unsurprisingly, achieve any popularity at all.

**Opposite:** *Charlie's Angels* star Farrah Fawcett in the 1978 film *Sunburn.*
**Above:** A swimsuit and extravagant kaftan from the 2013 David Jones collection.

# Swimming Trunks

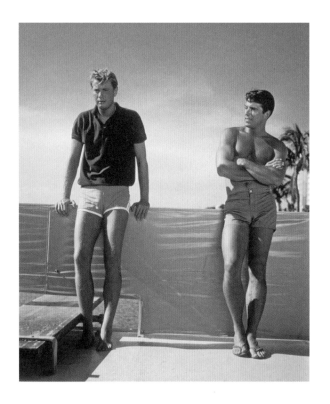

**Above:** Actors Troy Donahue and Van Williams in the early 1960s' detective series *Surfside 6*.
**Opposite:** Swim shorts gave men licence to wear the kinds of big bold prints that were less acceptable in everyday attire, as French brand Rasurel identified from the late 1960s.

Men's swimwear has evolved since the late nineteenth century with three concerns to the fore: style, fabric innovation and a varying societal fear of degrees of public nudity. Arguably, the last has been the most influential.

The 1960s might have ushered in what there was of designer Rudi Gernrich's first thong for a man – and, in fact, figure-hugging bikini-style nylon briefs (dubbed 'budgie smugglers' by the Australians) were being worn by the more daring male professional swimmers since 1960, when designer Peter Travis created the style for Australian company Speedo. The trick, he said, was to position the briefs on the hips, not at the waist, and cut the sides high – all the better for swimming in. All the same, the first man to wear them on Bondi Beach was arrested, but not charged because no pubic hair was on show.

But if the modern era has settled largely on the comfort, practical design and discretion of board shorts as offering the best of all worlds, a century previously a man would have been encumbered by what was effectively a knitted woollen body-suit that protected his modesty but which (despite being less water-absorbent than cotton) would have weighed several pounds when wet and made swimming a potentially dangerous business.

Come the 1920s, most swimwear was, in the United States, for example, still being defined by the American Association of Park Superintendents' 'Bathing Suit Regulations in The American City' of 1917, and these determined that even men's bathing suits, now cut to the top of the leg, required some kind of skirting effect to cover the trunks, extending to at least two inches below them. The legs of the trunks, meanwhile could end no more than four inches from the knee. And the guardians of decency thought of everything: flesh-coloured swimsuits were also prohibited.

It was more innovation in cut and cloth than styling – the deep armholes and closed leg trunks of the one-piece 'speed suit' for example, or the introduction of Lastex, a new synthetic rubber yarn – that did most to move men's swimwear on, and to give them a more athletic-looking physique. Yet it would remain one-piece until at least the pre-war years: although attempts were made,

from 1933, to introduce the 'men's topper', swimsuits with streamlined, vest-like top halves that could be unzipped from the trunks, for a man to bare one's chest would be to risk accusation of indecent exposure. It was not until 1937 that swimwear finally exposed the chest and focused on the provision of simple, streamlined trunks.

The idea came from France and a company called BVD. Its good fortune had been to hire the Olympic swimmer and 'aquadonis' Johnny Weissmuller as a model and advisor in 1929 – the man who in 1932 would win a seven-year contract with Goldwyn-Meyer to play Tarzan, which would make him (and his choice of swimwear) internationally famous. The idea only spread slowly however; by the late 1940s half-hearted off-the-shoulder style one-piece swimsuits for men were not uncommon.

Ironically perhaps, the style of trunks that first appeared were form-fitting – with supports sewn right in, so that men no longer had to wear underwear under their swimwear. This was deemed to give them a smart, smooth appearance but perhaps also left little to the imagination, not to mention sometimes proposing a challenge to straight faces, as swimwear manufacturer Jantzen's 1947 campaign starring actor James Garner suggested: its high-waisted 'Savage Swim Trunks' came in a waffle weave, complete with a flap pocket to the front, and resembled an outsize nappy. Other attempts to give swim trunks a sartorial edge included a fly-front and even a contrast-coloured buckled belt. Neither idea stuck.

It took both the cool of surfing, and its practical need for a greater ease of movement, to introduce a looser style. The shift to what might pass as the first modern form of swimwear came with the golden age of surfing, when high-waisted, lace-up board shorts were popularised by Hawaiian surf pioneer and Olympic swimmer Duke Kahanamoku, although it took a small tailoring shop in Hawaii, M. Nii, to make the version (dubbed Makaha trunks, after the Hawaiian surfing mecca) that would transcend both the surfing community and the fledgling world of body-building.

Celebrity surfers likes Richard Boone and Rat Packer Peter Lawford soon took the style, although the publicity surrounding them being worn by Lawford's friend John F. Kennedy no doubt mattered more to the burgeoning middle classes looking to holiday on the beach or away in exotic locations. Worn with a matching Terry towelling-lined cabana shirt (often in a loud animal pattern), board shorts were sufficiently smart, and discreet, to wear for poolside cocktails. They could even be bought in denim or needle corduroy.

maillots de bain au masculin...

RASUREL

30 rue de Gramont, Paris 2ᵉ

# The Bikini

**Above:** Betty Grable's legs were, at one point, the most highly insured in Hollywood – here she relaxes between shooting scenes in 1942.
**Opposite (above):** Brigitte Bardot, on her way to becoming an international sex symbol, posing on Cannes beach in 1953.
**Opposite (below):** Halle Berry makes her entrance ascending from the surf in *Die Another Day* (2002), a nod to Ursula Andress doing the same in *Dr. No* forty years earlier.

When Ursula Andress emerges from the sea in the first James Bond movie *Dr. No* (1962), it is not her collection of shells or diving knife that impresses. What made the moment a classic of cinematic sexiness is Andress's bikini, designed for the scene by costumier Tessa Prendergast. It signalled a key transition in womenswear, too: the one-piece swimsuit, itself only respectable since the turn of the twentieth century, before which time women were expected to bathe in an ankle-length garment, was out. The bikini – all curves and strategic erotic revelation – was in for good. In the same year, it was on the cover of *Playboy*, and, in 1964, on the cover of the inaugural swimsuit issue of *Sports Illustrated*.

The sexual revolution of the 1960s may have diminished the bikini's power to shock, yet this was a testament to the speed of social evolution. Just sixteen years previously, in July 1946, the inventor of the bikini struggled to find a model who would wear it. Its radicalism was tantamount to outright indecency. Louis Réard, a one-time car engineer, had to turn to a nude dancer, Micheline Bernardini, to wear the skimpy style at its unveiling at the trendy Piscine Molitor swimming pool in the centre of Paris. The effect was as predicted: an international media storm, an immediate ban in the Catholic countries of Italy, Spain and Portugal, as well as in Australia and Belgium, and general disregard in the United States. 'It is inconceivable that any girl with tact and decency would even wear such a thing,' opined *Modern Girl* magazine in 1957.

Not for nothing had Réard named his beach style after Bikini Atoll in the South Pacific where the first nuclear weapons were tested by the US military in the same year. He expected it to be just as explosive. And, no wonder: even the original bikini was small, requiring just 76 cm (30 inches) of fabric. It 'wasn't a bikini unless it could be pulled through a wedding ring,' claimed his advertisement for the new style.

All this did not dissuade the French. Some 50,000 people wrote fan letters to Réard and a race

for ever tinier bikinis seemed to begin. Also in 1946, Parisian designer Jacques Heim introduced the 'Atome'. With a nod towards the weapon of mass destruction, the name also hinted at its size: this, it claimed, was the world's smallest swimsuit yet, more a weapon of mass distraction.

Over the next decade, the French Riviera rapidly made the bikini its own, with movie starlets such as Brigitte Bardot at the Cannes Film Festival finding it a perfect magnet for the paparazzi. So much so, that, in the United States, Marilyn Monroe, Jayne Mansfield and the 'Million Dollar Mermaid' Esther Williams soon followed her lead. In 1960, Brian Hyland said it all with his hit 'Itsy Bitsy Teenie Weenie Yellow Polka Dot Bikini', as the style entered pop culture. From Annette Funicello in *Beach Party* (1963), one of a new wave of surfing movies, to the prehistoric interpretation offered by Raquel Welch in *One Million Years B.C.* (1966), the bikini was everywhere.

For all the fuss, the idea of a two-piece swimsuit was not a new one, albeit that taking it to such minimalism was. Two-piece garments were worn for exercising by ancient Romans and Greeks. Carl Jantzen designed a two-piece style, akin to swim-shorts and a thigh-length vest, back in 1913. Even this was enough to cause some scandal: six years earlier, Australian swimmer Annette Kellerman had been arrested in Boston, Massachusetts, for wearing a figure-hugging one-piece. But it was not enough to stop the style taking hold. From then on, there was a gradual creep towards increasing amounts of exposed flesh, with even wartime fabric rationing playing its role in shortening and cropping the swimsuit's constituent parts. It would take another forty years but, thanks in part to a fashion for tanning, the bikini would eventually reach a point of maximum exposure just short of nudity with the tanga, thong and Brazilian G-string.

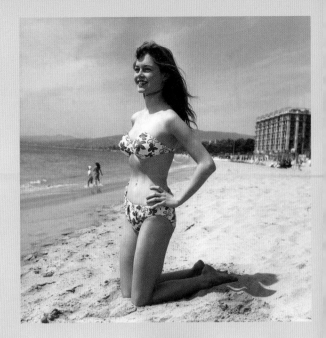

# The Jumpsuit

||||||||||||||||||||||||||||||
||||||||||||||||||||||||||||||

An ideal example of a garment that is utterly utilitarian in its origins yet, thanks to tweaks of cut and choice of fabric, able to achieve the kind of glamour typically reserved for an evening dress. The jumpsuit is, after all, anti-fashion in more ways than one. It took its cue from the protective overalls of factory workers, aviators, firefighters, racing drivers and skiers and from a siren-suit-style garment that could be put on in a hurry, as fan Winston Churchill recognized. Yet it also represented the kind of outfit worn in the future when society had found fashion redundant, a future that could be technological and shiny or dark and dystopian. The workers of George Orwell's *1984* would wear a jumpsuit.

Certainly, it was among the Futurists of the early twentieth century that the jumpsuit found its first expression beyond the world of manual labour. In 1919, the Florentine painter Thayaht (Ernesto Michahelles) proposed a minimalistic version in cotton and canvas – cut in a T-shape and fastened with buttons and a belt – to subvert fashion's pretensions and as a means of freeing its wearer from the constraints of having to consider one's dress on a daily basis. As unisex as the garment was, it seemed all the more subversive on a woman, even though many women had worked on factory floors across Europe during the First World War, which had ended the previous year. In 1923, the Russian constructivist Aleksandr Rodchenko and his wife Vavara Stepanova began wearing 'production clothing', a single-piece overall made by Stepanova. It revived the idea of the jumpsuit as the most practical, uncomplicated and logical of everyday garments.

Elsa Schiaparelli was the first bona fide fashion designer to dabble with the idea of bringing the jumpsuit out of the world of functionality and into the world of fashion in the 1930s. Her garment was part practical, part stylish, coming in light blue with a hood, braided cuffs, ankles and waist and even a water bottle to be worn across the body. Up until the end of the 1950s, jumpsuits were worn by women on the construction line for the war effort – leading

**Below:** Singer Dua Lipa performs in
shocking pink stagewear in 2022.
**Opposite:** Bjorn Ulvaeus, far left,
often wore a jumpsuit in performance
with ABBA, here in 1979.

to Norman Rockwell's iconic 'Rosie the Riveter'
propaganda image in the *Saturday Evening Post* –
while more show-stopping versions were sported by
Hollywood stars Katharine Hepburn (in a monogramed
silk number), Veronica Lake and Lauren Bacall.

Perhaps unsurprisingly, it was an ex-bomber
pilot, Emilio Pucci, who in 1960 first introduced
the idea of the jumpsuit as a catwalk fashion item,
produced in his patented fabric Emilioform, a synthetic
jersey. He was quickly followed by society designer
Irene Galitzine, who produced palazzo pants with a
bib-style top to create a more feminine jumpsuit, and
Norma Kamali, while space-age versions appeared
by André Courrèges and Pierre Cardin. In the UK,
however, Diana Rigg – playing Emma Peel in a
skintight leather number by costume designer John
Bates for television series *The Avengers* – really drove
the style home. Valentino showed a jumpsuit, too,
first in 1966 and again in 1971, when he dispelled any
connotations of manual labour by making it white,
with the top tailored like a double-breasted jacket. It
was a long way from the 2012 'onesie' romper-suit fad.

By the 1970s, the jumpsuit in all permutations
– backless, flared, knitted, stretch, with outsize collars
or halterneck – had become a fashion staple. The style
was a favourite of all four members of ABBA, and
was regularly seen at New York's landmark nightclub
Studio 54. In silver and synthetic materials, it also
gained a glam-rock edge, although Suzi Quatro would
only ever wear one made from black leather. Since
then, Dolce & Gabbana created a tuxedo jumpsuit
for Madonna and Prada produced a version in plaid
silk, while Givenchy offered a multi-pocketed design.
Designers as diverse as Stella McCartney, Thierry
Mugler, Yohji Yamamoto and Yves Saint Laurent
have all kept the style at the forefront of fashion.

# The Leotard

Increased interest in health and fitness during the 1980s saw exercise reconsidered as an activity for all, and beyond the traditional realms of school gym and sports field. The exercise class rapidly became the accessible means of enjoying a routine of organized high energy movement under expert tuition. Aerobics became the lifestyle buzzword, and particular clothes were required: sweatbands, leg warmers, cropped cardigans (the latter two items being borrowed from ballet attire) and, most memorably, the leotard.

But it was not just the term aerobics that was old by this point – it was coined in 1968 – so was the leotard. The tight-fitting garment, originally with full-length sleeves and legs, and entered by the neck, was first worn by the man who gave it its name, Jules Léotard, in 1859. Léotard was a flying-trapeze artist and, although his special attire was made in knitted jersey – rather than such stretch fabrics as DuPont's Lycra spandex with which it would much later be associated – the story has it that this was sufficiently revealing of his male physique to be a draw in itself.

Although the idea of such a snug garment was not new in Léotard's time – versions had been worn under more diaphanous styles of clothing since the late eighteenth century – it was his that caught on. It sparked a trend and was worn by a wide variety of artistes, especially those involved in the performing arts of circus, burlesque and ballet. Legend has it that male ballet dancers wore a full-length body suit under fitted trunks until, in the early twentieth century, pioneering Russian dancer Vaslav Nijinsky forgot to don the shorts for a dance.

The revealing nature of the leotard, covering up and yet seemingly showing all, was only enhanced when activewear company Danskin first made it in spandex. Its designer, Bonnie August, had 'got almost everybody going around in next to nothing', as *People* magazine suggested in 1979. August saw the potential for the leotard to be worn as much as a fashion item, with a short skirt, for example, as a sports garment, although the Californian roller skaters of the era saw

the leotard as fit for both purposes. A colour palette of garish brights and neon detailing was favoured, yellow, purple and electric blue were especially popular, and Lycra was made a household name.

With the popularity of the video-cassette recorder – first made commercial in 1964 but not widespread in homes until the Betamax/VHS format wars of the early 1980s – aerobics exercise at home also took off. The million-selling *Jane Fonda's Workout* (1982) – just one of the movie star's twenty-three exercise videos – ensured aerobics style went global. By then, popular culture could only underline the fashionability of the leotard, although, with the love of leotards among more extravagant performers of rock and pop from Van Halen's David Lee Roth to Queen's Freddie Mercury, men were introduced to the style. The video for Olivia Newton-John's song 'Physical' (1981), the television series *Fame* (1982), movies *Flashdance* (1983), *Heavenly Bodies* (1984) and *Perfect* (1985) with John Travolta and Jamie Lee Curtis, all made the leotard the look of the moment on the street as much as in the dance studio.

At least for a while. More relaxed, more forgiving clothing took over for sports and exercise. But the leotard was adopted by such designers as Donna Karan in 1985 and repurposed as a means of covering up under semi-transparent clothing, and as a super-smooth alternative to a blouse under a tailored jacket. It was precisely because the leotard was so closely associated with the late 1970s and early 1980s that it could have such a retro fashion impact years later, when Madonna prompted a brief revival after wearing one designed by Jean Paul Gaultier for her 2006 tour.

**Opposite:** Beyoncé Knowles performs at the Super Bowl in 2016, wearing a dramatic leather leotard. **Below:** Jamie Lee Curtis in *Perfect*, in 1985, just as the aerobics dance craze had its greatest influence on fashion.

Stiletto
Platform
Ballet Pump
Riding Boot
Desert Boot
Trainer
Sandal
Plimsoll
Basketball Shoe
Work Shoe
Work Boot
Loafer
Kitten Heel
Peep-toe & Slingback
Wedge
Driving Shoe
Brogue
Deck Shoe
Cowboy Boot

# 10.
# Shoes

# The Stiletto

○○○○○○○○○
○○○○○○○○○

No style of shoe has been as much the subject of desirability, status, fetish and controversy as the stiletto. In its most towering and most reduced form, the stiletto was designed by Roger Vivier for Dior in 1954, with the intention that its narrow toe, low-cut vamp and talon aiguille (needle heel), a thin, tapered, 8 cm (5 inch) heel (like the stiletto dagger), would suggest one thing: sex. And, sex as a blunt counter to the grey deprivations of the post-war 1940s, at that.

As shoe designer Manolo Blahnik noted: 'The thing is that wearing shoes like these transforms you, the way you feel, the way your buttocks move. That's what's sexy, not the shoes.' This idea was not lost on many screen sirens of the 1940s onwards, not least Marilyn Monroe, who famously had her shoes made with one heel slightly shorter than the other, to emphasize the sway of her hips.

An advance in engineering during those grey 1940s had made such a particularly high heel feasible. Metal extrusion had allowed for the production of short lengths of thin but extremely strong steel rods, which André Perugia may well have used to produce a stiletto-type shoe ahead of Vivier. But the idea of the heel itself was not new. High heels in some form were worn by ancient civilizations: in Egypt, by butchers to keep them above the piles of offal; in Rome as an indicator that the wearer was a prostitute; and in China, where concubines wore them to express their sexual availability, although it is believed that Venetian women of the sixteenth century first wore them for reasons of style.

Then, as now, they provoked debate: one claim was that the style was invented by husbands to make their wives' movement awkward and love affairs consequently less likely. They were much more difficult to walk in then as, until the 1800s, the shoes were produced (ill-fittingly) to be worn on either foot, so technically hard was it to make high heels to accommodate left and right feet. If the high heel had a champion, it was Catherine de Medici (1519–89), future wife of Henry II of France, and as such a

**Above:** Sarah Jessica Parker wearing heels on the set of *And Just Like That* in 2023.
**Opposite:** Sketches of designs from the shoe designer who popularized stilettos through the 1980s, Manolo Blahnik.

huge influence in matters of fashion. Her conflation of height with stature in society (hence the phrase 'well-heeled') saw her take to wearing heels 5 cm (2 inches) high, a move also emulated by Mary Tudor.

Two centuries on, and the outward elegance of European court life was expressed by ever more streamlined and refined styles of heel, along with the first inklings that they could provide a new form of eroticism. This led the Puritans in America's fledgling colonies to legislate against the wearing of the style to entrap a man. Furthermore, after the French Revolution (1789–99), Napoleon banned them in the spirit of equality, both between classes and between men and women.

It was not until the mid-nineteenth century that the high heel made a return, and with a vengeance. At sometimes 15 cm (6 inches), the heel exaggerated a pronounced instep, thought to be an expression of good breeding. The high heel was even said to help avoid backache rather than cause it. While the fetishization of the high heel continued apace, by the twentieth century the style's popularity was subject largely to the vagaries of fashion, aside, that is, from claims by women's rights supporters that the style represented a repressive, contemporary form of foot binding, rather than a source of pleasure or power for women.

With the late twentieth century seeing shoe design reappraised as a skill in its own right – rather than secondary to fashion design – stilettos have won a new cachet and collectability, notably those by Blahnik ('slut pumps', as the comedian Joan Rivers dubbed them) and Christian Louboutin, whose signature ruby red soles (see p.286) echoed the red heels (or *les talons rouges*) which only aristocracy could wear in Louis XIV's France.

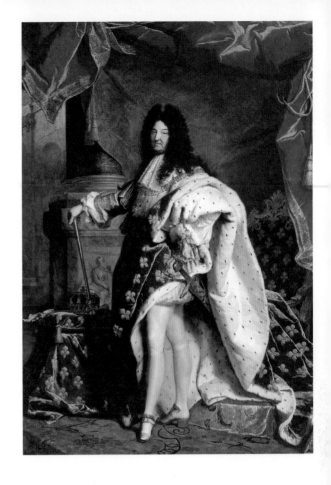

**Opposite:** Actor Tessa Thompson makes a towering impression at a Venice Film Festival premiere in 2022. **Above:** Heels were originally worn by men - the height literally echoing their high status – as the French King Louis XIV demonstrates in this painting by Rigaud from 1701.

# The Platform

○○○○○○○○○
○○○○○○○○○

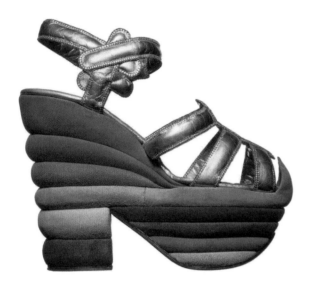

Since the early twentieth century, the platform has often been considered something of a curiosity. In 1939, an advert for the Beachcraft Sandal Company of New York, for example, proclaimed its new platform design to be a 'novel idea in wooden soles'. The same year, a cartoon in the *Boot and Shoe Recorder*, a US trade publication, saw a shoe salesman telling a woman trying on a pair of platforms: 'They'll make you tower over your husband Mrs. Green!'

At the time, it would have been considered unusual to wear a platform shoe on the street; in the United States, the style had first found popularity in 1938 specifically as beachwear, a development on the layered cork platform shoes designed by Salvatore Ferragamo for similar purposes on the French Riviera and Mediterranean coastal resorts the year before. The platform elongated the leg, providing a touch of elegance, but also lifted the foot out of the hot sand. This was an echo of the patten, one of the earliest conceptions of a platform shoe and worn in the fifteenth century as a way of lifting its wearer above the refuse, sewage and manure with which most streets were littered. By the seventeenth century, the well-to-do of Italy and Spain wore their towering chopines under floor-length skirts simply as a means of exaggerating their height.

As platforms found practical popularity on US beaches, such designers as Roger Vivier, Elsa Schiaparelli and Ferragamo explored their fashionability. Yet it was not until the early years of the 1940s that platforms became a widespread fashion choice, the wall of the platform giving ample room for various forms of decoration, from appliqué to tassels. Some attribute this to the rise to stardom of five-foot-tall dancer and singer Carmen Miranda – aka the Brazilian Bombshell – who was Hollywood's highest-paid entertainer by 1945 and who made platform shoes (often by Ferragamo) a signature style. But while the United States saw the platform as glamorous, it was more necessity that drove the look elsewhere. In war-torn Europe, and especially in occupied

**Above:** A platform in golden kid multicoloured suede and a cork heel, designed for the American star Judy Garland by Salvatore Ferragamo in 1938.
**Opposite:** Brazilian Bombshell Carmen Miranda – wearing gold platforms and her signature fruit hat – in *Copacabana* (1947).
**Next page:** Bianca Jagger's backstage pass for the 1975 Rolling Stones tour – worn, naturally, on her shoe.

France, a lack of leather for soles or components for heels saw women adopt a wooden platform as a plentiful alternative. Shortages, similarly, were said to have prompted Ferragamo's first experiments with high cork soles in Italy during the 1930s.

The platform would, periodically, be revisited by fashion. Biba's Barbara Hulanicki introduced a platform boot in 1968, while British shoe designer Terry de Havilland helped make the platform as much part of the iconography of the 1970s as the 1940s, especially since his vertiginous versions for Bianca Jagger and Angie and David Bowie were so outrageous. The theatrical stagewear donned by Elton John or glam rock bands like the Sweet and Slade during the 1970s typically featured a pair of platforms too. Marvin Gaye making a signature of platform boots in silver – made by his wife Janis – while George Clinton, Keith Moon and even early AC/DC would find themselves taller than usual.

Platforms returned again in the 1990s, when a thick sole was found on all styles of footwear, from black fetishistic boots to clogs and from brothel creepers to sneakers, mainly thanks to Vivienne Westwood. In 1993, model Naomi Campbell tumbled while on the catwalk for Westwood wearing her blue, 25 cm (10 inch) Super Elevated Gillie shoes.

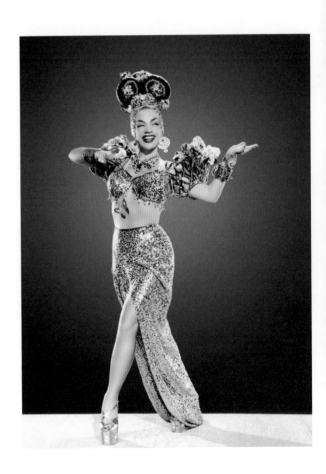

# The Ballet Pump

○○○○○○○○○
○○○○○○○○○

**Above:** Supermodel Kate Moss steps out in ballet pumps, in 2011.
**Opposite:** Audrey Hepburn, gamine in svelte black and decorated ballet pumps, in *Sabrina* (1954).

The ballet pump is typically regarded as pirouetting from stage to catwalk during the 1940s and 1950s. It was in 1944, towards the end of the Second World War, that the pioneering American casualwear designer Claire McCardell asked the New York-based ballet shoemaker Capezio to create a version robust enough to be worn outside. McCardell christened the style 'ballerinas' and soon had a hit on her hands. It was a supremely comfortable shoe whose simplicity meant it could be worn with almost anything and, crucially, it could be made without the restrictions imposed by wartime rationing. Indeed, ballet pumps were exempt. Such was the success of the style that, by the following decade, the ballet flat was the definitive shoe choice of teenage girls, especially as its thin sole and super-soft flexible upper allowed easy movement for the dance crazes that accompanied both big band and fledgling rock 'n' roll music.

As with many fashion staples, it was cinema, however, that cemented the ballet pump within the womenswear canon. Audrey Hepburn – whose influence made the little black dress (see p.94), white shirt and Capri-style pants (see p.154) important fashions too – adopted the shoe for a number of her biggest films, including *Roman Holiday* (1953), *Sabrina* (1954) and *Funny Face* (1957). Hepburn, interestingly, had once been a ballet dancer herself. But perhaps the bigger contribution to its success was the decision of the costumier for Roger Vadim's film *And God Created Woman* (1956) to dress its star, Brigitte Bardot, in a pair. Specifically, a pair made for her in red lambskin with a front tie by Parisian ballet shoemaker Rose Repetto, since the late 1940s the choice of professional dancers. This gave what had come to be perceived as a girlish, gamine shoe a new sexiness. Come the 1960s, the ballet pump was the easy choice to wear with pedal pushers, or, decades later, dresses or jeans.

The ballet pump's uptake as a fashion item, however, does not simply owe a debt to ballet. It is equally true that the modern conception of the ballet shoe – heel-less, unlike the earliest ballet

shoes worn at France's Académie Royale de Danse from 1681 – owes a debt to fashion. For roughly half a century from the late 1700s, a silk slipper-like shoe much like the ballet pump in its cut and simplicity (with perhaps a ribbon fastening for the ankle or, later, a strip of elastic) was the day-to-day choice of any fashionable Western European woman, the only fashion variation being in changes to toe shape, whether rounded or more pointed.

Repetto has gone on to become one of the world's most prestigious producers of ballet pumps, and, in 2011, it launched an atelier service in London's Selfridges department store, whereby customers could design their own ballet flat, and a bespoke pair was made at the firm's factory in France. The brand still uses the same stitching techniques found on traditional pointe shoes to make a strong toe seam.

From the pale pink shades to the two-tone style introduced by Chanel, ballet pumps are timeless, as Calgary Avansino, *Vogue*'s executive fashion director, states: 'It is very rare in the fashion world – the ballet pump has the unique trait of combining comfort and ease with class and style.'

**Opposite:** The stripped-back ballet pump became almost a modernist choice, worn here with slim-line trousers in the mid-1960s.
**Below:** Singer (and later shoe designer) Katy Perry mixes ballet pumps with bustier and shorts.

# The Riding Boot

○○○○○○○○○
○○○○○○○○

**Above:** Two-tone riding boots designed by Pierre Cardin in the 1960s to allow trouser legs to be tucked into them, 'Cossack-style'.
**Opposite:** Jerry Hall, right, and friend ride the sidewalk in their riding boots, 1978.

Shoe designer Christian Louboutin was not the first to paint a sole red. Mongol tribesmen painted the heels of their boots red, and it is possible to attribute the invention of the heel for riding to the Mongols of the thirteenth and fourteenth centuries (their period of empire-building). As with the cowboy boot, the toe was pointed, the better to go through a stirrup, while the heel of the boot was higher than typical and angled towards the toe, giving a purchase on a stirrup while preventing the shoe from slipping right through it. These then, might be considered the first riding boots, and subsequent styles were an equal mix of function and panache: riding boots of early-seventeenth-century Western Europe, for example, had the same 5 cm (2 inch) heel, pointed last and straight soles (meaning that either boot could be worn on either foot, allowing wear to be more evenly distributed), but the shaft flared at the top of the thigh. They were as dramatic and piratical as they were practical.

Some women wore various styles of boot for riding during the seventeenth and eighteenth centuries, though it was not at all uncommon for them to wear shoes or ankle boots of some kind. Yet it was not until the early nineteenth century that boots became fashionable, in particular for women, despite their association with nobility, generally the only people wealthy enough to own a mount. War may have provided the turning point, with the 1815 victory of Arthur Wellesley, 1st Duke of Wellington, over Napoleon Bonaparte at the Battle of Waterloo prompting in the UK a national trend for what was deemed the Wellington boot – with a low heel and mid-calf shaft, these were made of leather, not the rubber of the twentieth-century wellie.

By the 1850s, the two-piece Wellington boot, known as a Full Wellington, had become standard issue for military men, adding to the style's glamour. Equestrian boots for women often came with a field-boot closure, lacing like a corset from the top of the vamp and up the lower part of the shaft, making them considerably easier to put on in a ladylike fashion.

Womenswear continued to experiment with various heights of boot from then onwards; ankle boots, for example, had been worn for walking as an outdoor pursuit since the late 1780s, but would in turn become the side-laced Adelaides of the 1830s (named after King William IV's queen consort), the button-fronted boots of the 1880s, through to designers Pierre Cardin and André Courrèges's modish go-go boots of the 1960s.

But any boot that could really claim to be a riding boot would derive from the initial Wellington style. Often practicality was at the root of the choice; the high boot underwent a resurgence in the 1890s, for example, when bicycling became fashionable for women and a boot was required to protect their stockings, while the vogue for the close-fitting, pull-on, knee-high Russian boots of the early 1920s were regarded as a more chic, leather alternative to galoshes or rain boots, and were originally designed for his wife by couturier Paul Poiret.

The riding-boot style soon superseded necessity. Russian boots prefigured the types of boot that would be termed young and modern in the 1960s, thanks in large part to those designed by Balenciaga and Roger Vivier for Yves Saint Laurent, which would be hailed as more progressive, capable alternatives to the post-war ladylike and dainty fashion attributed to Christian Dior's New Look. It is perhaps ironic that it was the practical, masculine nature of the tall boot that in the end made it so fashionable for women.

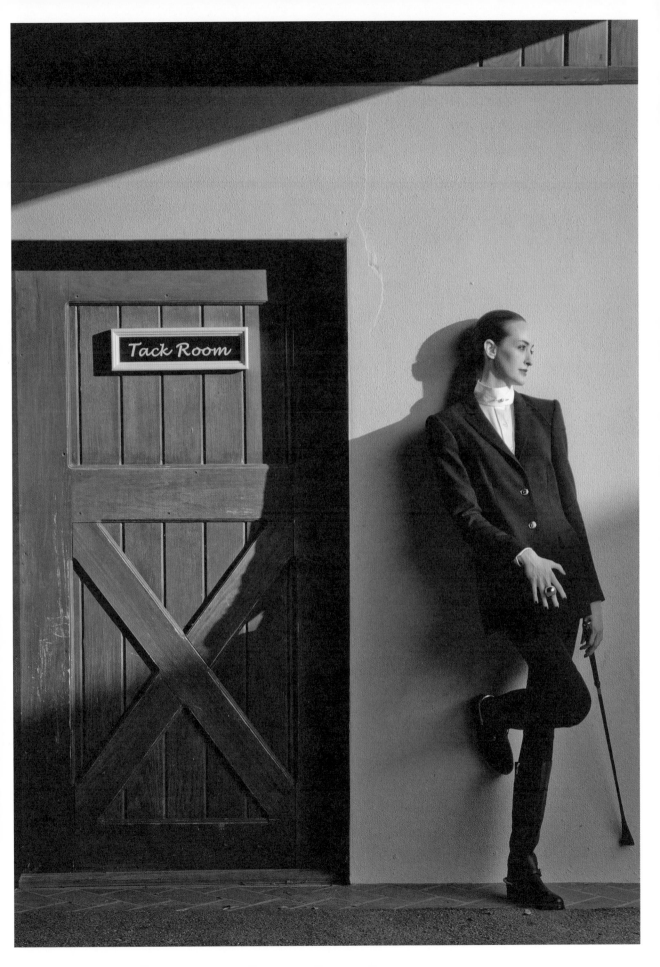

# The Desert Boot

○ ○ ○ ○ ○ ○ ○ ○ ○
○ ○ ○ ○ ○ ○ ○ ○

The Clarks desert boot is one of the most versatile of men's footwear styles. It can take the formal edge off a suit, as Savile Row couturier Hardy Amies explored during the 1960s. It looks sharp with a deconstructed jacket, and is a dressier alternative to sneakers when worn with jeans. The boots even look good teamed with baggy khaki shorts, as they originally were: after all, they have 'legendary qualities in hot climates', as the company's advertisements declared in the 1950s.

Perhaps these qualities are what caught the eye of Nathan Clark of the C. & J. Clark shoemaking family, based in Somerset, England. During the Second World War, when he was serving in Burma with a West African brigade, he spotted what he described as 'crepe-soled rough suede boots' on the feet of off-duty Eighth Army officers who had previously been fighting in Egypt. They had been made for the officers in the Old Bazaar in Cairo, where a more rough-hewn version was worn by traders. Clark was under the impression that, in turn, the style was derived from the boots of South African soldiers, which were based on the *veldschoen* (shoes for the open country) worn by Dutch Voortrekkers.

In 1949, after his return to Somerset, Clark asked pattern-cutter Bill Tuxhill to re-create the comfortable, streamlined construction: a two-piece upper, back stiffener and crepe sole on a wide, round-toe last. Many people at the company were convinced the boot would never sell but Clark thought otherwise; its pioneering sole was the first comfortable alternative to leather. Desert boots were a big hit in the United States, where they were first appreciated as part of the preppy look, as a consequence of both an editorial in a 1950 edition of *Esquire* and the company's imaginative launch of the style at the Chicago Shoe Fair: Clark re-created a desert oasis, complete with belly dancers who presented the boot on a silk pillow.

Although it was a British-made product, the desert boot was not launched in Europe for another fifteen years, when it was so successful that in Italy it came to be regarded as quintessentially English, and

in France any desert boot, original or copy, became known as *les Clarks*. The style has been a favourite of style and cultural icons over the decades – Steve McQueen (in 1963's *The Great Escape*), Bob Dylan and the Beatles were fans – and is a recurring stalwart of many style movements. The desert boot was the choice of the mods of the 1960s and 1970s, hip-hop crews of the 1980s (customized with a marker pen), house music fans in the 1990s (comfortable enough for dancing until dawn) and its popularity has continued to the Brit Pop era of the 1990s, and beyond.

The desert boot has come in many forms: made in Harris tweed, patent leather, tartan checks, in recycled shirting fabrics, in the red, white and blue of the Union Jack... But the classic remains suede, as supplied from the start by the Charles F. Stead & Co. tannery in Leeds, northern England.

Clarks has a knack for discovering classics. In 1964 Lance Clark launched the Wallabee, another soft shoe whose design seems to defy easy categorization. And in 1974 the Desert Trek – a variant of the desert boot, with a lower cut and a centre seam over the upper – was introduced as a response to the oil crisis, when more people took to the streets to walk to work.

**Clarks days are back again.**

ORIGINAL
DESERT BOOT · *Clarks*

**Opposite and above:** First seen on the feet of traders in Cairo's Old Bazaar, desert boots were an unofficial part of British army uniform for soldiers serving in North Africa during the Second World War. It took Nathan Clark's commercial version to make them part of the uniform for beatniks and mods.

# The Trainer

○ ○ ○ ○ ○ ○ ○ ○ ○
○ ○ ○ ○ ○ ○ ○ ○ ○

The trainer, or sneaker, began its life as a simple rubber-soled, canvas-uppered casual shoe – a plimsoll, ideal for wearing on the beach or for light sport. Although the London Rubber Company was likely first to make such a shoe in the 1890s, it was the Converse Rubber Shoe Company's Chuck Taylor All Star – launched in 1917, the same year that ad man Henry McKinney coined the term 'sneaker' for the silent, stealthy steps one could take wearing a pair – that is arguably the classic branded version of this, with many imitators of this basic style having followed. Subsequently companies the likes of Adidas (formed by the German Dassler brothers in 1949) and others would create training shoes for dedicated and specialist use by athletes in various sports.

But the more modern incarnation of the sneaker – more colourful, more substantial, more technical and definitely more pop cultural – would not come for another sixty or so years. Then it inspired a global lifestyle of collectors and obsessives and redefined expectations of comfort in footwear, even if many wearers were only passingly interested in the purpose for which their shoes had actually been designed.

The genesis might be dated to the mid-1970s, when Nike pioneers Bill Bowerman and Phil Knight paid $10 to a local graphic artist to design a 'swoosh' logo as part of his plan to capitalize on the new fitness craze for jogging, and started a design revolution for trainer designs ever more outlandish in their styling and technical sophistication – starting with Bowerman's creation of the Nike Waffle sole by pouring modelling clay into his wife's waffle iron.

Many of its subsequent sneakers would transcend the Nike brand – Dunk, Air Force 1, the hugely successful Jordan line and so on – with their designers, from Bruce Kilgore to Tinker Hatfield, becoming celebrities in their own right. With the distinctive looks came performance enhancements (Air, comprising a series of bubble-like compartments in the soles of the shoes, being the most famous) that in some instances would challenge the regulations

**Above:** Sneakers would become collectable and tradable, some changing hands for thousands.
**Opposite:** Michael Jordan – basketball hero and global sneaker brand-to-be – in a slam-dunk competition in 1988.

of the sport they were created for. It was in breaking the rules that Nike drove a cult: basketball shoes were meant to be only in regulation white; Nike made Michael Jordan's in red and black, and just paid the fines that accrued with every game.

Nike's success in sport – and in developing its rebel, 'Just Do It' ethos – would also foster a rivalry with Adidas, each brand driving its own tribal followings, in the latter's case more in the counter-culture of the times. Adidas would be worn by Bob Marley and David Bowie, and run the gamut from early hip hop (Run DMC would sing their tribute anthem 'My Adidas') to the terrace Casuals of 1980s UK. Like Nike, it too would find its own classic, if more understated styles: among them Gazelles, Stan Smiths, Sambas and Superstars, many of them styles dating to the 1960s yet finding new fan bases with each generation.

But the sneaker world would soon transcend the sports brands that made their shoes, ostensibly at least, to be worn for sport. In 1984 Gucci became the first fashion house to create its own sneaker, a tennis shoe with the brand's signature green and red stripes – thus starting the sneaker on a trajectory from sports item to urban item to high fashion item. By 1996 Prada entered the market, kick-starting the market for luxury designer sneakers that would explode over the next two decades.

Adidas was quick to recognize the shift – creating collaborations with designers such as Yohji Yamamoto and Jeremy Scott, and later with Kanye West or Raf Simons – but most designer brands were in the sneaker game soon enough, producing shoes in fine leathers, and often with extreme shapes or detailing. Trainers offered men especially the chance to indulge in such flights of fancy while remaining otherwise soberly dressed, though many start-up brands (Clae and Common Projects among others) soon also offered upscale versions of more pared-back styles that chimed with increasingly relaxed dress codes, even in a business setting.

**Opposite:** 'My Adidas' was both homage and hit for Run DMC, performing here in 1986. **Above:** The giants of sportswear would, inevitably, collaborate with those of fashion – as with this Adidas/Gucci shoe of 2023.

# The Sandal

○ ○ ○ ○ ○ ○ ○ ○ ○
○ ○ ○ ○ ○ ○ ○ ○

**Above:** Shorts, sandals, headscarf – a fashionable outfit for the fashionable Capri, Italy, in 1959.
**Opposite:** A sandals-centric advertisement for the Clarks shoe brand, from the early 2000s.

'The time of the fable is over, the Reign of History is beginning.' Such was Josephine Bonaparte's admonishment to society beauty Madame Tallien and two friends whose excessive dress, she warned them, would not be tolerated again. And when the wife of the Emperor of France criticizes one's clothing, one might well take note. These women's offence? In 1799, they appeared at a state function wearing tunics and, what seemed to fuel the furore, sandals with purple straps. For good measure, they wore rings on their exposed toes.

Such things might have been acceptable portrayed in art, inspired as it was at the time by the taste for classicism and the style of ancient Greek and Roman statuary. Like many ancient civilisations, the Greeks and Romans, men and women, all wore sandals as a matter of course.

But to wear open-toed sandals in real life was a step too far. The solution, it turned out, was to create the illusion of doing so, by painting straps and cut-outs over a closed shoe and using an underlay matched to coloured stockings. Come 1800 – and even though the sandal style had, in effect, been worn for tens of thousands of years, tying a protective leather layer to the sole being one of the most basic ways of creating a shoe – the word 'sandal' meant just that: any closed shoe with laces that crossed over the instep and tied around the ankle.

Remarkably, it was not until 1907 that the sandal in its modern (or rather ancient) conception – a shoe held on with straps that exposed the feet and toes – entered fashion, and then tentatively. Ahead of her time, that year the French couturier Madeleine Vionnet showed her models wearing sandals, but it would not be until the 1920s that the shoe form became widely acceptable, and then mainly as a practical style to wear at the beach or the new seaside resorts.

One reason for its appeal was the new fashion, popularized by Coco Chanel, for having a tan. Traditional bathing shoes covered the instep and created a tan line around the ankle. The platform style that followed originated as a beach

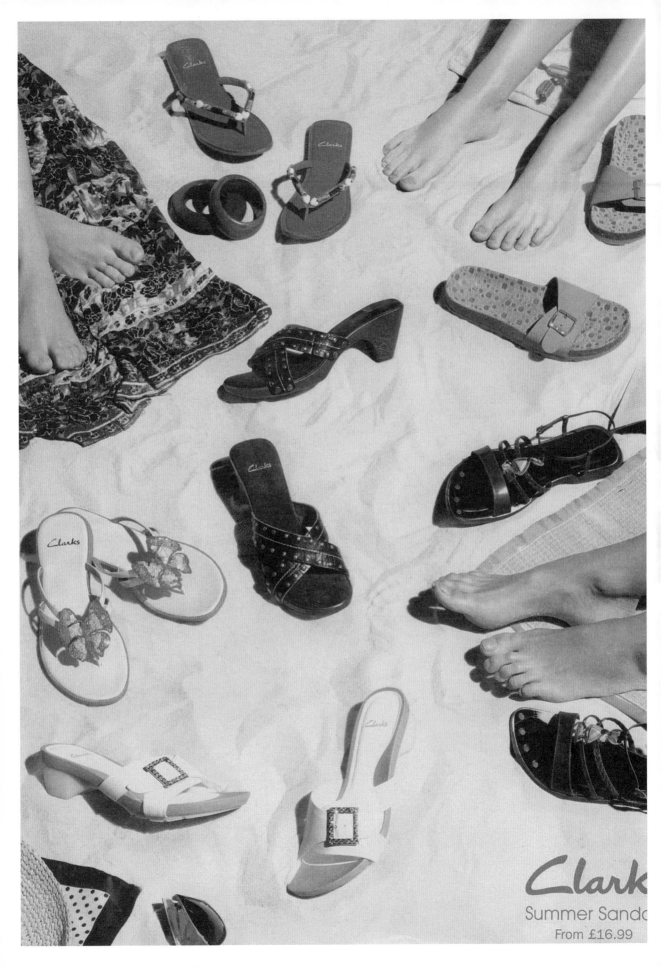

Clarks
Summer Sandals
From £16.99

sandal too, its thick sole designed to sink into the sand allowing the foot to remain protected above it. By the 1930s, the basic sandal might be worn for eveningwear, but only styles with a closed toe, and only worn with stockings. To have bare legs at this time was deemed almost as unacceptable as exposing one's toes in Napoleonic France.

The sandal might be said to have lived a double life: while some were getting dressier, others were becoming much more basic. One theory has it that the demand for the latter was due to their being worn by Hollywood starlets off-set, who in turn had been introduced to them through the spate of biblical epics filmed before the Second World War. Cecil B. DeMille, the director behind many of these, had, after all, hired shoe designer Salvatore Ferragamo to make the footwear as authentic as possible, an ethos that would similarly appeal to sandal-wearing hippies in the 1960s.

War helped the sandal's progress: shortages encouraged minimal use of leather wherever possible and the style became the shoe of choice for the pin-ups, both photographed and, more typically, as illustrated by Alberto Vargas and George Petty. These sassy girls – role models of a sort – underpinned the sexiness of the sandal, with its 'peekaboo' style and the notion of 'toe cleavage', only made more popular by the advent of colourful nail varnish.

As for men in sandals it would arguably take the hippy flower power of the 1970s – with a general tenor of dressing down and cutting loose – for the sandal to find widespread acceptance on male feet. It was 1973 that saw the launch of the Arizona, an unconventional, orthopedically-correct two-strap sandal from a little-known German company called Birkenstock.

# The Plimsoll

○○○○○○○○○○
○○○○○○○○○

The ancestor of what by the 1980s had become the ubiquitous and unisex trainer, or sneaker in the United States, was designed for a much more sedate purpose: walking on the beach. The original plimsoll was a product of British seaside holidays in the mid to late nineteenth-century, and the discovery by working men that their sturdy boots were inappropriate for the setting and the sand. The result was an uptake of the 'sand shoe', a new, cheap, lightweight shoe with a cool, fast-drying canvas upper and rubber sole, popularized by the Liverpool Rubber Company (established in 1861 and later bought by Dunlop). The sole was secured to the canvas by way of a rubber strip that gave the shoe its name, echoing as it did the white Plimsoll line introduced in 1876 to indicate the maximum depth to which a ship's hull might be immersed when loaded with cargo. The seafaring analogy was particularly apt given its typical beach use.

The shoe was soon being worn by sporty men and women, proving itself ideal for court sports due to the cushioning and grip it provided and the protection it afforded the playing surface. Yachtsmen and women appreciated the plimsoll for similar reasons, while the armed services made the shoes part of standard issue kit for use during physical training. Advances in the design saw the addition of a rubber toecap to prevent the big toe wearing through the canvas, and the first instances of branded plimsoll-type footwear began to appear.

Most notably, 1908 saw the founding of the Converse Rubber Shoe Company, based in Malden, Massachusetts. The company quickly established a firm reputation making rubber-soled shoes, breaking into the tennis shoe market in 1915 and launching the Converse All Star basketball shoe in 1917. A boot followed when company salesman and ex-basketball star Charles ('Chuck') Taylor suggested the addition of a patch to protect the ankle. The boot became the staple footwear for college sports in the United States for many decades, and was available only in black until 1947, when a white version was

introduced. This fast became part of the uniform of the American teenager of the 1950s, along with white T-shirts and a pair of Levi's. By 1966, the Converse take on the plimsoll had become the firm market leader, and seven colour options were introduced.

From the 1970s onwards, there was an increased availability of sports shoes designed for specific activities and much more outlandish styling, thanks in part to the technical advances made possible by new materials. Fashion, however, remained fond of the minimalistic simplicity of the plimsoll, and the way that, like denim, it improved aesthetically with age. The plimsoll formed a stylistic component of key, often music-led, subcultures from the late 1970s onwards, including American punk rock, grunge (worn with a floral dress and outsized cardigan), American West Coast hip hop and hardcore punk/emo as well as many others with a retro leaning. Then, the plimsoll's often short shelf-life – scuffs, dirt and holes – only added to its appeal. In the 2010s, when its back-to-basics design and near disposability saw it dubbed the 'Shoreditch slipper' (after the then fashionable area of East London), versions from Keds, Superga, Vans, as well as brand-free traditional school plimsolls, were teamed with rolled-up jeans and tea-dresses.

**Opposite:** Katherine Hepburn and Spencer Tracy, in plimsolls and on the set of *Pat and Mike* (1952). **Below:** Vans would take the idea of the basic canvas plimsoll and update its functionality for the first skateboarders. Now it has crossed over into the everyday shoe.

# The Basketball Shoe

○ ○ ○ ○ ○ ○ ○ ○ ○
○ ○ ○ ○ ○ ○ ○ ○ ○

**Above:** The Converse Chuck Taylor All-Star, designed in 1917, and one of the best-selling sneakers of all time.
**Opposite (above):** Elvis Presley in atypically unglitzy style – college sweatshirt and basketball boots.
**Opposite (below):** Leonardo diCaprio wearing Chuck Taylors in *The Basketball Diaries* (1995).

How the Converse All Star originated is a story that belongs to more innocent times. Back in 1921 an established basketball player, Charles ('Chuck') Taylor, walked into Converse's Chicago offices looking for a job. These were the days before celebrity ruled the world and the company didn't sign him up as the new face of its product – it hired him as a salesman. Taylor duly sold the brand's basketball boots, and in the 1930s Converse decided to add his name to a product.

Taylor's boss was Marquis Mills Converse, the manager of a footwear company who in 1908 had decided to go it alone and launch his own business. The Converse Rubber Shoe Company, based in Malden, Massachusetts, had soon established a firm reputation with its gents' rubber-soled shoes. It broke into the tennis shoe market in 1915 and launched the Converse All Star basketball shoe two years later. It was a ground-breaking style, but it was the Taylor version that resulted in the company claiming an icon.

The shoe had all the design enhancements Taylor suggested, most notably the patch to protect the ankle. But it was his sales efforts that ensured what came to be known as Chuck Taylors were the official shoes for physical training in the United States Army during the Second World War. His salesmanship also led to the first Converse Basketball Clinic being established to improve the basketball skills of college students across the United States – and persuaded coaches and local sporting goods stores to switch to Converse shoes. By 1949 the All Star was the official footwear for every player in the National Basketball League, the forerunner of the National Basketball Association.

Taylor was a salesman and frontman for the basketball shoe for some forty-eight years, until he died in 1969. More importantly he also oversaw the simple canvas All Star boot, or hi-top, as it became part of American folklore. Only available in black until 1947, when an all-white version was introduced, the boot became as much part of the teenage and collegiate uniform as denim and checked flannel shirts, and was a choice of the era's rockabilly subculture. This

was largely down to clever marketing: each year the company produced the Converse Yearbook, which celebrated the highlights of the basketball year and included high school athletics. It came complete with illustrations by Charles Kerin, whose work, along with that of Norman Rockwell, created the archetypal imagery of the 1950s American Dream.

By the 1960s Converse dominated the athletics footwear market – in 1966 it even decided to introduce seven colour options for the boot. However, its time at the top did not last. Rival companies were launched throughout the 1970s; Converse failed to innovate and was eclipsed by more technically advanced designs from Nike and Adidas.

Nevertheless, Chuck Taylors – also affectionately referred to as Chuckies, Connies and Cons – have continued to retain the loyalty of many fans and, from the late 1970s onwards, have been well worn by key, typically music-led, subcultures, including American punk rock, grunge (Nirvana's Kurt Cobain rarely wore any other footwear), G-funk (the bass-heavy variety of American West Coast rap/hip hop) – and, at the turn of the twenty-first century, the gothesque style of hardcore punk/emo. With such a strong following outside sports, it's small wonder that the Converse All Star can claim to be the best-selling sneaker of all time.

# The Work Shoe

○○○○○○○○○
○○○○○○○○○

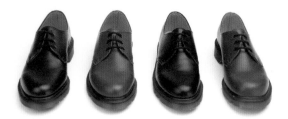

Rather than being named prosaically after a stockroom number, the Dr. Martens 1460 boot is so called because the first one came off the production line at the R. Griggs shoemakers in Wollaston, Northamptonshire, on 1 April 1960. The eight-holed, cherry-red boot was distinctive from the outset, as was the shoe version, the 1461, launched the following year. But, unexpectedly perhaps, given the clumpiness of this footwear, the 1460 was about comfort rather than appearance, and once the pains of breaking the boots in had been overcome they were extremely easy to wear, especially compared with other work footwear of the time.

'It's a fact! The working man has never before been offered a really comfortable boot,' an advertisement for Dr. Martens declared in 1960. '"Hard work – Hard boots" had to be accepted. The revolutionary Dr. Martens Air Cushioned soles puts an end to this foot-breaking torture … a most pleasant experience for the much abused foot.'

Although the famed AirWair sole is now considered to be a characteristically British product it was invented by a German during the Second World War. Dr Klaus Maertens, a twenty-five-year-old who was home from the front, was convalescing after a skiing accident in 1945 and had the idea of making an air-filled material for soles that would help his painful foot. This came to fruition when he teamed up with Dr Herbert Funck, a chemical engineer. The two men bought up the disused rubber to be found abandoned at Luftwaffe airfields and devised a method for heat-sealing, rather than stitching, the sole onto a shoe's upper, which created airtight compartments (which later proved useful for inventive drug-smugglers).

The DM, as their footwear came to be known, had inauspicious beginnings: it was sold as being ideal for older ladies, for gardening. It was not until 1960 that the Griggs shoe business acquired exclusive manufacturing rights, made design changes that would define the DM's characteristic look for boots and shoes alike – bulbous shape, ribbed welt and yellow welt-stitching – and decided on an anglicized Dr. Martens

as its name. 'Dr Funck's' was rejected as a brand name on the grounds that it was potentially offensive.

The comfortableness of the DM ensured it was a staple of public service uniforms – from post office and railway workers to London Underground staff and police officers (who were often instructed to cover the yellow stitching with black ink) – for some decades. But, almost uniquely, its look also captured the imagination of every youth subculture from the 1960s to the 1990s, until the advent of the sneaker as a fashion item, which saw tougher times for the footwear and for the Griggs company.

DMs were worn (and customized) by punks, goths, grungies, hard mods and, most notably, skinheads – both the original working-class ska fanatics and the later nationalistic variety who would come to taint all skinheads. 'Skins' preferred them in brown, with black polish smeared into the creases to 'antique' them, often oversized, with laces passed through the AirWair heel tag and tied around the leg; trousers were worn short enough for this to be seen. They were worn by the Clash, Slade, Madness and the Who's Pete Townshend.

DMs became something of the everyman shoe or boot. Football hooligans found the steel toecaps useful, to the extent that during the 1970s police made fans abandon their DMs outside football grounds. At the other end of the spectrum, teenage girls discovered, through DMs, that they did not have to dress 'prettily'.

**Opposite:** Dr. Martens became one of the leading makers of work shoes for the European market, outfitting police officers and postal workers. **Below:** Gwen Stefani performing in knee-high Dr. Martens boots, in 2012. **Next page:** A group of skinheads – a British subculture that grew out of ska during the 1970s – that took particular pride in well-polished work boots.

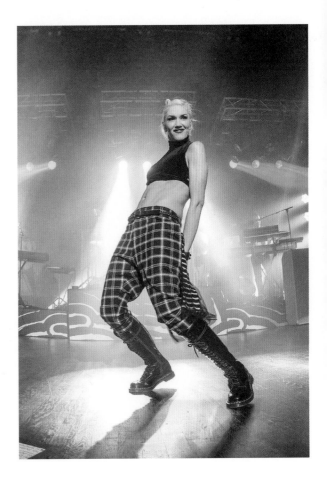

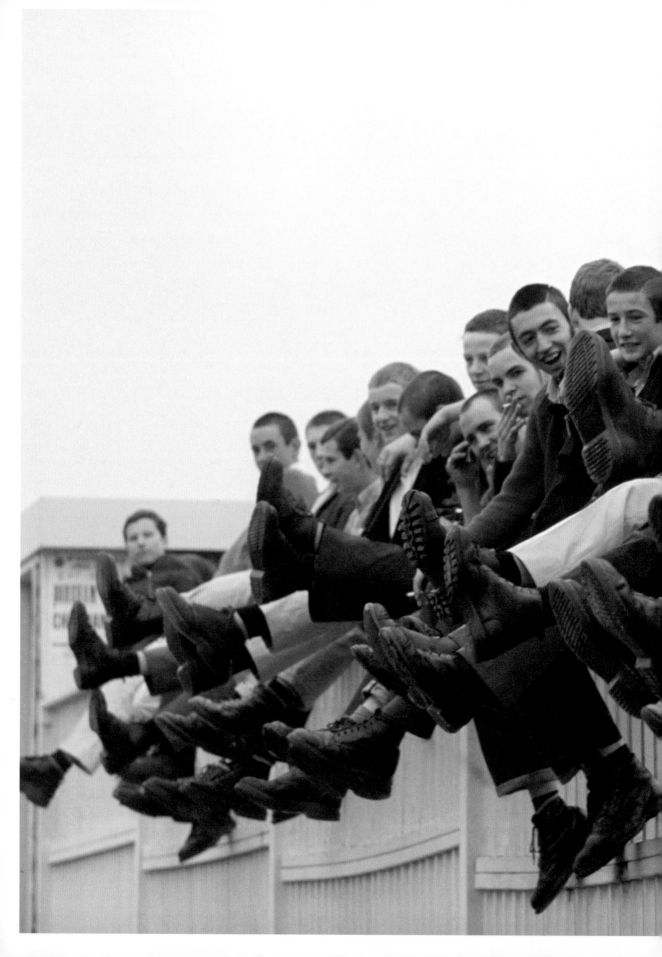

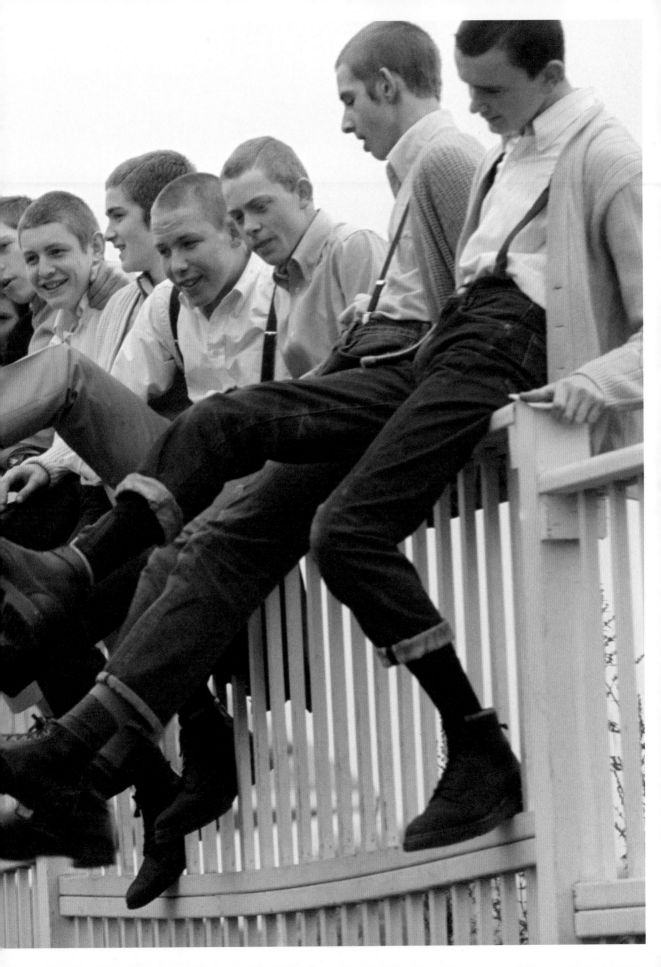

# The Work Boot

RED WING BOOTS

BEST

UNDER THE "SON"

THE HOME OF
BLACK and BROWN CHIEF
THE FARMER'S
SHOE

RED WING SHOE COMPANY

Just as Timberland's 'yellow boot' became a standout flagship style for the company, so the Irish Setter work boot, with what would become its distinctive white sole and its russet-reddish leather upper that mimicked the coat of the dog after which it was named, came to be an emblem for its manufacturer, Red Wing. A template for work boots, this 1930s style also built on a kind of Americana – a blue-collar chic, arguably originating with Levi's 501 jeans, that appreciated the authenticity and hard-wearing qualities of products built for a purpose: for mining, chopping wood, stoking a steam engine, driving big trucks. Engineer boots with their wrap-over buckle, which date back to around 1933 but have long since been co-opted by bikers, have the same appeal.

The Red Wing company was started in 1905 by Charles Beckman, a German immigrant who named it after a town of just 16,000 people, set in the bluffs of the Mississippi River in Minnesota. The town was itself named after the Dakota tribe's chief, Red Wing, the first of whose predecessors was known – appropriately for a boot company – as Walking Buffalo.

The territory was ideal for selling hard-wearing boots. It comprised huge forests, farmlands and iron mines, all subject to extremes of weather: searing heat in summer and temperatures as low as -30°C (-21°F) in the winter. With heavy industry in the region expanding, Red Wing boots found a ready market, most notably for its Brown Chief farmer's model of 1919. The predecessors of the Irish Setter were launched in the 1920s as the company's first 'outing boots', which were specifically designed for outdoor leisure pursuits, in particular, hunting, fishing and boating. War provided the company with an even more buoyant market: it supplied the United States Army with its No. 16 boot in the First World War, and again in the Second World War, when it was available in 239 sizes and widths to ensure comfort on long marches.

But it wasn't until the 1950s and early 1960s – the classic era of Americana to which retro trends most frequently return – that the Irish Setter, seemingly

designed to look just so with jeans, became a popular leisure boot across the United States. Perhaps nothing could drive this point home more succinctly than the fact that the advertising images of the time were drawn by Norman Rockwell, whose hard-working, hard-playing red-cheeked characters, straight from Main Street, helped to define the era in the popular imagination.

Red Wing boots might play an even greater role in street culture's history if a costume designer hadn't given way to an actor. Harrison Ford was slated to wear a pair when he played Indiana Jones in Steven Spielberg's *Raiders* film franchise. But Ford suggested an alternative: the boots made by another United States bootmaker, Alden, that he had worn when he was a carpenter. This boot may now be known as the Indy but it cannot claim the rugged heritage of the Red Wing.

**Opposite:** An early Red Wing advert for its Farmer's Shoe model, driving home how the company positioned itself as a provider of footwear to manual workers. Much later its blue-collar reputation was sealed by being worn by Jack Nicholson in *One Flew Over the Cuckoo's Nest* (1975).
**Above:** The much-imitated Red Wing classic work boot. The style, with its characteristic white sole, had undergone a long evolution. Earlier models had a plain sole with a distinct heel piece, more akin to the styles Red Wing had developed for other specialist activities, including logging and driving locomotives.

# The Loafer

○○○○○○○○○○
○○○○○○○○○

The origins of the modern loafer are as much in accident as in intent. US shoe manufacturers were looking for a style that would be definitively their own, rather than effectively an import from the famed English shoemaking towns in Northamptonshire. It came during the 1930s when New Hampshire-based Spaulding marketed a soft, slip-on style of shoe it called the loafer, with everything the name implied of comfort and leisure.

Around the same time, in 1936, an employee of G.H. Bass, also an East Coast manufacturer, based in Wilton, Maine, brought a hand-sewn, moccasin-type shoe back after a trip around Norway. The style was traditional to the indigenous Sami people and Scandinavian fishermen, who wore the shoes when they were not at sea, and was also associated with Native Americans, who wore rough-hewn deerskin shoes without stiff soles to aid movement – silent movement at that. These were so comfortable that they were worn by early traders – and by the end of the eighteenth century settlers in America were sending the shoes to Europe. One story has it that fishermen in Norway adopted them when Norwegian explorers returned from North America, creating a circular exchange.

Inspired by its employee's find, Bass added a thick sole in order to make the style sturdier, dressier and suitable for the US market, as well as what would become the design's most celebrated aspect: a vamp saddle or strap with a cut-out, diamond-patterned slot. It called the style the Weejun, a corruption of Norwegian.

The slot was intended to be a purely decorative detail. But when American college students began to wear the style – comfortable and smart, but sufficiently casual to avoid being corporate – during the period after the Second World War that saw the birth of the teenager, they slid a coin into the slot, hence the style's nickname: the 'penny loafer'. One company, Kerrybrooke, even produced a shoe, the Teenright Smoothie, complete with a good luck coin. Such was the loafer's almost overnight popularity – as unconventional as it was for women to wear

**Above and opposite:** Loafers epitomized a certain easy dressing in the 1950s, and became the core footwear of the preppy style, seen on women's feet as readily as on men's. Sebago, another major US footwear company, became Bass's main rival in the production of loafers.

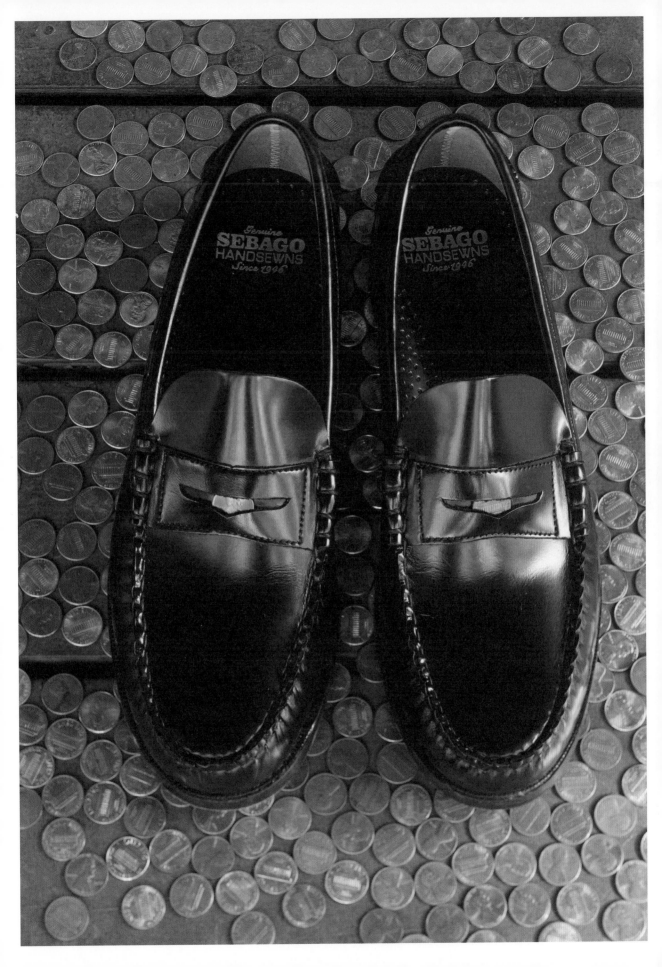

at man's shoe at the time, comfort won out – that the University of Carolina's newspaper, the *Daily Tar Heel*, ran an article that asked 'What are Bass Weejuns?', and declared wearers of the shoes were 'with it'. Almost inevitably, James Dean, embodiment of the 1950s teenage archetype, made loafers part of his uniform of denims and white T-shirt. Grace Kelly wore loafers (with cuffed jeans and a mannish shirt) for publicity photos in 1954. Elvis Presley wore a white pair in *Jailhouse Rock* (1957), Audrey Hepburn a pair by Salvatore Ferragamo in *Funny Face* the same year.

The pennies were not the only flourish over the years that added distinction to an otherwise streamlined style. In 1952 – supposedly at the request of actor Paul Lukas, star of 1938's *The Lady Vanishes* and 1943's *Watch on the Rhine* – US shoemakers Alden (also an East Coast company, from Massachusetts) created the tassel loafer. For them the tassel, in effect a lace that passed through the shoe's upper and ended in a knot of leather, was not only a debonair touch; it suggested the shoe fitted so well without laces that none were required. When Brooks Brothers decided to carry the style from 1957, the loafer's place in the preppy wardrobe was assured. Other decorations followed. US brand Sebago, for example, introduced the beef-roll – a thick tube of stitched leather at both ends of the vamp saddle. Kiltie fringes were also popular, as was the Venetian style with no vamp saddle or decoration. Gucci's lighter-weight, status-symbol style – beloved of John Wayne and Clark Gable, later Jane Birkin and Madonna – replaced both slot and tassel with a snaffle bit.

With its informality, ease of wear and a certain insouciance, the loafer is the quintessentially American shoe. By the 1960s increasingly it was worn not only at weekends but also to the office, even as John F. Kennedy was popularizing the wearing of Weejuns without socks. It was with socks – thick white ones – ankle-skimming trousers and a sci-fi-style red leather jacket created by costume designer Deborah Landis that Michael Jackson chose to wear his patent-leather version some two decades later, in 1984, in the video for his 'Thriller' single. Loafers subsequently became a signature style for the singer.

# The Kitten Heel

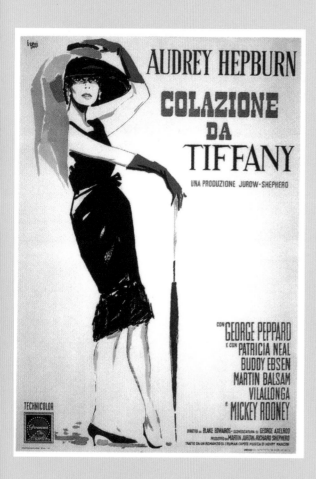

If the stiletto of the 1950s suggested sex, soon a more respectable heel would be in demand – still a heel, but sweeter, maybe even girlish. The name kitten heel, after all, came from period slang for a young, inexperienced girl for whom a short, tapered heel, between 3.5 and 5 cm (1.4 and 2 inches) high, supported by a metal internal stem safely situated right in the middle of the heel, would be an appropriate starter heel before graduating on to more towering footwear. In fact, some US shoe retailers referred to the kitten heel as the 'trainer heel'.

The rival stiletto was also something of a statement – fashion and otherwise – that not all young women wanted to make so soon after the model's introduction. Yes, teenage girls quickly embraced the kitten heel in the expectation that they might one day move on to higher things. But many adult women began to wear them too, regarding them as a compromise between the extremes of crippling stilettos and inelegant, childish flats.

The kitten heel typically came with a pointed toe, but its chief characteristic – the dainty heel – meant that, unlike its taller cousin, it left most wearers considerably more mobile, and with less of a sassy walk to boot. Sometimes its height was part of its appeal in a more complex way: by keeping women more diminutive in relation to men and so suggesting youth and innocence. And, as heel height had been used since medieval times, it also spoke of status and power. Oscar-winning costumier Edith Head selected a pair of kitten heels for Audrey Hepburn to wear in *Sabrina* (1954) opposite Humphrey Bogart, to ensure they did not stand eye to eye; the kitten heel, consequently, became known as the 'Sabrina heel'. Hepburn, who came to be associated with the style (as well as the ballet pump), also wore them a few years later in *Funny Face* (1957), opposite Fred Astaire. In both instances, the shoes were by Salvatore Ferragamo, the Italian shoe designer whom Hepburn met while living in Rome to shoot *Roman Holiday* (1953), and to whose shoes she became a life-long devotee.

During the 1960s, the kitten heel went 'toe to toe' with the stiletto as the grown woman's shoe of choice, the latter attracting increased criticism from the era's burgeoning women's liberation movement, before more radical styles such as the platform returned in force during the 1970s. But the kitten heel's practicality meant it never quite disappeared, even if it battled with its image of being rather prim and ladylike. However, it was for this reason that it became popular in the 1980s as more women found themselves needing to dress for executive positions in the workplace. And, again during the 2000s and 2010s, the style proved ideal for 'first ladies', from the United States' Michelle Obama to France's Carla Bruni; the kitten heel expressed femininity but not the inappropriate femme fatale.

**Opposite:** Italian promotional poster for *Breakfast at Tiffany's* in 1961, by which time its star Audrey Hepburn was a style icon.
**Below:** A kitten heel forms part of one ensemble for the Kate Spade autumn/winter 2023 collection.

# The Peep-toe & Slingback

**Above:** Disco Queen Donna Summer in peep-toes, around the time of the release of her breakthrough album 'Lady of the Night' (1974).
**Opposite:** Jane Birkin in slingback platforms in 1973, three years before she gained notoriety in 'Je t'aime moi non plus'.

If the Victorian gentlewoman was careful, as propriety dictated, to expose a minimum of bare skin in her dress, leading to the Victorian gentleman famously palpitating at the sight of a bare ankle, such concerns, one might imagine, would be long out of date come 1938. But the vogue for open-toed and slingback shoes – both styles a version of the standard pump and both largely down to Italian shoe designer Salvatore Ferragamo – provoked controversy when they came out in that year. The slingback is a backless shoe, characterized by a strap that crosses behind the heel or ankle, while the peep-toe has an opening at the front of the shoe to allow the toes to show. This was an era when bare legs away from beach or sport were simply not done, yet both styles of shoe, the slingback in particular, were hard to wear with stockings because the heel tended to slip out and because stockings of the time still had unsightly reinforced toes and heels.

In 1939, the editor of American *Vogue* railed against the slingback: 'From the beginning of this fashion I have felt it was a distinctly bad style. You [the shoe industry] have gotten women almost barefooted now.' The industry responded in some small way: peep-toes were made smaller and strips added to heel straps on slingbacks to hide the reinforced part of stockings. But neither the slingback nor the peep-toe went away, even if slingbacks tended to be worn only at the beach or as part of formal eveningwear, when a long dress largely hid the shoe anyway. By the 1940s, stocking manufacturers came up with a solution: the launch of stockings without the obviously reinforced heel or toe.

It was just as well. Both peep-toes and slingbacks became styles that defined the much less conservative, post-war 1940s, gracing the feet of Hollywood starlets from Greta Garbo to Joan Crawford and from Anne Miller to Carmen Miranda (leading exponent of the platform peep-toe), and becoming notably sexualized objects in the process. Indeed, it was Ferragamo's work with costume departments at Hollywood studios that helped ensure these shoes were the styles of the era's bombshells and pin-up girls.

Ironically, given the initial controversy, what appealed to many designers and their customers about the slingback especially was not only that it could be slipped on and off without needing to actually undo the heel-strap buckle, but also that this strap so secured the shoe to the foot that it allowed more of the upper to be coyly (and not so coyly) cut away, thus exposing more of the foot. This also encouraged the use of new synthetic materials in brighter colours and unusual finishes, in itself an added bonus in the face of post-war leather shortages. As one Sears Roebuck advertisement of the era had it: 'Backless Beauties in Butterfly Colors – Pastels, new and terrific ... or in rich, deeper hues ... Light, graceful, they make the most of pretty feet, the least of summer temperatures.'

# The Wedge

○○○○○○○○○○
○○○○○○○○○

Many styles of shoe date back centuries; such has been the symbolism of the shoe in courtly life that radical experimentation in shoemaking means that even the most extreme designs are often much older than might be imagined. But the wedge, the more accessible forebear of the towering platform, can be dated to 1936 and a look created by Italian designer Salvatore Ferragamo. He filled the space between a shoe's traditional block heel and its sole, extending the heel so it ran under the foot. The use of wood made the shoe solid and inexpensive, and his first designs comprised two pieces of wood that produced an F-shaped curve in the back of the heel. Later, the use of layered cork created wedges that offered both previous advantages while also being light. The fashion press helped promote their appeal; *Harper's Bazaar* in 1938 noted that 'Italian women [in particular] have literally gone mad for them', though offered no evidence to explain whether it really meant the unlikely scenario of a shoe style prompting insanity.

The style's qualities were to become important the following year with the outbreak of the Second World War and the introduction of rationing. In fact, it was the imposition of rationing that gave the wedge some of its more unusual treatments. The wedge in suede became fashionable because suede was considered suitable for formal and informal wear and also because it allowed the use of less high-quality hides (suede being the result of buffing or sanding the imperfections out of these hides). Ironically, perhaps, it also encouraged the use of more exotic skins, such as snake, lizard, crocodile and alligator, because they could still be easily imported to the United States from South America (largely unaffected by the war), and because they were deemed of no use to the war effort. In the United States, where materials were more widely available, the wall of a wedge might be wrapped in linen or raffia, espadrille style.

A solid, balanced shoe, the wedge also found popularity during this period as more people were walking or using public transport because

most private cars had been co-opted for the war effort or were too expensive to run. The wedge answered the call for the stylish but practical. That Ferragamo had in 1939 created a pair – the sole of which comprised multicoloured fabric layers – for Judy Garland, then one of the world's biggest stars, only helped to ensure its fame. By the time publicity shots caught a bikini-clad Marilyn Monroe wearing them poolside in 1950, the wedge, which elongated the leg without being uncomfortable to walk in, was well established as a wardrobe staple.

The wedge enjoyed bouts of fashionability over the coming decades: in the 1970s, for example, and again in the 2010s. While the idea for hidden lifts was not a new one – a patent for the design was filed in the United States by C.O. Christy in 1952, and athletic footwear companies had unsuccessfully also tried to launch styles using them in the 1990s – it took French designer Isabel Marant to spark a trend. She showed her spring/summer 2012 catwalk models wearing Nike Air Force 1-style sneakers with what might be called an internal wedge, and was quickly and widely copied, with other companies applying the idea to many sorts of shoe. 'It's something I did since I was a teenager: I would cut up cork and put pieces into my trainers because I wanted to look taller,' Marant noted. 'Sneakers are comfortable but at the same time not very elegant. To have a little heel in it makes a difference, it gives you legs.'

Opposite: The patent application for a wedge – 'shoes with lifted heel but without stiletto heel' – filed by Salvatore Ferragamo in December 1937. Above: Robert Cavalli's Just Cavalii spring/summer 2003 collection highlights the power wedge.

# The Driving Shoe

○○○○○○○○○
○○○○○○○○○

With their super-soft construction they look more slipper than loafer, an impression that is only enhanced by the fact that they appear to be without a sole; this is replaced with serried ranks of 133 rubber nodules that curve distinctively up the heel and are coloured to match the leather. Certainly, the Tod's loafer – also known as the gommino (Italian for pebble) after its rubber studs – is some way from the penny loafer model popularized as part of America's 1950s Ivy League style.

It could not be anything other than Italian, both in style – somewhat louche, decadently casual in a dolce vita kind of way – and in sensibility; it was, after all, ostensibly designed as a shoe for driving, ideally something very fast and in a certain shade of red. Coincidentally, perhaps, Tod's founder, Diego Della Valle, has been a board member of both Ferrari and Maserati. And it was paparazzi shots of Gianni Agnelli, head of Fiat and an Italian style icon, wearing a pair of Tod's after he broke his leg skiing that sealed the style's success.

The gommino may have taken its inspiration from car shoes of the 1950s, but it has defined its category and spawned countless imitations. It also put an old family business on the map. Filippo, Diego's grandfather, was a leatherworker and shoemaker in the north Italian region of Le Marche, famous for its artisanal leather goods. Della Valle's father, Darino, expanded the business to produce high-end shoes for US department stores, sold under their names. Della Valle joined it in 1975 after dropping out of law school in New York.

He concluded that the family business could be more successful if it made shoes under its own brand. The problem was how to stand out against the myriad other luxury Italian shoemakers. A signature style was required – one that might work for the more casual dressing that was then a distinctively American style but was slowly becoming a global one; a style that worked with a suit while simultaneously undercutting its propriety.

Della Valle found what he wanted four years later, in 1979, in the shape of an old driving shoe–loafer hybrid, a look that appealed to his interest in Ivy League style (in 1998 he bought John F. Kennedy's boat, Marlin, at auction). The brand name, originally J.P. Tod, was lifted from a Boston telephone directory and was chosen because it was easy to pronounce in any language and suggested an old family firm; when J.P. was dropped from the name the company received enquiries into the death of its patriarch. To drive home the American flavour of the Italian product, images of Cary Grant, Audrey Hepburn and Della Valle's own style hero, Steve McQueen, were used in advertising.

For the shoe itself, Della Valle simply added studs to the hybrid style and made it in the best leathers, most notably Vacchetta, a tan calfskin that is something of a signature. The pattern of holes in the leather sole, through which the studs protrude from a rubber panel, is cut by hand. The sole is sewn to the upper and the soft construction is then hand-moulded over a last and the stitched seams are hammered down – just a few of the 100 or so steps in the production process. It is a lot of work for an unostentatious product. But that, in part, is what has ensured its popularity.

**Opposite:** Tod's driving shoe – whether in classic leather or more colourful suede – is characterized by its distinctive rubber-studded sole, which has to be carefully set into the leather of the shoe by hand. **Below:** Michael Douglas, when he starred in *Basic Instinct* (1992).

# The Brogue

○ ○ ○ ○ ○ ○ ○ ○ ○
○ ○ ○ ○ ○ ○ ○ ○

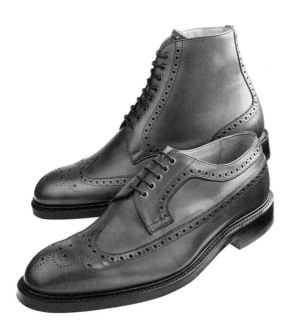

Punching holes through the toecaps of a pair of shoes to allow the insides to dry out after they have been soaked (or so that feet can cool on a hot day) may be a blunt solution to a problem, but it gave rise to one of the most distinctive, and highly decorative, shoes in the male wardrobe: the brogue. The characteristic pits and serrated or 'gimped' edging are added to what is essentially a simple, closed-lacing Oxford or an open-lacing Derby style (also known as Bluchers, after Gebhard Leberecht von Blücher, the late-eighteenth-century Prussian field marshal who popularized the shoe by ordering it for his troops). But, like many menswear classics, the brogue has its origins in utility.

It was Irish and Scottish agricultural workers, farming bogs and marshland, who in the sixteenth century first took an awl to their somewhat makeshift, heel-less shoes – *brogue* or *brog* means shoe in Gaelic – and created decorative patterns that were typical of the more flamboyant men's dress of the Elizabethan Age. Even as the style became more recognizably like the brogue of today, tackling the elements remained a key issue; the early shoes were made of leather shavings glued together, and were typically rubbed with candle wax to make them more water-repellent.

After some three centuries the decoration of the shoes remained, but their function was lost and the modern notion of brogues had been established. Even so, their country roots remained and the sturdy style was worn by gamekeepers until the turn of the twentieth century, when it was adopted by gentlemen – and then only for wear in the country, typically for sports. It was this association with the outdoors that led to a studded version of the brogue being taken up as a golf shoe, when Edward, Prince of Wales, broke yet another of the rules of dress etiquette (in this case that gentlemen wore only plain shoes) that so dominated society until the mid-twentieth century. The prince's influence during the 1920s in particular meant his radical views on fashion were adopted as the mainstream across Europe

**Above:** The brogue – a shoe originally made with holes to allow water drainage – here by classic English shoemaker Cheaney, its factory also seen here in action.
**Opposite:** The classic English benchmade shoe – which the brogue has come to epitomize – is the product of some 200 separate operations; punching and placing its decorative holes involves even more. This factory in Northamptonshire, England – the benchmade shoe's spiritual home – has been producing brogues since the mid-nineteenth century.

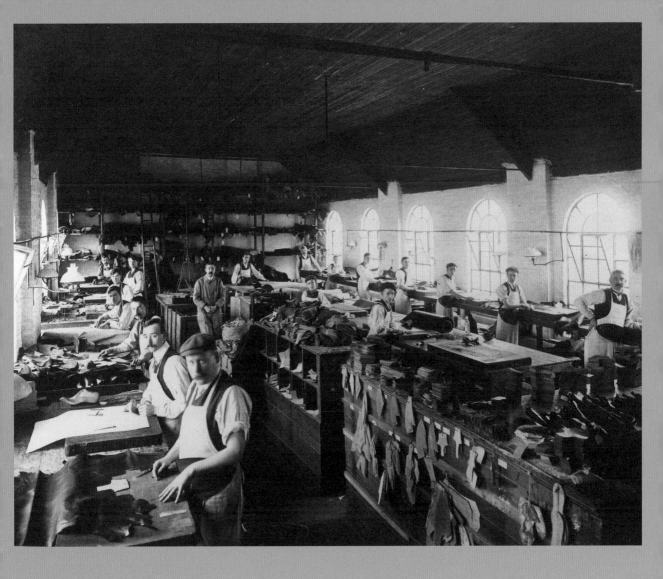

However, the brogue soon escaped its sporty connotations. It became fashionable in East European high society, thanks to handmade shoes from Budapest – and was also known as the Budapester. Arguably, it was the Prince of Wales, again, who first wore brogues on social occasions; he introduced the half-brogue (with a decorated toecap rather than the more expansive wingtip of a full brogue) and helped the style to move from country to city life.

The first black brogues were also seen at this time; until then tradition had dictated that they should be brown, in keeping with their country environment. This was only the first derivation for the brogue. With the wingtip separating a shoe's upper into delineated sections, two-tone (aka spectator or co-respondent) shoes followed, and helped to define the look of the Jazz Age, as well as the much-imitated dress sense of dancers Fred Astaire and Gene Kelly.

Brogues came to defy their humble origins, and by the 1940s were considered one of the more upmarket, dressier variants of men's shoes, made by companies such as Florsheim, established in Chicago in 1892, which built its reputation on the elegant wingtips with which its name would become synonymous. Small wonder that when Jack Nicolson's private detective J.J. Gittes is nearly drowned in a reservoir in *Chinatown* (1974), his chief concern is the loss of one of his shoes. 'Son of a bitch!' he says. '[That was a] goddamn Florsheim shoe.'

**Opposite:** Actor Emma Corrin in a solid pair of traditional tan leather brogues, 2023. **Below:** The brogue is considered a classically British footwear style, produced by long-established shoemakers such as Loake.

# The Deck Shoe

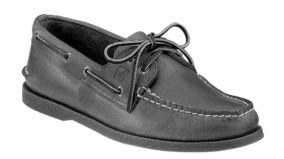

When deck shoes appeared on the cover of Lisa Birnbach's tongue-in-cheek *The Official Preppy Handbook* in 1980, it cemented their place in the upper-crust WASP wardrobe as the dressier alternative to sneakers – suggestive as they were of owning a yacht to wear them on. How fitting, then, that the readiness with which this shoe was taken up by men and women alike for its comfort and connotations – with countless versions on the market, of which some, such as Sebago, were more authentic than others – belied its debt to a prince. Of a kind.

The shoe's origins go back to the early 1930s when Paul Sperry, a one-time employee of Abercrombie & Fitch, learnt just how slippery the newly painted decks of a yacht can be. He had bought a rough-and-ready schooner and, after sprucing it up, set sail. But as soon as the decks became wet they were akin to an ice rink, and his sneakers offered little grip. So Sperry had an idea. Not to improve what he was wearing on his feet, but to improve the decks by repainting them with a layer of emery dust. This worked, at least in terms of providing grip. 'But if any part of the human anatomy came into touch with them, it was like giving yourself a rub down with sandpaper,' he explained.

He turned his attention to footwear. He rejected the espadrille-type shoes made by an English yachting company; they gave great traction when decks were wet but, ironically, their rope soles were slippery on dry surfaces. Instead, he conducted hundreds of experiments with rubber-soled shoes, none of which added up to much – until he noticed that his cocker spaniel, Prince, was able to handle slippery surfaces, and realized that what gave the dog's paws their grip was the tiny, multidirectional cracks that ran all over their pads. He took a more geometric but similar herringbone pattern and cut it into a rubber sole that he ran over his test bed – a sheet of polished metal.

The problem of slipping appeared to be resolved. An on-board trial of a prototype pair of shoes, worn by a young member of the schooner's crew, proved that the soles worked. Deck shoes had been invented.

Sperry patented what he called the Razor-Siping design, and tried to sell the concept. He approached the United States Rubber Company, who decided the complex sole would price the shoes out of the market. Converse, however, was not so blinkered. From 1935 it made blank soles and shipped them to Sperry. He cut them and Converse finished the shoes.

Then marketing took over: Sperry's friend Donald White, an advertising man who worked for McGraw-Hill, came up with the name Sperry Top-Sider and persuaded him to sell the shoes (price $4.50) by mail order – a highly innovative sales medium at the time. Sperry sent handwritten letters to the 100 members of the prestigious Cruising Club of America. All of them wrote back. Word spread. One Mr Vanderbilt put in an order for the crew of his yacht, and Sperry struggled to meet orders for the shoes – even more so when in 1939, two years before the United States entered the Second World War, he won the contract to supply shoes to the US Navy. It stayed that way until he sold his interest in the business – to the United States Rubber Company.

But the story is not so easily resolved. Despite creating an icon, Sperry also sparked a debate that rages on. As the cover of *The Official Preppy Handbook* noted, Top-Siders are a 'crucial element' in preppy style. But they also pose what Birnbach called 'the sock controversy'. To wear, or not to wear – the argument has yet to be won.

Opposite: The patent drawings for Sperry's design and an early prototype that he carved by hand. Above: The boat shoe has always had preppy appeal, worn here in 2002 with Ralph Lauren khaki shorts, button-down shirt and cricket sweater.

# The Cowboy Boot

○○○○○○○○○
○○○○○○○○○

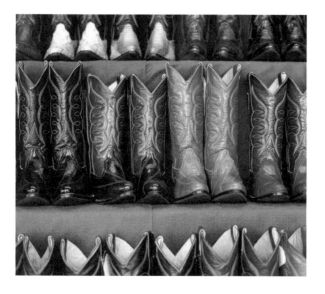

The cowboy boot is sometimes perceived as being a largely decorative form of bygone dress with its rococo shape, highly ornate leatherwork and, of course, more than a hint of the nineteenth-century American Wild West about it. It was during Hollywood's efforts in the 1930s to turn the mythology of the cowboy into cinematic gold – initially through actors like Gene Autry and Roy Rogers – that the cowboy boot was first worn for fashion. Yet, almost everything about the boot, which was originally worn by both men and women, was shaped by consideration for its function while riding a horse.

The heel was made high, at 5–8 cm (2–3 inches), large and angled towards the instep to help the foot stay in the stirrups, but to prevent it from passing all the way through them. It also dug into the ground when the cowboy or girl wearing them had to restrain or pull back on a wayward horse. Meanwhile, the toe was more chiselled to make it easier to get the foot into the stirrups when mounting a horse. The boot's wide opening and lack of lacing not only made it easier to get on while wearing heavy-duty all-weather clothes, but also made it easier to free the foot from the boot and stirrup if thrown from the horse. A tight-fitting vamp kept the boot secure on the foot while upright. The height of the main part was selected to protect the rider's legs from stones, brambles and the like (the shorter, so-called Roper, version of the cowboy boot came in with rodeo, since rodeo riders had to be free to ride but also to run after and rope a calf).

As for the decoration, that was merely an imaginative response to the fact that cowboy boots are stitched on the outside in order that no seams are left to rub against the foot or leg on the inside. The more ornate take on the boot, with inlays and overlays of boldly patterned and coloured leathers, only arrived on later styles of boot from the 1920s onwards. This was when boots began to be worn for show as much as for work; rodeo blended ranch skills with entertainment, while Hollywood sought to give its big-screen cowboys – and, eventually, cowgirls such as the B-movie favourite Yvonne De Carlo – ever more spectacle.

**Above:** The cowboy boot has always had its typically more decorative, point-toed Mexican version – called *botas picas Mexicanas* – here for sale in Guadalajara.
**Opposite:** A fourteen-year-old cowgirl Jimmy Rogers shows off the new western trend for *Life* magazine in 1940.
**Next page:** Patricia Arquette takes the cowboy boot royal blue in *True Romance* (1993), with Christian Slater.

Hollywood had a lasting effect on the appeal of the boot, encouraging its embrace as a symbol of American history and of heroic individualism, much as it did with denims. Marilyn Monroe posed in cowboy boots, in some early shots wearing little else bar a Stetson, in keeping with the illustrated pin-ups of the period. By the 1960s, they had become a fashion staple, backed by the rising popularity of country and western music and the boot being worn by stars like Dolly Parton. By the 1990s they were ripe for reinterpretation, worn around town, found to be useful at muddy music festivals and as likely to be seen on Britney Spears, Jessica Simpson or Kate Moss as anyone near a horse. And again in the 2010s the boot made a fashionable return with designers such as Marc Jacobs and Balmain creating styles for women in metallics, black velvet or black-and-white co-respondent designs.

Remarkably, given the level of consideration and innovation that went into the cowboy boot, who invented them has escaped record. It has been suggested that the style probably originated in either Texas or Kansas and a forerunner was Kansas's Hyer Boot Company, established by Charles and Edward Hyer after taking on their German immigrant father William's shoemaking business in 1880. However, ancient cultures in which the horse figured highly also wore similar footwear. The fifth-century Huns of central Asia may have passed on their designs to the Moors, who took them to Spain, with the Spanish then exporting the style to the New World via Mexico and California, becoming, in effect, the first cowboys, the *vaqueros*.

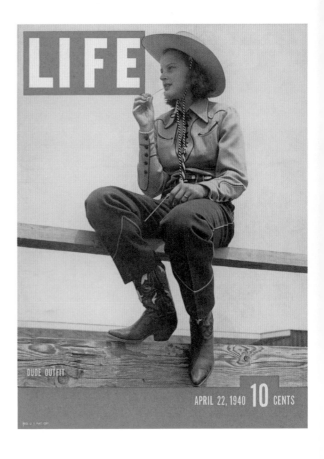

Silk Scarf
Costume Jewellery
It Bag
Beret
Panama Hat
Baseball Cap
Sports Watch
Necktie
Aviator Sunglasses

# 11.
# Accessories

# The Silk Scarf

**Above:** The most famous and decoratively opulent of all silk scarves – those made since 1937 by Hermès.
**Opposite:** Faye Dunaway stars as Bonnie Parker, one half of the bank-robbing romance in *Bonnie and Clyde* (1962).

The scarf can be worn in many ways: around the neck, as a shawl, around or over the head or as an observance of religious direction – historically Christian women wore wimples, today married Jewish women wear a tichel and some Muslim women a hijab. The scarf also has a practical use worn this way, to protect and to provide warmth.

However, the scarf, particularly the printed silk scarf, has connotations of a certain style, and in some cultures a certain class. Worn over the head and tied under the chin in babushka fashion – after the Russian for 'grandmother' – it could denote seniority in Eastern Europe, or upper-class or even aristocratic leanings in Western Europe. Queen Victoria did much to popularize the wearing of then novel accessories such as scarves, the quality and colour of which were used as distinct means of class differentiation. Not for nothing was one of the most celebrated headscarf-wearers Queen Elizabeth II.

While head and neck scarves have been worn since ancient Egyptian times – images of Queen Nefertiti show her wearing a headscarf under a headdress – and throughout the Middle Ages, in the modern era they have also been regarded as fashion items. Napoleon Bonaparte helped spark a trend for them by sending cashmere scarves (by the dozen) back to his empress, Josephine, while American, early-twentieth-century modern dance pioneer Isadora Duncan, who popularized the wearing of long flowing scarves, paid the highest price for her style – she died when her scarf became caught up in the wheel of a car and broke her neck ('affectations can be dangerous,' Gertrude Stein noted). This was the golden era of such stores as Liberty of London, whose bold art nouveau printing found a perfect vehicle in the headscarf.

Liberty scarves, however, were pre-dated by arguably the leading proponent and maker of the most desirable examples of the silk scarf: French company Hermès. It launched its first *carré*, as it refers to its square-shaped scarves, in 1937 under the direction of Robert Dumas Hermès, with a print illustrating the

inauguration of the Parisian Madeleine-to-Bastille bus line (indeed, scarves were often created and bought as souvenirs). The company went on to commission artists from Cassandre to Jean-Louis Clerc to design its collectible, 90 cm (35 inch) square, silk twill *carrés*.

But the scarf's history was not all silky smooth. The invention of rayon as a staple fibre in the 1920s made more inventive printing and a more affordable price possible. By the 1950s, the scarf was in its heyday, regarded as colourful but demure and, perhaps above all, ladylike – all characteristics that could be applied to wearers Grace Kelly, Elizabeth Taylor and Audrey Hepburn. 'When I wear a silk scarf I never feel so definitely like a woman, a beautiful woman,' Hepburn once said.

However, those same traits did not suit the sexual revolution and gender politics of the 1960s, in spite of the far from conservative prints available from such designers as Elsa Schiaparelli. During the following decade, it took the first applications of designer logos, a new modernism in prints and a reappraisal of the scarf as something else entirely (something that could be worn creatively, as a belt or even tied around the torso as a kind of bandeau top) for it to be revived. By the twenty-first century, new digital-printing technology gave a further lease of life to the silk scarf, but rarely was it worn babushka-style, Queen Elizabeth II aside.

**Opposite:** A silk scarf worn by the singer and fashion experimenter Harry Styles in 2022. **Below:** Janet Leigh, wearing a red floral head scarf, photographed in the late 1960s.

# Costume Jewellery

**Above:** Grace Kelly wears costume jewellery – standing in for the real thing – for her part in Hitchcock's *To Catch a Thief* (1955).
**Opposite:** American actress Suzie Parker, the first supermodel and inspiration for a Beatles song, in the 1960s.

In some ways, costume jewellery was the forerunner of fast fashion. Jewellery had, for generations, been intended to be passed down through the generations; it was by definition precious and timeless, and this was reflected in the materials used and craft employed to make it. Costume jewellery, its name reflecting the use of the word 'costume' to refer to what we now call an 'outfit', was meant to be as short-lived as the clothing style it was designed to complement.

Czechoslovakia became the world leader in costume jewellery production in the 1930s. But it was not necessarily about being cheap. Affordable jewellery had, in fact, been made since the eighteenth century using glass, paste and base metals to look like gems and gold. By the nineteenth century, with an emerging middle class, there was also new demand for an accessible but not imitation product, resulting in an increase in production using, for example, semi-precious stones and rolled gold. Both types were, however, still considered as jewellery to be worn throughout one's life. Not so costume jewellery; like clothing, it went out of date and needed replacing.

Among the earlier twentieth-century designs are those ascribed to Coco Chanel during the 1920s. She produced pieces in faux pearls, encouraging the string of pearls to be worn as a fashion, and making them a signature style for herself to boot. Other designers sought to make the most of the graphic designs then popular thanks to the art-deco movement, which was itself in part about marrying artistry with mass production. Jewellery quickly moved from being sensuously curvaceous to boldly geometric. But through the 1930s, and especially with the outbreak of the Second World War in 1939 which destroyed much of the European costume-jewellery business and saw many of its designers emigrate to the United States, a more American mood, blending Hollywood glamour with new unexpected materials, became prevalent.

Add in the pressures of the war, during which time rapid changes in fashion were few and clothing had to last, and the appeal to regularly update an

outfit with new jewellery was only heightened. As the *New York Times* put it in 1943: 'Designers have rallied valiantly and have evolved various ingenious creations from non-priority materials. Everything from spaghetti to cloth dipped in wax is utilized for beautiful or amusing gadgets [jewellery], to add an individual touch to the simplest of suits and dresses.' Acetate was treated to look like sparkling stones, plastic polished to simulate 'berries glistening with dew', paper added, silvered or made clear and embedded with ceramics. Leather, wood, seashells, straw, wool, fabric and moulded glass were all used. The spaghetti, by the way, was coloured, fixed and twisted into rope necklaces then dried so that it never went doughy.

So high was the turnover of fashions in costume jewellery that, from the 1940s, some companies offered make-it-yourself kits. One Chicago maker, Flower Materials, launched a scheme whereby people could make costume jewellery in their spare time to sell to friends. 'All you do is select the mounting for a ring, necklace or bracelet and add the lustrous beauty of opulently colored stones, gleaming rhinestones or majestic pearls,' explained its 1951 catalogue. 'And the results – stunning costume jewelry made with your own hands that looks so much like real expensive jewellery that you'll be proud to wear it.'

Far from being considered a poor man's alternative, costume jewellery soon developed a prestige in its own right: not just through the name Chanel, but also Pennino, Sphinx, Crown Trifari, Lisner, Miriam Haskell, Kim Craftsmen and Kenneth Jay Lane. Costume jewellery, after all, was a product the movie stars of the period, notably Jane Russell, Vivien Leigh and Elizabeth Taylor, were happy both to wear and to put their names to in advertisements. Kenneth Jay Lane made one-off designs for Audrey Hepburn and Jacqueline Kennedy Onassis.

The accessibility of costume jewellery encouraged both more outlandish design and changes to the way in which jewellery was worn. Rather than a single, eye-catching piece, costume jewellery was piled on: a dozen bracelets on one arm, multiple necklaces of all lengths and outsize earrings. 'This winter may go down in fashion history as the time when the old term of contempt, "she's done up like a Christmas tree," became a compliment,' noted one 1951 US article. Since costume jewellery's accessibility also brought with it the idea of novelty, a pair of Christmas tree earrings was duly produced.

**Above:** Margot Robbie wearing a heavyweight brace of pearls for the London premiere of *Barbie* (2023). **Opposite:** Socialite Luciana Pignatelli in deep collar necklace of meshed coloured stones by Tiziani Boutique, 1970s.

# The It Bag

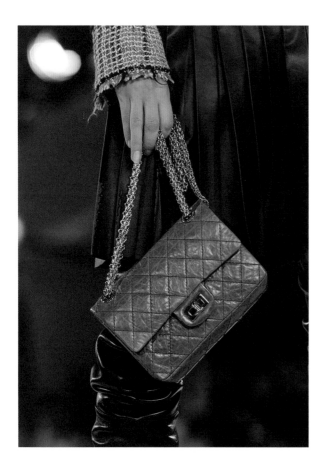

Whether or not it can be called the definitive 'It bag' – the fashion industry term from the 1990s for a high-priced designer handbag and borrowed from the 'it girl' reference to Clara Bow in the 1927 silent movie *It* – the Hermès Kelly bag took a curious road to fame. Designed in 1923 by Emile-Maurice Hermès and Ettore Bugatti (of the Italian car-makers), the bag was based on an 1892 saddle holder known as the Haut à Courroies (bag with tall handles). It was updated again during the 1930s by Robert Dumas, Hermès's son-in-law, as a spacious travel bag called a *sac à dépêche*. But it first came to prominence in Alfred Hitchcock's *To Catch a Thief* (1955) when costumier Edith Head selected it for Grace Kelly to use in her role. The bag, a trapezium closed with two straps, has four studs on the bottom and a single handle, and is sold in eight sizes. The padlock, keys and hardware are made from white or yellow gold, and the construction of each bag takes between 18 and 25 hours.

Grace Kelly used it off set, too. A little over a year later, now married to Prince Rainer III of Monaco, she appeared on the cover of *Life* magazine in 1956. There the bag was: on the lap of the movie star, less as a statement of her good taste or her practicality, and more as a way to hide the fact that she was pregnant. Certainly, Kelly held on tightly to the bag, and so loyally that, although other stars such as Ingrid Bergman and Marlene Dietrich also used one, the bag unofficially took Kelly's name. In 1977, Hermès officially renamed it the 'Kelly bag'. In the interim, it had become both a statement and a status symbol, pioneering the way for bags to say so much more about their 'wearers' than their need to carry lots of stuff. Fashion companies could now pursue the alchemist's dream of turning mere panels of leather into fashion gold – the iconic bag – and many have tried.

Hermès struck gold again in 1981 when a chance encounter on a flight between actress Jane Birkin and Hermès chairman Jean-Louis Dumas on a flight sparked an idea. When Birkin's straw bag broke, spilling her effects all over the cabin, he determined

**Above:** A quilted Chanel bag from the autumn/winter 2005 collection. **Opposite:** Grace Kelly – in 1956 and newly announced as the future Prince Grace of Monaco – using the Hermès bag which would later take her name in order to hide her pregnancy.

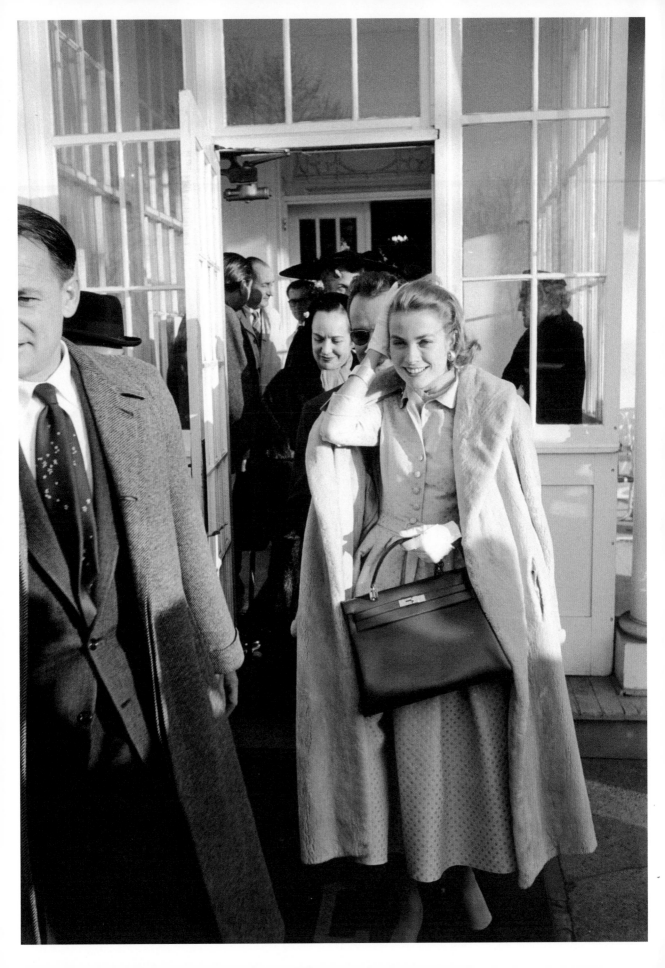

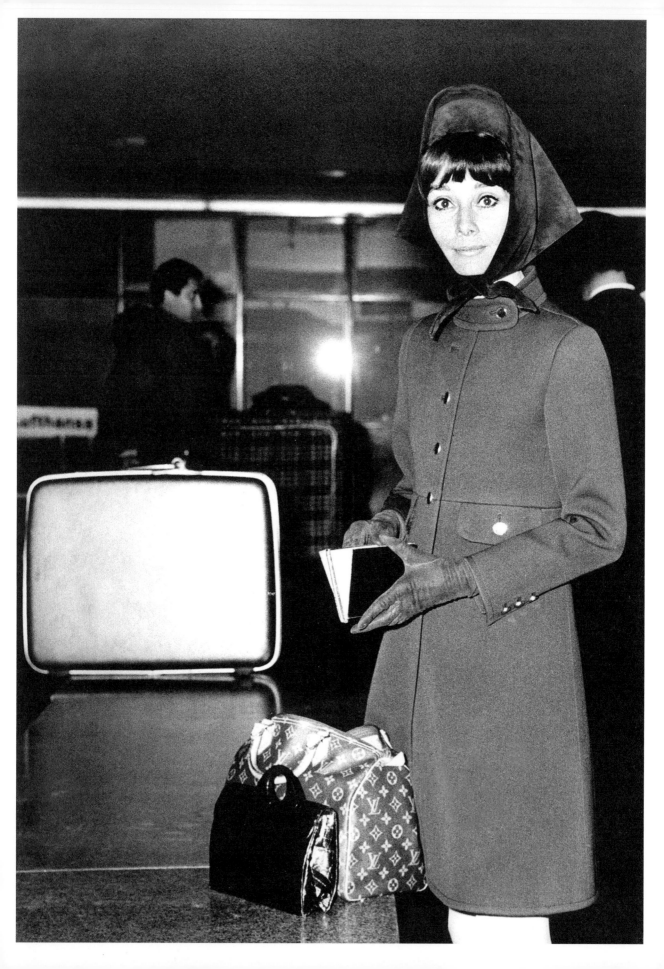

to produce a roomier version of the Kelly, with double handles and spill-proof flaps, which launched in 1984. Again, Birkin's loyalty to the design (until, at least, she jokingly claimed to be injuring herself by carrying too much all the time) saw it take her name. Sold in a range of hides from ostrich to crocodile, the bag is lined with goatskin and can even be encrusted with diamonds.

Other notable It bags include Louis Vuitton's Speedy, designed in 1932, akin to a traditional doctor's bag and beloved of Audrey Hepburn, who asked the company to devise a smaller version for her; Chanel's 2.55 quilted clutch bag of 1955; Gucci's Bamboo and Constance bags, often seen on the arm of Jacqueline Kennedy Onassis throughout the 1960s; and Fendi's Baguette, designed by Silvia Venturini Fendi in 1997 to be carried under the arm like the French loaf of the same name. The list goes on: Prada's black nylon backpack, Chloé's Paddington, Mulberry's Bayswater and Bottega Veneta's Intrecciato leather-weave bags, designed by Tomas Maier, a man who once called the whole idea of the It bag 'totally marketed bullshit'.

Perhaps he was right. When handbags first replaced pockets in revolutionary France in the late 1700s, they were referred to by the English (who soon followed the French lead) as 'indispensables', suggesting even then a dependence on these accessories. The French, however, often called them 'ridicules', mocking the attention that women paid them (though increased travel and restrictive dress would, some fifty years on, make them truly practical). But, rightly or wrongly, the waiting lists for It bags in the late twentieth century spoke of their straight, undeniable desirability. Perhaps the benchmark of the It bag was how quickly and extensively counterfeit versions were made available on backstreet markets.

**Opposite:** Audrey Hepburn passes through airport customs, with her Louis Vuitton Alma bag.
**Above:** Jane Birkin, with the Hermes bag style introduced in 1984 and named after her.

# The Beret

**Above:** Marlene Dietrich in a still from the film *No Highway in the Sky* (1951), wearing the hat style she would make her signature.
**Opposite:** Jazz supremos Thelonious Monk, on the left, with Howard McGhee in 1947.

Often associated with not just menswear but particularly masculine menswear, the beret has its origins with Basque fishermen and sheep farmers, a version of similar head coverings that date to the Bronze Age. It also had widespread use as part of undress uniform within the military of many armed forces around the world, the French doing so first, in 1889. It has a somewhat stereotypical association with the French Resistance during the Second World War, but also has strong links with some of the most iconic men of the second half of the twentieth century: Pablo Picasso, Che Guevara, Dizzy Gillespie, Ernest Hemingway, John Lennon and the figures of the Beat Generation, among others. It is perhaps surprising that the beret, alternately arty, bohemian and revolutionary, should have a place in womenswear at all.

That it does is a testament to its practicality. Traditionally worn in either brown, red or blue, even though black would become the staple, the beret was easy to make in one piece from wool felt, making it affordable and protective. It is rimless and soft with a flat crown, so it is foldable, comfortable and easy to style. And, above all, it is one of the most simple and versatile head coverings. It fits snugly around the head and can be shaped in a variety of ways: pushed to one side, square on the head or jutting forward, among others.

Women, Coco Chanel included, first appreciated the beret's practicality as sportswear during the 1920s, wearing it pulled low much like a cloche, a style it would come to replace. By the end of the decade, the hat had sidestepped its historically male and peasant leaning to become a fashion item for women. Most progressively, Marlene Dietrich wore a beret, acquired from milliner Caroline Reboux in Paris, perched over the side of her head as a decorative rather than protective item. Greta Garbo and Jean Harlow wore the style too. Lauren Bacall wore a beret throughout the 1940s, when the beret became more widespread, in part because it could easily be made in many colours and from crocheted cotton, wool or acrylic fibres. In 1954, hatters Kangol advertised that its

Anglobasque, Tambourin and Beret Capette fashion berets were available in '40 captivating colours'. However, later in the 1950s, and given increasingly intricate hairstyles, the beret had partly fallen out of favour. But it was revitalized as a symbol of French patriotism; naturally Brigitte Bardot wore one.

It could be said that it was a movie that helped revive interest in the headpiece beyond France. The beret was one of the key elements of Faye Dunaway's gangster's moll costume in *Bonnie and Clyde* (1967), such that the movie's costume designer Theadora Van Runkle noted that 'the beret was the final culmination of the silhouette. In it she combined all the visual elements of elegance and chic. Without the beret it would have been charming, but not the same.' The following year influential British model Twiggy wore one, with 'Swinging London' designer Mary Quant launching a line of berets in twelve pop colours.

# The Panama Hat

Long a favourite of ageing golf pros, dapper horse-racing pundits and the retired middle class, the Panama hat is the king of summer headwear – and perhaps the only icon of menswear to hail from Ecuador. The modern incarnation has been a staple of men's dressing since the early twentieth century and, indeed, was a key accessory during menswear's golden age, from the 1930s through to the early 1950s. The Panama was favoured by movie stars, among them Humphrey Bogart and Gary Cooper, world leaders including Winston Churchill and Harry Truman, and the diverse likes of Salvador Dalí and Frank Sinatra. But the hat's history dates back many centuries.

The Incas clearly knew about keeping cool as well as human sacrifice – in the sixteenth century they were the first to wear Panama-style hats. Called *paja toquilla*, these screened them from the intense sun and were made out of palm leaves. Then, as now, the leaves were stripped into strands not much thicker than thread and woven so tightly – at anything up to 1,200 weaves per square 2.5 cm (1 inch) – that the result looked like linen.

Each hat is handmade – no two are alike – and takes months of work by one of a dying band of artisans, who prefer to weave without bright light and ideally on a cloudy day as this makes it easier to see the fibres. On the very best examples, the edges are woven back into the brim; on lesser versions the brims are trimmed and sewn. After the hat is made it is pummelled – a craft in itself – to create regularity and suppleness, washed in rainwater, hand-ironed to bring it back to shape and, finally, trimmed. Panamas are naturally pale cream, though darker fibres are sometimes worked into the design for interest's sake, or an entire hat is bleached white using sulphur from the region's volcanoes. The first style that would now be recognizable as a Panama was created by Francisco Delgado in the early eighteenth century. The best examples today – such as those from Hawaiian-based Brent Black or from the London hatmaker Lock & Co., which has sold the hats since 1676 –

**Opposite:** Mick Jagger, wearing the Panama hat, shortly after the Rolling Stones' self-imposed tax exile to France, early 1971.

are still made in Ecuador in the manner effectively laid down by Delgado. Lock was one of the first hatters to help popularize the Panama in Europe; the classic style is most favoured. With a wide brim and black band, it's made in cottage industries in the Ecuadorean provinces of Manabi and Guayas, and focused on the coastal town of Montecristi.

The Panama hat should technically be known as the Ecuador hat, as it has never been made in Panama. The style received its name when it became internationally known thanks to workers building the Panama shipping canal in the early twentieth century, who donned the hat as protection against the sun. Soon after this, Azuay and Canar, Ecuador's chief hat-production regions, established a vibrant export business – the plants used to make the hats even came to be known as panama hat palms. Royal patronage in England, at a time when royalty was a touchstone for stylish dressing, ensured that the Panama hat became a summer staple.

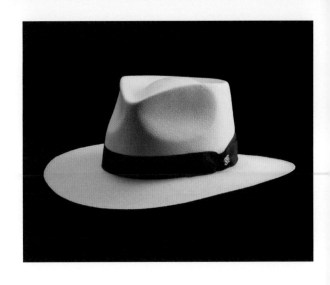

**Opposite:** Making a Panama hat by hand is a long, exhaustive and age-old process. True fans of this headwear accept no imitations.

# The Baseball Cap

ADRIAN C. ANSON.
**ALLEN & GINTER'S**
RICHMOND. *Cigarettes.* VIRGINIA

**Above:** Late-nineteenth-century Major League Baseball player Adrian Anson, nicknamed 'Cap' for captain, not for his headwear.
**Opposite (above):** Sylvester Stallone may have jump-started the fashion for wearing a baseball cap backwards in *Over the Top* (1987), but Jennifer Aniston ties on the styles for *Picture Perfect* (1997).
**Opposite (below):** Ice Cube in his Detroit Tigers baseball cap, for *Boyz n the Hood* (1991).

The beanie, beret or flat-cap may also have claims to being everyman styles of headwear, but in the twenty-first century none can compete with the dominance of the baseball cap. Despite the marginal nature of the American national sport that inspired it, the simple utility of the baseball cap, or of its close cousin the mesh-backed trucker cap – effectively a six-panel, cloche-style head covering with long sun visor attached – has given it cross-generational and cross-cultural appeal.

It is simultaneously something akin to the T-shirt, in being a billboard-style site of promotion or a means of stating affiliation, while also being what one wears if seeking a degree of anonymity. For every proud wearer of a team cap – think Tom Selleck as Magnum PI in his Detroit Tigers cap, or, indeed, Donald Trump in his MAGA cap, after his election pronouncement to 'Make American Great Again' – there's a celebrity trying to hide from paparazzi in one.

That perhaps only underscores the style's adaptability – because it was first worn in the mid to late nineteenth century, the wool crown and leather peaked style adopted by baseball players to keep the sun out of their eyes, much as cricketers would later adopt the bucket hat. Subsequent years saw the addition of design details in steps towards the style recognised today: in the 1890s air holes were added, for example, while the first team logo appeared on a cap in 1901 – that being for the Detroit Tigers too. In 1908 the peak was stiffened and in the 1920s extended, while in the 1940s the crown became more elevated and, as agricultural and construction companies were the first to realize in the 1960s, the perfect spot for some advertising. Wool would give way to more breathable, lighter cotton or polyester.

The ubiquity of the baseball cap by the 1970s and 1980s – especially in the United States as a blue-collar choice, so inevitably favoured by US presidents as a means of expressing their 'the man on the street' credentials; or in the UK as the more upper-middle-class choice of the west London 'Sloane Ranger', as

Princess Diana demonstrated – encouraged more individualistic ways of wearing it. It might be worn low down the back of the head with the peak reaching skywards, for example – think Boy George in his 'Boy' brand cap in the late 1980s – worn turned slightly to one side, or even worn back to front.

Initially this last approach allowed catchers in baseball to wear their protective face-masks or made use of the visor to protect the back of the neck. But it would also become a statement of rebellion, especially for followers of more urban street fashion and culture, from Will Smith in *The Fresh Prince of Bel-Air* (1990) through to Mark Wahlberg, when he performed as rapper Marky Mark in the early 1990s. Baseball caps would become codified by the smallest details – be that the 'correct' curve of the brim (sometimes achieved by shaping it around a food tin), to the 1990s trend for not removing retail stickers and labelling in order to show off your cap's authenticity, as parodied by the comedy duo Key and Peele.

# The Sports Watch

When Mercedes Gleitze became the first woman to swim the English Channel, in 1927, her success was marred when a hoaxer claimed to have done so in a shorter time. So, just a fortnight later, she set out to swim the 35 or so kilometres (22 miles) again in what was dubbed the Vindication Swim. It received considerable publicity and Hans Wilsdorf, founder of the Rolex watch company, realizing the marketing potential of sponsoring her, asked her to wear one of his new Oyster watches. Gleitze had to be pulled out of the water 11 kilometres (7 miles) short of the shore – but a journalist from *The Times* noted she was wearing a gold watch on a ribbon around her neck; it was still keeping perfect time. And a legend was born. One month later the Rolex Oyster Perpetual was launched in the UK.

Wilsdorf, a German watchmaker, had moved to London in 1906 and founded the Rolex brand in 1908; the name was said to emulate the sound of a mechanical watch being wound and worked internationally. The company was based in Geneva from 1912 to save on export duties. Wilsdorf, and his partner and brother-in-law Alfred Davis, had originally made cases and imported movements. However, with Cartier's creation, in 1904, of what is recognized as the first wristwatch – for the aviator Alberto Santos-Dumont – this style began to replace pocket watches and Wilsdorf saw his opportunity.

The Rolex Watch Company immediately set about creating a new breed of tough watches unassailable by the elements. In 1910 it received the first official chronometer certification for a wristwatch; and the creation of water-resistant watches continued to progress. But it was not until Rolex bought the rights to the patent for a screw-down crown from Swiss watchmaker Perret & Perregaux that the Oyster could finally be realized. In 1926 the first dustproof, airtight and, most impressively for the time, waterproof watch was launched.

Further advances included the addition of a self-winding movement in 1931. This meant the

crown was only occasionally unscrewed to adjust the time, which saved wear on seals and enabled the watch to remain waterproof for longer. In 1945 a date display mechanism was created, leading to the Oyster Perpetual Datejust. The Rolex Submariner, the first watch to be waterproof to a depth of 100 metres (328 feet), came in 1953 and made the leap from specialist tool to luxury item. The Explorer was introduced in 1954, the GMT Master, the first dual-time watch, in 1955, the Sea Dweller in 1967 and the Cosmograph Daytona in 1976.

Other watches may be more striking than the basic Oyster, and even more accurate. But few have been more desired, as the counterfeiting industry's backhanded compliment suggests. It has come to define the archetypal watch: simple but sturdy, smart but manly. Thanks to a special service organized by Wilsdorf, British prisoners of war during the Second World War were able to order, by letter and direct from their camps, an Oyster – typically a Speed King. Corporal Clive Nutting, one of the organizers of the famous Great Escape, ordered an expensive 3525 chronograph and, although he was not an officer, was afforded the same arrangement. The watch was said to have been used to time sentry movements and so aid escape attempts. Wilsdorf took a serviceman's word as his bond and was happy to wait for payment until the war ended; this boosted morale as the arrangement implied the Axis forces would be defeated.

Tenzing Norgay and Edmund Hillary wore Oysters when they conquered Everest in 1953, and the watch worked well at some 8,848 metres (29,000 feet) above sea level. Seven years later the special edition Sea Dweller, worn by pioneering diver Jacques Piccard, performed at the bottom of the Mariana Trench, at 10,916 metres (35,800 feet) the deepest point on earth. However, perhaps the greatest accolade is found in fiction: an Oyster Perpetual was James Bond's choice in Ian Fleming's novels, with a Submariner chosen by the Bond of the movie franchise until 1995.

**Opposite (above):** The original Oyster watch. **Opposite (below):** Mercedes Gleitze. **Above:** An early Oyster Christmas advertisement: 'Make it a Rolexmas'. The Oyster's waterproof properties were stressed in all early advertising. A front-page ad in the UK's *Daily Mail* newspaper in 1927 had it that the watch can be worn 'in the sea or bath without injury, nor would arctic or tropical conditions affect the wonderful precision of its beautifully poised movement'.

# The Necktie

The tie's function is to decorate. It does not keep any part of the body warm, nor does it secure another garment in place. What it does do, is bring colour and pattern where it is often lacking – in men's formal attire. The modern tie dates only to 1924 when Jesse Langsdorf, an American tailor, patented an 'allweather, wrinkle-free' design that is characteristic of most neckties in western dress today: three pieces of cloth, stitched and folded into a point and, most pertinently, with the fabric cut on the bias, at a 45-degree angle to the fibres of the material, so that the tie can be knotted and untied without being almost permanently creased.

Until the 1940s ties were comparatively short. The idea was to provide a flourish of colour at the neck, hence the emphasis on width (and extravagant pattern) rather than length. For a garment as simple as a tie, fashions have been extreme, from the minimalistic boot-lace variety that dates back to the 1860s to the wide kipper tie of the 1970s, created by Michael Fish – founder in 1966 of the influential Savile Row tailors Mr Fish.

Despite the tie's seeming frivolity, its origins are military. Roman legionaries on Trajan's Column in Rome, which dates from the second century AD, are shown wearing what is said to be the earliest recorded example of neckwear: a scarf-like focale. The soldiers of the terracotta army of Shih Huang Ti and the Qin dynasty (221–206 BC) wore silk cords around their necks, although more as a symbol of status than an article of clothing. But it was not until the sixteenth century that something akin to the modern, decorative tie appeared. During Europe's Thirty Years' War (1618–48) Croatian mercenaries in the French army sported neckwear similar to a cravat (the word is a linguistic mangling of Croat), ostensibly to signal their comradeship. Louis XIV of France adopted the style and gave it credibility in civilian society.

During the early eighteenth century the cravat morphed into stocks – a strip of muslin wound repeatedly around the neck and then pinned into

place. From the 1850s, this developed into the looser, simple four-in-hand, a knotted, rectangular piece of cloth that, in turn, elongated to become a more structured version that could be tied into a neat knot suitable for the new turn-down shirt collars of the turn of the twentieth century.

From the 1920s ties striped in regimental colours were widely worn by British armed forces personnel at functions that required civilian dress. In the United States the influential men's outfitters Brooks Brothers took the style and made it a menswear standard, with one change: while the stripes on regimental ties ran from the left shoulder down to the right, Brooks' version ran from the right down to the left. The rep tie, called after the weave of the silk used in its construction, soon became an Ivy League style fixture. Certain colour coordinations were especially popular: the Prince of Wales' Foot Guards tie, in blue and maroon, was a best-seller.

British universities had already popularized wearing striped ties to denote membership of their colleges: in 1880 students at Exeter College, Oxford, began donning the ribbons from their straw boaters as a form of neckwear. Ties in college colours soon followed. Similarly, gentlemen's private clubs adopted their own ties. Anecdotally at least, this tradition was prompted by a joke. The actor Norman Forbes-Robertson, a prominent member of London's esteemed, thespian Garrick Club, wore a pale-pink and green tie to lunch one day and, when he was asked about its origin, quipped that it was the official club tie. Soon after, it was adopted as such.

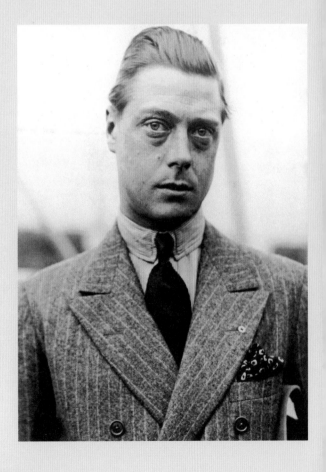

# Aviator Sunglasses

A wardrobe item becomes an icon because it has held its position as a staple of style over generations, but Hollywood can certainly be helpful in winning it this accolade. Perhaps no accessory has been reborn with more impact thanks to an appearance in a movie than Ray-Ban Aviators. In 1986's *Top Gun* student fighter pilots played by Tom Cruise and Val Kilmer competed to be best in their class. Their clothes may have provided limited opportunities for imitation – they wore flying suits for much of the film – but their Aviator sunglasses sparked massive worldwide sales.

Aviators have appeared in other films before and since: James Stewart wore a similar style in *The Spirit of St Louis* (1956), about Charles Lindbergh's pioneering transatlantic flight; Peter Fonda wore them in *Easy Rider* (1969); and they have made appearances in several later period pieces, among them 13 *Days* (2000), *Almost Famous* (2000), *Pearl Harbor* (2001) and *Bohemian Rhapsody* (2018). But while a pair has certainly given attitude to many a woman in the movies (Jessica Chastain in 2012's *Zero Dark Thirty*, for example), it was the undiluted machismo of *Top Gun* – a perfect vehicle for the brash spirit of the 1980s – that made them not only a classic but also what is reputed to be the world's bestselling style of sunglasses.

Fashion may have taken note of the style because of the movie, but the film's costume designers did so for its authenticity. It was worn by the cast of *Top Gun* precisely because it was what fighter pilots wore, and still wear. The style was launched in 1929 after General MacCready of the United States military commissioned a manufacturer to design eye protection for United States Air Force pilots that would offer a clear field of vision, and reduce glare from the sun – which was causing headaches – and the effects of ultraviolet and infrared radiation on flyers' eyes. The commission was effectively responsible for the Ray-Ban company being established. In 1935 the military designated the style it helped to create as the Type D-1; the first time Aviators went on sale to the public was in 1936, when Ray-Ban was formed.

**Above:** Aviators are not just for aviators – here a serviceman with the US Navy wears a pair by Randolph.
**Opposite:** Perhaps the most famous of aviator wearers, Tom Cruise as Pete 'Maverick' Mitchell in *Top Gun* (1986).

The original model had a plastic frame, so that no metal touched the faces of the ground crew working in subzero conditions (although it was later replaced by a gold-coloured metal one) and an antiglare lens in a distinctive green colour. This lens was a characteristic, oversized, side-on teardrop shape, much like that of the goggles already in service. Because the lenses came low over the cheeks to protect the entire eye socket, they were said to leave pilots with a Ray-Ban tan. Nevertheless, the style was embraced by naval flyers especially, and even came to be a mark of distinction. US army and air force pilots typically preferred a smaller, squarer style by American Optical, which was introduced in 1958; the glasses could be easily removed or put on while a helmet was worn.

Given the intimate association between the aviator style and combat flying, it is ironic that the sunglasses were not commonplace during the Second World War. Goggles, sometimes tinted, were worn until the introduction of helmets with drop-down visors during the 1950s, and early sunglasses were designed to accommodate them. Indeed, the military specification often referred to sunglasses as a category of goggle. It was not until 1941 that D-1 goggles were officially replaced by what were at last referred to as 'Glasses, Flying, Sun, Rose Smoke, Type 2'.

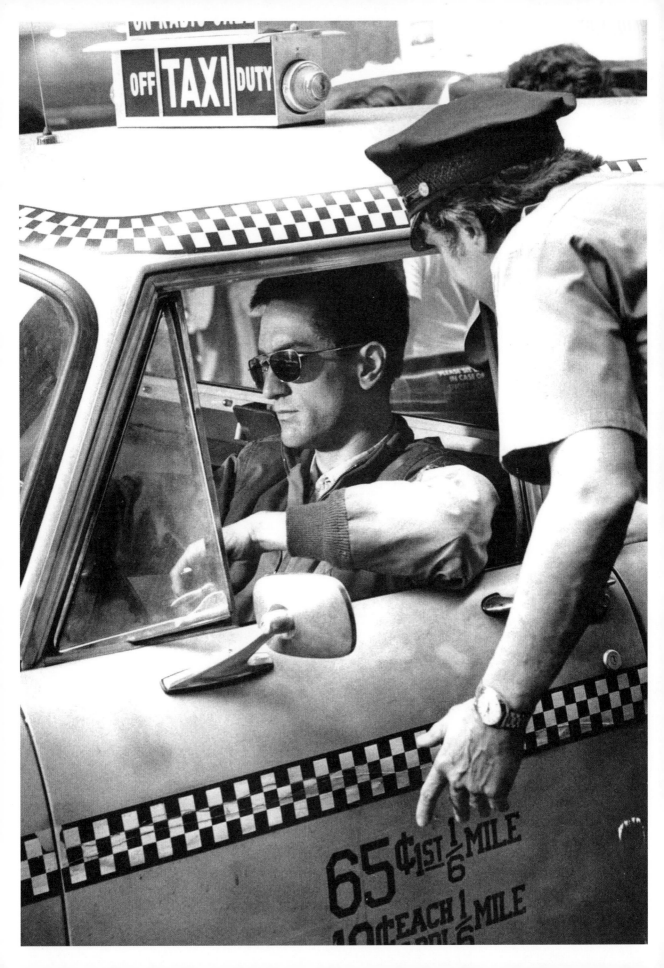

# Index

# Picture Credits

The publisher would like to thank the copyright holders for granting permission to reproduce works illustrated in this book. Every effort has been made to contact the holders of copyright material, and any omission will be corrected in future editions if the publisher is notified in writing.

**Front cover:** Everett Collection Inc/Alamy Stock Photo. **Back cover:** Studio Canal/Shutterstock. **7** Mirisch/United Artists/Kobal/ Shutterstock. **8** Bettmann Archive/Getty Images. **12** Courtesy Aquascutum. **13** Courtesy Burberry. **14** Everett Collection Inc/Alamy Stock Photo. **15** Courtesy Aquascutum. **16(t)** Chronicle/Alamy Stock Photo. **16(b)** Everett/Shutterstock. **17** Photo by Edward Berthelot/Getty Images. **18** Courtesy Levi Strauss & Co Archives, San Francisco. **19** Hulton Archive/Getty Images. **20** Courtesy Levi Strauss & Co Archives, San Francisco. **21** Courtesy Lee. **22** Photo by Raymond Hall/GC images/Getty Images. **23** Photo by Simone Joyner/Getty Images. **24** Photo by Fin Costello/Redferns/Getty Images. **25** Ilpo Musto/Shutterstock. **26** Photo by Reg Lancaster/Daily Express/Hulton Archive/Getty Images. **27** Moviestore Collection Ltd/Alamy Stock Photo. **28** Photo by Stephane Cardinale/Corbis via Getty Images. **29(t)** Mondadori Portfolio/Getty Images. **29(b)** Moviestore/Shutterstock. **30** Courtesy of Baracuta. **31** Bettmann/Getty Images. **32** John Dominis/The LIFE Picture Collection/Shutterstock. **33** Bold Films/Kobal/Shutterstock. **34** Courtesy of Barbour. **35** Photo by Tim Graham Photo Library via Getty Images. **36–7** Courtesy of Barbour. **38** Hulton Royals Collection/Getty Images. **39** Courtesy Cordings. **40** Barham/Stringer/Hulton Archive/Getty Images. **41** Mcpix/Shutterstock. **42** Courtesy Gloverall. **43** Studio Canal/Shutterstock. **44** Courtesy Gloverall. **45** Photo by Danny Martindale/WireImage/Getty Images. **46** Maidun Collection/Alamy Stock Photo. **47** Warner Bros/ Kobal/Shutterstock. **48–9** Courtesy of Alpha Industries. **50** Courtesy of Aquascutum. **51** Photo by Jean-Claude Sauer/Paris Match via Getty Images. **52** Mgm/Kobal/Shutterstock. **53** Courtesy of Barbour. **54** Courtesy of Schott. **55** Santi Visalli Inc/Getty Images. **56** Retro AdArchives/Alamy Stock Photo. **57** Courtesy of Schott. **58** Courtesy of Alpha Industries. **59** Photo 12/Alamy Stock Photo. **60** Photo by Ron Galella/Ron Galella Collection via Getty Images. **61** Courtesy of Alpha Industries. **62** 2009 Shirlaine Forrest/Getty Images. **63** Photo by Antonio de Moraes Barros Filho/WireImage. **64** horst friedrichs/Alamy Stock Photo. **65** Frank Connor/Curbishley-Baird/Kobal/ Shutterstock. **66–7** Courtesy of fishtail parkas. **68** Courtesy of Eastman Leather Clothing. **69** ScreenProd/Photononstop/Alamy Stock Photo. **70** Esmeralda Llaca/Shutterstock. **71** Photo by Virginia Turbett/Redferns. **74** Bettmann/Getty Images. **75** Photo by Larry Ellis/ Express/Getty Images. **76** Kobal/Shutterstock. **77** Ken Towner/ANL/Shutterstock. **78** Photo by Max Mumby/Indigo/Getty Images. **79** ScreenProd/Photononstop/Alamy Stock Photo. **80** Karwai Tang/WireImage/Getty Images. **81** Associated Press/Alamy Stock Photo. **82** ScreenProd/Photononstop/Alamy Stock Photo. **83** Photo by Sasha/Hulton Archive/Getty Images. **84** Photo by Tim Graham Photo Library via Getty Images. **85** Photo by Dominique Charriau/WireImage. **86** TopFoto. **87** Photo by Dave Hogan/Getty Images. **88–89** Paramount/ Rso/Kobal/Shutterstock. **92** Keystone-France/Gamma-Keystone via Getty Images. **93(t)** Bert Stern/Condé Nast/Shutterstock. **93(b)** Bill Ray/The LIFE Picture Collection/Shutterstock. **94** Snap/Shutterstock. **95** Photo by Gareth Davies/Mission Pictures/Getty Images. **96** Kobal/Shutterstock. **97** Reg Lancaster/Stringer. **98** Moviestore/Shutterstock. **99(t)** By kind permission of Laura Ashley Ltd. **99(b)** Arthur Elgort/Condé Nast/Shutterstock. **100** ACTIVE MUSEUM/ACTIVE ART/Alamy Stock Photo. **101** Photo by Fairchild Archive/Penske Media via Getty Images. **102** Photo by Max B. Miller/Fotos International/Getty Images. **103** Photo by Slim Aarons/Hulton Archive/Getty Images. **104** Sipa/Shutterstock. **105** Photo by Sal Traina/WWD/Penske Media via Getty Images. **106** Photo by Victor VIRGILE/Gamma-Rapho via Getty Images. **107** Adc/Shutterstock. **108** Photo by Silver Screen Collection/Getty Images. **109** Silver Screen Collection/Getty Images. **110** Photo by Susan Wood/Getty Images. **111** Photo by Antonio de Moraes Barros Filho/WireImage. **112** Arthur Elgort/Condé Nast/Shutterstock. **113(t)** By kind permission of Laura Ashley Ltd. **113(b)** Photo by Chaloner Woods/Getty Images. **114** David Rojas/Getty Images. **115** Photo by Hulton Archive/Getty Images. **116** Roger-Viollet/TopFoto. **117(t)** Photo by YOSHIKAZU TSUNO/AFP via Getty Images. **117(b)** 20thC.Fox/Everett/Shutterstock. **120** Photo by Rachpoot/Bauer-Griffin/GC Images. **121** Independent/Alamy Stock Photo. **122** Brian Mc Creeth/Shutterstock. **123** Photoreporters/Shutterstock. **124** Photo by Galerie Bilderwelt/Getty Images. **125** Photo by Victor VIRGILE/Gamma-Rapho via Getty Images. **126** Courtesy Levi Strauss & Co Archives, San Francisco. **127** Kobal/Shutterstock. **128** Mgm/ Kobal/Shutterstock. **129** Courtesy Levi Strauss & Co Archives, San Francisco. **130** Henry Clarke/Condé Nast/Shutterstock. **131** Getty Images Europe. **132** Photo by Juan Naharro Gimenez/WireImage. **133** Photo by Harry Langdon/Getty Images. **134** Photo by © Hulton-Deutsch Collection/CORBIS/Corbis via Getty Images. **135** Photo by Steve Wood/Popperfoto via Getty Images. **136(t)** Courtesy Levi Strauss & Co Archives, San Francisco. **136(b)** Courtesy Levi Strauss & Co Archives, San Francisco. **137–8** Courtesy Levi Strauss & Co Archives, San Francisco. **139** 20th Century Fox/Kobal/Shutterstock. **140–1** Photo by Nancy Moran/Sygma via Getty Images. **142** Photo By Raymond Boyd/Getty Images. **143** Photo by Victor VIRGILE/Gamma-Rapho via Getty Images. **144(t)** Hi-Story/Alamy Stock Photo. **144(b)** Photo by Giovanni Giannoni/Penske Media via Getty Images. **145** Photo by Shirlaine Forrest/WireImage. **146** COURTESY Brooks Brothers. **147(t)** COURTESY Bermuda Tourist Board. **147(b)** Photo by Harry Todd/Fox Photos/Getty Images. **148** Alan Band/Keystone/ Getty Images. **149** Guy Marineau/Condé Nast/Shutterstock. **150** Steve Schapiro/Contributor. **151** Ken McKay/Shutterstock. **152** THA/ Shutterstock. **153** Snap/Shutterstock. **154** Photo by Victor VIRGILE/Gamma-Rapho via Getty Images. **155** Photo by Gene Lester/Getty Images. **156** Photo by Pascal Le Segretain/Getty Images. **157** Laurent Vu/Sipa/Shutterstock. **160** Anderson and Sheppard. **161** Masheter Movie Archive/Alamy Stock Photo. **162** Anderson and Sheppard. **163** Courtesy Hardy Amies. **164** Copyright owned by Arcadia Group

Ltd (formerly called Montague Burton Ltd) 1939. **165** PictureLux/The Hollywood Archive/Alamy Stock Photo. **166(t)** Photo by Jeff Kravitz/FilmMagic. **166(b)** Snap/Shutterstock. **167** Courtesy Gieves & Hawkes. **168** Michael Rougier/The LIFE Picture Collection/Shutterstock. **169** COURTESY Brooks Brothers. **170** Bettman Archives/Getty Images. **171** Photo by John Pratt/Keystone Features/Getty Images. **172** Copyright owned by Arcadia Group Ltd (formerly called Montague Burton Ltd) 1939. **173** Photo by Daily Herald/Mirrorpix via Getty Images. **174** Photo by Walter Nurnberg/SSPL/Getty Images. **175** Copyright owned by Arcadia Group Ltd (formerly called Montague Burton Ltd) 1939. **176(t)** Courtesy Gieves & Hawkes. **176(b)** Greg Balfour Evans/Alamy Stock Photo. **177** Photo 12/Alamy Stock Photo. **178** ARCHIVIO GBB/Alamy Stock Photo. **179** Photo by Express Newspapers/Getty Images. **180** Fotos International/Getty Images. **181** Corbis via Getty Images. **184(t)** Bettmann Archives/Getty Images. **184(b)** Courtesy Hanes Magazine/Hanesbrands Inc. **185** Moviestore Collection Ltd/Alamy Stock Photo. **186** Photo by Fairchild Archive/Penske Media via Getty Images. **187** Nils Jorgensen/Shutterstock. **188–9** Photo by Michael Putland/Getty Images. **190** Photo by Michael Ochs Archives/Getty Images. **191** Photo by Hulton Archive/Getty Images. **192** Photo by Popperfoto via Getty Images/Getty Images. **193** Everett Collection Inc/Alamy Stock Photo. **194** Mansell/The LIFE Picture Collection/Shutterstock. **195** Everett Collection Inc/Alamy Stock Photo. **196** Photo by Giovanni Giannoni/Penske Media via Getty Images. **197** Photo by Rob Kim/Getty Images. **198(t)** Hector/Alamy Stock Photo. **198(b)** Photo by Tim Graham Photo Library via Getty Images. **199** Photo by Popperfoto via Getty Images. **200** Alpha Stock/Alamy Stock Photo. **201** Photo by Silver Screen Collection/Getty Images. **202** Photo by Jim Steinfeldt/Michael Ochs Archives/Getty Images. **203** Photo by Kevin Mazur/WireImage. **204(t)** Photo by Victor Boyko/Getty images for IRFE Paris. **204(b)** Photo by Michael Ochs Archives/Getty Images. **205** Photo by CBS Photo Archive/Getty Images. **208** Courtesy Gieves & Hawkes. **209** Photo by Robert Whitaker/Getty Images. **210** Bettmann Archive/Getty Images. **211** John Springer Collection/CORBIS/Corbis via Getty Images. **212** The Print Collector/Heritage-Images/TopFoto. **213** John Springer Collection/CORBIS/Corbis via Getty Images. **214** Photo by Steve Callaghan/Shutterstock (274668f). **215** John Bramley/Revolution/Mgm/Columbia/Kobal/Shutterstock. **216** COURTESY Brooks Brothers. **217** Pictorial Press Ltd/Alamy Stock Photo. **218** Courtesy Le Tricoteur. **219** Courtesy Le Tricoteur. **220** 1956–2009 Tori Richard Ltd, All Rights Reserved. **221** Corbis via Getty Images. **222–3** 1956–2009 Tori Richard Ltd, All Rights Reserved. **224–5** Courtesy Lacoste. **226–7** Courtesy Fred Perry. **228** Courtesy Pendleton Woolen Mills. **229** Photo by Popperfoto via Getty Images/Getty Images. **230** Courtesy Pendleton Woolen Mills. **231** Photo by James Devaney/WireImage. **232** Photo by Hulton Archive/Getty Images. **233** ABC – Image ID: 2RCEJEY (RM). **234–5** Photo by Frank Micelotta/Hulton Archive. **238** Otto Dyar/Mgm/Kobal/Shutterstock. **239** Cinematic/Alamy Stock Photo. **240** PictureLux/The Hollywood Archive/Alamy Stock Photo. **241** TopFoto/PA Images. **242** Pierluigi Praturlon/Shutterstock. **243** Pictorial Press Ltd/Alamy Stock Photo. **244** Chronicle/Alamy Stock Photo. **245** Everett/Shutterstock. **246** Photo by Dave Benett/Getty Images. **247** Ian Dickson/Shutterstock. **248** Courtesy Fruit of The Loom. **249 (top)** Photo by C Flanigan/Getty Images. **249 (bottom)** Photo by Estrop/Wireimage. **250** Courtesy Fruit of The Loom. **251** Michael Rougier/The LIFE Picture Collection/Shutterstock. **252** Photo by David Turner/WWD/Penske Media via Getty Images. **253** Advertising Archives. **254** Photo by Stebbing/Henry Guttmann Collection/Getty Images. **255(t)** Photo by Chris Polk/WWD/Penske Media via Getty Images. **255(b)** Photo by Gie Knaeps/Getty Images. **258** Photo by SSPL/Getty Images. **259** Everett/Shutterstock. **260** PARAMOUNT PICTURES/Album/Alamy Stock Photo. **261** Getty Images/2013 Don Arnold. **262** Warner Bros Tv/Kobal/Shutterstock. **263** Kharbine-Tapabor/Shutterstock. **264** Everett Collection Inc/Alamy Stock Photo. **265(t)** Sipa/Shutterstock. **265(b)** © 2000 MGM File Reference # 30846637THA For Editorial Use Only – All Rights Reserved/Alamy Stock Photo. **266** Photo by Hulton Archive/Getty Images. **267** Photo by Eric CATARINA/Gamma-Rapho via Getty Images. **268** Photo by Samir Hussein/WireImage. **269** Photo by Gus Stewart/Redferns. **270** Mediapunch/Shutterstock. **271** Everett/Shutterstock. **274** Photo by James Devaney/GC Images. **275** Courtesy Manolo Blahnik. **276** Photo by MARCO BERTORELLO/AFP via Getty Images. **277** Getty Images/Universal Images Group Editorial. **278** Salvatore Ferragamo. **279** Everett/Shutterstock. **280–1** Photo by Christopher Simon Sykes/Hulton Archive/Getty Images. **282** Photo by Neil Mockford/FilmMagic. **283** Snap/Shutterstock. **284** Photo by Popperfoto via Getty Images. **285** Photo by Neil Lupin/Redferns. **286** Photo by Keystone/Getty Images. **287** Media Press/Shutterstock. **288** Photo by Alessio Botticelli/GC Images. **289** Smiley N. Pool/Houston Chronicle. **290–1** Courtesy Clarks. **292** Photo by Dina Rudick/The Boston Globe via Getty Images. **293** Alamy Stock Photo/(AP Photo/John Swart). **294** Photo by Ezra Maurer/Ebet Roberts/Redferns. **295** dpa picture alliance/Alamy Stock Photo. **296** Photo by: Circa Images/GHI/Universal History Archive/Universal Images Group via Getty Images. **297** Retro AdArchives/Alamy Stock Photo. **298** Getty Images/Jack Robinson. **299** Photo by Giovanni Giannoni/Penske Media via Getty Images. **300** Everett Collection Inc/Alamy Stock Photo. **301** Photo by Kirstin Sinclair/FilmMagic. **302** imageBROKER.com GmbH & Co. KG/Alamy Stock Photo. **303(t)** Everett Collection Inc/Alamy Stock Photo. **303(b)** Island/Kobal/Shutterstock. **304** Courtesy Airwair Intl. Ltd (Dr Martens). **305** Photo by David Wolff – Patrick/WireImage. **306–7** Photo by Terence Spencer/Popperfoto via Getty Images. **308–9** Courtesy of Red Wing Brands of America, Inc. **310** Courtesy of Bass Weejun. **311** Courtesy of Sebago. **312** Photo by Chris Walter/WireImage. **313** Photo by John Springer Collection/CORBIS/Corbis via Getty Images. **314** Snap/Shutterstock. **315** Photo by Getty Images/ Randy Brooke/WireImage. **316** Keystone/Zuma/Shutterstock. **317** Shutterstock. **318** Salvatore Ferragamo. **319** Photo by Corry Corrado/Shutterstock. **320–1** Courtesy Tod's Group. **322–3** Courtesy Cheaney. **324** Photo by Darren Gerrish/WireImage. **325** Courtesy Loake. **326** Courtesy sperry top-spider. **327** Photo by Darren Gerrish/WireImage for Ralph Lauren. **328** Danny Lehman/Corbis/VCG. **329** Peter Stackpole/The LIFE Picture Collection/Shutterstock. **330–1** Morgan Creek/Davis/Kobal/Shutterstock. **334** Photo by Kasia Wandycz/Paris Match via Getty Images. **335** Everett/Shutterstock. **336** Photo by MEGA/GC Images. **337** Hulton Archive/Getty Images. **338** Everett/Shutterstock. **339** Joseph Leombruno/Condé Nast/Shutterstock. **340** Photo by JUSTIN TALLIS/AFP via Getty Images. **341** Henry Clarke/Condé Nast/Shutterstock. **342** Photo by Stephane Cardinale/Corbis via Getty Images. **343** Howard Sochurek/The LIFE Picture Collection/Shutterstock. **344** Everett/Shutterstock. **345** Photo by Michel Dufour/WireImag. **346** Snap/Shutterstock. **347** Photo by Heritage Art/Heritage Images via Getty Images. **348** Courtesy of Lock & Co. **349** Anwar Hussein/Hulton Archive/Getty Images. **350–1** brent black production. **352** Joe Vella/Alamy Stock Photo. **353 (top)** Photo by Mitchell Gerber/Corbis/VCG via Getty Images. **353 (bottom)** Columbia/Kobal/Shutterstock. **354–5** Courtesy Rolex. **356(t)** Courtesy Hardy Amies. **356(b)** Courtesy Gieves & Hawkes. **357** Hirz/Getty Images. **358** randolph engineering. **359** Paramount/Kobal/Shutterstock. **360** Jonathan Olley/Annapurna/Kobal/Shutterstock. **361** PictureLux/The Hollywood Archive/Alamy Stock Photo.

# Further Reading

Amies, Hardy. *The Englishman's Suit*, Quartet, London, 1994.

Blackman, Cally. *100 Years of Fashion*, Laurence King, London, 2012.

Blackman, Cally. *One Hundred Years of Menswear*, Laurence King, London 2009.

Brayley, Martin and Ingram, Richard. *The World War II Tommy: British Army Uniforms, European Theatre, 1939–45*, Crowood Press, Marlborough, 2007.

Brunel, Charlotte. *The T-Shirt Book*, Assouline, New York, 2002.

Brunner, Gisbert L. and Pfeiffer-Belli, Christian. *Wristwatches*, Könemann, Cologne, 2006.

Cirker, Alan D. *The Alpha Story*, Baker Hill, Chantilly, VA, 2009.

Cumming, Valerie. *Understanding Fashion History*, Batsford, London, 2011.

Design Museum. *Fifty Dresses that Changed the World*, Conran, London, 2009.

English, Bonnie. *A Cultural History of Fashion in the 20th and 21st Centuries: From Catwalk to Sidewalk*, 2nd edition, Bloomsbury Academic, London, 2013.

Enjames, Henri-Paul. *GI Collector's Guide*, volumes I and II, Histoire & Collections, Paris, 2003.

Farren, Mick. *The Black Leather Jacket*, Plexus, London, 2008.

Fukai , Akiki, et al. *Fashion: A History from the 18th to the 20th Century*, Taschen, New York, 2006.

Gavenas, Mary Lisa. *The Fairchild Encyclopedia of Menswear*, Fairchild Books, New York, 2008.

Hope, Dale. *The Aloha Shirt: Spirit of the Islands*, Beyond Words, Oregon, 2000.

Knight, Nick. *Skinhead*, Omnibus, London, 1982.

Laver, James and de la Haye, Amy. *Costume and Fashion: A Concise History*, Thames & Hudson, London, 2002.

Lenius, Oscar. *A Well-Dressed Gentleman's Pocket Guide*, Prion, London, 1998.

Newman, Alex and Shariff, Zakee. *Fashion A to Z*, Laurence King, London, 2009.

Roetzel, Bernhard. *Gentleman: A Timeless Fashion*, Könemann, Cologne 2004.

Rothstein, Natalie, ed. *400 Years of Fashion*, V&A Publishing, London, 1999.

Sims, Josh. *100 Ideas that Changed Street Style*, Laurence King, London, 2014.

Sims, Josh. *Cult Streetwear*, Laurence King, London, 2010.

Sims, Josh. *Rock Fashion*, Omnibus, London, 1999.

Sweeting, C.G. *Combat Flying Clothing: Army Air Forces Clothing during World War II*, Smithsonian Institution Press, Washington, DC, 1984.

Vass, László and Molnár, Magda. *Handmade Shoes for Men*, Könemann, Cologne, 2008.

Wilcox, Claire, ed. *Fashion in Detail 1700–2000*, V&A Publishing, London, 2013.

Windrow, Richard and Hawkins, Tim. *The World War II GI: US Army Uniforms, 1941–45*, Crowood Press, Marlborough, 2008.

Worsley, Harriet. *100 Ideas that Changed Fashion*, Laurence King, London, 2011.